GOTHIC ART IN BOHEMIA AND MORAVIA

BY ALBERT KUTAL

HAMLYN

London · New York · Sydney · Toronto

Frontispiece: The Original Sin. 1390–1400. Limestone with old polychrome. h. 50 cm. Console in the choir of St Vitus's Cathedral, Prague

1394

TRANSLATED BY TILL GOTTHEINER
GRAPHIC DESIGN BY JIŘÍ BLAŽEK
TEXT © 1971 BY ALBERT KUTAL, ILLUSTRATIONS © 1971 BY ARTIA
DESIGNED AND PRODUCED BY ARTIA FOR
THE HAMLYN PUBLISHING GROUP LIMITED
LONDON • NEW YORK • SYDNEY • TORONTO
HAMLYN HOUSE, FELTHAM, MIDDLESEX, ENGLAND

ISBN 0 600 01658 7
PRINTED IN CZECHOSLOVAKIA BY POLYGRAFIA
2/01/01/51

Contents

The specific and quite unique geographical position of the Czech Lands (Bohemia, Moravia and part of Silesia) in the very heart of Europe has had a profound influence on their destiny, their spiritual life, and their art. Once part of a continuous Slavonic settlement, stretching from the mouth of the Elbe to the Alps, they alone resisted the advances of the Germanic tribes eastwards, so that by the thirteenth century they were surrounded on three sides either by countries with a German-speaking population or by countries ruled by the Germans. In the meantime the Hungarians moved to the south-east having, on the disintegration of the Great Moravian Empire, broken off direct contact with Bulgaria and Byzantium. The full weight of political power moved from Moravia to Bohemia, and the Czech Lands became part of the Western European cultural and political sphere. In religious life Latin rites predominated; in political adherence they leant towards the Holy Roman Empire. Their culture, and particularly art, were closely connected with neighbouring and more remote German regions, which, for a time, were an interim step to the Western cultural centres. How was it that the Czech Lands stood up to the pressures of the German tribes while their Slavic neighbours gradually succumbed to them? One reason may be sought in their advantageous geographical position, with mountains and impenetrable forests surrounding them on all sides. Only southern Moravia opens out into the Danube basin. An important factor must have been the early adoption of Christianity, which lessened the ideological excuse for intervention, acquainted the people with the traditions of Antiquity and placed them among the cultured nations of Europe. Another, no less important, factor was the early establishment of a strong central power capable of paralysing the particularism of the individual tribes and of assuming the leadership of the entire territory. Prague's unifying function was similar to that wielded by Paris over the whole of France. In this connection it should not be forgotten that symbols of continuity in the nation's history came into being at an early time and were able to withstand all future dangers. Particularly important were the local saints, often members of the ruling Přemyslide dynasty, including St Wenceslas, who soon became the country's patron saint.

These links with the past were not weakened even by the colonisation of the thirteenth century, which brought large numbers of foreigners to the Czech Lands. Most of them were Germans, who settled in the then sparsely populated borderlands and soon took a leading part in the economic life of the towns. This colonisation, organised chiefly for economic reasons to raise the country's general living standard, exerted an influence in all spheres of life in subsequent history. But the links with the past were never severed. On the contrary, they tended to grow stronger as it became necessary to oppose the alien elements penetrating to the highest places in State and Church administration. This competition had a positive aspect in the exceptional growth of the spiritual alertness of the Czechs. This is apparent in all fields of culture, including the arts.[1] The resulting cultural atmosphere proved strong enough to absorb alien stimuli and transform them to locally conditioned forms. This process of active assimilation reached its culmination at the time of Charles IV and Wenceslas IV, when a qualitative change gave rise to characteristic values which spread from the Czech Lands to the surrounding countries and even further afield. This book should therefore, strictly speaking, be entitled 'Czech Gothic Art' and not 'Gothic Art in Bohemia and Moravia'.

The title of this book is somewhat deceptive. The text deals only with architecture, sculpture and painting and makes no mention of the crafts. This undoubtedly detracts from the picture of Czech Gothic art as presented in the book. The craftsmen contributed far more to the life of people in the Gothic period than one can judge from the fragments that survive. The wealth of craftsmanship proved too valuable, too tempting to survive the greed and animosity of the days that followed. The author tried to follow the scheme of Blažíček's book Baroque Art in Bohemia, *published in the same series and similar format (Hamlyn, 1968). He was afraid that this brief outline crowded with facts would not bear further encumbrance. Nor was he certain that he could master such an enlargement when it proved difficult enough to merge the picture of architecture, sculpture and painting into one continuous story where matters were not presented simply mechanically. He had to rely on the result of research done by other scholars. To name but a few: V. Mencl in architecture, A. Matějček and J. Pešina for panel painting, E. Dostál, J. Pešina and J. Krása for book illustration. Many others helped him to gain knowledge of individual problems and the broader European connections, among them V. Dvořáková, G. Fehr, A. Friedl, J. Homolka, V. Kotrba, D. Líbal, Th. Müller, K. Stejskal. This is but a brief and somewhat arbitrary selection of names. Full references can be found in the bibliography. Where the author adapted the facts and explanations contained in their writings to his ideas of what really happened in Czech Gothic art, the responsibility is fully his own. The manuscript was handed over to the publishing house in 1968. More recent literature could not, therefore, be taken into account.*

I. *The Thirteenth Century*

SOCIAL CHANGES; THE PŘEMYSLIDE DYNASTY; THE MONASTIC ORDERS – ST FRANCIS AND ST SAVIOUR, PRAGUE; CISTERCIAN CHURCHES AND MONASTERIES; BURGUNDIAN INFLUENCE IN ARCHITECTURE – TIŠNOV, TŘEBÍČ; SPREAD OF CLASSIC GOTHIC ART – ZLATÁ KORUNA, VYŠŠÍ BROD; SCULPTURE – PORTAL AT PŘEDKLÁŠTEŘÍ; THE TRANSITION FROM ROMANESQUE IN PAINTING AND BOOK ILLUSTRATION

Far-reaching changes were occurring in the Czech Lands when the first tidings of Gothic art penetrated there. The economic structure was in a state of flux; the social structure and way of life was being transformed. Even the hitherto unified ethnic character was changing. The extensive colonisation undertaken with the aim of raising the standard of living had brought large numbers of foreigners into the country, mostly of German tongue. They brought with them new methods of production and trade. Economic and cultural life centred upon the towns which were growing in place of older settlements, on cleared land or around newly built castles. Economic progress, stimulated by intensive ore mining, particularly silver, soon made an impact upon political life. The last kings of the old dynasty, the Přemyslides, who date back to mythology, had set out to turn the Czech Lands into a great power. This policy reaped success in the West, in France and England. Přemysl Otakar II built an empire which stretched as far as the Adriatic. But he lost it, and his own life, in the battle against the German Emperor Rudolph of Habsburg. His son Wenceslas II concentrated on Poland and Hungary and furthered the political ambitions of his father. His aims were followed up by his son-in-law, John of Luxembourg and his grandson, Charles IV. Education, which quickly rose to a higher level of social importance, shifted from the countryside to the towns. Wenceslas II had tried to found a university in Prague. His intention was carried out, half a century later, by Charles IV, who in other matters, too, followed in his grandfather's footsteps and shared many of his interests in culture and art. The new social conditions were reflected in the arrival of mendicant orders who developed feverish activity in towns and had an important influence on architecture. The old aristocratic orders who had fostered education did not lose any of their significance. It is typical of the transitional character of the period that it was the Cistercians who were largely responsible for the introduction of Gothic architecture to the Czech Lands.

Yet one of the oldest Gothic churches in the country, if not the oldest, is that of St Francis (sv. František) in Prague, belonging to the convent of the Order of the Poor Clares which was founded in 1233 by the Blessed Agnes, sister of King Wenceslas I. It is the oldest Franciscan convent in Central Europe, and perhaps the oldest existing anywhere north of the Alps. The oldest part of this complex building, with the church of St Francis, dates from the thirties and the first half of the forties. It reveals close connection with architecture in Champagne of the first thirty years of the thirteenth century.[2] The second phase of building activity reveals Cistercian in-

fluence from the abbey at Tišnov. In the third quarter of the thirteenth century St Saviour's church (sv. Salvátor) was built for the convent of the Prague Clares and the church of St Francis was handed over to the Lesser Brethren. The apse of the new church already belonged to the classic phase of Gothic architecture.

The impact of Champagne architecture on the building of the Prague convent of the Poor Clares, probably due to the participation of travelling stone-masons from Champagne, is unique. Far greater and more noticeable is the influence of Cistercian architecture from Burgundy which retained much of the massive Romanesque solidity and was hardly affected by the rational functionalism of the Gothic cathedrals of northern France. The wall retained its full material and aesthetic substance. The architectural members remained independent; the interior, still largely composed of relatively isolated units, had little in common with the exterior. This style, aptly called 'transitional', was more acceptable in a country where architecture was ruled by the old tradition of block structures, which was alien to the rational structural principles of the articulated architecture of northern France.

The oldest Cistercian church buildings in the Czech Lands date back to the Romanesque period. Most of them today are Baroque in appearance. The monastery churches at Osek and Velehrad, founded in 1205 or 1207, show the arrival of the new style in some of their details, such as the pointed arches of the arcades. At Velehrad, ribbed cross vaulting was already applied consistently. But even in places where the French system was fully adopted the tradition of block structure was not abandoned. A clear example of this stage of development is the Cistercian abbey and church at Předklášteří near Tišnov. It is remarkable that its main parts have survived comparatively unspoiled and without any substantial later alterations.

Inside the smooth and solid walls of the towerless basilica, supported by buttresses, are groups of shafts supporting the ribbed cross vaulting, sexpartite in the presbytery. Small semi-circular windows are set high in the smooth walls. They are pointed only in the presbytery where they have tracery. The southern and western façades are adorned with the Cistercian circular windows in which small circles are centred upon a larger one in the middle. The massive piers of the arcades show a last echo of Romanesque monumentality but already broken up by ribbed cross vaulting and diagonally placed shafts. The building with its typical Cistercian simplicity has richer ornamentation only on the capitals, and the consoles in the

cloisters. Most of the decorations depict berries. For this reason the west portal is the more surprising; it is significant not only for its Burgundian, still almost Romanesque, ornaments covering the rounded pillars of the jambs and archivolts, but also for its figural decorations, which are quite unique east of the Elbe.

This disregard for Cistercian principles may have been due to the Přemyslide patrons' decision to make this church their final resting place. The founder of the monastery, Queen Constancia, was buried here in 1240. That same year the main altar was consecrated to the Virgin Mary. By that time the main parts of the church must have been completed. It is quite possible that the stone-masons from Tišnov then moved on to building the St Francis monastery in Prague.

Other Cistercian churches and abbeys were built in the same spirit (Oslavany, Osek – chapter-house, Hradiště nad Jizerou, Pomuky). So were churches belonging to other, particularly mendicant orders. For example, the Minorite and Dominican monasteries and churches at Jihlava are strongly influenced by the Cistercian style, even though their plans were altered to suit the needs of the respective orders. Typical of the solid block structure of the Minorite church is the remarkable long choir, which can also be found in the slightly younger Dominican church. It was built as a hall church. Its almost square ground-plan shows a highly developed sense of well-balanced spatial unity. A hundred years later this was to become one of the main features of Czech architecture. The example set by the Cistercians became important both for town churches and secular architecture. An example is the deanery church at Písek, built by the same workshop that constructed the royal castles at Písek and Zvíkov. The forecourt at Zvíkov, of irregular ground-plan, is surrounded by a two-storied gallery with ribbed cross vaulting, which in one section is replaced by quite unusual tripartite vaulting. How alien the rational articulation of the new Gothic style was to the Bohemian environment is shown in certain town churches where the already simplified Burgundian style is further reduced. Equally, some churches belonging to the Cistercian Order took recourse to the older principles omitting even those achievements which Burgundian Gothic architecture had brought to the country – possibly via Swabia. For example, the monastery church at Žďár, begun in 1253, is without any buttresses, and inside the building heavy solid walls dominate over the articulated system of supports. The influence of the Cistercian masonic lodges, which apparently turned into workshops in the service of big building contractors, and especially of the Court, made itself felt in almost every building undertaken at that time. Mention should be made in particular of the Benedictine church at Třebíč, where the sculptural decoration shows links with the Cistercian workshops at Tišnov and Oslavany. But the church differs in layout and construction, deriving from another, more complex, origin. The octagonal rib vaulting of the presbytery, originally intended for the whole church, proves that the inspiration came from south-western France. It is probable that the stone-masons moved from there across Burgundy, the source of the blind arcades at the apse and the north porch, to the Upper Rhine, the inspiration for the Romanesque apse

with a gallery which originated at Worms, and perhaps they passed through Regensburg, as is suggested by the abstract decorative motifs of the north portal. When they came to the Czech Lands they encountered a strong local Cistercian tradition. There are close links between the church at Třebíč and Benedictine buildings in Hungary and Austria, which shows how the victorious Gothic style displaced the old Romanesque builders' workshops, whose members moved eastwards, learning many lessons on the way. The building that came into being at Třebíč is eclectic enough, harmoniously linking Gothic and Romanesque elements. The building was erected without interruption and without any substantial changes to the original plan at a later date. Only the nave was given sexpartite instead of octagonal vaulting and again altered during Baroque times. The result is an extremely interesting architectural work, showing both variety and homogeneity. After the middle of the century classic Gothic features began to penetrate into Bohemia from the Paris region. Naturalistic foliage replaced earlier abstract or Classical Romanesque ornament, and soon showed great observation and perfection in execution, rivalling that made in France. Some examples are the capital in the chapter-house of the Franciscan monastery in Prague, the north portal of the abbey church at Hradiště nad Jizerou, the old parts of the church of St Bartholomew (sv. Bartoloměj) at Kolín and St Wenceslas (sv. Václav) at Olomouc. The same is true of the structural articulation of the walls with compound shafts, found in the apse of the church of St Stephen (sv. Štěpán) at Kouřim and particularly in the first phase of the nave and aisles of St Bartholomew's at Kolín. The culmination of these endeavours, inspired by the classic Gothic art of the Ile de France or Reims, is the apse of the church of St Saviour (sv. Salvátor) in Prague. Large windows with rather intricate tracery are set between slender composite shafts with intersecting shaft-rings. In the manner of central France, the windows are outlined with bar tracery, also with intersecting rings. The weight-bearing function of the walls is symbolised by a rational but redundant system of supports. It seems that this line of development, leaning towards classic Gothic art, was adopted even by the Cistercians. This is demonstrated by the abbey buildings which they erected at Zlatá Koruna and Vyšší Brod, founded in 1263 and 1259 and connected with the rivalry between the king and the powerful Rožmberk family of southern Bohemia. The actual building of the monasteries and churches took place a few decades later.

At Zlatá Koruna a two-storey chapel of the Guardian Angels (kaple Andělů strážných) dates from the late thirteenth century. The tympanum and capitals of the west portal bear naturalistic foliate decoration which has already lost the freshness of natural form. At Vyšší Brod the most interesting section from that period is the chapter-house, with four compartments of tripartite vaulting supported by a central pillar. Here we have a foretaste of the manner developed in double-nave churches of the fourteenth century. This trend influenced secular architecture, too, as shown in the chapel, with nave and side aisles, of the castle at Horšovský Týn and especially the chapel at Bezděz. An impressive cornice below the windows divides the clerestory of the apse from the lower part in which the massiveness

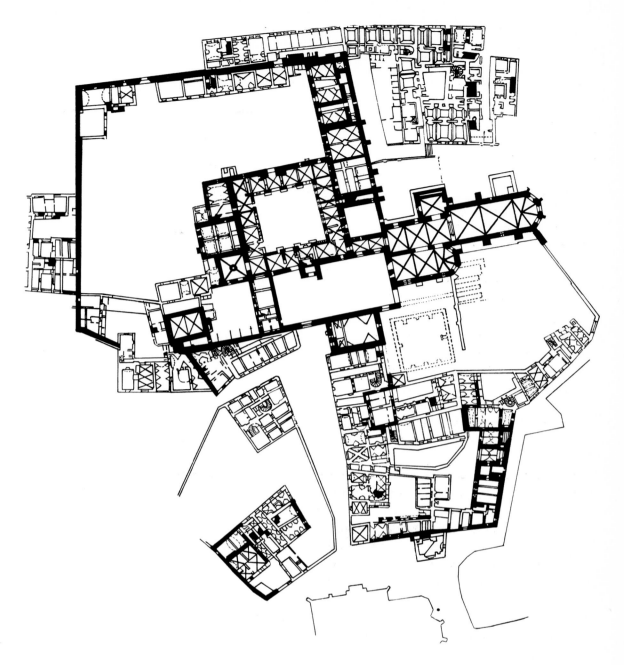

1 Plan of the Convent of the Poor Clares of the Blessed Agnes. Founded before 1234, finished c. 1280.

of the walls is stressed, even though lightened by the blind arcade of the sedilia. Even these buildings, advanced as they were for their time, show features of the architecture of the Cistercians, who may have introduced French naturalistic ornamentation to the Czech Lands. As the second half of the century progressed, however, this ornamentation lost its initial spontaneity and liveliness.

The strongly rooted Czech trends towards heavy, unarticulated walls can be seen, in particular, in buildings which, after an initial attempt at classic Gothic form, were completed in the old conservative spirit. This is true of St Bartholomew's in Kolín where instead of the proposed cylindrical pillars, heavy, solid cross-shaped piers with attached shafts were used,[3] retaining the Romanesque principle of frontality, slightly modulated by the diagonal positioning of some of the capitals.[4] Likewise the articulation of the apse of St Saviour's, Prague, contrasts

with the solidity of the other parts. In the Old-New Synagogue in Prague the classic articulation of the shafts was replaced by simple bars or highly placed consoles, leaving the whole area of the walls free. In the rich foliate ornamentation, naturalistic motifs alternate with increasingly abstract shapes.

* * *

The prevailing block construction of thirteenth-century Bohemian architecture did not permit articulation, that is to say, a rational embodiment of the structural forces hidden within the walls; nor did it encourage the development of monumental sculpture, particularly figural sculpture. Even if a representation of the human figure was part of a wall it was always given a certain individuality; it was something that emerged out of the block. Only when the interior functionalism of the building became visible in Gothic art, in the form of individual-

ised members, could relatively independent sculpture develop, symbolically linked with the architecture. This individualisation, which introduced movement into architecture, ran counter to the entire existing tradition of block structure in which building material was conceived as something inert. It can therefore be assumed that there was little demand for monumental sculpture. Its origin can be linked with the wishes of certain individuals rather than with a general demand. It was not taken as a matter of course and required a special impulse to bring it about. But there must originally have existed far more works of monumental sculpture than have survived. We know, for example, that in 1257 a stone monument was built in Prague with the figure of Wenceslas I. In this connection mention must be made of a stone tomb, with the effigy of Wenceslas II, in the Cistercian church at Zbraslav. It disappeared together with his favourite monastery, which had been built on his orders and which was to have become the burial church of the kings of Bohemia. Apart from the relief on the Little Quarter Bridge Tower representing a petitioner kneeling in front of a figure on a throne, in all likelihood a king, which was recently convincingly attributed to the twelfth century

(Mašín)[5], there are only few surviving works of early thirteenth-century sculpture which deserve to be called 'monumental'. Moreover, it is doubtful whether they can be considered Gothic. In figural sculpture the borderline between Romanesque and Gothic is even less distinguishable than in architecture. The relief of a Madonna in Majesty with members of the Přemyslide dynasty, in the church of St George (sv. Jiří) at Prague Castle, is Romanesque, so is the tympanum of the former hospital church of St Lazarus (sv. Lazar) now no longer standing. The figures on the tympanum of the north portal of St Bartholomew's at Kolín, with a very expressionist Annunciation, can hardly be considered Gothic. The work is of an expressive Late Romanesque style with partly stylised naturalistic ornaments. Everywhere one can observe the disappearance of frontal design, which pointed towards a change in style, but the method which sculptors used to express a new, more sensitive attitude to the world sprang from a Romanesque tradition.

Neither is there any unity in the style of the largest set of figure and ornamental sculpture in the Czech Lands which decorates the west portal of the Cistercian abbey at Předklášteří near

2 Plan of the Cistercian abbey at Předklášteří near Tišnov. Founded 1233, finished c. 1250.

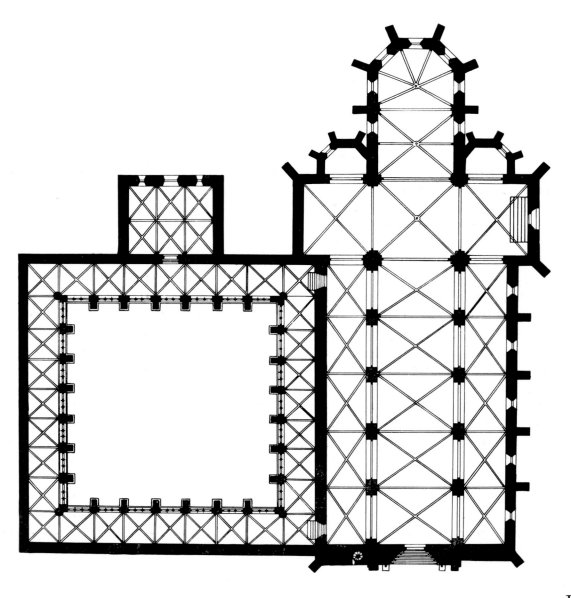

Tišnov. An attempt was made here to apply Gothic ornamental elements, even an entire Gothic portal. Yet the compromising manner in which this intention was carried out is typical of the immaturity of Bohemian art before the middle of the thirteenth century. The pointed arches of the archivolts, the diagonal position of the columns, the unbroken pedestals and cornices breaking up the frontality of the pillars, the large, diagonally placed figures on the jambs, all attest to the Gothic approach of the men who constructed the portal. But excessive ornamentation points to a close link with Romanesque tradition, especially in the predominance of acanthus and palmette ornaments, intermingled with buds and other motifs which are already close to local flora (for example, foliage, like that in the cloisters and the presbytery of St Francis in Prague, resembling nasturtium leaves). Romanesque features appear also in the statues of recumbent lions along the sides of the doorway, in horizontal layers of different coloured stones, and in the lack of structural feeling. Elements derived from the West and the South are mixed here. The tympanum has rich figural ornaments. Under the protection of the Virgin Mary and John the Baptist, Margrave Přemysl and his mother Constancia present a model of the church to Christ, who is shown in a mandorla. Ten Apostles are to be found on the jambs. The remaining two were placed on the façade of the church. The positioning of the figures on the jambs is unusual. The apostles do not stand in front of the columns nor in front of the smooth wall of the jambs, as would be expected, but below the head of and between the portal pillars – an illogical solution and contrary to Gothic principles. It might perhaps be explained by the fact that the positioning of the Apostles was decided upon after the portal as such, or at least its lower portions, had been completed. Most of the heads of the Apostles are of a later date. Other parts of the statues and the foliage must also have been renovated in later times. Best preserved is the relief on the tympanum. It points to a knowledge of sculpture in Saxony (the Wechselburg pulpit). Saxony was the main inspiration for the figure sculpture at Tišnov and part of the design of the portal. Yet the positioning of the figures on the portal derives from the Golden Gate at Freiberg and the Prince's Gate at Bamberg. But there the figures stand in niches carved into the pillars, while at Předklášteří they are placed in front of the pillars. In that respect the portal at Předklášteří is closer to the south portal of St Servatius at Maastricht. Most of the figures are broad, with strong curves and some of them are shown in quite complex postures. Classically inspired garments cling to their bodies, following the line of movement in rather slender, soft folds. Only the dense parallel lines of the robes worn by St John, and their sharper modulation, are reminiscent of French sculpture (as for example, the Evangelist Luke on the column of the *Last Judgment* in the Cathedral of Notre Dame, Strasbourg`. Differences can be detected also among the remaining figures, but they all took their source from Saxony. It is probable that the stone-masons who made them had nothing to do with the workshop at Předklášteří and were specially commissioned to make the figural ornaments on the portal and other work of this nature at Předklášteří, some of which has survived.

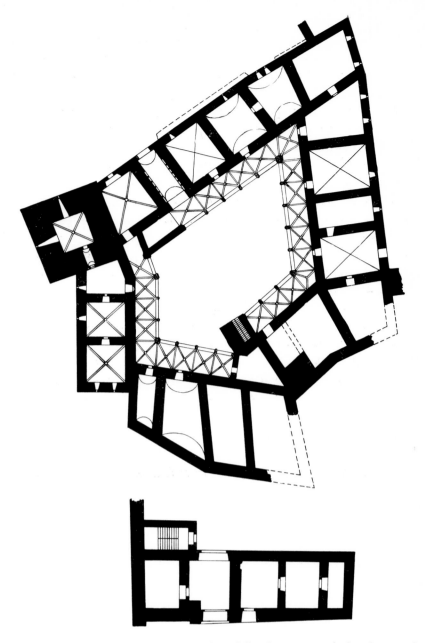

3 Plan of the royal castle at Zvíkov. Third quarter of the thirteenth century

But no other work by these stone-masons can be found elsewhere in the Czech Lands.

The portal at Předklášteří is a good example of Bohemian sculpture of the late thirteenth century. The portal is unique, like other works of monumental sculpture in Bohemia. Being eclectic in its composition, it links elements from various and different ages. Furthermore, its wealth, magnificence and deliberate progressiveness characterise the social setting whose needs and desires it satisfied.

It is certainly no mere chance that the two buildings which were erected at almost the same time – the Cistercian abbey at Předklášteří and the Franciscan monastery in Prague – were undertaken by the ruling dynasty of the Přemyslides. It is characteristic of this transitional period that their favours were divided equally among the mendicant orders working in a city environment and the old aristocratic order of the Cistercians, who isolated themselves in remote country places.

At this period the Czech Lands stood at the turning-point of two epochs. The time was a revolutionary one in all respects. The whole way of life was changing and adapting itself to the West. The influx of new ideas and methods, brought by immigrants, penetrated State and Church offices and influenced the way of life of high society. German poetry was cultivated at the Court of Prague and the old Bohemian families adopted German names. Opposition to this, together with a growing sense of historical continuity, made its impact on progress only in the fourteenth century.

At a time of alien influences, one cannot expect to find continuity or any typical regional features in sculpture. Chronology is of no consequence when one can encounter old and new forms standing side by side. Cistercian ornamental sculpture was reasonably unified in character, but alongside it can be found works of various stylistic origins.

In the late thirteenth century this divergence in sculptural style began to give way to a certain uniformity, in the sense that all of it belongs to the post-classic phase of Gothic art. This can be observed in ornamental sculpture adorning architecture, where natural flora was rapidly becoming stylised and its spontaneity turned into rigid ornament. The same features can be observed in wooden sculpture, of which only a few fragments survive. There are two seated Madonnas from the close of the century; both show a trend towards structural lightness and a growing regularity and decorativeness of form, which had originally been organic. This is the result of a process taking place outside the borders of the Czech Lands. Although related in theme and composition, the statues differ in expression. The *Madonna* from the Pilgrimage Church at Tuřany near Brno (related to a statue of unknown origin in a private collection in Vienna)[6], is rationally plain and concise and close in style to French types. The *Madonna* in the National Gallery, Prague (of south Bohemian origin), is more emotional and expressive in appearance and more closely linked with Central European work. The leading representative of this type of

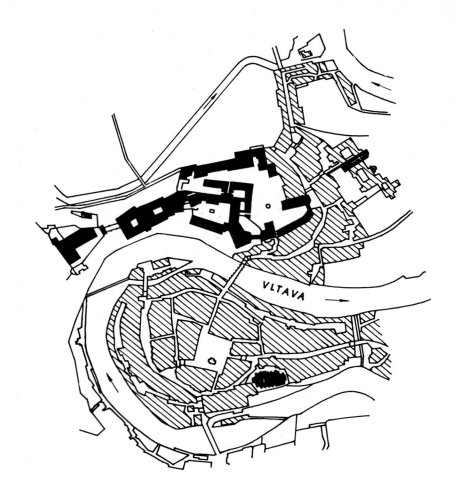

5 *Plan of the Gothic town of Český Krumlov*

work was the master who made the tomb of the Blessed Erminold at Prüfening near Munich. The grandeur found in the work of the great Bavarian sculptor, who apparently knew French sculpture from personal experience, was, however, very much reduced in this *Madonna*.

The feeling for volume did not lessen as the century progressed, and survived into the first few decades of the new. The *Madonna* at Rudolfov, and particularly the Strakonice *Madonna*, show clearly how real volume, the heritage of the thirteenth century, was deprived of its functional organic aspects. It was converted to abstract stylisation, bringing it closer to the regularity of architectural members. Even a genre motif, as the Byzantine gesture of the child's arm, is given as a formality untouched by psychology.

It is impossible, today, to find any connection between works of this kind, which increased in number in the early fourteenth century. Most of them remain isolated pieces. We may get quite the wrong impression, however, as hardly any sculptures have survived in the most important religious, cultural and political centres, although many must once have existed there. But it is probable that the regional traditions in sculpture did not develop until a slightly later period.

* * *

If a certain disparity in style is noticeable between architecture and sculpture in the thirteenth century, it becomes even more evident when we turn to contemporary painting. Everything

4 *Plan of the Gothic town of České Budějovice. Founded 1265*

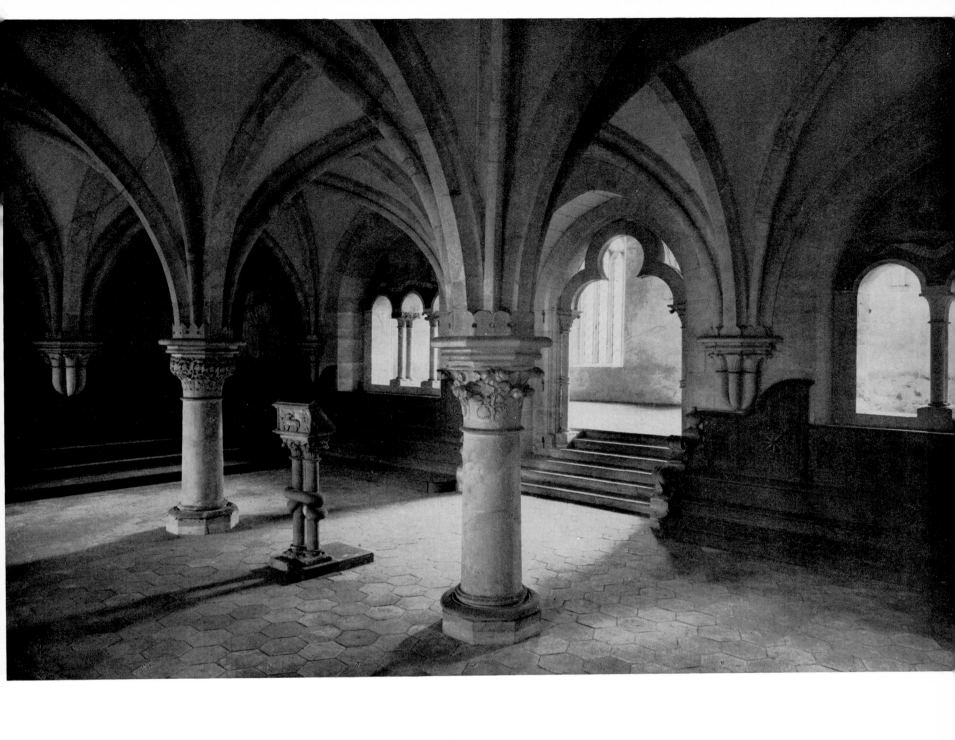

1 The former Cistercian abbey at Osek. Chapter-house. c.1240

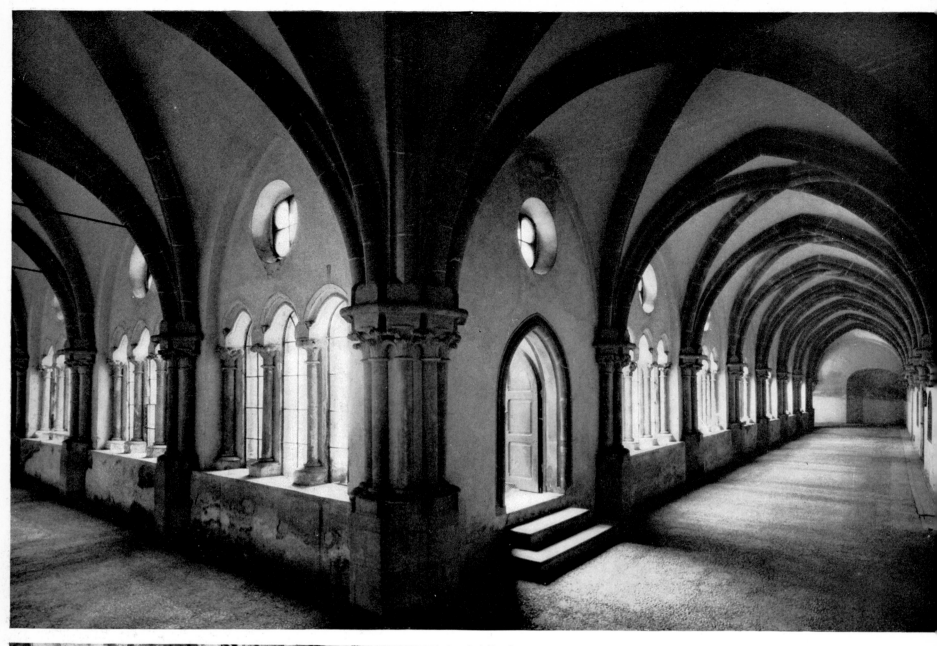

2 The former Cistercian abbey at Předklášteří near Tišnov. Cloisters. c. 1240

3 The former monastery church at Hradiště nad Jizerou. North portal. c. 1260
◄

▶
4 The former Benedictine church of St Procopius, Třebíč. Vaulting in the presbytery. Before 1250

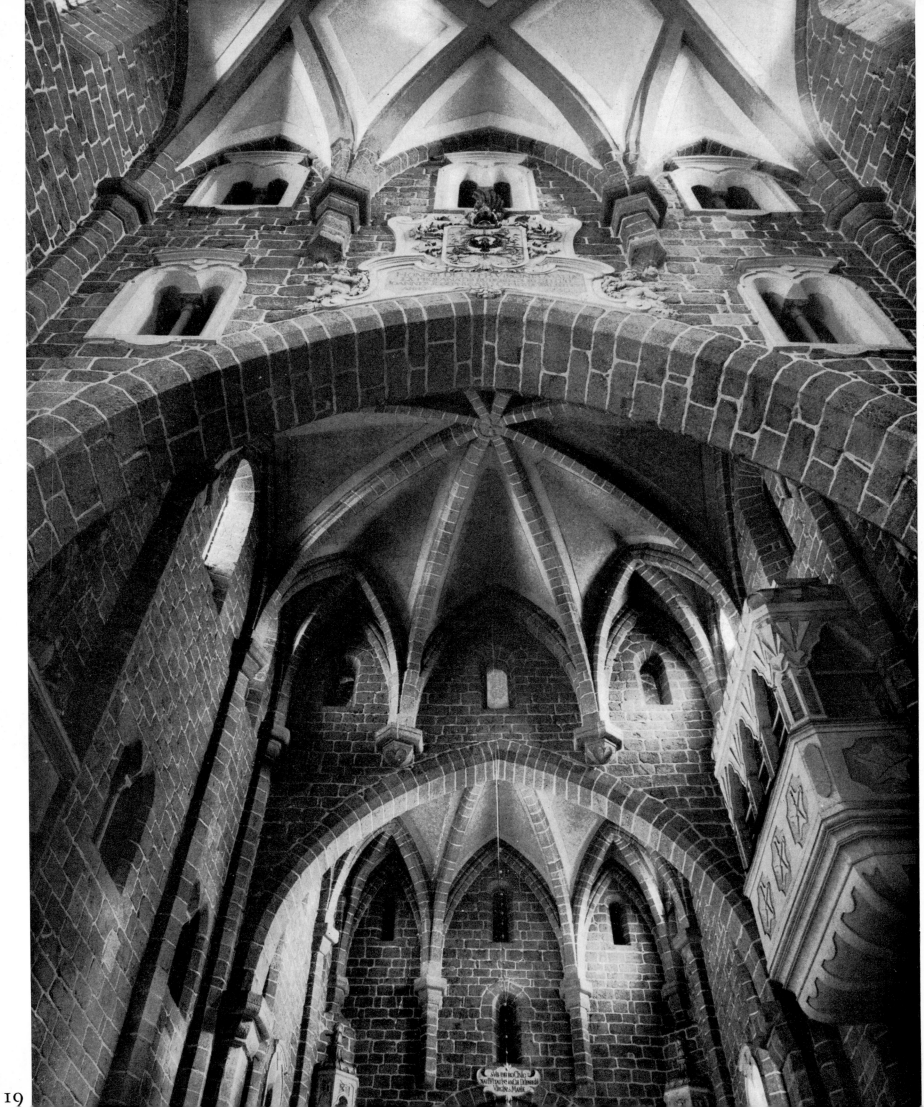

19

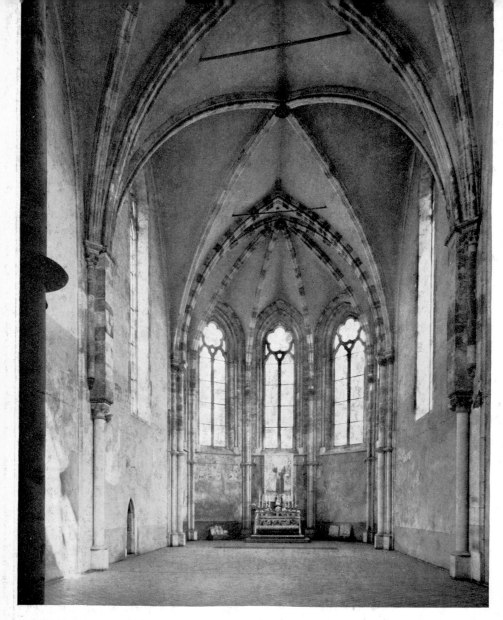

8 Castle chapel, Bezděz. Interior. c. 1280 ►

5 The former convent of the Order of the Poor Clares of the Blessed Agnes. St Saviour's church, Prague. c. 1280 ◄

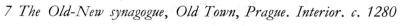

7 The Old-New synagogue, Old Town, Prague. Interior. c. 1280 ▼

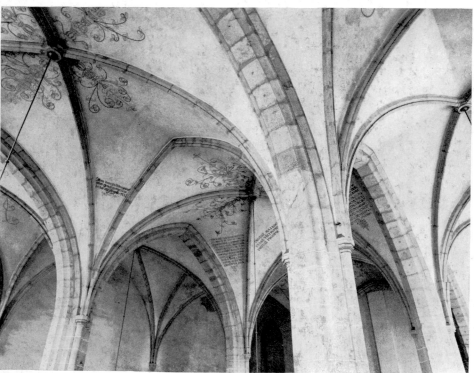

6 The former Dominican church at Jihlava. Nave and aisle vaulting. c. 1250

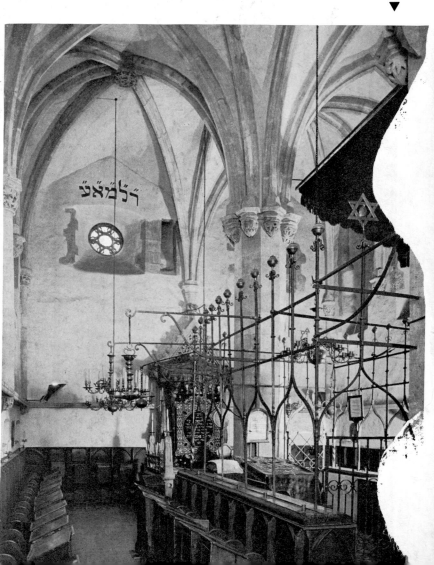

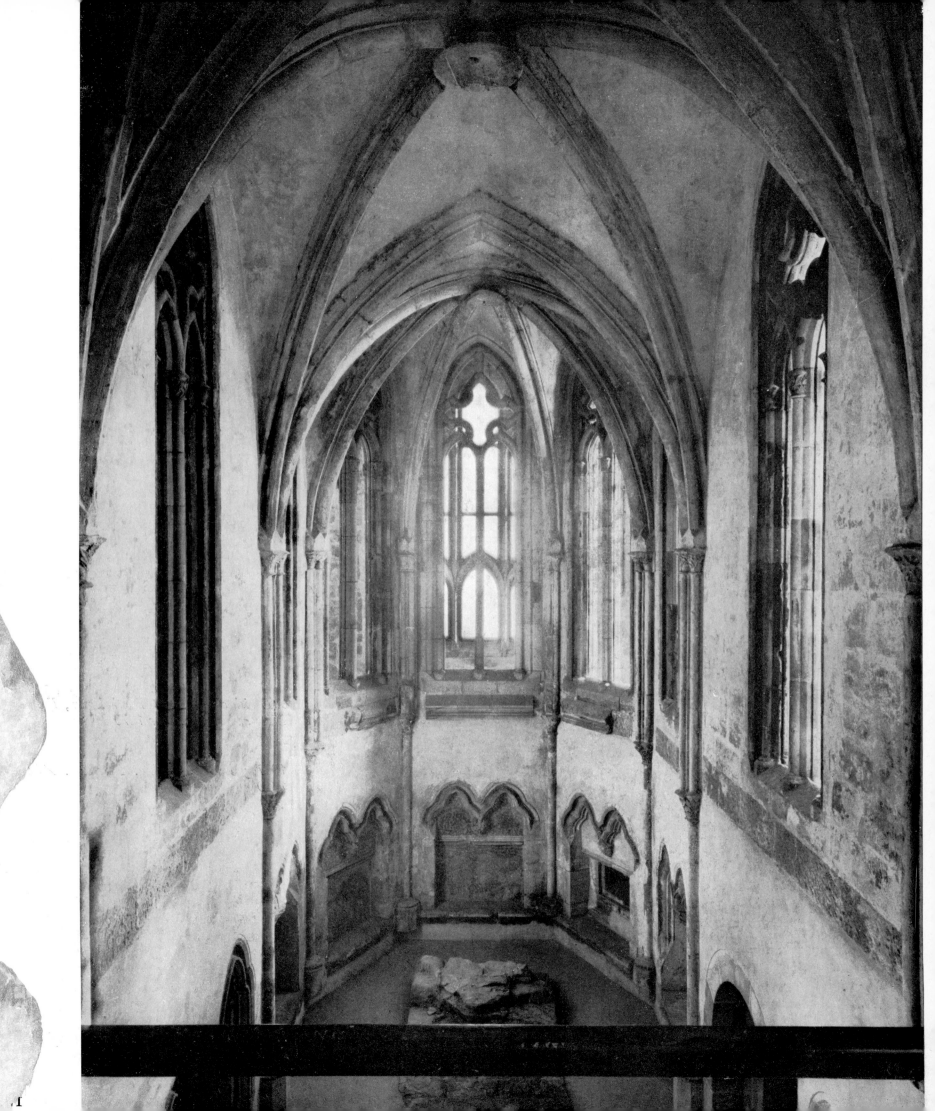

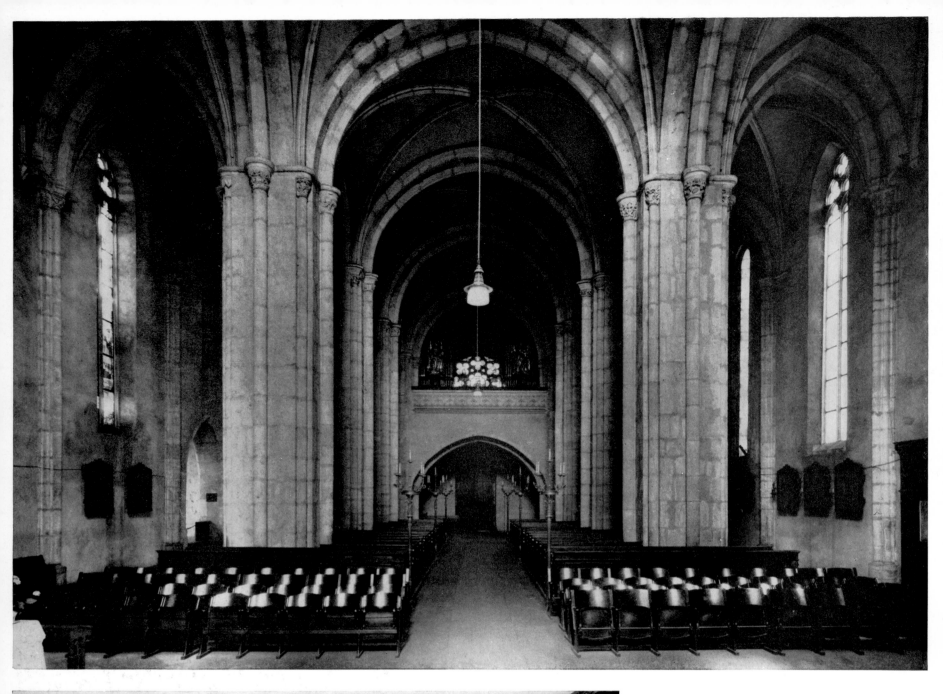

9 Parish church of St Bartholomew, Kolín. Nave and aisles. After 1270

10 Royal castle, Zvíkov. Forecourt. After 1250

◄

▶

11 Royal castle, Zvíkov. The southern fortifications and watch-tower. c. 1260

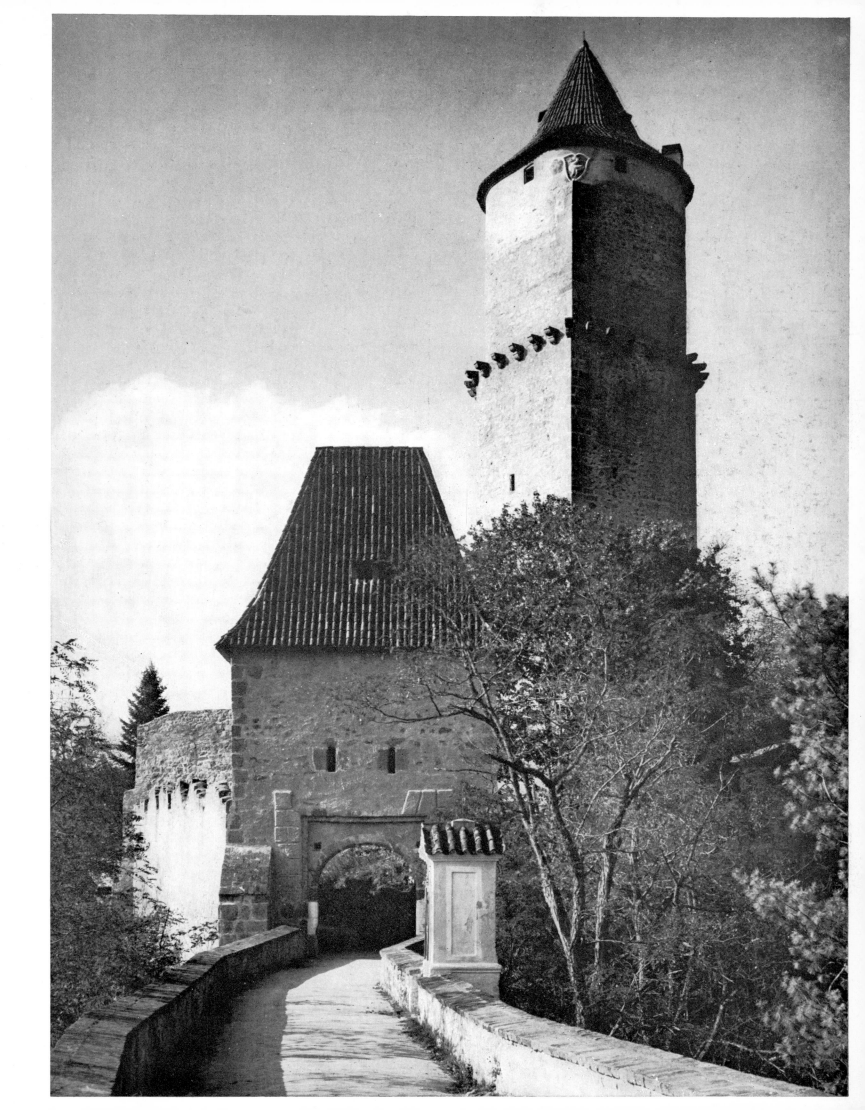

23

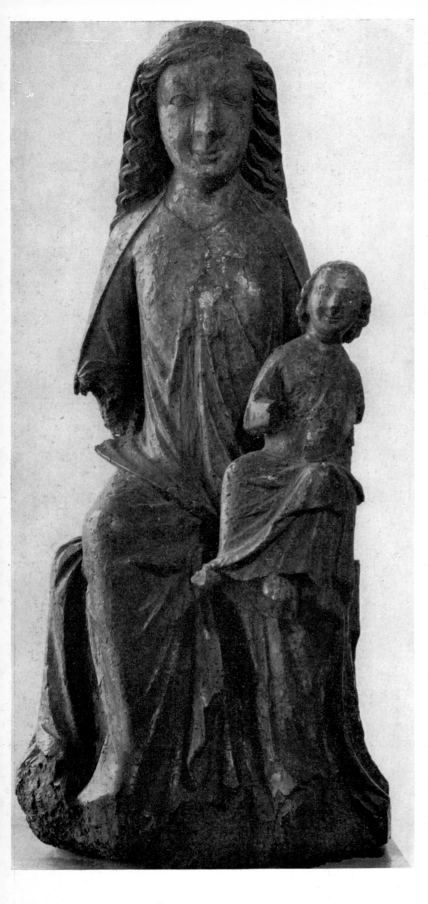

12 *Virgin and Child from south Bohemia. Late thirteenth century. Wood. h. 68 cm. National Gallery, Prague*

▶

13 *The former Cistercian, now parish church at Předklášteří near Tišnov. West portal. 1240–1250*

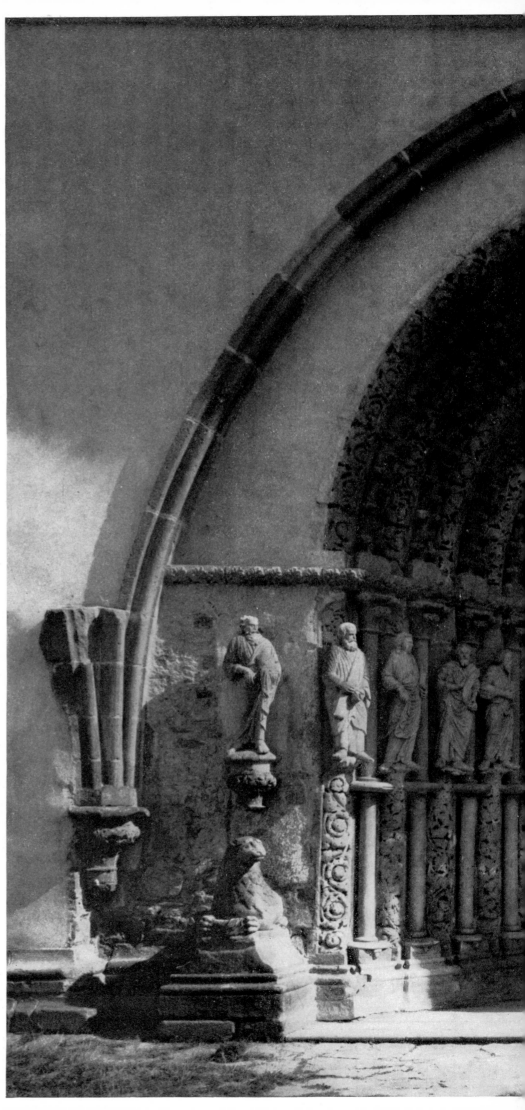

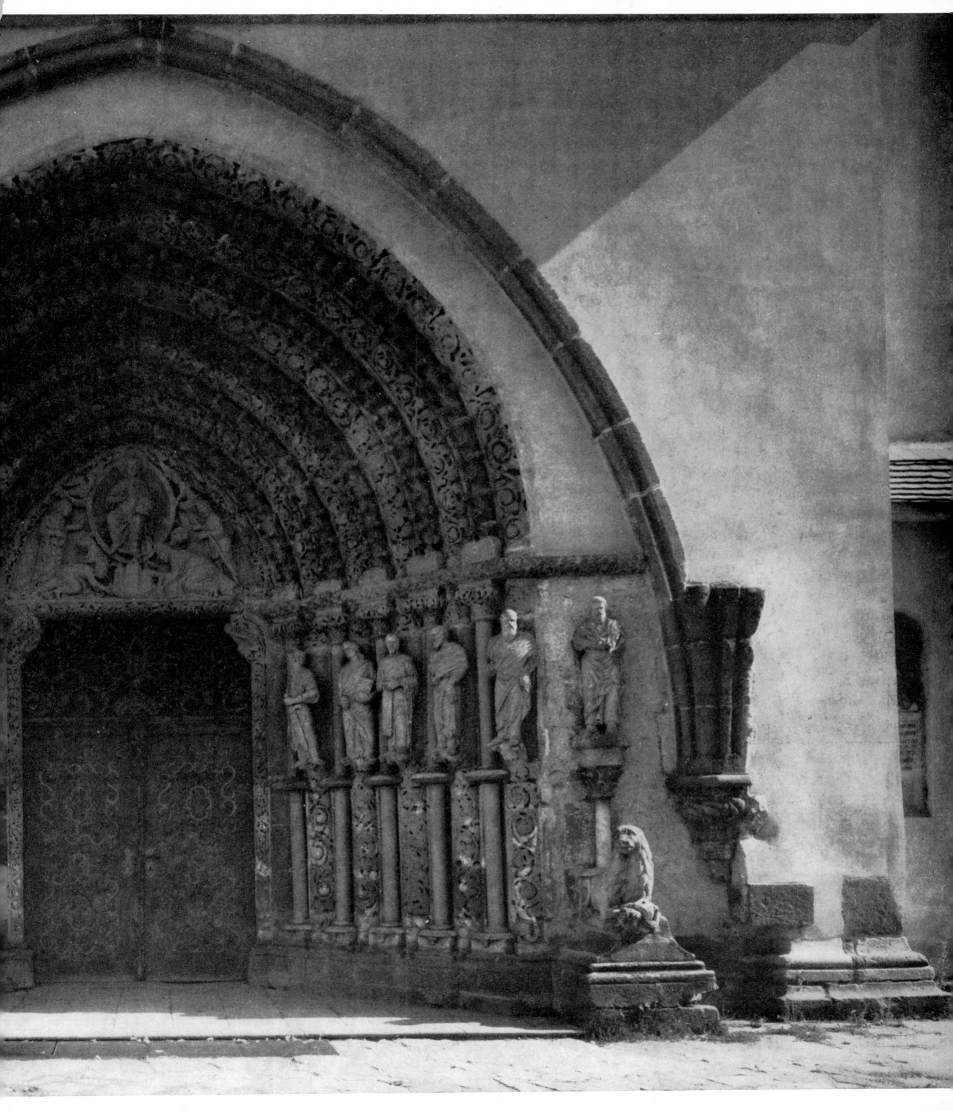

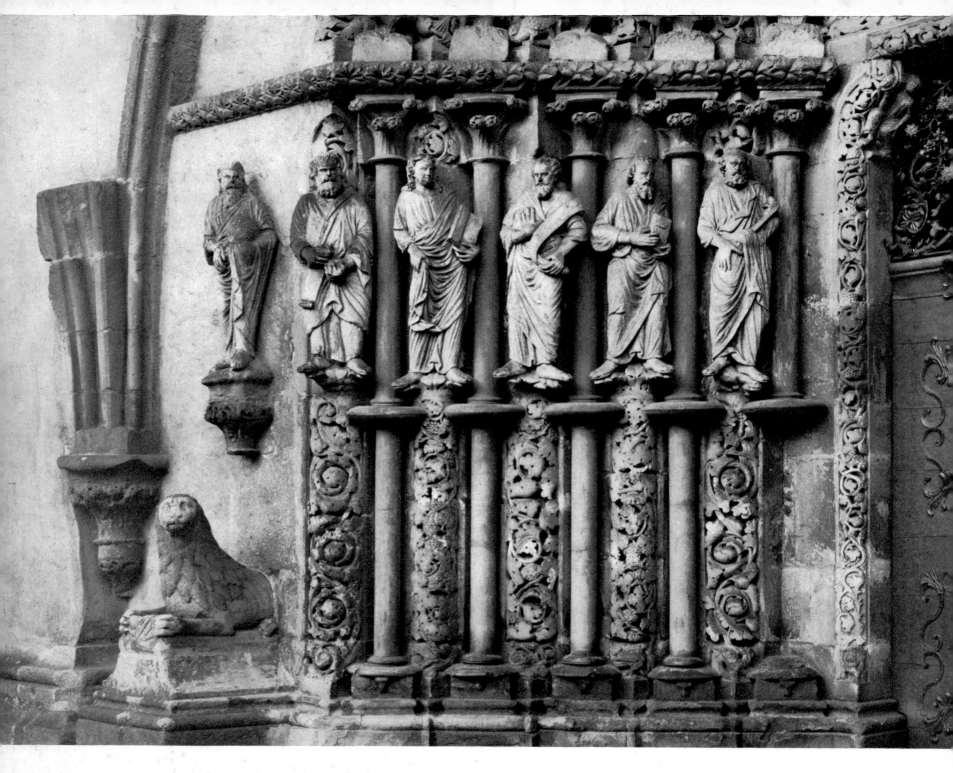

14 The former Cistercian, now parish church at Předklášteří near Tišnov.
Figures on the jambs of the west portal. 1240–1250

15 Cistercian abbey at Vyšší Brod. Chapter-house. c. 1270

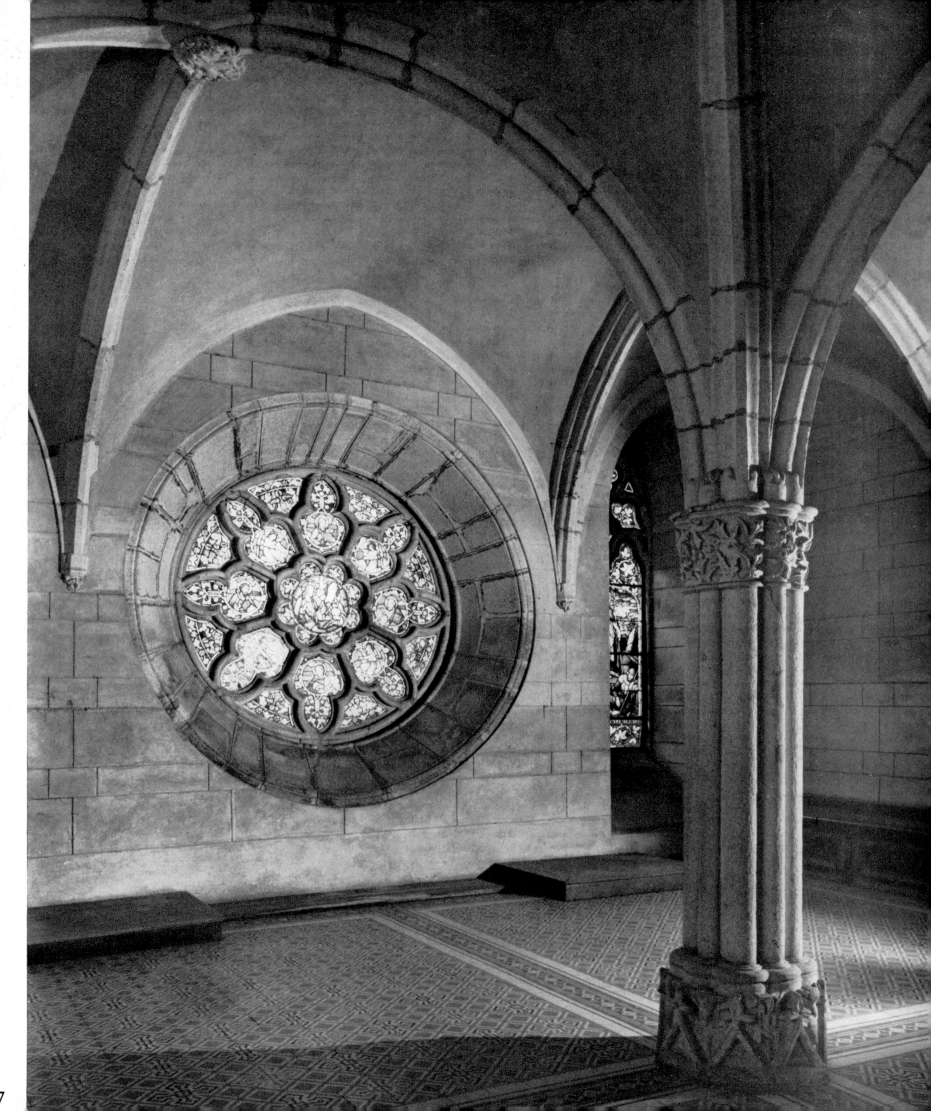

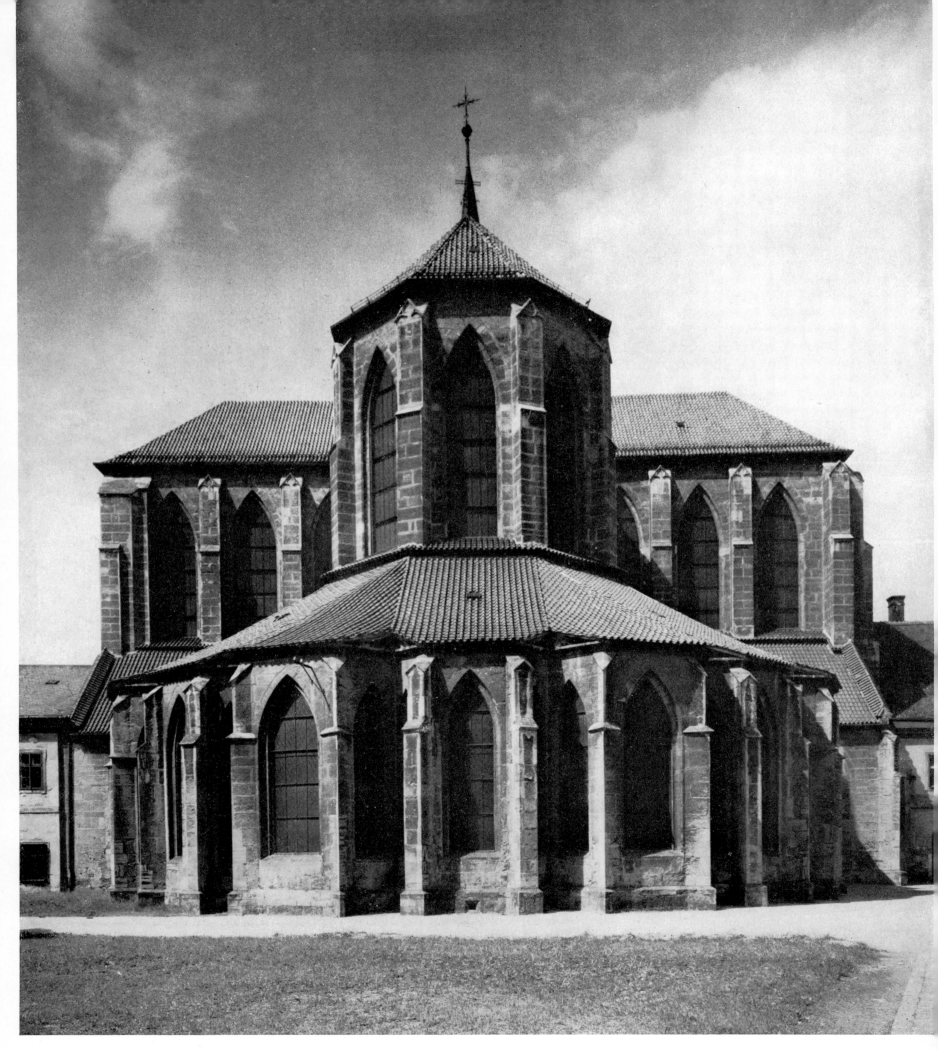

16 *The former Cistercian abbey church at Sedlec, near Kutná Hora. Presbytery. c. 1300*

here remained Romanesque until 1300, although in the second half of the thirteenth century and, in particular, towards the close, certain features appeared which brought it closer to Gothic expression. Even though all the arts grew out of the same social and psychological climate, they followed inherent laws of development, which in the initial phases assumed a disparity of expression, but gradually conformed, submitting to the leading art of that time, namely architecture.

In France this balance, which was one of the basic features of the classic period, took place around and after the middle of the thirteenth century. By that time, painters had found adequate means of conveying that feeling for life expressed, long before, in architecture: that system of proportions and relationships which produced the French calligraphic style, a style which embraced results of observation and symbols of emotion already found in Byzantine art and which determined the course of European art until the middle of the fifteenth century. Its stress on line has a close analogy in architecture. Its influence on the Czech Lands is first seen at the turn of the century. A clear example of the process of transition is seen in the wall paintings in the church at Písek. The *Crucifixion* has all the morphological marks of late Byzantine art, particularly the nervous, broken, interrupted lines. But they serve an entirely Gothic emotional impact. The mighty and impressive figure of Christ is not far from the mystical naturalistic crucifixes of the early fourteenth century, although, like

the other figures presented, it is based on Byzantine art. The Classical background is even more noticeable in a *Madonna in Majesty* in the same church which bears a certain analogy, particularly in the drapery, to the Classical style of mid thirteenth-century sculptures. On the other hand, in the local *Deposition from the Cross*, the central part is given with a feeling for continuous, long and rhythmical lines, which were becoming the bearers of the emotional content. This is doubtlessly based on Western principles. From here the path leads directly to the *Passional of the Abbess Chunegunda*, a leading example of early Gothic painting in Bohemia.

This development applied equally to book illustration. It can safely be assumed that most of the illuminated manuscripts imported into Bohemia had Gothic illuminations. (Some of them were bought in Paris in 1292 by Bohemian Cistercian abbots from money provided by King Wenceslas II.) But manuscripts of local origin, from around 1300, retained the late Romanesque style with its Byzantine elements enriched by the North Italian style of miniatures, linked to Giovanni da Gaibana. Gothic elements were only very gradually penetrating into the Romanesque style of Bohemian miniature painting. They made themselves felt more rapidly in the calligraphic ornaments which were imported into the Czech Lands and neighbouring countries from the region around the English Channel. A decisive turn of events came in the early decades of the fourteenth century.

THE LUXEMBOURG DYNASTY; THE DEVELOPMENT OF THE CZECH GOTHIC STYLE; VAULTING; CISTERCIAN ABBEYS AT ZLATÁ KORUNA, SEDLEC; SCULPTURAL THEMES; EASTERN AND WESTERN INFLUENCES IN BOOK ILLUSTRATION AND MURAL PAINTING; THE PASSIONAL OF THE ABBESS CHUNEGUNDA; THE VELISLAV BIBLE

The Czech Lands entered the fourteenth century, which was to bring a period of flourishing development, under unfavourable conditions. The ruling Přemyslide dynasty died by the sword on the threshold of the new century and the fights for succession, which put the kingdom in turmoil for several years, prohibited it from becoming a great power. With John of Luxembourg's ascension to the throne of Bohemia, the situation did not improve. John was a son of Emperor Henry VII, and his marriage to the Přemyslide Elizabeth, daughter of Wenceslas II, was to assure the new dynasty a continuity with the past rulers of Bohemia, at least along the maternal line. But this did not help the young king to grow closer to his kingdom. Real power rested with the ruling aristocratic families, and royal power, after an initial attempt to strengthen it, waned in the ceaseless battles between various groups of this powerful aristocracy. Finally the King was satisfied with the funds he drew from Bohemia to finance his adventurous life and his no less adventurous political plans. He became a typical case of the 'decline of the Middle Ages', living with the outmoded ideas of knighthood, which were being ousted by the new social forces claiming a share in power. Nonetheless, the diplomatic games in which he so fervently took part did prove of some use to his kingdom. Among other lands he acquired Silesia, which was to remain part of the Bohemian Crown until the eighteenth century. And though his attempt to establish Luxembourg power in Italy did not meet with permanent success, it did help to strengthen the old cultural ties between the two countries. Crown Prince Charles was sent to Italy for several years and his residence there proved of great importance to Czech culture as the fourteenth century progressed. No less important was his French cultural background due to Luxembourg's position between France and Germany, and expressed, for example, by Guillaume de Machaut's appointment as Court poet. John had inherited this inclination from his father and confirmed it by sending his son Wenceslas (Charles IV) to be educated at the Court of France. From there Charles returned with a great many incentives for his future policy. An endeavour to strengthen and enlarge the estates of the Luxembourgs in the West led to intensive social relations with the Rhineland, and particularly the Netherlands. This created certain conditions which were to be of consequence to the history of Czech art. In spite of the unsettled political condition of Bohemia, internal development prepared the ground for a transformation which occurred in all spheres of life in the middle of the century. The country's social structure and way of life were getting closer to that of the West. The nobility, the Church hierarchy and the leaders of town life shared political, spiritual and economic power. They dominated a culture in which secular elements were rising to the fore. There was, nevertheless, a growing national awareness among the autochthonous inhabitants, suppressed and simultaneously roused by German immigration in the thirteenth century and the influence of knightly culture introduced from Germany. The initiative for this resistance to foreign culture was given by the nobility and the Church while the towns, ruled mainly by rich German burghers, became more Czech in atmosphere as the rural population moved in. This resulted in a flourishing national literature, showing clear signs of national awareness. The King's German counsellors were gradually removed, and from 1315 the Czech nobility ruled the country. Moreover, membership of the important Roudnice monastery was limited only to Czechs with both parents of Bohemian origin.

John of Luxembourg's son drew conclusions for his home policy from these trends. He placed great weight on continuity with national history, which he managed skilfully to combine with his interests in the Holy Roman Empire. In all spheres of human activity the conditions which paved the way for the benefits and contradictions of the time of Charles IV were gradually coming into being.

Although there was not as yet a cultural centre at Court, individual members of the ruling dynasty, as well as high-ranking members of the Church and aristocracy were active and the scope for art was considerable in architecture, sculpture and painting. In 1348 the Brotherhood of St Luke was established in Prague, a proof of the extent of the work, which had to be organised and protected from foreign competition. The first half of the fourteenth century was a time when foundations were being laid on which Czech art of the time of Charles IV could be built.

We saw that in the thirteenth century Bohemian architecture largely retained its block structure. The consequences of the introduction of groined ribbed vaulting was accepted with some hesitation. The structural function of this vaulting and its inherent principle of individualisation must obviously affect the walls. Since the supporting strength, at least symbolically, rests in the ribs, a thrust came into existence which was transferred to the walls in the form of shafts. Hitherto they had been separated from the ribs by the capital and the brackets, to distinguish the parts that upheld the thrust from those that caused it. But architectonic matter still retained its three dimensions. All architectural members were convex, projecting into space, and they alone were active. Matter determined

space, not space matter, but certain conditions for activating space existed already. The upward movement through the individualised parts, running against gravity, was one way of activating space. Similarly, the diagonal trend of the cross vaulting, which influenced the supporting members, revealed resistance to the inertia of matter. A similar effect was achieved by the rapid succession of arcades and vaulting compartments.

Towards the end of the thirteenth century the consequences of these trends began to be felt in the Czech Lands, which were never properly affected by the classic Gothic style. The influence of French Gothic architecture of the classic period began to be felt in the Czech Lands at a time when these principles had already been superseded in the West and when activation of space was at an advanced stage. The first phase is called linear expressionism. It denied objective volume by abstracting structural members into lines which, unbroken by capitals and other horizontal features, rose without interruption to the apex of the vaults. Externally they had a parallel in the canopies and finials, which transferred the building matter into space, creating an intricate silhouette.

Linear expressionism produced a certain structural lightness, using concave forms where convex ones existed before. Inverted profiles of architectural members made space penetrate into matter. Walls were reduced and window space became larger, connecting the building with the world outside. The interior and exterior were separated by stained glass windows, a link that tended to be ideal, spiritual in character, rather than optical. A trend towards unification revealed itself in the transformation of structural elements whose function became obscured; their individual character was suppressed, for example the supporting system was no longer divided into functionally important components, or else it was incorporated in the walls and became part of them. The most important change was a transformation of the solid wall, which had isolated the interior and had borne the thrust, into an optical screen. Just at the time when architecture entered this phase of optical unification, Bohemian architecture began to play an active role on the continent of Europe.

Again it was the Cistercians who introduced these post-classic trends to the Czech Lands. To give an example, one might cite the chapter-house in the abbey at Zlatá Koruna, where rapid progress towards abstraction and linearisation can be seen in the ribs running towards vertically articulated consoles, the slim pillars, and the completely rigid, moulded plant ornamentation on the windows. All this was still happening in the thirteenth century.

The same is true of the presbytery of the abbey church at Zlatá Koruna and the long choir of the Dominican church in České Budějovice, which was modelled on the former. Both buildings show strong vertical tendencies. A trend towards unification, without any functional distinctions between individual architectural members, can also be seen in the nave and aisles of the abbey at Zlatá Koruna. It was probably not finished till after the middle of the fourteenth century. The sharp-edged flutes of the arcade pillars rise without interruption to the very apex of the arch, and the impression of upward movement is enhanced by slender, carefully moulded shafts. A plan to build a third aisle and flying buttresses was abandoned even though the foundations had already been laid. In this connection it may be of interest to know that, in the fifties, Michael Parler worked at this building site. His brother was, at that time, building St Vitus's Cathedral in Prague, for which a 'cathedral ground-plan', unusual in Central Europe at the time, was developed.

The Cistercian abbey at Sedlec bears witness to Bohemia's capability, at this time, of adopting highly complex building types. Sedlec had been richly endowed by King Wenceslas II, as also the abbey at Zlatá Koruna and another Cistercian abbey at Zbraslav, now destroyed, of whose grandeur we can only read in surviving documents. The abbey at Sedlec has a raised central nave with double aisles on each side; these lead into the transept with nave and aisles and the presbytery with an ambulatory and radiating chapels. As we are dealing with a Cistercian church the design is plain and concise; the Cistercian ideal of simplicity did not allow the full development of flying buttresses, even though the nave rises to a height of thirty metres.

The ground-plan of the abbey otherwise disposes of all the features of the French cathedral system. The interior was later remodelled to Baroque taste by Giovanni Santini, applying the romantic elements of Baroque Gothic, but the alterations did not greatly affect the original impression of the interior. The close-set arcades give depth, while the vertical movement is mainly apparent in the nave, which is three times as high as it is broad. The octagonal piers rise without interruption into the fluted arches of the arcades. Above the arcades where, in the Cistercian manner, there is no triforium, are broad, smooth wall surfaces, made less ponderous by the rising lines of the slender shafts. The same features can be found at Zlatá Koruna. This insistence on bare walls in Bohemia prevented a consistent use of linear expressionism. This is true of the presbytery of the church of St Bartholomew (sv. Bartoloměj) in Plzeň and the Carmelite church of Our Lady of the Snows (Panna Maria Sněžná) in Prague, even though the shafts here merge into the window jambs and the walls form only a narrow strip below the windows.

In the second half of the century, older trends appeared alongside newer ones which expressed the meaning and aims of contemporary art more poignantly. Cistercian architecture had no longer any share in this. Already in the early fourteenth century the Cistercians' dominant position, encouraged by the support given by Wenceslas II, was drawing to a close. The Order continued its building activity, as can be seen in the remarkable brick church of the Cistercian abbey in Old Brno, founded by the Queen Mother, Elizabeth Rejčka. But the most important contribution to the development of architecture was made elsewhere.

The main problem was the unification of the structure and its interior. There were two ways of achieving this; through the attenuation of the mass of the walls and of the architectural members, or through the removal of all that subdivided the interior. The walls thus assumed the weight-bearing function and merged into one with the supporting members. This can be seen in the presbytery of the church of St James (sv.

Jakub) at Kutná Hora and the chapter-house of the Sázava monastery, where the shafts stand on a flat base, outlined by the ribs above the windows. Another way of achieving this new aim was to reduce the articulation of the architectural members; this was done, as we saw, at Sedlec and Zlatá Koruna. In the nave of the Franciscan church in Plzeň the fluted arches of the arcades run uninterruptedly into the rounded body of the cylindrical piers. This gives the impression that the arches do not rest on the piers but are part of them, that they grow out of them. The cylindrical shape of the piers itself has a unifying function if used in small buildings with a square ground plan, as for example in the chapel of the church of St James (sv. Jakub) in Prague.

In the second half of the century, this trend towards unity appeared in architecture as well as in sculpture and painting and was the forerunner of a period when optical effect took precedence over the principles of construction.

* * *

Unlike the thirteenth century, the first half of the fourteenth was a period when all the arts became far more homogeneous. This may well be a sign of artistic maturity and the period perhaps deserves the term 'High Gothic' rather than does the middle of the preceding century. This is certainly true of Bohemian art, which did not actually go through a phase of 'classic Gothic' in the true sense of the term.

In turning our attention to sculpture, we find an equally clear trend towards reduced volume and lighter form, just as in contemporary architecture. Similarly the surface was cut with small, shallow incisions, which created sharp lines along the edges, producing expression in the sculpture and determining its shape. The suppression of an organic relationship between garments and body, characteristic of classic thirteenth-century sculpture, meant the abandoning of natural form and the introduction of stylised flattening and elongation of proportions. Both in architecture and sculpture there was a trend towards continuous, unbroken lines, and in both of them this process led to a strengthening of expressive tendencies.

It is hardly surprising that this brought about certain features which could be called Mannerist. The fact that the laws of nature were suppressed shows that Man was uncertain about the world he lived in. There was an accompanying stress on the psychological interpretation of subject matter. This meant that religious symbols, which had so far existed relatively independently in the sphere of abstract ideas, became related to matters of human interest. Now, gradually, they became images of human situations. Although Northern European art at that time was far removed from Antiquity, this humanisation of religious images led towards the discovery of the concrete world.

Sculpture took an active part in these changes. The decisive impulse towards a new orientation in iconography and form came from the West, with a conceivable contribution from Byzantine and Italo-Byzantine art.

From the West, in all likelihood from the Rhineland, came the type of mystical crucifix which spread throughout Europe and was equally popular in the Czech Lands. Its somewhat drastic but highly stylised naturalism was intended to arouse emotions to the human aspect of Christ's supreme sacrifice. The most outstanding example we have is the cross in the church of St Ignatius (sv. Ignác) at Jihlava. This may once have belonged to the local Dominican monastery. Its enormous size and dramatic expression recall the thirteenth century and its formal characteristics clearly show that its type originated from the Rhineland. The other important contemporary theme in sculpture, the Pietà of the vertical or heroic type, arose out of a similar emotional content, but was much less widespread and never adopted in Latin countries. In Bohemia it was apparently known in the twenties,[7] though examples which survive are of a later date. The Pietà in the church of St James (sv. Jakub) in Jihlava dates from around the middle of the century. Form was entirely given over to an expression of pain. This affects both the proportions of the figures and the composition as such, where the vertical lines disregard the laws of the physical world. The relatively small figure of Christ touches upon the mystical idea of a link between Christ's childhood and death, derived from mystical poetry. Other themes of sculpture dealing with new psychological spheres and the human background to religious themes were also known in Bohemia and Moravia; for example, the Man of Sorrows, the Entombment. But we now possess only inferior examples, which may have been modelled on better originals.

Typical for the period is a group of sculptures that has survived from the workshop of an anonymous wood-carver who was active in the second quarter of the century, probably in Brno. The surviving five or six carvings made here show both the high standard of wood-carving in the Czech Lands at this time and the dominant style, which resembles the work of other European countries north of the Alps. It shows how a regional school was beginning to develop. The master who managed the workshop may have come from the West, as his work is close to the *Madonna* of Saint Aignan in Notre Dame in Paris, the sculptural ornamentation in the St Catherine chapel in Strasbourg Cathedral, and the Holy Sepulchre in Freiburg Cathedral. His work also shows close connections with contemporary Bohemian painters and reveals a trend that became intensified in the following generation of sculptors. The most extreme examples of the slender, calligraphic form probably date from an early period. In the figure of *St Florian*, in the Austrian monastery of St Florian, volume is reduced to a system of densely carved lines stressing the vertical flow of the slim figure. Similarly, the statue of the *Virgin and Child* in Znojmo Museum shows exclusively vertical tendencies with the exception of a few horizontal folds across the Virgin's abdomen; the Virgin's head is set erect and lacks all contact with the Child. As on the vertical Pietàs, and in contemporary architecture, the upward movement goes beyond the sculpture and is not balanced by symbols of gravity. Later works of this group gain in solidity and breadth – or gravity – without the calligraphic design of the drapery becoming any weaker. This movement can be seen in the *Virgin and Child* in the parish church at Velké Meziříčí, in the statue of a Saint from Veveří Bitýška, and in particular in the *Madonna* from Michle, now in the National Gallery, Prague. It originally came from Brno, and

probably dates from the thirteen forties. Its features are not entirely alien to work done by the Master of Vyšší Brod. There are close links between the Brno workshop and the *Virgin and Child* from Prostějov, in the National Gallery, Prague. The Brno workshop may also be responsible for a small *Virgin and Child* from the monastery church at Broumov, clearly indicating changes in linear abstraction taking place when, in the middle of the century, interest in true volume began to spread throughout Northern Europe.

The calligraphic style of the Brno workshop was not its prerogative. It seems to have applied to the whole of Bohemia. It had its examples in western Bohemia – the *Virgin and Child* from Dýšina (Madona z Dýšiny), Regional Museum, Plzeň, and in Prague – the *Crucifix of the Carmelite Nuns* (krucifix od Barnabitek) in the National Gallery, Prague, where the calligraphic tradition – related to the Brno workshop – reveals possible Italian links. Radical examples of this type of work include a wooden *Virgin and Child* from Buchlovice (Madona z Buchlovic) in the Moravian Gallery, Brno, and its stone replica in the Bührle collection in Zürich, with quite unsurpassed, entirely consistent graphic abstraction.

* * *

In the first half of the fourteenth century, painting and sculpture developed along parallel lines, probably with direct links, and by the second half of the century this had led to a unified style. We saw earlier in the *Deposition from the Cross* in Písek that various styles had been used as examples. Contemporary work now shows the new style consistently employed on a large scale. This applies to both book illustration and mural painting; although no panel paintings from this time survive, they must undoubtedly have existed.

Book illustration provides some obvious examples of this consistent adherence to the Western style of ornamentation, such as, for instance, a group of nine manuscripts, which Queen Elizabeth Rejčka, the widow of Wenceslas II and Rudolph I, had commissioned from an unknown scriptorium. The Queen presented them to the Cistercian abbey at Old Brno, which she founded, and where she spent her last years. Work on the manuscripts was begun in 1315 and continued into the fourteen thirties. The workshop probably included Pešek and Ulrich, both mentioned in the Queen's last will.[8] Motifs of Italian inspiration were blended with more schematic French ornamentation and less stylised themes of East Anglian provenance. This mixture of elements from Southern and Western Europe forms a preparatory stage for the synthesis which occurred in the Czech Lands around the middle of the century. Queen Elizabeth Rejčka's manuscripts show how the painters endeavoured to master Western styles with remarkable technical skill. Genuinely outstanding painting, however, is found in a manuscript made for another member of the royal family, Chunegunda, the daughter of Přemysl Otakar II, who was Abbess of the Benedictine convent of St George at Prague castle. Coloured drawings accompany a text of mystical content, in which cosmological symbols play a considerable part. The author of this remarkable text was the Dominican Kolda of Koldice, and the scribe was Canon Beneš, who is thought to have been the illustrator as well.[9] The manuscript was produced in two stages, between 1312 and 1313, and then some time before 1321. Due to the donor's death the manuscript was never completed. The illustrations derive from the Western miniature style. The main centres of this style were East Anglia, northern France and the southern Netherlands; some art historians think that Metz may have served as an intermediary.[10] The work shows a mastery of rhythmical line drawing, a feeling for volume and an aptitude for depicting complex movement and expressing emotional content with great skill. Certain features link this work with Italo-Byzantine art, but basically it is of Western origin. The main characteristic is a soft, smooth-flowing line which expresses many symbolic meanings and fills the picture with human emotions. The *Passional of the Abbess Chunegunda* shows us the kind of demands which the Court of Prague made on painters. As mentioned earlier, Prague did not have the right conditions for making its Court a centre of art. That is to say, nothing has survived in the way of mural or panel painting to make us think otherwise. We are therefore forced to consider provincial work, particularly work commissioned by the local aristocracy. In scope and quality the most outstanding is a cycle of paintings in the commandery (manor) of the Order of the Knights of St John at Strakonice, where the powerful family of Bavors were patrons. The chapter-house, the cloisters and the church of St Procopius (formerly St Adalbert) were embellished with paintings at various periods.

Most interesting among them is the *Christological Cycle* in the cloisters. It shows scenes from the Passion and a series of Christ's miracles, one of the most extensive works of this type in existence. The paintings are in bad condition and only fragments are better preserved. But they are good examples of that linear trend which expressed a growing human aspect of religious events in smooth-flowing rhythmical lines, rather than by observation from nature.

Line stresses the intense emotional content, but none of the paintings attained the monumentality and intensive expression of the miniatures in the *Passional of the Abbess Chunegunda*. The Strakonice paintings are not far removed in time from the latter and even show signs of similar stylistic origin. The majority of the paintings must have been produced at the same time, even though there are remnants of older and newer layers of paint. It is possible to distinguish the work of two painters. The one, who is responsible for the cycle of the miracles, places greater importance on the rhythmical effect of the lines. The other, who is responsible for the scenes of the Passion, shows a leaning towards a calmer, more static design. Many mural paintings from this period survive. Some of them are of great value; in the church of St John the Baptist (sv. Jan Křtitel) at Janovice nad Úhlavou the iconography, basically Romanesque, shows a new sensitivity and an exceptional sense for monumental effect. Paintings in the church of Our Lady (Panna Maria) at Průhonice show a connection with book illustration of the first quarter of the century. The calligraphic virtuosity of the chief painter in the chapel at Houska castle is quite outstanding. In the castle chapel at Jindřichův Hradec the paintings dating from 1338 illustrate the legend of St

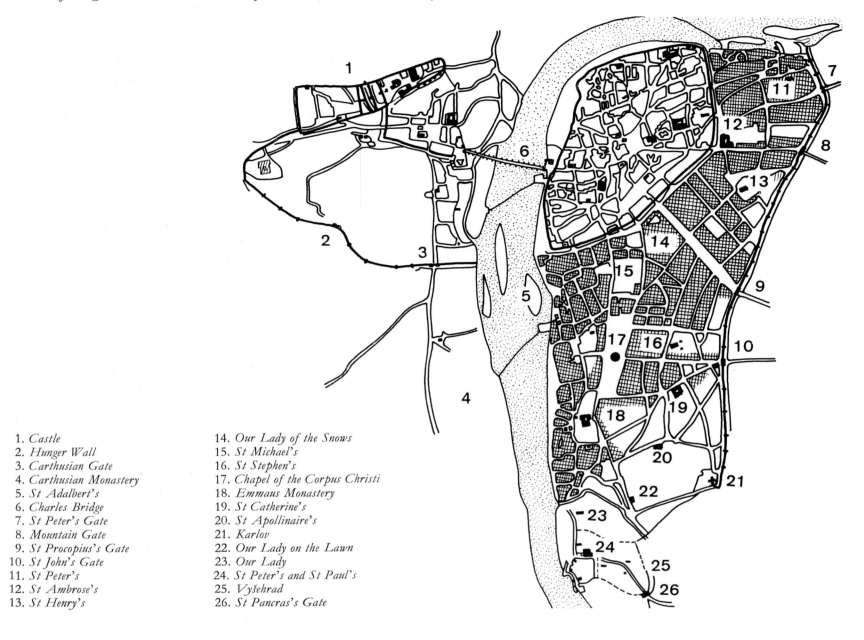

1. *Castle*
2. *Hunger Wall*
3. *Carthusian Gate*
4. *Carthusian Monastery*
5. *St Adalbert's*
6. *Charles Bridge*
7. *St Peter's Gate*
8. *Mountain Gate*
9. *St Procopius's Gate*
10. *St John's Gate*
11. *St Peter's*
12. *St Ambrose's*
13. *St Henry's*
14. *Our Lady of the Snows*
15. *St Michael's*
16. *St Stephen's*
17. *Chapel of the Corpus Christi*
18. *Emmaus Monastery*
19. *St Catherine's*
20. *St Apollinaire's*
21. *Karlov*
22. *Our Lady on the Lawn*
23. *Our Lady*
24. *St Peter's and St Paul's*
25. *Vyšehrad*
26. *St Pancras's Gate*

George. Unfortunately, they were badly damaged during nineteenth-century restoration. In the church of St James the Great (sv. Jakub Větší) at Křeč the painter, perhaps apprenticed to the first Strakonice Master, employed a strikingly lyrical style, which was later to find wide application in Czech painting. One of the richest sets of mural paintings has survived in the church of St Laurence (sv. Vavřinec) at Brandýs nad Labem, though it is more interesting for its variety of themes than for its quality, which is uneven. In the Minorite church at Jindřichův Hradec the linear style was daringly used to produce figures of monumental size which form a wealth of decoration in connection with the architectural and ornamental motifs. They were partly destroyed by the lower late Gothic vaulting and also suffered during nineteenth-century restoration.

In the first half of the fourteenth century, painting underwent considerable changes. The iconographic programme turned away from Romanesque tradition. New, unaccustomed themes were used, and among them local legends became important.

Form was enriched by new motifs involving movement and intricate architectural elements; artists even began to master certain aspects of perspective. Direct observation gradually penetrated into *a priori* formal structures; narrative features began to dominate. The paintings in the churches at Hosín, Myšenec, Žďár near Blovice and Starý Plzenec illustrate the condition of Bohemian painting around the middle of the century, a time immediately preceding – or even the same time as – the revolutionary work done by the Court workshop of Charles IV. Local trends survived the middle of the century and did not change their basically linear approach.

Quite a number of these paintings show a link with contemporary book illustration. There are some examples even of paintings which were used for altarpieces. Altar mural panels from that time have, as mentioned earlier, almost completely disappeared. But book illustration has survived to a larger extent and helps us to trace connections with other countries. Books could easily be transported and moved over

great distances. The book acted as a mediator in ideas on art which came into being in other parts of Europe. Books imported into the Czech Lands must have helped to even out the differences between local and Western book illustration. We know, for example, that Vojslav, a Prague vicar, or the dean of Vyšehrad, William of Leskov, acquired books in this manner, and that Bishop John of Dražice brought back with him from his prolonged stay at Avignon not only builders for the bridge and the Augustinian monastery at Roudnice, but also books, which he presented to the latter. Today they are deposited in the Library of the National Museum in Prague. Church dignitaries and members of monastic orders who paid visits to their chapters, students visiting Italian, French or English universities, all had the opportunity, and many of them, furthermore, had adequate means to acquire illuminated books, which came to influence local production.

A considerable number of these books must also have been lost, so that it is difficult to trace a line of development from the second decade, when local work in the new style first began, right through to the middle of the century, when Bohemian book illustration was at its peak. Echoes of the *Passional of the Abbess Chunegunda* can be found in the *Missal* in the University Library (M 1151) at Wroclaw, and even the Rejčka manuscripts did not lack followers. But none of these derivations has the excellent quality of the *Passional*. If one can rely on surviving material, book illustration recorded remarkable achievements towards the middle of the century, as proved by the canonical folio in the *Chotěšov Missal* (University Library, Prague) and that of John of Dražice (National Museum, Prague), in which the Western calligraphic style became linked to an endeavour to make volume stand out. Some works from this period are of remarkable originality, showing that in this field a locally conditioned style was

emerging, particularly evident in the richly illustrated *Velislav Bible* (University Library, Prague), probably made for the subsequent Chancellor of Charles IV. A pure linear style can be found in 747 illustrations depicting scenes from the Bible, cycles about the Anti-Christ and from the Apocalypse, the legend of St Wenceslas and other themes. The smooth-flowing lines depict a variety of subjects without trying to give any impression of volume or to distinguish individual figures physiologically or psychologically. Though linear rhythm was becoming less pronounced, the *Velislav Bible* is one of the culminating works of linear book illustration, which was applied, above all, in books of spiritual or educational content. Brief texts accompany the illustrations, which remain the principal means of conveying the story. There must have been many such books in the Czech Lands during this time.

Their linear style survived even after the middle of the century. This can be seen in the *Liber Depictus* (Nationalbibliothek, Vienna), which originated in the Minorite monastery at Český Krumlov around, or after, 1358.[11] Apart from the Biblia Pauperum it contains, in particular, legends of the saints, among whom the patron saints of the Kingdom of Bohemia hold an important place. It seems likely that the illuminators based their work on a certain south Bohemian cycle of mural paintings. One illuminator can be connected with Strakonice, while another's work is somewhat softer: his rhythmical and harmonious style is less rigid, and his endeavour at depicting volume shows that linear abstraction was being abandoned. Narrative was also given more importance than were purely theological considerations. The effects of the new era are visible, bringing with it echoes of 'great' art. Similarly, one can detect a close analogy to contemporary sculpture in the style of the *Velislav Bible*. All the arts were, in fact, moving closer to one another. The time was ripe for a unified style.

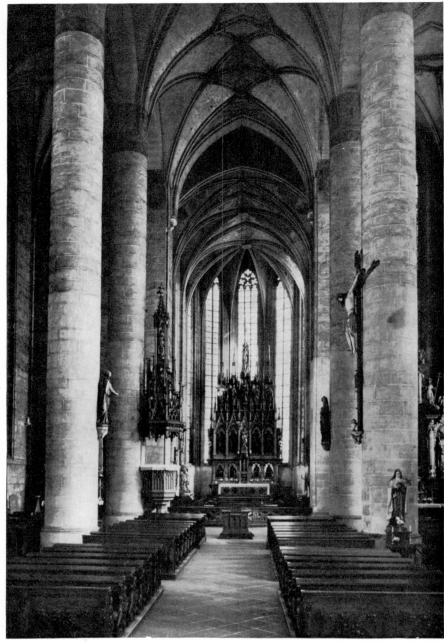

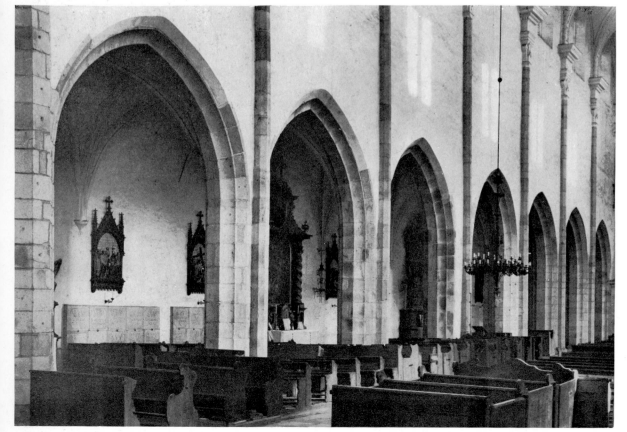

17 Parish church of St James, Kutná Hora. Presbytery. c. 1330

18 Deanery church of St Bartholomew, Plzeň. Nave and presbytery. Second quarter and after the mid-fourteenth century

19 Cistercian abbey church at Zlatá Koruna. Nave. End of the thirteenth and after the mid-fourteenth centuries

◄

►

20 The former Benedictine abbey at Sázava. Chapter-house. 1340–1350

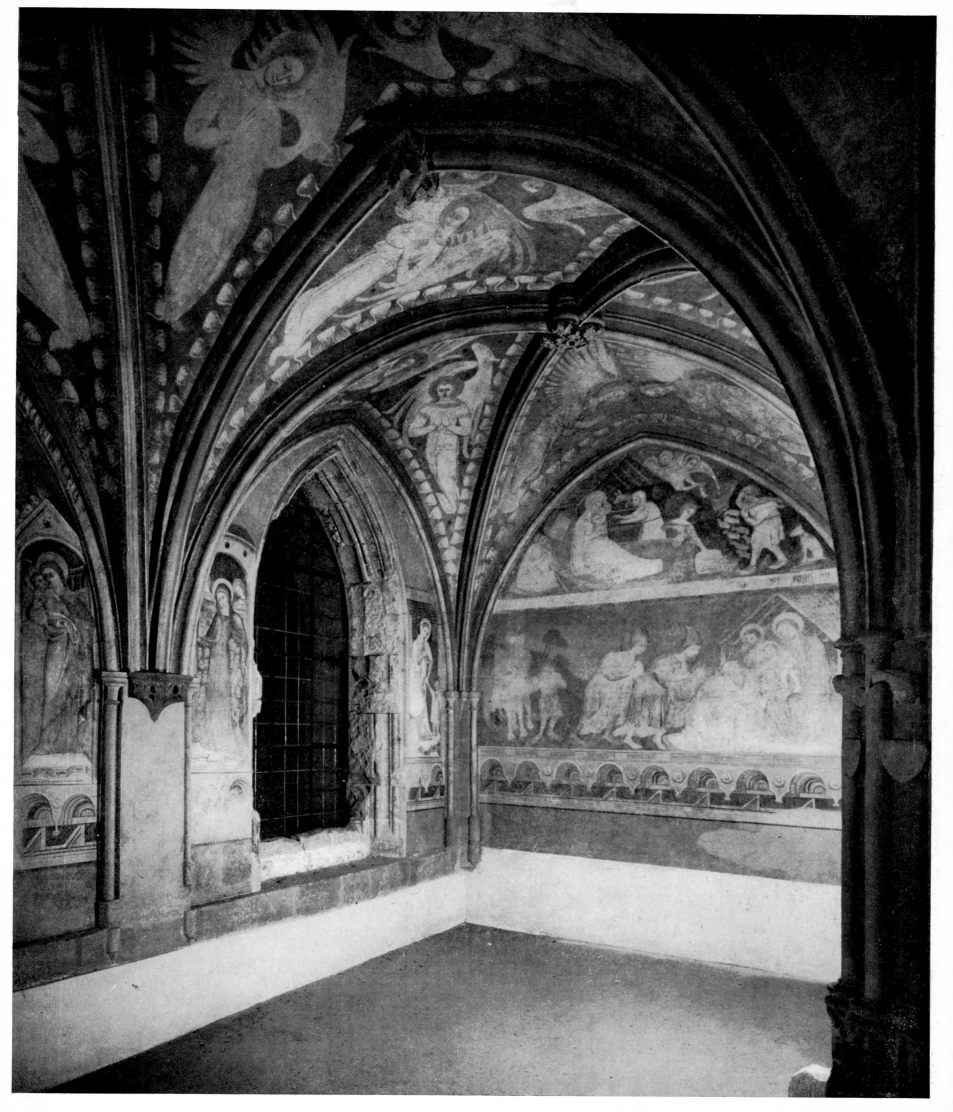

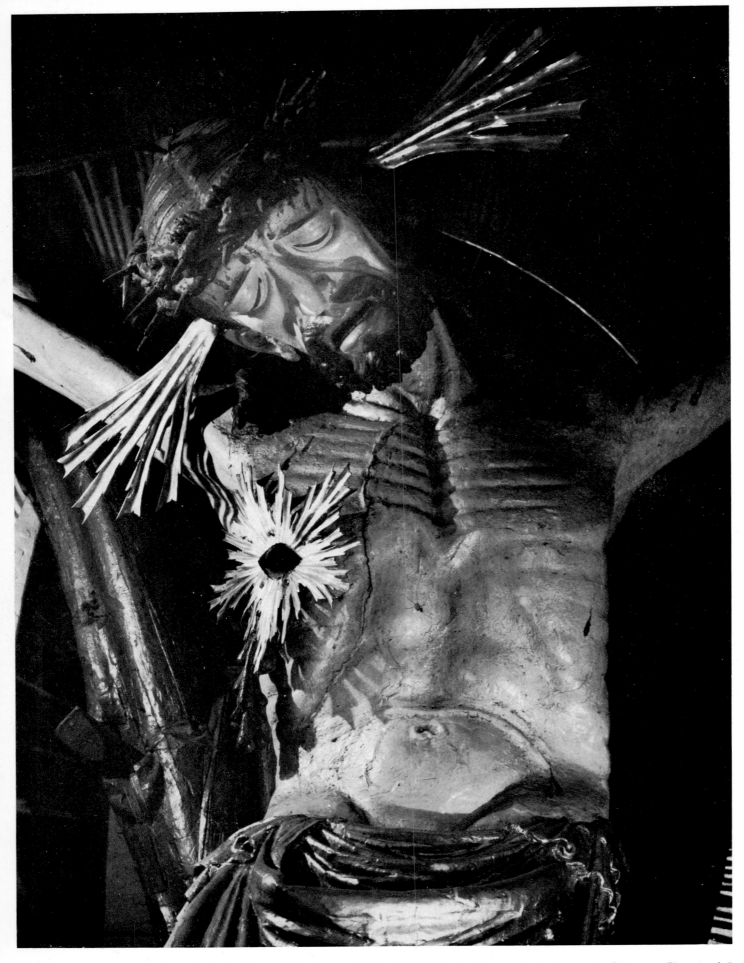

21 *Christ's body. Detail of the Přemyslide Cross. 1320–1330. Wood with new polychrome. h. 240 cm. Church of St Ignatius, Jihlava*

▶

22 *The Crucifix of the Carmelite Nuns. c. 1350. Wood with original polychrome. h. 123 cm. National Gallery, Prague*

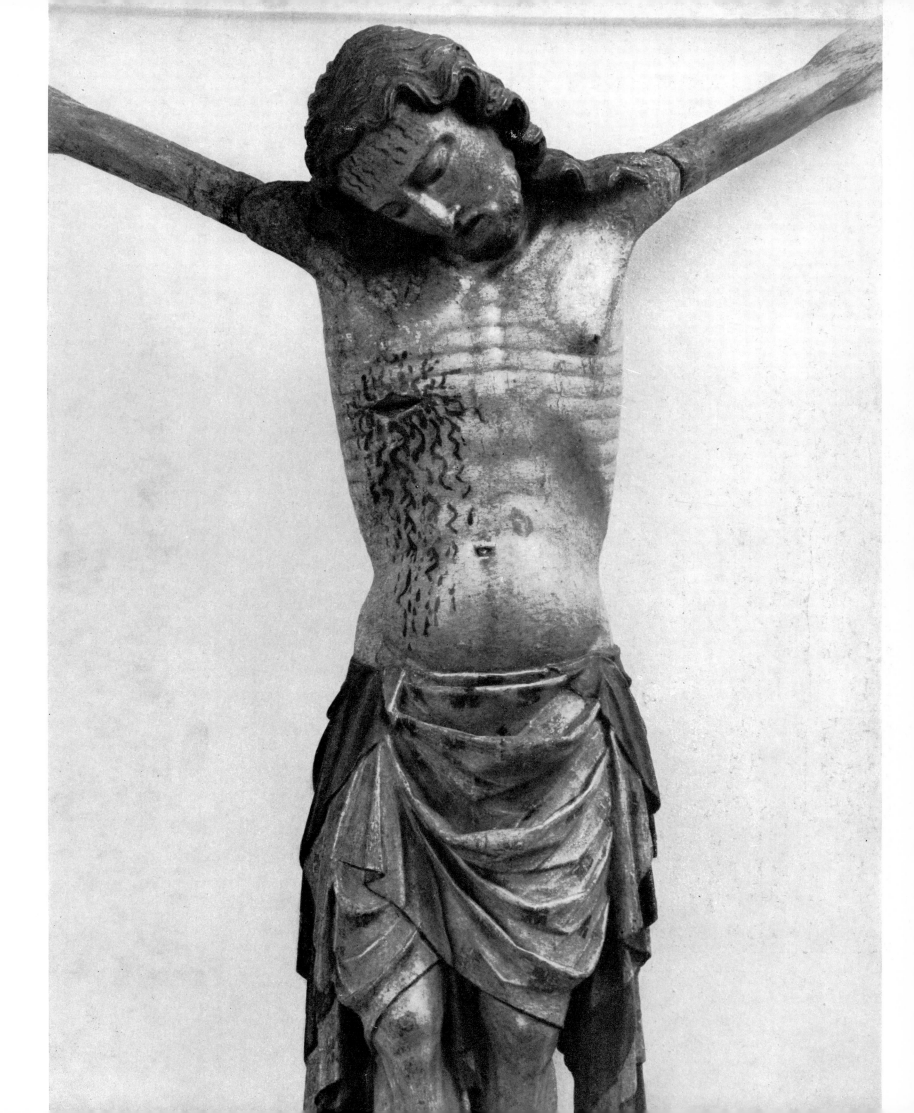

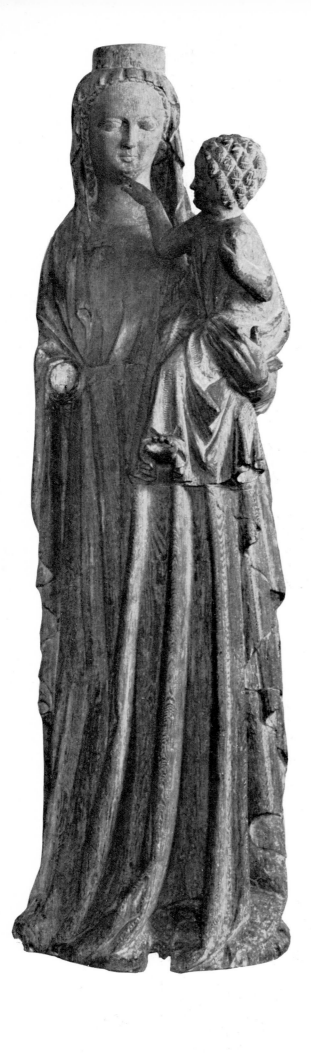
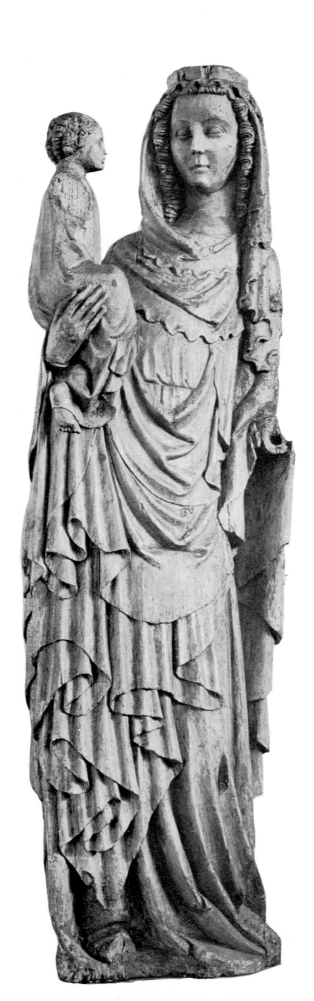

40

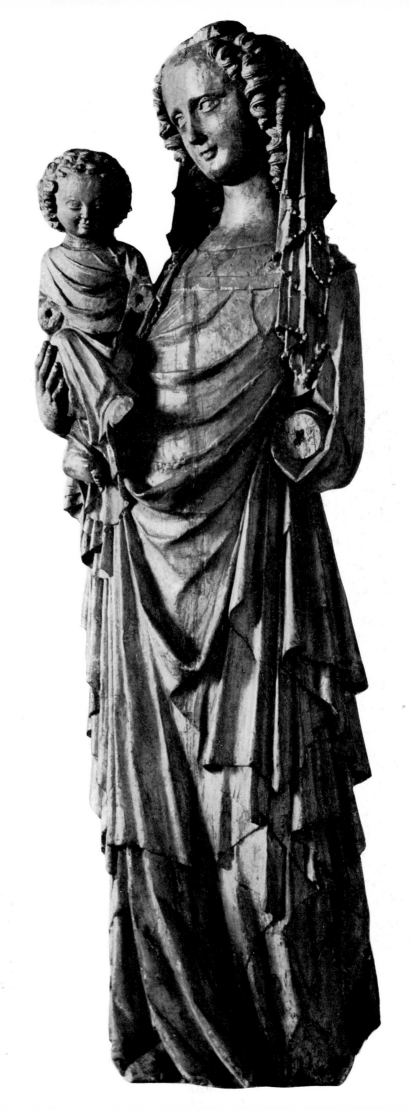

23 *The Madonna of Strakonice. 1320–1330. Fir with minute remnants of polychrome. h. 183 cm. National Gallery, Prague*

24 *The Madonna of Buchlovice. Second quarter of the fourteenth century. Limewood, no remnants of polychrome. h. 161 cm. Moravian Gallery, Brno*

▶

25 *The Madonna of Michle. c. 1340. Pearwood with insignificant fragments of original polychrome. h. 120 cm. National Gallery, Prague*

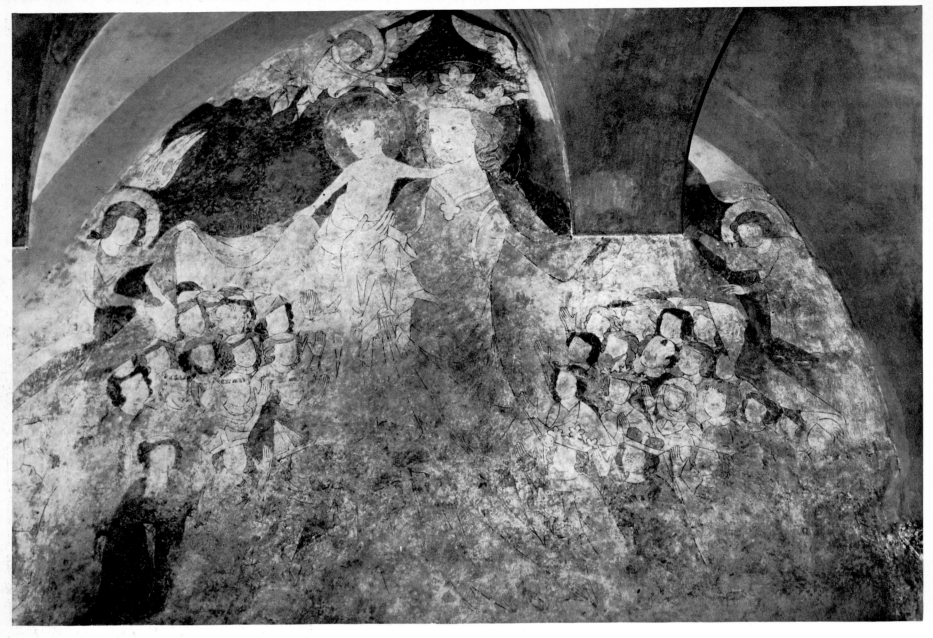

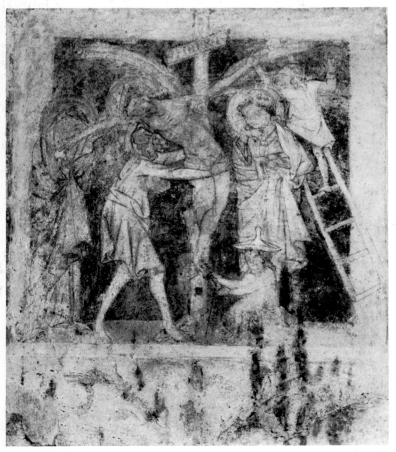

26 *The Virgin Protectress (detail). c. 1340. Mural painting. Commandery of the Order of St John, Strakonice*

27 *The Deposition from the Cross. First quarter of the fourteenth century. Mural painting. Deanery church, Písek*

◄ ►

28 *Apostle. c. 1330. Mural painting. Commandery of the Order of St John, church of St Adalbert, Strakonice*

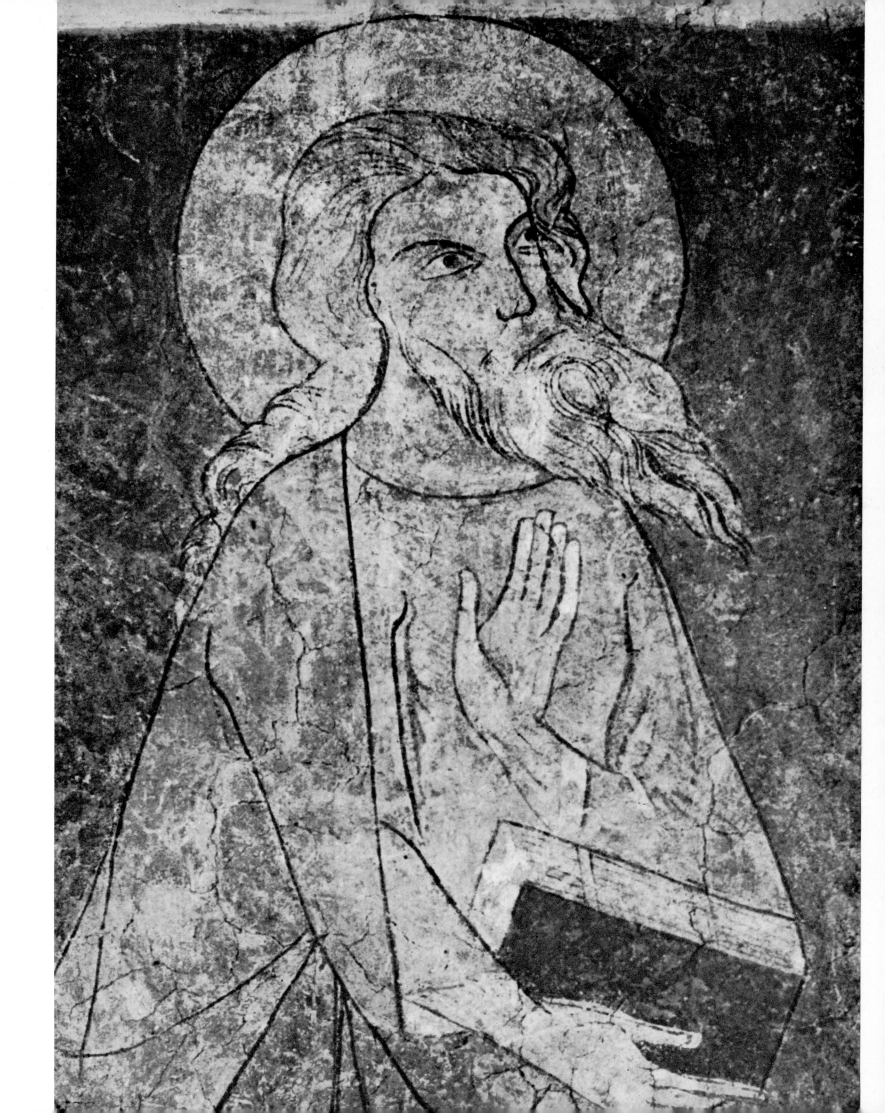

43

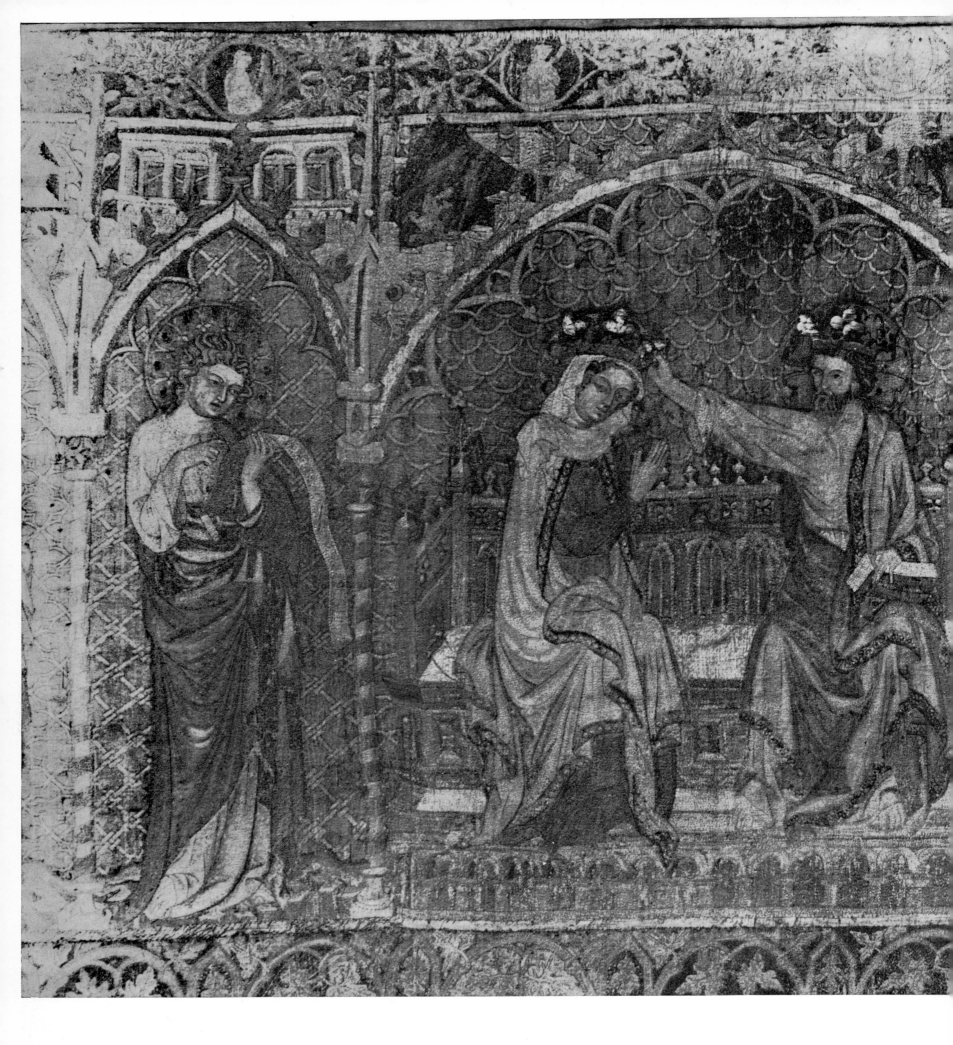

29 Antependium of Pirna (detail). c. 1340. Embroidery. 95×345 cm. Staatliche Kunstsammlungen, Meissen

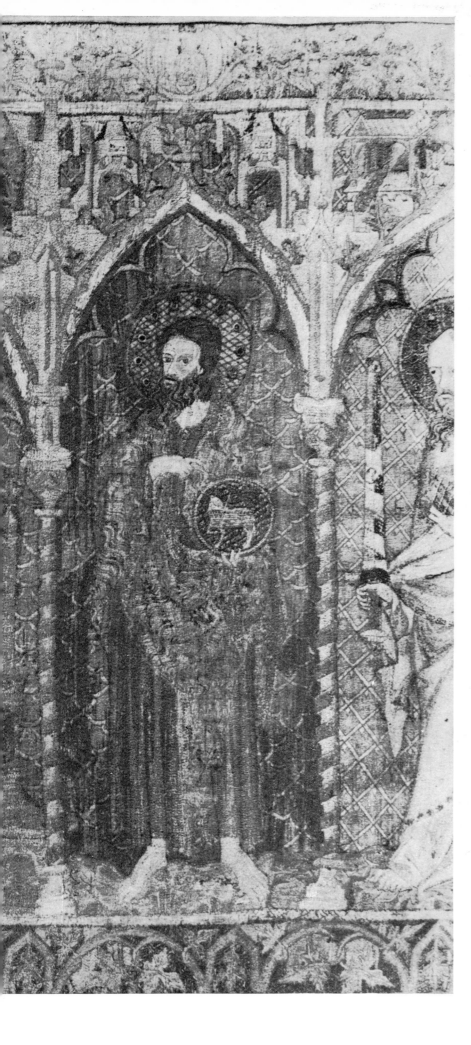

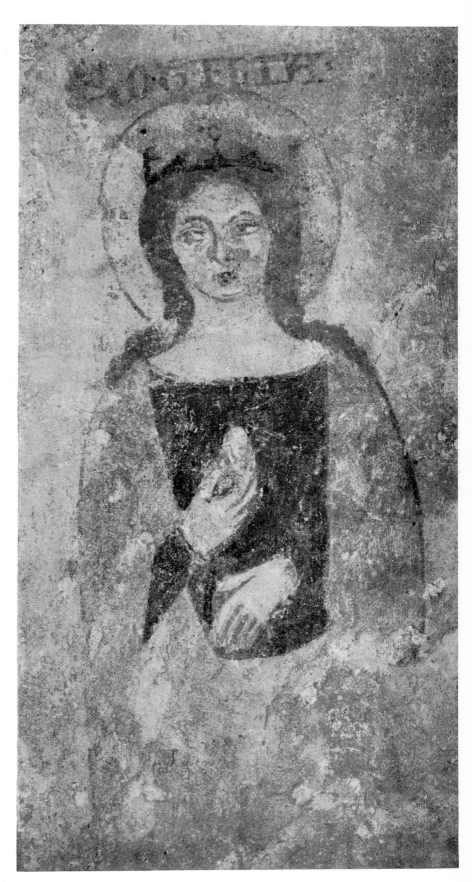

30 *St Catherine. 1343–1350. Mural painting. Church of Our Lady, Holubice*

salbati aurea rutilatione resplenduit iuxta
quod psalmugraphus longe antea ppheravit
Nox inquiens sicut dies · illuminabitur et
sit facta est hec nox illuminatio mea fideli-
tis meis eram subito nueht dilectus filius asti
tit et refulgente inhabitatulo lumine hys
uerbis me dulciter salutauit aue inquit
mater mi aue. Quasi dicat ve iam merors
depone quia sine ve me inutero concepisti et
sine dolous molestia iurgo pmanens peperstil
plangere desine lacrimas absterge genitus re
pelle suspiria recte iam enim inplete sut scrip
ture quia opoituit me pati et Amortuis resur
gere iam prostrato princepe mortis insernum
expoliaui potestatem incelo et terra accepi· et
ouem perditam adoule pro humero repor
taui quia hominem qui perierat ad regna
celestia renocaui· Gaude igitur mater aman
tissima quia facta es celi et terre regina ·
Et sicut morte inteuenente obtinui dominium
interotum sic ascensionis gloria refulgente
regnii accipiam super nos ascendam igitur
ad patrem meum ut preparem me dilugen
tibus locum Tu autem surge dilecta mea co
lumba mea speciosa mea electa mehi ₇ pre
electa recipe iam npresenti gaudium tibi insu
turo longe glorious eternaliter pmasi ₇ ultii
mo inmontem syon matre cu discipulis con

31 Mystical Embrace, from the Passional of the Abbess Chunegunda. 1313–1321. Parchment manuscript. 30 × 24.5 cm. University Library, Prague

32 Gradual (cod. 1774, folio 72). 1317–1320. Parchment manuscript. 32.3 × 44.7 cm. Nationalbibliothek, Vienna ▶

33 Passional of the Abbess Chunegunda. 1313–1321. Parchment manuscript. 30 × 24.5 cm. University Library, Prague

▶

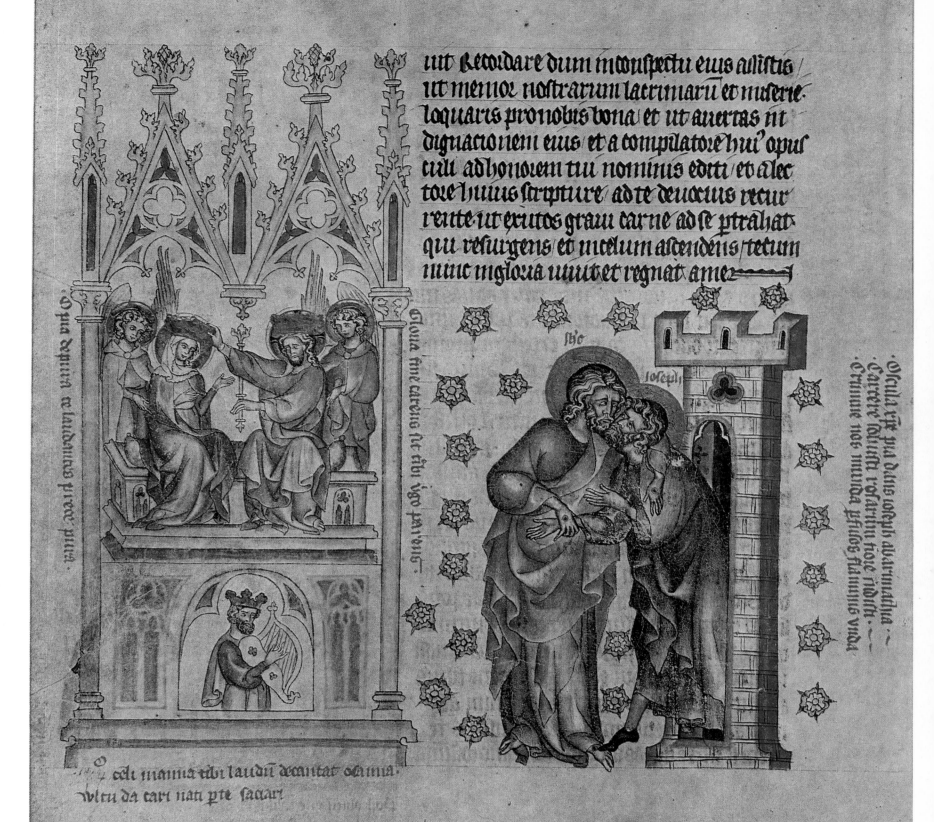

nit Recordare dnm inconspectu eius assistis
nt memor nostraru lacrimaru et miserie
loquaris pronobis bona et ut auertas nt
dignacionem eius et a compilatore hui opus
culi adhonorem tui nominis editi et alec
tore huius scripture ad te deuocius recur
rente ut exutos graui carne ad se ptrahat
qui resurgens et incelum ascendens tecum
nunc ingloria uiuit et regnat amen

O pia sedula ac laudantis prece pulla

Gloria fine carens sit tibi uirgo pariens

O celi manna tibi laudu decantat ocinna
vltu da cari nati pte saciari

Oscula sit pia deus ioseph obarunatha
Carcere solutu rosaritu rioie rionii
Crimine nos munda pfilios flammus vnda

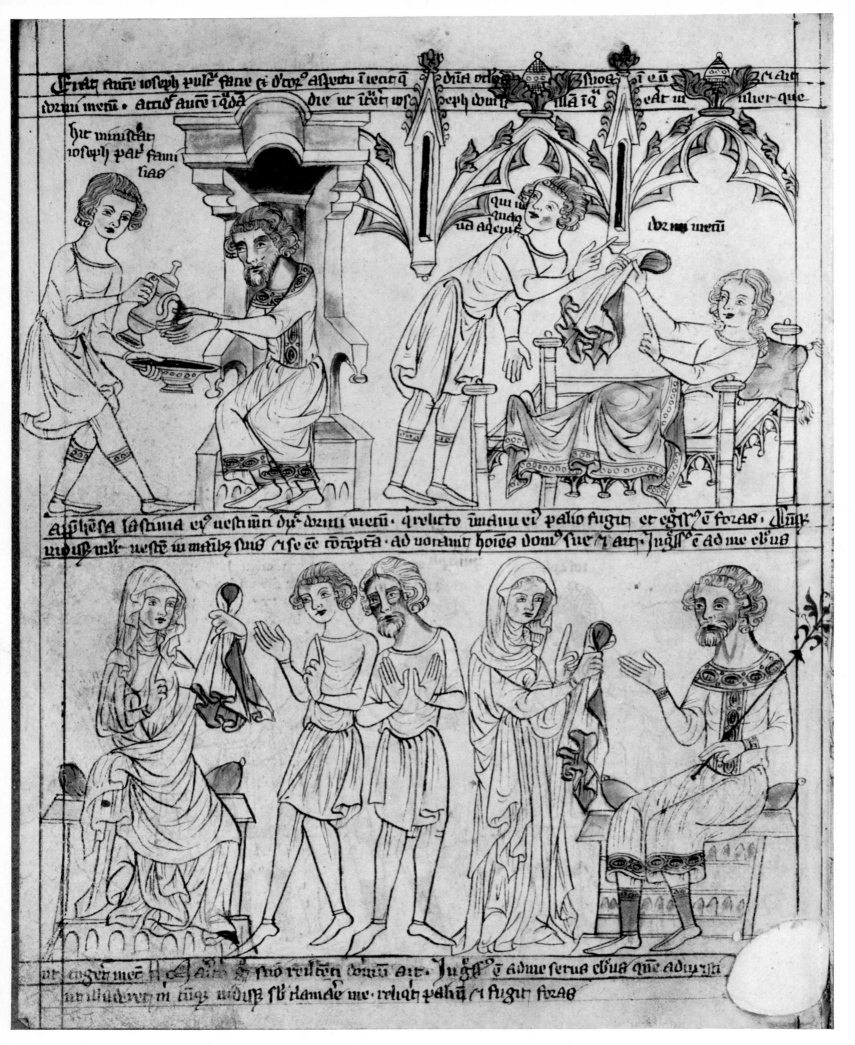

34 *Velislav Bible (folio 41). c. 1340. Parchment manuscript. 30.7×24.5 cm. University Library, Prague*

THE COURT OF CHARLES IV AND JOHN OF STŘEDA; THEME OF ST WENCESLAS; THE ROŽMBERK FAMILY AND SOUTH BOHEMIAN ARCHITECTURE – JINDŘICHŮV HRADEC; ST VITUS'S CATHEDRAL, PRAGUE; MATTHIAS OF ARRAS; PETER PARLER AND THE PARLERIAN LODGE; ST BARTHOLOMEW, KOLÍN; ST BARBARA, KUTNÁ HORA; SCULPTURE – ST VITUS, KARLŠTEJN CASTLE; THE VYŠŠÍ BROD ALTARPIECE; PAINTINGS OF THE VIRGIN; MURAL PAINTING – KARLŠTEJN CASTLE, MONASTERY OF EMMAUS, PRAGUE; THE BOSTON MADONNA; THE MORGAN PANELS; BOOK ILLUSTRATION – THE LIBER VIATICUS

The middle of the fourteenth century was more than just a milestone in Czech art. New stimuli came to the fore in all spheres of art, having previously been hidden behind alien influences. A continuous line of development ensued, with its own causal relationships. This does not mean that Czech art lost its contacts with the rest of the world. On the contrary, the horizon opened up to encompass the whole of Europe, and the influx of foreign artists to Bohemia increased due to a tremendous growth in important work which was entrusted to them. The growing internationalisation of European art, typical of that period, had another side to it: it stimulated regional schools to make their own contribution to European art. The origin and training of the artist, as well as the environment in which and for which he was working, and the task itself, determined the character of this work. Where the environment proved strong enough, it brought diverging elements closer together. When the work was conducted by an outstanding personality who managed to bring new impulses to art and to direct them, this process materialised very rapidly. External and internal conditions enabled Czech art to turn from being merely a passive part of a greater European movement to actually contributing towards its development.

When, after long years of sojourn in France, Charles IV returned to Bohemia, he found the country in desolation. In France he had adopted a new name, that of his uncle Charles V, for he had been christened Wenceslas. He had brought his first wife, Blanche de Valois, with him from France. He had spent some time in Italy where he was governor in his father's place, but had not managed to uphold the rule of the Luxembourgs there. As the new administrator of Bohemia and Margrave of Moravia, Charles at once began to impose order into the unruly conditions of the Kingdom of Bohemia. In his efforts to strengthen royal power and to raise the standards of culture and civilisation in his kingdom, Charles introduced a rapid succession of new measures and improvements.

Thus he created prerequisites for his further activity, which soon turned to international politics. Charles had been King of Rome even before he was crowned King of Bohemia; in 1355 he was crowned Holy Roman Emperor. He selected Prague as his seat of residence. It thus became the centre of the Roman Empire, and Charles spared no efforts to give it an appropriate appearance. In 1344 the Prague bishopric was raised to an archbishopric and the City was no longer linked to Mainz. That same year the foundation stone of a great cathedral was laid in Prague. In 1348 Prague

university was founded, the oldest in Central Europe, and the foundation stone was laid for the New Town of Prague. Prague was thus becoming one of the biggest cities in Europe. Intellectual life was centred not only on Prague University; a centre of humanist enlightenment began to develop around the Emperor and especially his Imperial Chancellory, and in particular his Chancellor, John of Středa. There were lively connections with outstanding humanists in Italy; Petrarch, the poet, among them. National literature was rapidly developing, and soon as important a work as the *Legend of St Catherine* came into being. Here all the complexity of the contemporary world was described in refined, poetical language. Religious and scholarly literature flourished and included certain outspoken critics who paved the way for the Hussite Revolution. Charles stimulated the writing of Claret's large *Czech Encyclopedia* and also wrote works of literature himself. His autobiography and the *Legend of St Wenceslas* show the keen interest he had in the history of his mother's ancestors. The respect he showed for St Wenceslas, his ancestor and patron saint, is a sign of the efforts he made to steep himself in the Bohemian environment. He put emphasis on national consciousness by stressing the continuity with the former Great Moravian Empire. As Prague was not only the capital of the Kingdom of Bohemia, but also of the Empire, German enlightenment was also encouraged and the Imperial Chancellory became a centre for the development of the German literary language. There were lively connections with Germany for geographical and political reasons, moreover, the German minority held a very strong position, especially in the towns.

Spiritual life was no less influenced by intensive contacts with Italy, France and England, which greatly affected the arts in the Czech Lands. In conformity with other cultural centres in Europe, Prague, too, acquired international characteristics.

Great opportunities opened up for contemporary architects. There was lively building activity both at the castle and the New Town, as well as in the older parts of the city. Most of the new buildings came into existence on Charles's instigation and with his financial support, as his ambition was to make his capital a new Rome. Apart from fortifications and public edifices built by the King and by the City, most of the new buildings were churches, which sprouted like mushrooms; this was quite normal for the time. Churches, too, were in many ways representational buildings and served the State quite apart from having their religious function. Here we can see the dual aspect of Charles's personality: a sober-minded statesman who reacted to the romantic plans of Cola di Rienzi, the

Roman tribune, by imprisoning him, and who was deaf to Petrarch's pleas, being more interested in his own dynastic ambitions than in the renewal of the glory of Ancient Rome. But he was also deeply concerned with religious problems and remained a faithful servant of the Church, although he used her to further his secular aims. In spite of the feverish speed with which buildings were erected, Prague avoided the pitfalls of monotonous uniformity, a feature common to large architectural undertakings by the State. It would seem, on the contrary, that a differentiation in the types and artistic treatment of newly built churches was intentionally encouraged, giving rise to architecture of the most diverse conceptions. It has been rightly said that Charles's passion for collecting can be recognised even here. Thanks to his encouragement, Prague city architecture held a leading position, and the regional towns of Bohemia adapted themselves to it with provincial hesitation. The old aristocratic religious orders, who had once done a lot of building in the countryside, no longer took an active share in the architectural development of the time.

Trends which originated in the preceding period and had by now intensively developed, can be characterised as having moved from articulation towards unity, and from symbolism towards sensuousness. Architects were no longer interested exclusively in the structure of the building and the function of individual members. They also took an active interest in space as enclosed by a shell and outlined by it. This shell was no longer to be a rationally articulated organism, but an optically limited space, articulated only when and where its structural function required it. This called for a transformation – a gradual elimination of architectural members as events required a weakening of the ideological function of the building, enhancing its usefulness. The church was to be a gathering-place in which the voice of the preacher could resound evenly and in which people could move freely, no longer drawn towards the spiritual centre at the apse. The dominant type of architecture was the hall church, which dispensed with the hierarchy of nave and aisles. The main trend was one of centralisation, reducing movement in one direction and aiming at a static overall balance. The ideal ground-plan was square or multiangular. As in other fields of art, there appeared certain features which were to be taken further in the Renaissance, using certain elements derived from Antiquity. In style, of course, everything remained pure Gothic.

Under those conditions the basilica lost its attraction. It ceased to play an active part in architecture with the exception of St Vitus's Cathedral, which assumed a rather special place in Bohemian architecture in the second half of the fourteenth century. Those buildings that still kept the basilican ground-plan show an attempt at reduced elongation and greater balance between length and width. This can be seen in the nave and aisles of the parish church of St Stephen's (sv. Štěpán) in Prague or in the deanery church in Nymburk. A trend towards concentricity and unified interiors can clearly be seen in hall churches even where an expressly elongated shape was retained, as was the case with the church of the Slavonic Benedictines (Na Slovanech) in Prague. Here the tripartite choir merges with the nave and aisles. At this time a reduction or abolition of elongation, which directed the building past its centre, became a typical feature. Similarly the meaning of a work of sculpture in the linear expressive style went beyond its material limit. A perfect example of this centralised, unified type of church is the Frauenkirche in Nuremberg, built by Charles IV. Its Czech origin can be seen in its sculptural ornamentation. Its connection with the Prague workshop of Peter Parler is beyond doubt, even though it is older than surviving examples in Prague. The hall has an ideal ratio of 3×3 compartments. This idea of concentricity is applied even more consistently in the Augustinian church of the Assumption at Karlov (Na Karlově) in Prague. Its octagonal ground-plan was in all probability intended to resemble Charlemagne's chapel at Aachen Cathedral. Charlemagne's relics were kept in this Prague church, and Charles IV may have had this in mind when the church was being built. If Mencl's reconstruction of the original plan is correct, the vault was to be supported by four central piers.[12] The building has a perfect overall balance so that the interior is absolutely concentric and enclosed within itself. Its static form is not disturbed even by the presbytery, in the axis of which stands a pillar – in keeping with Peter Parler's style. Copies of this type of building are to be found in the Czech Lands and in Slovakia.[13]

A radical means by which a unified interior was achieved was the removal of all dividing elements, in particular arcade pillars. The collection of various types of churches in Prague became enriched by the addition of a single-nave type, namely the church of St Apollinaire (sv. Apolinář). It was founded in 1362. The single nave was not adopted for larger-sized buildings. Only the Carthusians used it, as is shown in the Carthusian church of Královo Pole, Brno, built in 1375 by the Margrave of Moravia, John Henry, brother of Charles IV. The Carthusian church at Prague-Újezd may have served as a pattern. This church was built in 1342, having been richly endowed. Later it was burnt down by the Hussites and is now lost without trace. Double-nave churches, which were to have a big future both in the Czech Lands, particularly in the south, and in Austria, found another way of achieving unified interiors. A row of pillars – in smaller churches only one pillar – was placed down the centre. This provided the axis to which the entire space of the double nave was bound and which had the simultaneous function of camouflaging the joint between nave and presbytery. This type of church was not entirely new. In the thirteenth century it had appeared in southern France (the Dominican church in Toulouse), and possibly even earlier in Paris. It was particularly popular among the Franciscans. In view of the close connections between the most important Czech building of the time (Prague Cathedral) and southern France, it is quite possible that the French example left its mark on Czech architecture. If this was the case, Czech architects selected a type of building which had not found great renown in France, perhaps because its layout upset the ideology of a church. It ideally suited the space-creating endeavours of Czech architects in the second half of the fourteenth century, however. This ground-plan was used in the fifties in Prague's Jewish Quarter for the church of the Holy Spirit (sv. Duch)[14], which has survived with radical alterations. Slightly later, the centralised church of Our Lady

7 Plan of Karlštejn castle (1348–1365) as restored in 1866

on the Lawn (Panna Maria na Trávníčku) in the New Town of Prague came into being. Its vaults, supported by a central pier, are a late Gothic reconstruction of the original ones, destroyed during the Hussite wars.

This type of building in Prague continued with the two northern aisles of the church of St Castulus (sv. Haštal) in the Old Town and the western double-nave wing of the cloisters of St James's monastery (sv. Jakub), today walled up. Both these buildings were erected at the end of the third quarter of the century. At that time these new ideas began to reach the provinces. In central Bohemia a good example of this type of architecture can be found in the centralised parish church at Vetlá where the vaulting is supported by an unusually slender pillar in the centre. The building, with its ideal proportions, foreshadows the work of other regions in Bohemia, which became a part of the history of architecture of that time.

South Bohemia deserves special mention. The wealthy family of the Rožmberks were trying to outrival the cultural centre of Prague. A great deal of activity took place in all spheres of art which were under the Prague influence. Gradually a kind of provincial school of remarkable high standard and unity

came into being. Although it did not take the initiative in the development of Bohemian art, it did exploit, though rather one-sidedly, the influences that came from Prague. This is true, in particular, of architecture, which was dependent on local supply of raw material more than some other branches of the arts. The double-nave church, with elongated or central plan, found fertile ground here and several remarkable constructions of great artistic merit were produced. In south Bohemia, early Gothic traditions survived for a long time. The square chapel of St Nicholas (sv. Mikuláš) in the Minorite monastery at Jindřichův Hradec, dates from about 1365; its round central pillar shows a trend towards a unified interior, while the vaulting and the articulation of the walls still bear clear marks of the thirteenth century.

But in the same decade the new trend in church interiors was consistently applied in the architecture of south Bohemia, with visual values predominating over structural ones. In 1367 the Rožmberks of Krumlov built the Augustinian monastery at Třeboň and summoned to it monks from their Mother House at Roudnice. The lofty interior of the double nave, with smooth, unarticulated walls, is supported by four round and slender

columns. The concentricity of design was further stressed by using lierne vaulting, not only in the east where the wide triumphal arch made this necessary, but likewise in the west, where the solid wall made it superfluous. There it was used for purely artistic reasons to produce a concentric and symmetrical vaulting design that weakened the elongation towards the presbytery. The lofty appearance and the fragile charm of the architectural members, particularly the slender columns, are truly representative of their time, linking a longing for sensuous beauty with an endeavour spiritually to transcend crude matter. An analogy with the work of the Master of Třeboň,[15] which will be discussed later, can be found in the character of this building, which became the starting-point for subsequent southern Bohemian architecture.

The hospital church of St Vitus (sv. Vít) at Soběslav followed the Třeboň example. Its double nave is separated by two columns. They are so slender that they seem hardly able to support the vaulting. Here we can find certain illogical Mannerist features which gave an impression of unsteadiness, conjuring up an atmosphere of unreality. This was to grow even stronger in later years.

Among other architectural works in this genetic series are the chapter-house of the Minorite monastery at Jindřichův Hradec, (unfortunately its original vaulting has not survived); the two naves of the church at Bavorov, attached to a presbytery and transept of more archaic design; the parish church at Milíčín, and other buildings in southern Bohemia. All are based on the Třeboň model. Finally, even Cistercian architecture could not resist this influence, as is shown in the hall-type nave and aisles of the abbey at Vyšší Brod.

At the time when an architectural style was thus developing, which must be considered autochthonous, work of foreign origin was being produced on a grand scale and in a different style. Its centre was the masonic lodge which was building St Vitus's Cathedral in Prague. This was to become the most important church in the kingdom, both as regards spiritual significance and grandeur of conception. It was natural for Charles, well acquainted with French culture, to turn to the 'cathedral country' of Europe and summon the chief architect from there, namely Matthias of Arras. Little is known of his previous work, but some scholars (Frankl, for instance)[16] are of the opinion that he had worked on the Cathedral of Narbonne. He must have been a man of high repute and well acquainted with the architecture of southern France. Arras brought with him the southern type of French cathedral.

As it was to be a royal cathedral, the building Arras designed was a cathedral-type basilica, differing basically from the classic cathedral type of northern France. Slim, concave shapes were to replace the moulded fullness of the architectural members, terse linear profiles were to suppress sculptural decorations and, according to the original plan, the wall, apparently, was to be strongly emphasised. The freedom with which he treated the heritage of the classic Gothic style contains certain late Gothic features and can be seen, for example, in the finials of the large buttresses of the choir which penetrate the 'roof' at the level of the balustrade. Arras died in the year 1352, having worked in Prague for eight years. By then the choir,

whose foundations had been laid, had only partly reached the height of the arcades. Only the apsidal chapels were completed, the chapel of St Anne on the north side, two other chapels and part of a third on the south side of the elongated part of the choir, and the arcades that belonged to it.

Charles IV made an exceptionally fortunate choice when, the following year, he brought Peter Parler to Prague from Swabian Gmünd, where the twenty-three-year-old architect had been working under his father, Heinrich, on building the choir of the local church of the Holy Cross. Peter Parler had probably served his apprenticeship at Cologne, believed to be the home of his family and of his first wife. He may have worked elsewhere in Europe, too, and must have been acquainted, but possibly only from plans, with English architecture.

The choir of the Gmünd church is the hall type, in which ideas used by the Cistercians in the Danube valley were applied. Many features indicate Peter Parler's subsequent work, among them a wealth of ornamental details.

In Prague, Parler had to take over a half-built cathedral-basilican-type church. He may already have been acquainted with this type of architecture from Cologne, where the tradition of classic French architecture survived into the fourteenth century, almost untouched by new trends. Parler, however, did not keep to his predecessor's ideas, nor did he use the classic French system. He did not try to make an eclectic merger of the two systems, but radically changed the design of the building, as worked out by Arras, in the sense of unifying the interior. He adopted the mighty convex shape of architectural members derived from classic French Gothic, which opposed the trend of interpenetration of space and matter and the merger of these two elements. To counterbalance the dark zone of arcade pillars he built a row of wide windows, which suited his liking for contrast, and he definitely abandoned the additive manner of creating interior space, which partly survived in Arras's plan. He turned the interior into one that was subdivided, yet had continuity and was unified. This radical change can be seen most clearly in two places: the triforium and the vaulting. The 'roof' of the windowed triforium (which in Narbonne still had a solid back wall) was upheld by strikingly solid columns. In number and spacing the columns matched the tracery bars, so that the triforium and the windows formed one source of light. The roof, furthermore, was set at an angle to the piers. The result was a kind of niche that widened the nave into the side aisles which were thus subordinated to it. The same effect was achieved by windows set among the shafts above this slanting roof – a kind of tabernacle or window-within-a-window topped by an ogee arch with a finial. Thus the big windows were transferred to the level of the nave walls. The slanting roof of the triforium covered the shafts of the piers and at times surrounded them, providing a continuous strip of strongly stressed horizontal articulation which thereby weakened Arras's intentional verticality.

This principle of the mutual interpenetration of architectural members and spatial units found here and elsewhere is clearly a late Gothic characteristic. Since some of these features appeared earlier in English architecture (for instance, the choir of Wells Cathedral)[17] it is likely that Parler adopted them from

ingenuity of this vaulting lies in the fact that the boss and the flying ribs, which would usually ensure the structural stability of the vault, are in this case pendant and therefore being supported. The English motif of the flying rib shows the increasing desire to interpenetrate mass and space, which are conceived no longer as qualitatively different components of architecture but as only quantitatively differing aspects. We shall see that similar tendencies also appeared in Czech painting and sculpture at that time. The fact that the boss was removed from the vaulting, and elsewhere shifted from the centre of the vaulting compartment proves clearly how aesthetic aspects were assuming prime importance. While before, in the system of symbolical references, the boss had represented Christ, it now became an active means of expressing spatial relationships.

Peter Parler reached the culmination of his art of vault construction in the chapel of St Wenceslas (kaple sv. Václava). It was the King's wish that this chapel should be adorned with special magnificence to underline its function in national and state policy. The chapel was to contain the tomb of the patron saint of the Kingdom of Bohemia. It had been part of the Romanesque basilica built under Prince Spytihněv which had replaced the Carolingian church of St Wenceslas. One end of the chapel stretched beyond the outer walls of the choir, the other, since it was to be square, penetrated deep into the transept. Arras's design might have taken into account the tomb of St Wenceslas, but the size and proportions of the chapel show a radical change from the original plan: the main entrance has been moved to the south side – opposite the royal palace. The south side was also chosen for the location of the tall tower which, in ground-

8 Plan of the Minorite church at Jindřichův Hradec. Aisle from the second half of the thirteenth century, presbytery from the second half of the fourteenth century, nave vaulting from the end of the fifteenth century, lateral chapel of St Nicholas alongside the presbytery before 1369

9 Plan of the Augustinian church at Třeboň. 1367 to after 1380

there. The same is true of the intricate patterns of tracery with typical flamboyant shapes and net and star vaulting. These probably derive from different sources. Important for further development is the net vaulting of the nave used here for the first time in Central Europe for a main cathedral nave. Since the net vaults broke up the sequence of each isolated vaulting compartment the impression created was of a unified interior. Where Parler was not bound by the original plan he tried to achieve a balanced and centralised ground-plan. It is characteristic that he replaced Arras's polygonal ground-plan of the chapels by a square design even where the building had been started on polygonal foundations. Of equal importance is his preference for semi-circular roof arches. It can be seen from the two square compartments of the vaulting in the sacristy how much he was concerned with a static impression in the interior. Here the patterns of the vaulting differ, and each is therefore independent and final. This may possibly have been due to Parler's endeavour to show his skill at vaulting, which in both cases is derived from a square set on a diagonal in each vaulting compartment. The specially effective means he used included the motif of hanging bosses where one would have expected pillars. From the end of these bosses, at the level of the rib consoles, flying ribs run upwards to the vaulting ribs. The

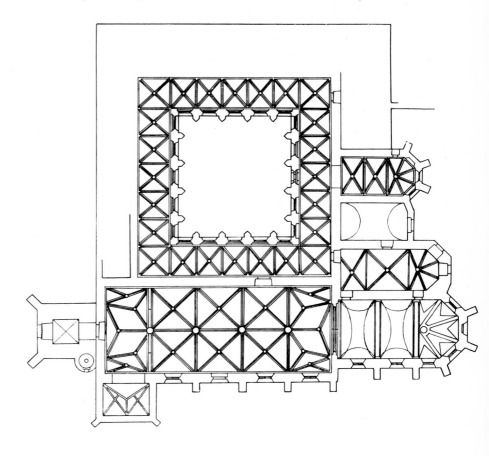

plan, corresponds to the chapel of St Wenceslas. Between the chapel and the tower was placed the magnificent Golden Gate with three portals outside and a double inner doorway, whose central pillar is placed outside the actual doorway and within the porch itself. Flying ribs end in this pillar as do the semi-circular arches of the jambs of the free-standing doorway. The wealth of sculptural decoration on the porch has been lost but must certainly have existed. The importance of the portal was intensified by the splendid mosaic of the *Last Judgment* on the front of the porch, quite unique north of the Alps. Its flatness and frontal character, its horizontalism ran counter to the Gothic spirit of the building. The mosaic had an antecedent, now vanished, in the abbey church of St Denis which Charles IV may well have seen.

There can be little doubt that Charles IV had a hand in this radical transformation of the layout of a classic Gothic cathedral. The south portal was used for solemn processions to the Cathedral. Here, too, the first stage of the coronation ceremony took place in which the adjacent chapel of St Wenceslas played an important role. The manner in which the King's wishes were realised shows how much freedom Parler had been given to do creative work. With his sound mastery of the classic heritage he adapted it to the needs of the moment and created a totally new work of art.

The ground-floor of the tall tower is still the work of Peter Parler. There his art of vault construction can be seen in the Hasenburk chapel which is now considerably changed. He used the motif of a central circular rib upheld by a four-pointed star. Cross vaulting was abandoned here. The circular rib appears also in the south porch. These new vaults made by Parler, which were a great influence on later development, were probably also a structural improvement. The important fact, however, is that vaulting was now used as an autonomous aesthetic factor. Architecture has become a work of art endowed with the views and imagination of the man who created it. St Vitus's Cathedral, whose original plan was conservative for its time, became under Parler's leadership the stimulus for further creative achievements. Its effect was felt far into the sixteenth century.

None of the other works made by Parler attained the significance of St Vitus's Cathedral. There are several secular buildings, for example the technically remarkable Charles Bridge and the Old Town Bridge Tower at its eastern end. This is a triumphal arch through which the coronation procession passed on its way from Vyšehrad Hill to Prague castle.

The gateway has net vaults which resemble the vaults of St Vitus's choir, but foreshadow later development in the remarkable vaulting brackets with intersecting ribs springing without consoles from the wall. The ground-floor, with its wide-open gateway, is light in appearance, in contrast to the first floor with its solid walls; this element of contrast was applied further in the different treatment given to the two upper storeys.

Another important building was the chapel of All Saints (kaple Všech Svatých) next to the royal palace at Hradčany which has survived, but unfortunately in its Renaissance form, greatly changed from the original.

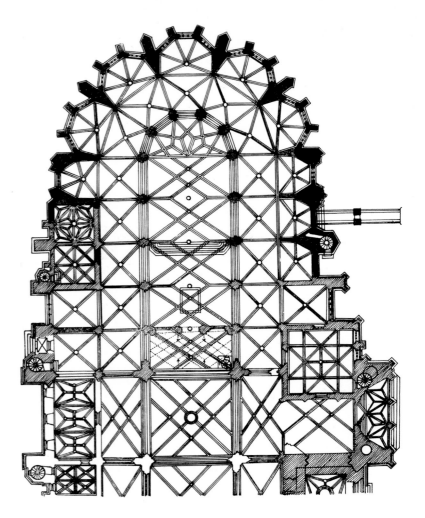

10 St Vitus's Cathedral, Prague. Matthias of Arras and Peter Parler. 1344–1420

Out in the country Parler built the choir of St Bartholomew's church at Kolín (sv. Bartoloměj) which he added to an early Gothic nave and aisles. Here, too, he built an effective contrast to the massive ground-floor in the light clerestory; the same contrast can be found between the dim nave and aisles and the well-lit choir. This dramatic effect which had a spiritual significance, found expression later in, for instance, the choir of the Franciscan church at Salzburg which Hans von Burghausen added to the Romanesque nave. The massive, inward-drawn piers, which form the walls of the Kolín choir chapels make a continuous solid plinth, whose impressive horizontal line, stressed furthermore by a traceried balustrade, contrasts with the upward movement of the upper parts of the building. The similarity to the roughly contemporary choir in the Cistercian church at Zwetll is obvious.

The church in Kolín was followed by the choir of St Barbara's (sv. Barbora) at Kutná Hora, based likewise on a cathedral plan. Its original nave and single-aisle plan was changed, at the beginning of the fifteenth century, to double aisles of a size that was to exceed even that of Prague Cathedral. The ambition of the rich burghers, who commissioned several buildings from Parler, was great indeed. The Hussite wars interrupted the construction of the building which was not finished until the late fifteenth and early sixteenth century.

In spite of the undoubted similarity between the first phase of construction, begun in 1388, and the church at Kolín, it is not clear whether Peter Parler personally designed the church. The influence of Parler's architecture can be found elsewhere in the Czech Lands, too: for example in the Týn church (Panna Marie před Týnem) and the Maltesian church in Prague (Panna Marie Pod řetězem), at Panenský Týnec and at Zlatá Koruna, while Arras's associates can be traced to the unfinished church at Sázava and the destroyed Cistercian church at Skalice near Kouřim, based on a cathedral ground-plan.

Czech architecture in general, however, was not deeply affected by the Court lodge. It followed its own independent path which came close to Parler's work at several points, partly because it was dealing with similar contemporary problems, and partly because Parler and his assistants soon grew into the Czech environment in which, at first, they had formed an isolated, alien enclave. The pressure of assimilation into the environment was very strong, as we shall see in other spheres of art.

Parler's lodge gave a mighty and far-reaching impetus to one aspect of local architecture: vault construction. Especially in south Bohemia, Parler's art of vault construction found convinced supporters who handed it on to the Danube region.

* * *

The immense growth of building activity at the time of Charles IV was reflected both in sculpture and painting. Artists were summoned to add decoration to the new buildings and to express their significance in pictorial form. Old records show us relatively well the interior fittings of the Prague churches; they indicate a wide range of painting and sculpture. But almost all of this has been lost and we possess only work from less important country churches. Their high standard is a guide to the quality of the sculpture which once adorned the main churches in Prague, and in particular St Vitus's Cathedral. Only architectural sculpture has survived in Prague and not even all of that. It is very sad that the magnificent sculptural decoration of the south portal of the Cathedral has not survived. This was the first large undertaking of the Court lodge and was completed at the end of 1367. The execution of the sculpture must have been in keeping with its significance. We have a record by the official chronicler and the director of the masonic lodge Beneš Krabice, which hardly admits of any other explanation: 'Eodem anno et tempore [December 1367] completum et perfectum est opus pulchrum, videlicet hostium magnum et porticus… de opere sculpto et sumptuoso nimis…'[18] The fourteen recesses along the side walls of the porch held minor figures; among them almost certainly those of Charles IV and his wife, probably displayed in a manner that was later copied on a more modest scale for the Prince's Gate of St Stephen's in Vienna. If this was so, the portrait figures, together with shield-bearers and patron saints, were placed in the four recesses of the front wall of the porch. In the recess of the central pillar inside the double doorway there probably stood a figure of the Virgin, and the sides of the porch were perhaps adorned with figures of saints, among

them most likely the patron saints of Bohemia. The inside of the porch is now a reconstruction of the original, which can be assumed to be correct.

Only a few decorative pieces have survived from this early phase of Carolinian monumental sculpture. The progress in building the Cathedral and other important buildings on which the St Vitus's lodge was engaged explains why monumental sculpture by Parler did not appear in Prague till the seventies. This lack of monumental sculpture is particularly striking when compared with paintings made soon after the middle of the century by the Court painters. Painting outstripped sculpture largely for reasons beyond the scope of art, but as a result painting assumed the leading role in the arts and probably became an influence on sculpture. Anyhow, a trend towards pictorial expression is typical for all arts, including architecture. Everywhere can be observed a tendency towards unity, merging, interlinking, blurring the borderlines between the individual parts of the whole, and to the triumph of visual over structural considerations.

As building progressed monumental sculpture began to appear. A great deal was produced during the seventies with the exception of the decoration of the Golden Gate, which was of particular concern to Charles IV. Only wood-carvings have survived from earlier decades. These were particularly prone to the influence of painting since they depended on painters for their final polychromed effect, and since on the altars they stood close to paintings. The carvings were probably often made in the same workshops as the paintings. These carvings, which were meant primarily for individuals, were free from the restrictions of official art. Their creators were open to new ideas in art and could more rapidly adopt the new approach to the world propagated by painting. Here the transition from depicting theological ideas to the description of historical events, from abstract ideas to their actual, sensuous form, was made for the first time and most consistently. This new attitude was due mainly to the growing importance of visual impressions in Man's attitude to the world. The visible world, through whose mediation eternal truths reveal themselves, is itself worthy of depiction, it is a means of revealing eternal truths to the people. Reality, however, is changeable, varied, unique, conditioned by place and time in geography and in the history of the world. Sensuous reality, therefore, is not static but is the result of processes and relationships. The individual, time-conditioned appearance of Man, the mechanics of his movement, his place in his environment and the ties that bind him to it enter the artist's consciousness and become a problem for him. The method in which this knowledge is acquired is purely empirical. Its theoretical justification was not given until the Renaissance. The artist's sensuous image of the world with its changing form, however, still remained a parable of what was unchanging and eternal. Events from the history of religion had several meanings, surpassing their literary meaning and probably incomprehensible to the majority. Symbolical references to the eternal world of religious, cosmological, and other truths had their parallel in Platonian-Augustinian realism, which was more concerned with what had existed through the ages than what was taking

place at any given time. This complex system of symbolical references was mainly a matter for donors and their advisors who elaborated a programme of parables which the artists were to depict in sensuous form. The artists themselves were affected by this longing for a firm, unchanging order and they searched for the fundamental forms of the chaotic and changeable world, whose colourful beauty they were discovering. Geometry was a reliable guide to them in this. Historically, however, this 'why' of the symbolical explanation of the world is less important than 'how' these symbols were expressed in sensuous form. This became a major preoccupation of the second half of the fourteenth century. As a result, the most important contribution made by the art of the time is the knowledge of things in their individual form. It is a kind of analogy to philosophical nominalism and the beginning of empirical science.

The new attitude had several effects on wood-carving. Firstly, in the growth of volume which rose from within and broke down the abstract linear system of the draperies by introducing a relationship between body and garments. (Volume, however, was often only simulated and the relationship between body and garments was only an illusion since the statue was conceived not from the inside but from without.) Secondly, in the attempt to give the figure, particularly the head, characteristic features which were to symbolise concrete reality. For some decades art developed a cult of the ordinary, not to say ugly, even in portraits of eminent persons, where it almost became an inverse convention. Thirdly, with the freeing of the linear rhythm, the surface of the statue became softened and form was built up on transitional sections rather than the borders between parts. This meant that the dividing line between the statue and its setting became less acute and the environment became a contributing factor. Since the symbols of religious ideas derived from the sphere of human life their depiction in art often assumed a kind of genre character.

If we examine a group of standing Madonnas, one of which was formerly in a private collection in Jihlava, the others in the town church at Broumov and St James's (sv. Jakub) in Jihlava, we soon recognise how the composition abandoned the *a priori* linear rhythms and developed a growing sense of visually probable relations between parts. The statue in St James's church in Jihlava reveals that Classical tradition, as transmitted through the sculptures of the thirteenth century, was of some importance in this process.

This new trend shows even more clearly in a group of seated Madonnas made of wood. Particularly characteristic are Madonnas in the churches at Bečov and Hrádek. The principle of a religious idea embodied in a purely human story was here realised with such consistency that only the attributes indicate the symbolical meaning. The form rejected the old calligraphic system. Movement relates the statue to its environment in a manner resembling Baroque art. Ordinary women with quite ordinary faces play with children, whose naughtiness gives hardly any indication of the lofty idea they represent. The accidental and the unforeseen play an important role here, breaking down the current conventions to an extent which was quite out of the usual even in the revolutionary

Europe of the time. This carving was undoubtedly influenced by contemporary Czech painting, in particular by book illumination in which the Italian, rationally constructed, form was soon transformed in terms of a direct attitude to the world. Even in sculptures that consistently followed this subjective, illusive line – concerned with total form and not with definition of its parts – below the soft, non-articulated but spatially differentiated surface, there was an abstract, *a priori* axis of movement even though it was derived from observation. Organisation of form, often hidden by accidental surface modelling, once again rose to the fore when, beginning from the end of the seventies and especially in the last two decades of the century, the need for greater discipline began to be felt. This

11 Plan of the church of St Bartholomew in Kolín. Peter Parler. Nave and aisles after 1270, presbytery 1360–1378

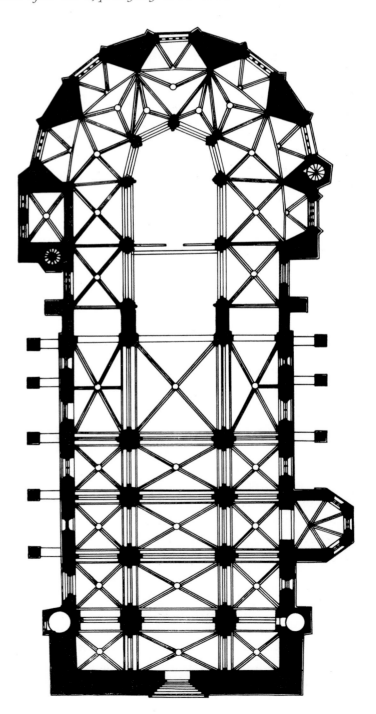

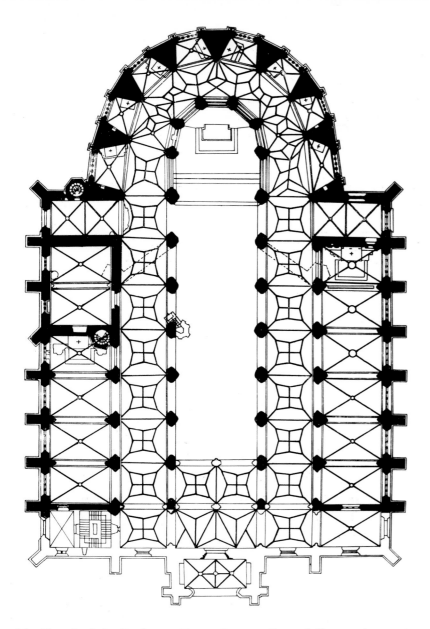

12 Church of St Barbara, Kutná Hora. Ground-floor. 1388–1548

reflected the general situation in Europe where the International Style was coming into being. Its basic features included the stabilisation of form based on the old French calligraphic tradition. There can be no doubt that the little *Madonna of Konopiště* (originally from Chvojno and now in the National Gallery, Prague) is linked in composition and motifs with the above-mentioned group of seated Madonnas. However, it differs from them by having a more regular rhythm, in which the folds of the garments show a submissive element of linear composition.

This trend can be observed even better on a small *Madonna* from Zahražany in the parish church at Most. Not only does it show the renewed function of line but also stylised movement. At the time of the Beautiful Style this became a prevailing element of composition. Artists were possibly influenced by the official art of the Court lodge, whose stone-masons were, at the time, busy on the decorations of the Cathedral. In spite of its official character, the Court lodge in its turn was not un-

aware of the possibilities that this autochthonous carving presented, as can be observed particularly in the later work of the St Vitus's lodge.

Work on the Cathedral had by then advanced so far that the time was ripe for the planned sculptural ornaments. Only a small part of these had been fashioned so far: the now lost ornamentation of the south portal. Sufficient of the remaining monumental stone sculpture of the Cathedral has survived to enable one to trace its political and social purpose and significance.

The ground-floor was devoted to the King's Přemyslide ancestors. In the chapel of St Wenceslas there stood a statue of the saint and King's namesake, and on the tombs in the ambulatory chapels of the choir there lay the effigies of Bohemian princes and kings on their tombs. In the triforium the current Přemyslide-Luxembourg dynasty was depicted with busts of the Emperor and his family, surrounded by portraits of the Prague archbishops, and the superintendents of the Cathedral works, canons of the Prague Chapter. The fact that among these leading members of feudal society there appeared also the two architects of the church is a proof of the respect their art enjoyed. Here we have a sign of the humanist atmosphere at the Court of Prague. In the upper triforium above the portraits of the royal family were placed busts of the heavenly protectors of the kingdom and the dynasty: Christ, the Virgin Mary and the patron saints of Bohemia. Throughout the part built by Peter Parler were scattered a multitude of fantastic or grotesque masks and symbolic figures of animals.

Most of these sculptures possess a profound feeling for three-dimensional form, for which we would vainly seek any analogies in previous Parlerian work, for example at Swabian Gmünd. Parler seems to have acquired this style under the influence of Czech painting, especially the compact form of Master Theodoric's figures at Karlštejn castle. The art of individual characterisation had also advanced very considerably. In the Přemyslide effigies this reached mighty, dramatic pathos; in the busts of the triforium it attained almost modern analytical portraiture. The busts of the saints in the upper triforium even reveal an attempt at depicting a certain mental state.

This immense set of sculptures is not unified in style and quality, although the whole of it must have been produced within a short period of ten to twelve years. The example set by Peter Parler imprinted itself upon stone-masons of varying talent and ability. The account book of the Cathedral, fragments of which have survived, confirms that Peter Parler personally fashioned the tomb of Přemysl Otakar I, finished in 1377. In view of the similarity in style we can attribute to him certain of the tombs. Parler's emblem is to be found on the statue of St Wenceslas, but there exists a report that Heinrich Parler worked on it for some days. We possess no reports as to who made the rest of the statues but it is highly likely that Peter Parler took a considerable share in this cycle of sculptures. This is most clearly seen on the Přemyslide tombstones. Peter Parler's authorship of the Přemysl Otakar I's effigy is confirmed by a record in the account book. Apart from this it can also be detected on those of Spytihněv II and Přemysl Otakar II. Mighty form with profound pathos recalling the thirteenth

century, and a Giotto-esque volume is accompanied by expressively characterised faces, bearing marks of experiences of times past and resignation to the inevitable end. Their source is Swabian Gmünd, where Parler worked in his youth and perhaps also Strasbourg where the prophets on the west porch of the Cathedral have some of the gloomy severity of the Přemyslide heads. But the development Parler's sculpture underwent from humble beginnings in Gmünd to the tombs in Prague shows a steeply rising curve. In the Prague setting of monarchy and Empire Parler's achievements represent one of the peaks of contemporary European sculpture.

Other masons also worked on the tombs. The one who made the effigy of Břetislav I had a softer concept of matter, close to contemporary carving, which differed from Parler's vigorous form. Yet another, who made the tomb of Bořivoj II, was probably well acquainted with the work of the Parisian tomb-makers and had perhaps been apprenticed to them.

Of particular historical importance is a series of portrait busts in the triforium. They were made in the years 1375 to 1385. The core of this series, the portraits of the Emperor and his family, holds a place of honour and is undoubtedly the earliest. The barely articulated busts seem to be blown outwards; they are enlivened on the surface only by a few individual characterisations. It may be assumed that the stone-masons derived their inspiration from the work of the Prague Court painters. Portraits had been painted there as early as the fifties. Of particular importance are Master Theodoric's busts of saints in the chapel of the Holy Cross at Karlštejn castle made in the sixties, whose summary, softly modelled volume and composition, to a large extent, harmonise with the earliest of the portraits in St Vitus's. The ability at portraiture developed very rapidly in Parler's workshop and soon surpassed the results which painting had attained. The earliest series of the triforium portraits already included works with individual faces and even characterisation of the person depicted: the young man's immaturity of Wenceslas IV; the girlish charm of Anne of Swidnica, which includes a touch of the charm of the 'beautiful' Madonnas; the proud severity of Elizabeth Přemyslide, the official graciousness of Charles IV. The later busts show two different approaches to portraiture, two manners of depicting the individuality of the model: one, to be seen in the remarkable bust of the superintendent of the building works, Nicholas Holubec, concentrates on the general, accidental visual form of the model. The other, represented in particular by the bust of Peter Parler, aims at precisely defined, clearly articulated facial characteristics. It would seem that the tone for this second group of portraits was set by Peter Parler himself. The third, slightly later group is represented by the bust of the superintendent of building works, Wenceslas of Radeč, which was made during the years 1380 to 1385, probably towards the end of that period. The precise description attained in this third group is reminiscent of modern portraiture, but one cannot overlook a certain stylisation. Some Gothic trends appearing here are typical of the eighties. At the same time the lodge continued optical illusionism, which in some busts of saints in the upper triforium achieved a truly psychological

characterisation of the human face. Close parallels to painting in the eighties exist here.

In the seventies two important works arose from these two different starting points. Both happen to be from the same year: 1373. The statue of St Wenceslas bears on its pedestal the mark of the Parlers, in all likelihood, that of Peter. But the Cathedral account book for that year reveals that a Heinrich Parler worked on it for five days. What his relationship to Peter Parler was is not known for certain. The statue may have been commissioned from Peter who had part of it completed by Heinrich. The statue, modelled in the round, is conceived on a large scale; the posture is admirably balanced. But the soft curves of the saint's body and his passive, melancholy expression do not fit in with the crude realism of Peter's Přemyslide portraits. The artist was, of course, working on a different theme. Temporal being and death had been superseded by that of an eternal ideal unaffected by the course of human life, the ideal of the good prince who was a pattern for the ruling monarch. But the garments of the Přemyslide giants show similar movement, and the cloaks likewise create rhythmic patterns of light and shade.

On the other hand, the delicacy of execution of the saint's face shows a certain relationship with the portrait bust of Wenceslas of Radeč, where, however, it attains a degree that recalls the precision of engraving. This is particularly evident with Radeč's hair, which is reminiscent of the thin strands of hair seen on Madonnas of the thirteen nineties. So it is perhaps possible to attribute the statue of St Wenceslas to Peter Parler and explain some of the dissimilarities by the difference in theme and the participation of Heinrich Parler, who may also have made the bust of Wenceslas of Radeč.

The second important work of the seventies is the bronze statue of St George in Prague castle. It was cast in 1373 by the brothers Martin and George of Kolozsvár in Hungary (today the town of Cluj in Romania). The well-known theme was carried out with an unusual sense of composition in space, for which we would vainly seek an analogy in European sculpture of the thirteenth and fourteenth centuries. The rider and the horse are contorted and, together with the writhing dragon, form an oval movement set freely in space. The result is a spiral narrowing towards the top and open on all sides to the surrounding space. The statue shows a remarkable knowledge of the anatomy of a horse's body and its mechanics. Typical of the sculptors' style was the careful attention they lavished on the details of the armour and the harness and the care given to the small creatures on the rock, which is stylised in the Byzantine manner, forming crystalline shapes. These details presuppose a concentrated study of reality, yet they do not prevent the shape from having soft transitions and a certain measure of uncertainty and vagueness, while retaining a sensitivity to the quality of the surface. These features link the statue to the busts of saints in the upper triforium of Prague Cathedral, made ten years later, and to the ornamentation of the north portal of the Týn church, which will be discussed below. The spatial treatment and other characteristic features link it also to the relief with the *Conversion of St Paul* in St Stephen's in Vienna. There undoubtedly exists a relationship between

the Parlerian statues in Vienna, among them the St Stephen's relief, and the Prague sculpture of this lodge. But the character of this relationship and its timing have not so far been satisfactorily explained.

*　　*　　*

In the field of painting the new style began to be felt first and most clearly on panel paintings. By the middle of the century this had reached a specific form. It served as the basis for a tradition that did not lessen in significance for half a century. Since panel paintings from the first half of the century have been almost completely lost, it is impossible today to discover when and how the foundations for the new style had been laid. The only work that can safely be attributed to the period before the middle of the century, the Roudnice predella, does not clarify the situation. The insubstantial half-length figures of three saints are clothed in garments which are suspended as from coat hangers. The rich folds of the robes and the carefully executed hairstyles contain a good deal of the abstract linearism of the first half of the century. But the faces, though conventional in type and non-individualised, show an attempt at suggesting volume. This juxtaposition of calligraphic linearism with renewed interest in volume characterises the major panel painting of the mid-century: the *Vyšší Brod Altarpiece*. The painting, now in the National Gallery, Prague, consists of a set of nine panels with themes from the *Life of Christ*. Originally it probably formed the central altarpiece in the Cistercian abbey at Vyšší Brod. The donor, a member of the Rožmberk family, is seen kneeling at the scene of the *Nativity*. As he cannot be clearly identified, it is difficult to date the altarpiece exactly. The conventional date given is *c.* 1350. This particular panel lends itself to a clarification of the style of the altarpiece. First of all, it is clear that the composition of the picture was derived from Italy. It is indirectly based on Giotto's wall painting of that theme in Padua. The Italo-Byzantine origin can also be traced in the crystalline terrain, arranged in terraced layers, forming the background to the human story. Space expresses meaning, and does not fulfil an optical function. The construction of the hut is Italian and the expressive volume of the figure of Mary and the chubby Christ Child are of the same derivation. The Child is lying on a magnificent couch sheltered by a thatched roof. Mary is dressed in costly robes. The folds of the fabric stressing the anatomy of the figure contain a good deal of French eurythmics. The layout is dependent on the area of the panel and does not take account of the observer. The painting is not a representation of reality seen through a frame, as was customary at the time and even earlier in Florence and Siena, the sources of most of its inspiration. The same is true of the rest of the pictures in the Vyšší Brod cycle. One painting shows closer links with the linear rhythmical style. Another derives from an Italian or Italo-Byzantine type. The painter's starting point was the Western European linear style, onto which he grafted lessons learnt from Italy. The result is a somewhat eclectic painting. Certain of its features, however, became typical of the Czech Lands: for example the garments and facial types. Their effect and validity still applied fifty years later, in the period around 1400. Among the other panels a special place is held by the *Descent of the Holy Spirit*. It shows a more advanced spatial arrangement, and the form has become noticeably softer. It foreshadows the development of panel painting in subsequent years.

Also important for further development are paintings of the Virgin from the same school. The most outstanding is the *Madonna of Veveří* (National Gallery, Prague). This work with its strong Italo-Byzantine features may even have been produced in the studio of the Master of Vyšší Brod. Here as in other paintings on this theme, for example the *Madonnas* from Strahov and Klodzko (Glatz), there are motifs which became a permanent feature of Czech Madonnas. One of these features is an exceptionally large Child, rather unusual for Northern Europe but common in Italy. This feature began to appear anew around 1400. Similarly the expression of ardent emotion and gentle lyricism was to become a permanent feature of Czech painting until the early fifteenth century.

Another work that belongs to the circle of the Master of Vyšší Brod is the Wroclaw *Holy Trinity* (Silesian Museum, Wroclaw). The other painters of the time, however, proved strong enough to transform inspiration derived from Italian or Western sources. The *Madonna of Most*, for instance, includes strong Byzantine and Italo-Byzantine features – apparently it was a replica of an Italo-Byzantine type – but adapted to the spirit of the new Bohemian style in painting. On the other hand, the *Madonna of Zbraslav* (parish church, Zbraslav) is a good example of the new style, even if here, too, we can find some echoes of Italo-Byzantine types. Though close to the circle of the Master of Vyšší Brod, it contrasts with it by the softer modelling and the emphasised intimacy between Mother and Child. Its later variant, the *Madonna of Rome* (National Gallery, Prague) belongs to a subsequent stylistic period.

Other paintings confirm the links between Czech painting of *c.* 1350 and Sienese painting. This is true not only of the *Kaufmann Crucifixion* (Staatliche Museen, Berlin) whose dramatic impact transcends the lyrical atmosphere usual in Czech painting but is definitely related to it in its colour scheme. The same is true of the *Death of the Virgin* from Košátky (Museum of Fine Arts, Boston), which is perhaps the most Italianised picture in the Czech school of painting. The construction of the heads and the convincing gestures of the hands is terse, expressing the Apostles' emotional reactions to the sad fact of the death of the Virgin. The scene is set in a remarkably mature rationalist construction of space. This would indicate a thorough knowledge of the principles of Italian Trecento painting; the gap between the figures and their setting, however, shows shortcomings in this knowledge.

The rigorous Italian influence, which characterises the Košátky panel, is rather an exceptional feature. Elsewhere we can find this intermingled with other traditions, of Western origin, and altered in the intensive process of synthesis. The same phenomenon can be observed even in the most Italianised manuscripts of the time, a group of illuminated books, with the main work, the *Liber Viaticus*, or travel breviary, of the Imperial Chancellor John of Středa. Though only slightly later in date it is of a different, more advanced style. Its basic features were no longer outline drawing and precisely defined

shape. This softening of form also appeared, as we saw, on the *Vyšší Brod Altarpiece* and a later work of this style, the *Madonna with St Catherine and St Margaret* (Hluboká Gallery). But the decisive turn away from abstract drawing to realistic form probably began in the Court studio, whose main task was to decorate the royal and imperial buildings.

Much work from the Court studio has been lost: for example the paintings that once adorned the royal palace at Prague castle, with a cycle of Charles IV's ancestors on the imperial throne; the paintings in the chapel of the Archbishop's palace in Prague; the ornamental paintings in the castles which the King commissioned from Nicholas Wurmser; an extensive cycle of paintings in the main hall of the imperial castle at Tangermünde in Brandenburg, including pictures of Charles IV and the electors, with a tournament and portraits of the Bohemian princes and kings from the first Přemyslides to Charles, Wenceslas and perhaps Sigismund; and many others of which not even records have survived. Furthermore, the majority of paintings in the many churches and monasteries built under Charles have vanished and of the paintings in the Cathedral only fragments exist. But the few objects that we do possess suffice to show that the Court studio was a centre of painting as important, and in its direct consequences perhaps even more important, than the circle of the Master of Vyšší Brod.

First of all, there exist two extensive cycles of paintings. One is to be found in the Imperial castle at Karlštejn near Prague and the second in the cloisters of the monastery of the Slavonic Benedictines in Prague, usually called Emmaus. Both these buildings and their ornamentation, together with Prague Cathedral, rank among the major achievements that mark Charles' aims in culture and politics.

In the royal palaces in Prague and Tangermünde the themes of the paintings were, as far as is known, exclusively secular. They were relevant to Charles' function as monarch. The paintings at Karlštejn present a far more complex problem. The purely secular themes were restricted to the large hall of the royal palace which, located at the lowest level, is likewise least in spiritual importance. Two chapels, the Lady Chapel and that of St Catherine, are situated in the Church Tower. Here religious subjects predominate, while secular figures appear only in connection with religious rites. Another tower, the higher of the two, known as the Great Tower, encloses the magnificent chapel of the Holy Cross where secular themes were entirely excluded. The notion of empire was closely linked with religion and even merged with it. From time to time the religious themes contain references to the idea of imperial power. The intricate meaning of the castle paintings derives from the various functions it served. Karlštejn Castle was one of the King's favourite residences. Here were kept the priceless treasures of the Kingdom of Bohemia, the relics of Christ's Passion and the symbols of the King and Emperor, his dignity and power, bound up with the religious concept of the world. It is, therefore, quite natural that the paintings comprise symbols of the genetic legitimacy of Charles' power as King and Emperor, expressed in the Luxembourg Family-tree and the legends of St Wenceslas and St Ludmilla, accompanied by theological explanations and linked to the theological system of fundamental truths about the world.

Such themes were nothing new. Similarly the metaphorical references to astronomy and astrology were of very ancient origin. This theological, historical and cosmological erudition was elaborated in person by the Emperor and his councillors and was stipulated as subject-matter for the painter. The manner in which these aspirations to eternity were depicted indicates that Charles IV selected his painters with as much wisdom as he had shown in the choice of his architects.

The concept of the paintings may well have had influence on their formal presentation. For example, the inner light radiating from the figures of saints in the chapel of the Holy Cross has something in common with the mysticism of light, proclaimed by St Augustine, which was fostered at the Court. But historically far more important is the indisputable shift towards experience and observation, which can be seen in the works of the Court painters, a feature which was opposed to the St Augustine realism on which the programme of the paintings was based. The retrogression from such advanced positions of realism in art which occurred cannot be considered a drop in quality. It is a sign of the contradictions of the time when the pendulum swung between the old and the new, and of the strength of the local environment which slowly adapted outside influences. This development was not limited to the Czech Lands.

The *Luxembourg Family-tree* in the large hall of the palace suffered destruction, but late Renaissance copies have survived; they are fairly reliable, even if not entirely so, as any comparison with existing paintings proves. This type of family-tree is derived from Brabant examples, none of which has survived in the form of mural paintings. The notion of the dynastic genealogy itself had been known in the Czech Lands since time immemorial. The *Přemyslide Family-tree* of 1134 in the Chapel of St Catherine (kaple sv. Kateřiny) at Znojmo indicates that it had a very old tradition. There is no reason to assume that it ever really suffered a caesura.

At Karlštejn castle the fictitious *Family-tree* leads from legendary and mythological characters and Old Testament figures to Charles IV and his wife, referred to as Blanche on a copy. All members were depicted as sitting and standing figures, some of whom formed counterparts. In all likelihood they were placed between the painted arcades. At least this is true of the existing *Relics Scenes* in the Lady Chapel, which also appear in copies but without their architectural setting. The figures in the *Relics Scenes* and the *Family-tree* had been given pedestals by the Renaissance copyist, which removed them from their original setting. The painter had a remarkable knowledge of Franco-Flemish painting of the Pucelle tradition. He had mastered a great many motifs of movement, was able to apply considerable characterisation, and managed to express roundness of volume and the relationship between body and garments, covering an uncertain construction of the anatomy. Marks of French calligraphy still survived but the form was softer, irregular, spontaneous, dependent on the momentary situation. This empiricism involved a good deal of visual observation; it was a radically new development which moved painting

ahead of the abstract linearism of the preceding period. Here we have the beginning of the road that led to relative form, conditioned by time and space.

The times favoured the development of individual portraiture, and this was fostered enthusiastically by the Court of Prague. The oldest examples we have, even though preserved only in copies, are the portraits of the Emperor and Empress in the *Luxembourg Family-tree*. The likeness is verified, in particular, for the figure of Charles IV, portraits of whom have survived in considerable number. As the *Family-tree* came into existence in the years 1355–1357, the Emperor's portrait is almost contemporary with a panel painting showing John the Good. A liking for portraiture was one of the Emperor's many passions. He encouraged it on every possible occasion, proving his understanding of contemporary currents in art, as revealed also in other fields. In the Lady Chapel and the chapel of St Catherine in the Church Tower at Karlštejn castle there are no less than five of his portraits and originally there may have been even more. His wives, too, appear several times. Charles IV is shown four times with relics, which he collected passionately. A reason for this might be explained by referring to the likely original purpose and consecration of both the chapels. According to A. Friedl,[91] the Charter issued by Charles IV (1357), establishing a canonical chapter to administer the chapels of the Relics of the Lord's Passion and of the Virgin Mary refers to today's Lady Chapel and that of St Catherine respectively. The wording of the Charter, according to which the smaller Lady Chapel was adjacent to that of the Relics, fully corresponds to the ground-plan. The iconographic programme of the mural paintings in these two chapels conforms to this explanation. Several paintings include references to the Relics of the Lord's Passion, among them, in the Lady Chapel, the *Relics Scenes* in which Charles accepts the relics from two kings and deposits them in a magnificent reliquary in the shape of a cross. One of the kings was John the Good, whose place on the real occasion was taken by the dauphin, the subsequent Charles V, so that he might be one of the persons depicted (the other king has not been identified with certainty so far); the walls and vault of the south-west window niche which contain the *Marian and Christological Cycles* of small scenes of the *Resurrection*, *Descent into Hell*, the *Descent of the Holy Spirit*, and the *Death and Coronation of the Virgin Mary*. In the chapel of St Catherine, half-length portraits above the threshold show the Emperor Charles IV and the Empress Anne of Swidnica, with a cross of a similar though not identical shape as the one in the *Relics Scenes*. In addition, in the chapel of St Catherine there is the *Crucifixion* altar frontal, and a votive painting of the *Madonna in Majesty* worshipped by the kneeling Emperor and Empress in the recess above the altar, which makes the original consecration of this chapel to the Virgin highly likely. On the north wall of the chapel of St Catherine are the *Seven Patron Saints of Bohemia*. Only their heads are visible for the walls of the chapel were later covered with polished semi-precious stones hiding their bodies, and there were perhaps also other, today unidentifiable, pictures. In the Lady Chapel the remaining walls are covered with scenes from the *Apocalypse*. They have survived only along the east, south and west walls. There was also a strip of paintings along the ceiling, the themes of which can be recognised only from the few remaining inscriptions. We know, also, that above the left *Relics Scene* there was a painting of the *Trinity* with Charles and his first wife Blanche in adoration. On the west side there were the Prophets and Apostles, among them Queen Anne of the Palatinate and Empress Anne of Swidnica, the Emperor's second and third wives.

These paintings were not all produced at the same time, nor by the same painter. The uneven state of preservation makes identification of the painters a very difficult task. But it would seem that the method initiated by the master who painted the *Luxembourg Family-tree* was continued, in the Lady Chapel, in the *Relics Scenes* and the scenes from the *Apocalypse* paintings on the south and west walls; and in the chapel of St Catherine in the portrait-busts of the Emperor and Empress, the votive painting of the *Virgin* above the altar and those of the seven patron saints of Bohemia. The similarity is best seen in the *Relics Scenes*, which are close to the *Family-tree* in subject-matter as well. The paintings are in bad condition, and since we only know the *Family-tree* from Renaissance copies any detailed comparison is difficult. Nor can definite conclusions be drawn. The same is true of the portrait-busts in the chapel of St Catherine. However, the heads of the seven saints in this chapel show distinct Italian influences, which do not appear in other paintings in this group, and are reminiscent of Bohemian panel painting from the middle of the century. This resemblance is particularly striking in the *Madonna in Majesty* in the same chapel where the rhythmical folds of the garment have much in common for instance with the *Madonna of Klodzko* (Glatz). Yet the head of the St Catherine *Madonna* shows stronger Italian features and the votive portraits of the Emperor and the Empress in this painting are more individualised than was usual in the circle of the Master of Vyšší Brod. The man who painted these pictures may have had close links with the painters of the panel pictures, if he was not, in fact, one of them.

Another Italian trait is the terraced colonnade below the *Relics Scenes*, which gives the illusion of enlarging the interior of the chapel and stresses the spiritual meaning of the paintings above. The playful treatment of perspective is in striking contrast to the comparative flatness of the *Relics Scenes*. It may have been the work of an Italian specialist.

The scenes from the *Apocalypse* on the west wall of the Lady Chapel are of a different character. Here we have a depiction of the *Woman Fleeing from the Dragon into the Wilderness* and the *Woman Clothed with the Sun*. In the first of these two pictures the highly fantastic story is depicted with great decorative effect, and the rich landscape scenes serve to enhance the spiritual meaning of the painting. The second painting, together with other Madonnas made in the Court studio, exerted an influence on the Bohemian type of the Virgin, at the time and for a long time to come. Similarly, echoes of the fantastic landscape in the former picture can be found in the work of the Master of Třeboň. The softly flowing form, hiding the transitions between individual parts, the endeavour to use figures from every-day life, and the emphasis on colours being changed by light, make these paintings comparable with incunabulae

of the soft style, a feature which prevailed in Czech painting for several decades.

Painting seems to have been interrupted once the scenes from the *Apocalypse* on the west wall of the Lady Chapel were finished. Probably the studio was given other jobs, mainly decorating the cloisters in the Emmaus monastery. It is generally assumed that before proceeding there they painted several pictures in the chapel of the Holy Cross in the Great Tower at Karlštejn. If this is true, chronological difficulties arise, if we take as proven that today's Lady Chapel and chapel of St Catherine (originally called the chapel of the Relics of the Lord's Passion and the Lady Chapel) were consecrated in 1357. If the earlier paintings in these chapels were mainly produced before the consecration in 1357, which is highly likely, especially in the case of the chapel of St Catherine,[20] how can one date the paintings by that studio in the chapel of the Holy Cross when it was not consecrated until 1365? If today's Lady Chapel were originally the chapel of the Relics of the Lord's Passion, this could have been so only on condition that the Great Tower had not been built at the time. For it can hardly be assumed that the chapel would have been adorned with paintings if the chapel of the Holy Cross in the Great Tower, which was to take over its function, had already been completed. The paintings in the chapel of the Holy Cross were probably made just before its consecration. It would, therefore, seem likely that the studio of the Master of the Family-tree worked there only in the years just prior to 1365 – on the assumption that the Lady Chapel was originally that of the Relics of the Lord's Passion.

In the chapel of the Holy Cross there is an extensive mural painting of the *Twenty-four Elders Worshipping the Apocalyptical Lamb*, and five drawings representing busts of saints, which were perhaps intended to test the layout and effect of subsequent panel paintings. The drawings have sketched-in frames, suggesting that panel paintings, which were later actually made, had indeed been planned from the very beginning. The skilfully made charcoal and brush sketches of SS Peter, Paul, Andrew, John the Baptist and a holy bishop have been attributed both to the Master of the Luxembourg Family-tree and to Master Theodoric. But it is not certain whether they were all made by one and the same master. On the one hand, the busts of Peter and Paul reveal restrained volume drawing; on the other, there is a soft, almost Baroque-like form, with robust features, used to portray SS Andrew and John the Baptist. The differences are too considerable for all these busts to be the work of one artist. (It should be said that none of these sketches was ever realised.) Perhaps we are witnesses here to some kind of competition held to single out the most suitable painter to carry out the decorations in the chapel, which is perhaps continued on the vault of the left window recess. There, facing each other, are an analytical linear painting with dramatic movement of the *Adoration of the Lamb* with features resembling the *Luxembourg Family-tree*, and the static form of the *God of the Apocalypse*, which is very close in character to the work of Master Theodoric. The skill at characterisation, which appeared only on individual figures by the studio of the Master of the Family-tree, is applied to the entire narrative scene in the *Adoration of the Lamb*, though the crowd is just a grouping of different individuals. The use of two angles of vision and the endeavour to link visual truthfulness and clarity weakened the illusion of space. But the painter's ability to depict individual objects was given full range here.

Once the decision on the ornamentation of the chapel of the Holy Cross had been taken and the job entrusted to Master Theodoric, radical changes were made to today's chapel of St Catherine and the Lady Chapel. The new and expensive alterations were probably due to the change in the purpose of the two chapels now that the function of the chapel of the Relics of the Lord's Passion (today's Lady Chapel) had been transferred to the church in the Great Tower, usually called the Chapel of the Holy Cross. Alterations were carried out especially in today's chapel of St Catherine (previously the Lady Chapel), which was turned into the Emperor's private oratory. The walls were encrusted with polished semi-precious stones which covered up part of the paintings that had been there before. A new workshop was commissioned to do the painting. They made the *Crucifixion* on the altar frontal in the chapel of St Catherine, and an extensive cycle of scenes from the *Apocalypse* in the Lady Chapel, only a part of which has survived on the east wall.

The painter, or painters, may have studied the art of the Master of the Family-tree, but they had different aims. Instead of a monumental layout we find a series of isolated pictures mechanically placed side by side, which in narrative tone and compact composition are reminiscent of panel or book painting. This is particularly true of the upper strip of Apocalyptical paintings, while the lower strip is conceived with more grandeur and is more ingenious in its layout.

The form of the figures remains rather stiff, whereas the landscape sections are freer. The fantastic views of crumbling towns gave the painter a chance of depicting not only disintegration of matter, but also frightening light effects. A loosely handled brush created improvised high-lights, for instance on the faces of the old men and the masks of voices from space. Sometimes colours brightened almost to white. But line drawing remained the substance of shape and layout. This has survived especially well in the carefully executed *Crucifixion* in the chapel of St Catherine, where the resemblance to panel and book painting is very striking.

The art of the Master of the Family-tree, which in the chapel of St Catherine and the Lady Chapel was replaced by the work of the studio of the Master of the Crucifixion, has a continuation in the second outstanding cycle of fourteenth-century Czech painting: the extensive typological cycle of mural paintings in the cloisters of the Emmaus monastery. There, events from the life of Christ are accompanied by parallel events from the Old Testament. They cover the enormous wall surfaces of the extensive cloisters. Only parts of them have survived, most of them in rather a poor state. But even these parts form one of the most extensive cycles of paintings from that time in Central Europe. The parts that exist in a sufficiently good condition give a fairly reliable idea of the original state. The painters did not use one style. In the south wing, devoted to history before the birth of Christ, all the figures are slim

with a linear rhythm. They stand side by side, or facing each other in shallow space surrounded by void. The impression of depth is created by complex architecture, whose construction and spatial effects cannot be conceived without lessons learnt from Italian examples.

In the west and south wings the character of the paintings is different. This is only partly due to the fact that the stories from the life of Christ and their Old Testament parallels could be told in greater breadth. But what is more important is that each scene is set in depth as a visual reality, where space is created both by the architectural and natural setting as well as by the figures. These figures dramatically express their participation in the event taking place. Furthermore, they act as space-creating elements in the composition, and individually or in groups form an impression of depth. The calligraphic tradition is not entirely forgotten. It re-appears in the preparatory sketches. But it is hidden from view by the endeavour to depict the natural form, independent of linear design. The paintings in the east wing, depicting *Christ's Passion*, are hopelessly damaged. Nonetheless it is clear that their painter was an outstanding individual who must be distinguished from the other painters who decorated the cloisters. Voluminous figures and objects, shown with a surprising knowledge of perspective, fill the area of the pictures and are the only space-creating elements.

There are certain principles that the first and second group of paintings in the Emmaus cloisters shared. They may indeed both have been made by the same studio led by two main masters. But the third group belongs elsewhere. Striking similarities have been discovered between the paintings in the south, west and north wings of the Emmaus cloisters and the work of the studio of the Master of the Family-tree at Karlštejn castle. So much so that, in all likelihood, it can be assumed that they were made by the same circle of artists. No such links, however, exist for the work in the east wing.

But even the identification of the Master (or masters) of the Family-tree with the Emmaus monastery painters presents problems. The Italian aspects, which at Karlštejn appear mainly in the accompanying decorative parts and affect the main scenes of the works only in rare cases, were applied far more freely at Emmaus. It is more than likely that the painter had come under the direct influence of Italian art. If we accept the thesis of the identity of the two workshops, two explanations may be offered: either between work at Karlštejn castle and the Emmaus monastery the painter concerned had come into direct contact with Italian painting – this involves a certain lapse of time – or the influence of an Italian working in the Czech Lands made itself felt here. It is known that Tomaso da Modena supplied Karlštejn with a triptych of the *Madonna, St Wenceslas and St Palmatio*, sited in a place of honour in the chapel of the Holy Cross, and a diptych of the *Madonna with the Man of Sorrows*. One might, therefore, easily assume that the painter visited the Czech Lands and left a mark on the development of painting in the Court workshop. But there is no proof of this, even though Tomaso's mural paintings in the Museo Civico at Treviso show certain common features with the Emmaus paintings.

At the beginning of the sixties, when the Emmaus cloisters probably acquired their ornamentation, thoughts turned to the fittings of the chapel of the Holy Cross at Karlštejn castle that was to hold the Imperial and Bohemian crown jewels. The chapel was consecrated on February 9, 1365. At the time, the decoration of the chapel must have been finished, or at least the major part. The magnificence of the decoration corresponded to the significance of the chapel, in which the whole idea of the castle construction found its culmination. The lower parts of the walls were inlaid with polished slabs of semi-precious stone, linked with golden stucco and forming repetitive patterns of the cross. (In the chapel of St Catherine, now the Emperor's private oratory, they formed the pattern of shields.) Above the semi-precious stones the whole surface right into the vaulting was covered with 129 panel paintings, busts of male and female saints: Christ's Army. In spiritual content and geometrically, their centre rested in a vertical strip above the altar and the recess enclosed with railings that contained the relics and insignia. Here, above the triptych by Tomaso da Modena, is a tripartite painting of *Christ at the Sepulchre* with angels and the three Maries. At the top of the wall there is a large panel with the *Crucifixion*.

The panel paintings are supplemented with murals on the vaulting of the window recesses depicting besides the *Adoration of the Lamb* and the *God of the Apocalypse* (which have already been discussed), the *Annunciation*, the *Visitation*, the *Adoration of the Magi*, *Christ in Bethany*, *Christ in the House of Simon*, the *Raising of Lazarus (?)* and *Noli me tangere*. Gold-lined glass lenses were fitted into the richly gilded ceiling to represent the heavenly bodies.

The architecture of the chapel is quite simple. It is divided into two compartments of cross vaulting separated into nave and choir by a gilded ornamental lattice. There were hardly any stone ornaments. Nothing was meant to disturb the unified impression of colour, where the gold as predominant feature created a solemn atmosphere. Along the walls in monotonous rows hang the rectangular panel paintings. They convey a feeling of immobility, which is intensified by the low vaulting. The emphasis on the horizontal prevents the vertical forces from making themselves felt. Not even the vaulting ribs themselves have the effect of a dividing element. They are covered in gold stucco, as are the frames of the pictures which otherwise might have added rational articulation into this non-articulated space. The gold ornaments on the frames merge without indication of borderline into the area of the pictures proper. Similarly the actual painting overlaps the frame and denies its limiting function, which is today more clearly noticeable on account of the darkening and the disappearance of the gold ornaments. It would be difficult to find a Gothic interior in which this desire for unity is expressed more clearly. But this is not actually a Gothic interior at all. The stress on the horizontal, the robust proportions, the emphasis on frontality and its separation from the rest of the world give it a very archaic character. This interior, as if carved out of the walls, has little in common with rational Gothic articulation. However, the painted and other ornaments counteract this solidity and the predominance of gold fills the room with a strange light.

The exceptionally unified conception of the ornaments was in full harmony with the character of the architecture. Undoubtedly it was the work of one artist. Charles IV's Charter of 28 April 1367 shows that this artist was a 'Magister Theodoricus, pictor noster et familiaris', who decorated the chapel 'skilfully and ingeniously' and as a reward was granted a privilege at his country estate at Mořina. This is the only authentic person to whom paintings at Karlštejn castle can be safely attributed, apart from Tomaso da Modena. There are no records that point to the activity of the royal painter Nicholas Wurmser of Strasbourg at Karlštejn castle. Another of Charles IV's painters, Osvald, is mentioned only in connection with St Vitus's Cathedral. It is, of course, quite possible that both of them did work at Karlštejn. On the other hand, we possess quite a number of records of Master Theodoric. In 1348 he was mentioned as *primus magister* at the Prague brotherhood of painters, and in 1359 he owned a house at Hradčany in Prague. At that time he was called *malerius imperatoris*. He still owned the house in 1368. Whether he is identical with Theodoric Zelo, mentioned in the Hradčany municipal records of 3 October 1359 is uncertain, though possible. He was evidently a highly respected and successful man. When he was commissioned to decorate the chapel of the Holy Cross at Karlštejn castle sometime before 1365, it must have been the climax of his artistic career.

It has already been pointed out that on the vault of the left window recess of the chapel of the Holy Cross there can be found, facing one another, two mural paintings of very different character, which, perhaps, were samples to decide who was to be given the task of carrying out the decoration: the *Adoration of the Lamb* and the *God of the Apocalypse*. The differences between them suggest two distinct programmes. The painter of the former picture gave a more detailed and more mobile depiction of the event, while the painter of the latter picture gave it an expression of changeless duration. The *Adoration of the Lamb* could have been depicted in a state of immobility and yet the painter has chosen an assymetrical, dramatic composition which relies on its descriptive content. By contrast to this analytical style: detailed, precisely defined, characterised, the painter of the *God of the Apocalypse* used a central, symmetrical composition in which everything was subjected to the main idea of the God Enthroned. The impression of finality and permanence is created by the short proportions, mighty volume, simple outline and strict frontal posture. Great differences can also be observed in the treatment of colour and light. While in the *Adoration of the Lamb* the colour is varied and stresses the linear articulation, and the light provides modelling (even though not consistently) thus contributing to the differentiation of objects, in the other picture colour seems to be dissolved by light and its defining function is thus weakened. The form is less definite, softer and gentler. Light plays a dual role here. It models the matter and is a quality of colour radiating from within. The greatness of Master Theodoric can best be seen on three other wall paintings which can almost certainly be attributed to him. They are also in the chapel of the Holy Cross. They are the *Annunciation*, the *Visitation*, and the *Adoration of the Magi* in the east window niche. Here it is clear that Master Theodoric

did not stand aloof from contemporary interest in realism and in this respect he can be compared with the Master of the Family-tree. In all likelihood he was stimulated by the latter's work, although he nevertheless made thorough changes. The figures, for example on the *Adoration of the Magi*, are clearly characterised in movement and expression in spite of their compact, simplified and softly merging forms. The painter also made use of the period liking for the commonplace and the ugly. It seems that he even made some attempt at portraiture, for the second king in the *Adoration* truly resembles the portrait of Charles IV. The sturdy figures in the *Adoration* act normally in an environment which corresponds to their status. Mary sits in the stable on an ordinary mat, dressed in simple garments, while St Joseph warms his hands over the hot brazier. The Christ Child, secure in his mother's arms, makes natural movements. Nevertheless, the scene makes an unreal impression. The bulky shapes seem strangely weightless. The reason is partly the unnatural colours which appear faded by some inner light, and partly the soft cotton-wool shapes which lack solidity. Mostly, however, it is due to a lack of feeling for spatial relationships. The concept of space as a contradiction of solid matter does not exist here. The picture was not meant to be a representation of reality, as aimed at by Italian, Western European and Czech painters.

The difference is shown clearly by a comparison of the Karlštejn *Adoration* with the *Flight into Egypt* at Emmaus, both of which are the most beautiful pictures of motherhood to be produced in the fourteenth century. At Emmaus we have an image of reality framed by the wall rib and inscription, and objects are given in a certain spatial relationship, however experimental and uncertain. At Karlštejn they are set in an entirely uncertain and undefined space. It is indefined, unlimited and homogeneous in the sense of being only quantitatively distinguished from solid objects. There is no borderline between pictorial space and the cosmic space of the heavens, and the glass stars of the sky-vault take a direct part in the event; their material form provokingly contrasts with the delicate colour scheme of the painted parts. The golden crowns, the haloes and the gifts are also shown in solid relief, omitting any signs of spatial relationships. They are depicted – like objects in Cubist pictures – in their absolute concreteness and solidity, undisrupted by the technique of perspective. Like the unlimited space and the inner light, this stress on the value of materials symbolising spiritual values is a remnant of or rather a return to the early Middle Ages.

The other scenes in the north-east window recess are executed in a similar way, as are the mural paintings in the south-east window. Here the unreality has advanced to a point where the figures have lost their robust appearance and are becoming elongated. Their environment has lost even more of its concrete reality. Whether these pictures were also by Master Theodoric or whether they were the work of some of his assistants who later worked at St Vitus's Cathedral (together with their master) is impossible to decide in view of the bad state that the paintings are now in.

This uncertainty does not concern the 129 panel paintings which cover all the four walls of the chapel of the Holy Cross and

which form an important part of the painted decoration. There can be no doubt that they were all made by Theodoric and his assistants. The monotonous series of half-length figures is subdivided by broad right-angled frames. But this rational layout was, as has been said, greatly weakened by the gold ornaments of the frames and pictures. The figures seem to float in the undefined space of the gold background. The only exceptions are the paintings above the altar, which are of a different size, are placed differently, and among which is the *Crucifixion*, the only picture in the whole collection which has a painted background. As in the mural paintings, the number of persons is reduced here to a minimum and their voluminous forms almost completely cover the surface. Only a small heap of earth around the foot of the cross is slightly distinguished from the neutral background which is otherwise meant to be non-optical infinity. The ugly, robust figures, with their lack of charm have no line drawing and their merging shapes can only barely be distinguished from the setting. This brought about a strange synthesis of the old and the new. The mighty volumes of the figures had no balance in the space in which they were set. The expressive characterisation of the ugly face of Christ and his shapeless body is not balanced by a depiction of the environment in which this realistic, suffering man was to be found. The neutral background is not a limit but unlimited depth. Italian influences, which can be felt here, were transformed in a spirit that had a certain affinity to Early Christian and Byzantine art.

A similar contradiction of means and meaning, the temporary and eternal, the relative and absolute, the human and the divine, is also typical of the half-length figures of the Army of Christ. These figures with their mighty, motionless, unarticulated volume painted with broad strokes of the brush, were not all painted by Theodoric in person. The immense task was almost certainly executed in great haste, and could not have been achieved without the aid of assistants. The quality of the painting fluctuates, and several pictures show that the master's example was reproduced without great exertion. After all, the painters relied on the works being seen from a distance, which encouraged brief execution. At the same time the free manner of painting is an expression of attitude: colour and not line was the main means of expression on these paintings and the work aimed at the overall colour impression, and not details. Many of these figures are simply variants of a few types. Several of them show a desire for great individualisation, which brings them close to individual portraiture. This can mainly be found – as usual – on the male figures. Some of the saintly Benedictine abbots, the Church Fathers and the Holy Popes are close to portrayal of individuals. The hands, too, are executed with a great deal of analytical description. This shows no less where a fragmentary background expresses the religious significance of the saint, as in the case of the Church Fathers. There, instead of the usual attributes we can find scribe's desks or lecterns with books and writing implements, given with surprising visual truthfulness, which strangely contrasts with their lack of spatial anchorage. Pieces of solid visual reality are torn out of their natural setting and in spite of being realistic become symbols removed from their environment, just as the

bulky figures that overlap the frames float in the unlimited glow of the golden ornaments.

Moreover, their three-dimensional volume is broken down by the flat application of the gold on the garments. With this decoration they belong to a different category of artistic means which does not take account of the realistic effect of the painting. The shields, which mark St Wenceslas and other saintly rulers, are not even painted, but carved out of special pieces of wood and attached to the paintings. This material verity denies all optical illusion. The impressive volume of the painted objects contrasts with the absolute flatness of the background, which is no other than undefined infinity. The penetrating description of individual objects rejects all relationships. All these features indicate that here two profoundly differing approaches were running counter: one was firmly rooted in medieval thinking whose prerequisite was the eternal and unchanging world of ideas. The other, starting from knowledge of individual, divergent objects, pointed to the future, but not the immediate future, for it brought to Europe and in particular the Czech Lands a new wave of Gothic, which rejected the rational explanations of the material world. The irrational features of Theodoric's work are a precursor of this change.

In order to give a comprehensive idea of the paintings that adorn Karlštejn castle, mention has to be made of those in the palace chapel of St Nicholas (sv. Mikuláš). We know their subject matter but the paintings as such, except for a few fragments, have disappeared. In addition, an extensive cycle of paintings of the life of SS Wenceslas and Ludmilla covers the walls of the staircase in the Great Tower leading to the chapel of the Holy Cross. As everywhere else, Charles did not forget his Přemyslide ancestors. The cycle has been spoilt by 'restoration' in the nineteenth century, so that its present state can only partially convey the character of the original paintings. Even so it is clear that it was the work of masters who managed to depict the narrative in a profound, natural and architectonic setting, using Italian art as their jumping off point. The analytical method of their work brings it close to the Karlštejn paintings connected with the Master of the Luxembourg Family-tree. The closest parallel are the paintings in the cloisters at Emmaus. There are remarkable landscape pictures in the window recesses which, in spite of their unreality and stylisation, are significant for the future.

In the Court workshop two currents were being fostered which ran closely parallel and probably mutually influenced each other: one, with the Master of the Family-tree as the leading figure, followed descriptive, analytical realism. The other, under Theodoric, aimed at synthetic, unified, pictorially undefined form, which derived from Northern realism and Italian volume, but rejected all attempts at justification of relationships and set fragments of visual reality into the shapeless fluid of unlimited space and time. This was the beginning of a process which meant a retreat from the positions both of naive Northern descriptiveness and the rational Italian organisation of the visual world. This process continued in various forms until the first half of the fifteenth century.

Though we are quite well informed about the Emperor's Court painter Theodoric, we know nothing about the other

painters who decorated Karlštejn castle and the Emmaus monastery. Attempts to attribute certain parts of the paintings to Nicholas Wurmser do not go beyond conjecture, since there is no proof of his participation in the work at Karlštejn. The Master of the Luxembourg Family-tree, who, it seems, headed a workshop of painters using different styles, has remained anonymous. He was, in all probability, a painter who had been summoned by Charles IV from the West, from an area where the Pucelle tradition came into contact with realistic trends from the Netherlands. The analysis of the Emmaus paintings suggests that there may have been two painters (as has been convincingly shown by Stejskal).[21] If not they personally, then their assistants must have also come into direct contact with Italian painting.

The Court workshop did not close down once the work at Karlštejn and Emmaus was over. The members were employed at other buildings erected by Charles. Here time has played a cruel trick. In Prague Cathedral only faded fragments of painted decorations have survived. The main artists here, as recent research has shown, were Master Theodoric and probably also Master Osvald, the third painter working under Charles, who is known by name.[22] He must have been an outstanding personality since he was granted the honour of being buried in the Cathedral. As far as we know, only the first architects of the Cathedral were given this honour.

The process we have been able to trace in mural paintings by the Court studio was paralleled, to a certain extent, in panel painting. Here we can trace the rapid disintegration of the linear style, beginning with the *Descent of the Holy Spirit* on the *Vyšší Brod Altarpiece*. The softening of form and the gradual relativisation of colour shows more clearly on the *Madonna with SS Catherine and Margaret* (Hluboká Gallery), where together with the light effects we find more common types. Calligraphic tendencies – particularly on the minor figures – have not been fully overcome and the Italian inspiration of the paintings is still noticeable.

A more radical transformation of shape took place on the small *Madonna of Rome*. The Vyšehrad *Madonna* likewise belongs to this group; it introduced to the Czech Lands the Italian type of 'Madonna del Umilta'. The Italian inspiration is also visible in the unusual growth in volume and in the Madonna's face. In spite of certain calligraphic features the firm enclosed shape is, likewise, of Italian origin.

The transformation – perhaps one might call it Bohemisation – of painting advanced considerably in a group of three small pictures which are closely related. The Boston *Madonna* (Boston, Museum of Fine Arts), follows up the type of the *Madonna of Most*, but modifies it in a characteristic manner to reveal changes then taking place in Czech painting: the symbolic motif of the bird has been left out and has been replaced by play with a veil. The position of the Christ Child has assumed a spontaneous, easy character. Mary's face has lost its solemnity based on Byzantine features and all the gold ornaments on the Virgin's garments have been omitted. Shape is simpler, more natural and also softer. This shift from solemnity to natural appearance is typical of painting in the third quarter of the fourteenth century. The feature of charm that accompanies it

is closely linked with the local setting. It was to have a great future in the Czech Lands even after the trend towards spontaneity had been rejected. As in many other Czech pictures of the time motifs were being introduced which, around 1400, appeared in a new context: for instance, the manner in which Mary holds the Child. Later this became an established feature of a certain type of painted and sculpted Madonna.

The trend towards more human features, and a more popular interpretation of the religious story is characteristic also for the *Morgan Panels*, particularly the *Adoration of the Magi* (Morgan Library, New York). The mighty, unarticulated, sack-like figures dressed in soft, irregularly gathered garments, fill up the whole area of the picture. The faces are strikingly individualised, and one of them, the second king in the cloak adorned with eagles, has features not unlike Charles IV himself. This picture presumably came into being around 1360, approximately ten years after the painting on the same subject in the Vyšší Brod cycle. And yet the difference between the two is enormous: the solemn atmosphere has been altered to one of human intimacy. The abstract linear stylisation has given way to visual relationships between objects. The whole concept of the picture indicates that the scene was depicted as it might be seen by a spectator: as a visual perception, unaffected by rational considerations. The painter did not aim at absolute clarity but at an impression of a fortuitous event. It is certainly no accident that this event took place in a landscape where the shepherds once heard the joyful message. The painter had, however, no sense of rational composition of space and treated spatial relationships without much care. He was more interested in a unified visual impression.

This becomes even clearer in the second of the pictures, the *Death of the Virgin*, where the symmetrical design weakened the drama of the event. Although it can hardly be doubted that the *Morgan Panels* are related to the *Death of the Virgin* from Košátky, there is a very radical turn away from the rational Italian construction of space. It is interesting to see how Italian gesticulation was limited and how the spiritual event was reflected on the faces. A similar transformation is typical of the *Death of the Virgin* in the *Liber Viaticus* of John of Středa, which otherwise is one of the most Italian of manuscripts of the time.

The *Morgan Panels* bring us close to the work of the Court workshop and its achievements at Karlštejn castle, the Emmaus monastery and St Vitus's Cathedral. It is, therefore, not surprising that the identification of authorship pointed to one of the workshop members: the Master of the Family-tree.[23] And, indeed, it is highly likely that the dividing line between mural, panel and book painting was easily surmounted at that time. Yet the attribution is not indisputable. In particular, the lack of feeling for spatial construction and the complete dominance of figures over the physical setting make it difficult to attribute these little pictures to the Master of the Family-tree, who, as we saw, had great mastery of spatial differentiation. The nervous drawing in the substratum, noticeable especially on the picture of the *Death of the Virgin*, differs from the vigorous, flowing drawing derived from the French calligraphic tradition, used by the Master of the Family-tree.

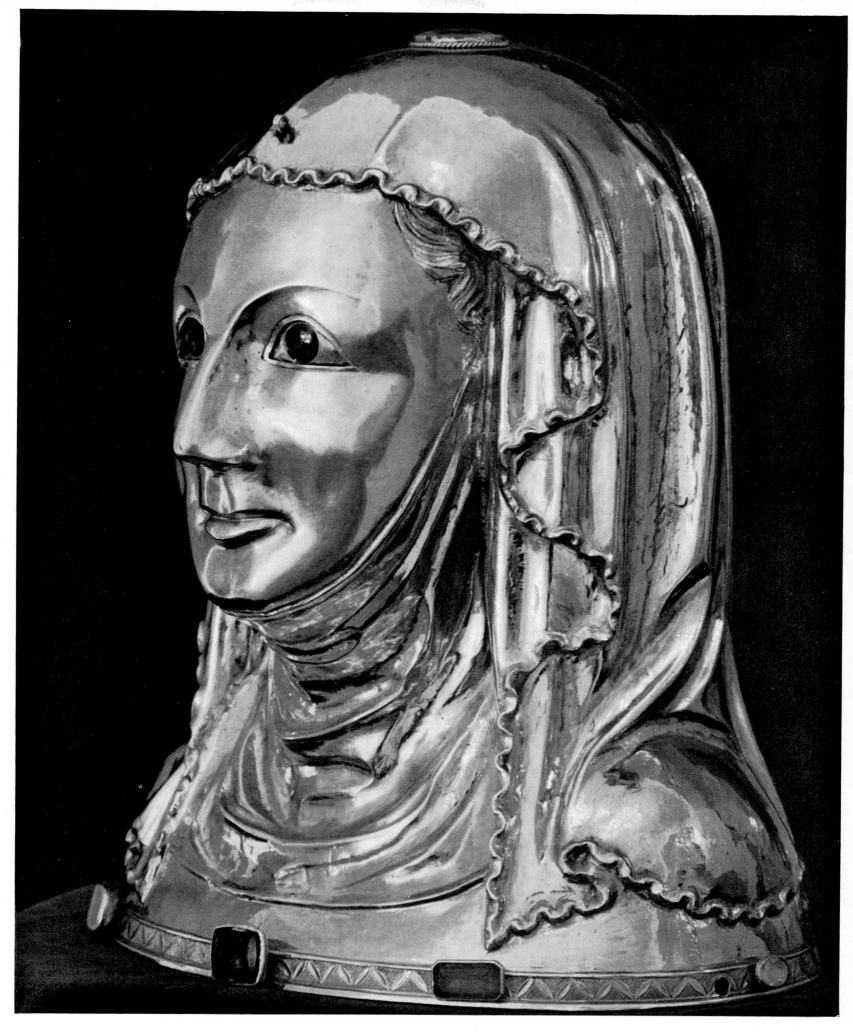

35 *Bust of St Ludmilla. After 1350. Wrought and gilded copper. h. 35 cm. Treasury of St Vitus's Cathedral, Prague*

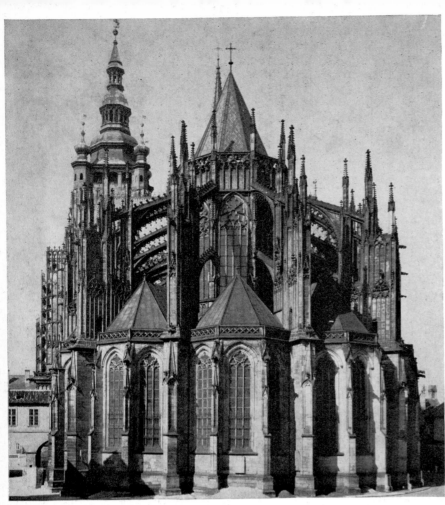

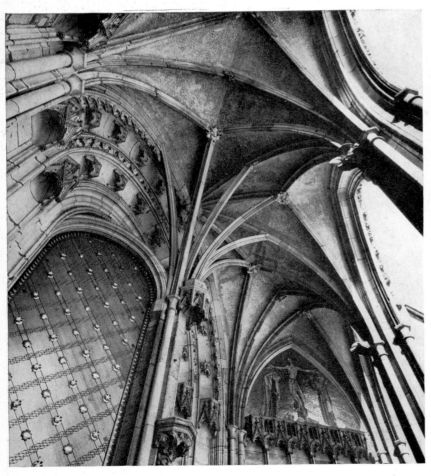

37 St Vitus's Cathedral, Prague. Vaulting in the south porch. Peter Parler. Before 1368

36 St Vitus's Cathedral, Prague. Presbytery. Matthias of Arras and Peter Parler. 1344–1385 ◄

39 St Vitus's Cathedral, Prague. Presbytery. Matthias of Arras and Peter Parler. 1344–1385 ►

38 St Vitus's Cathedral, Prague. St Wenceslas's chapel. Peter Parler. Before 1367 ▼

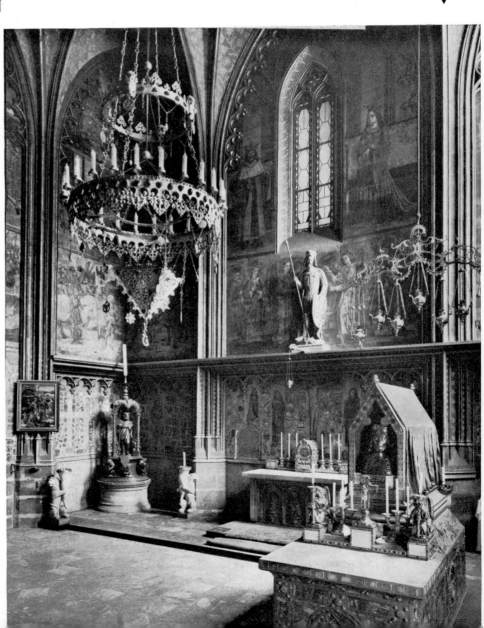

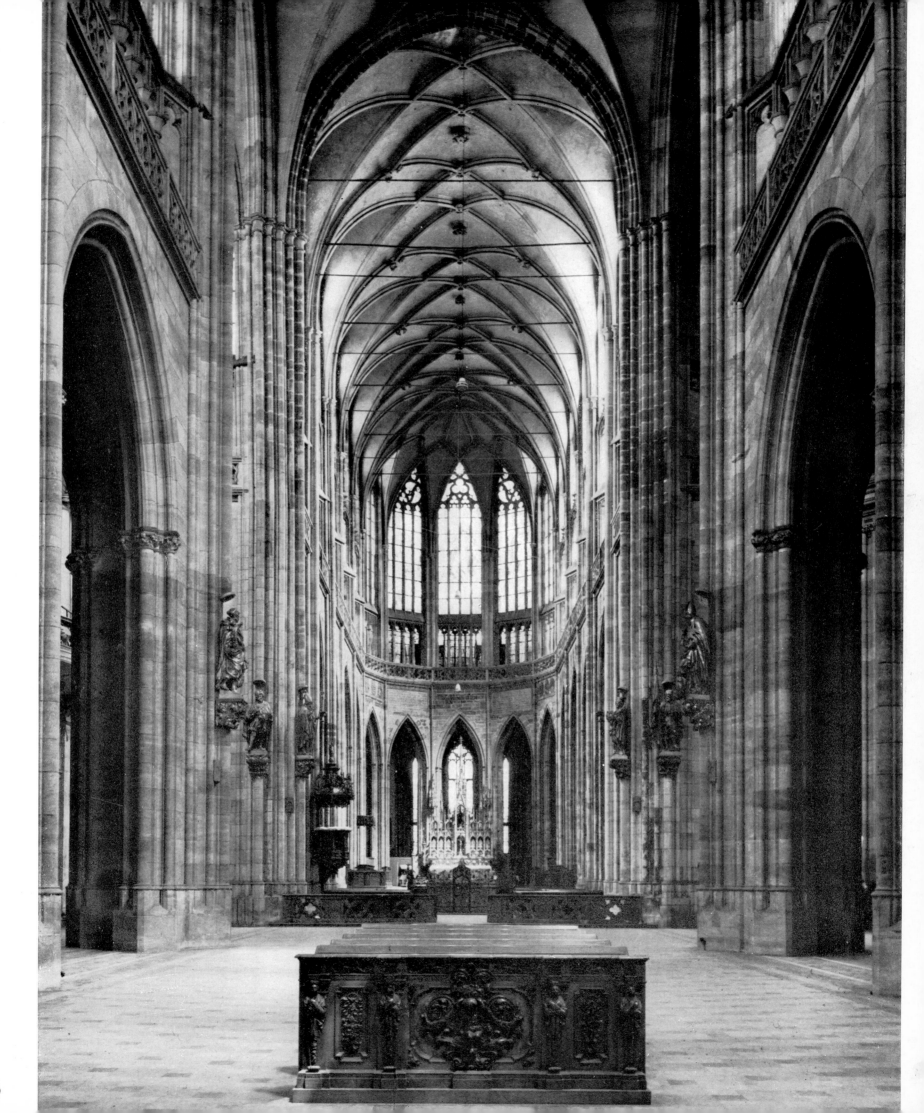

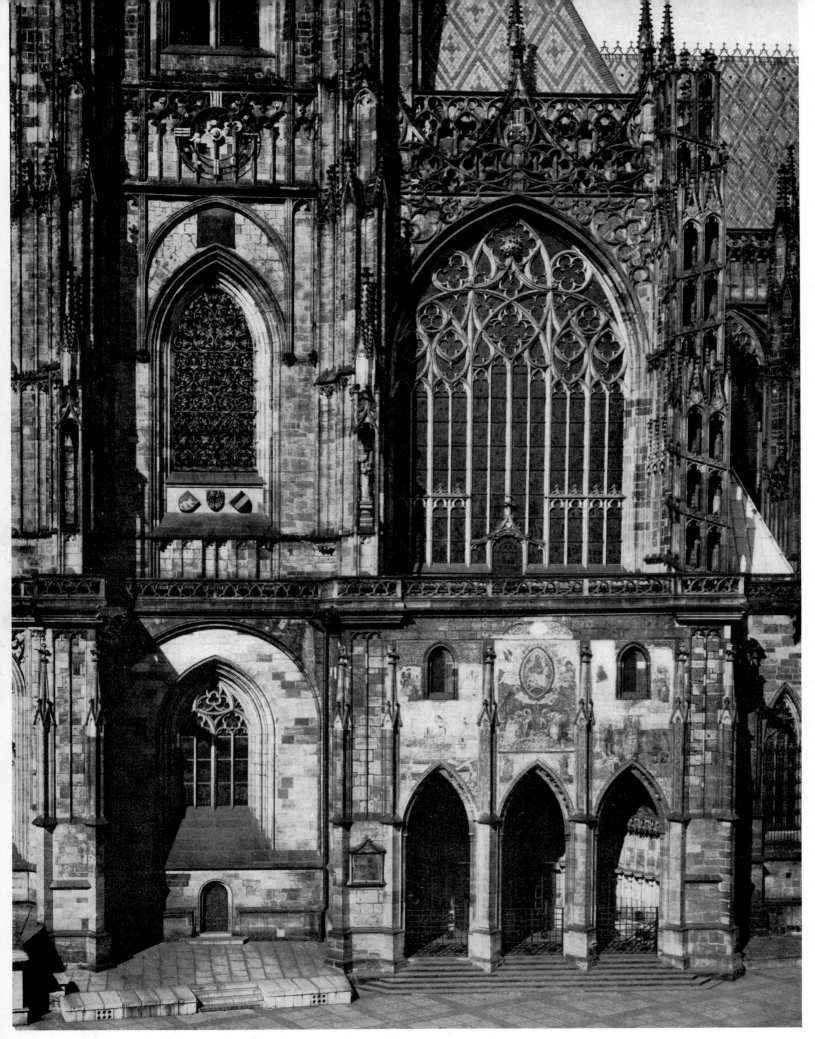

40 *St Vitus's Cathedral, Prague. South façade.*
Second half of the fourteenth century

41 *St Vitus's Cathedral, Prague. Detail of mosaic on the south porch. 1370–1371*

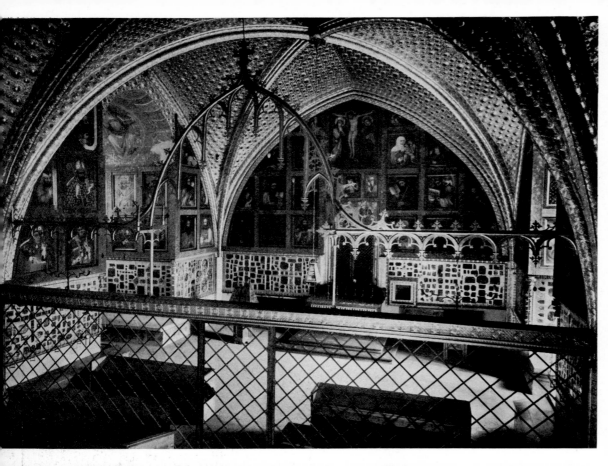

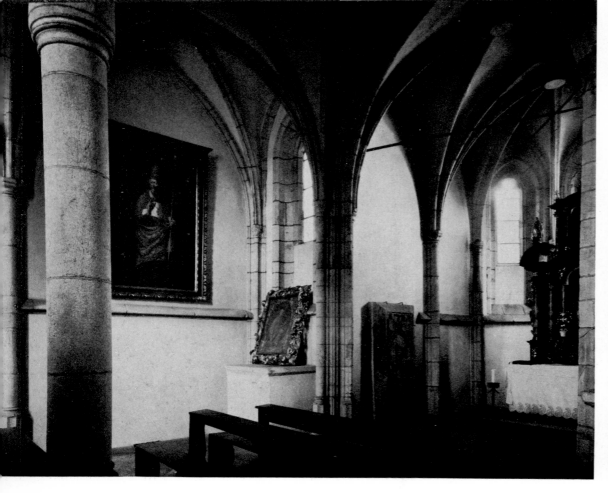

42 Karlštejn castle. Chapel of the Holy Cross. Before 1365

43 Church of St John, Jindřichův Hradec. Chapel of St Nicholas. Before 1369

72

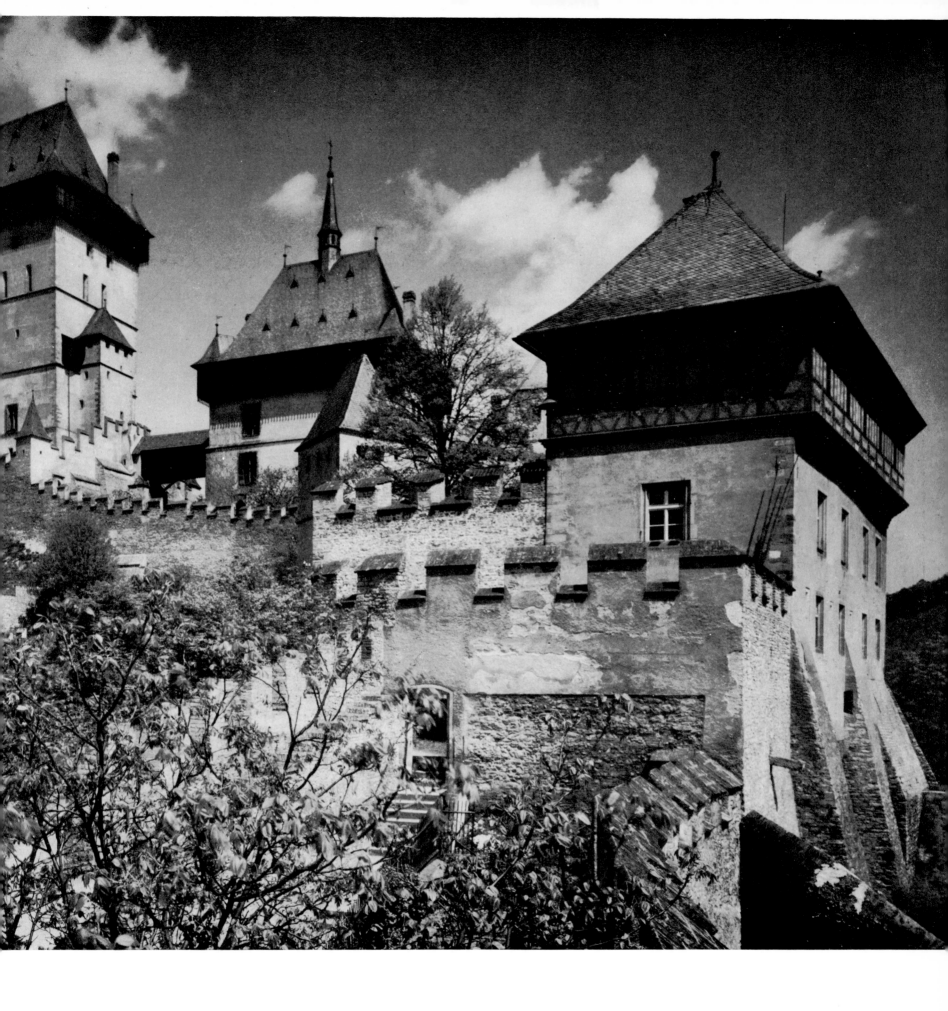

44 *Karlštejn castle. 1348–1365*

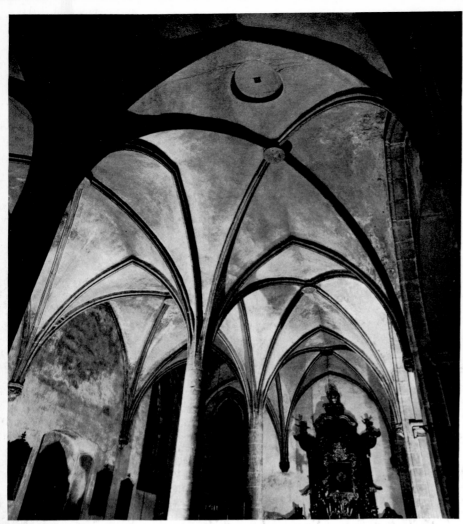

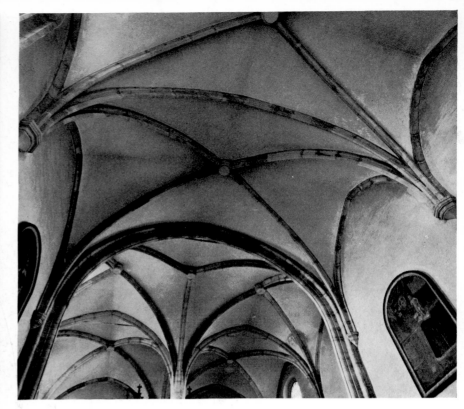

47 *Parish church at Vetlá. Last third of the fourteenth century* ▲

49 *Old Town Bridge Tower on the Charles Bridge, Prague. Peter Parler. Foundation stone for the bridge laid in 1357, the tower built in the thirteen eighties* ▶

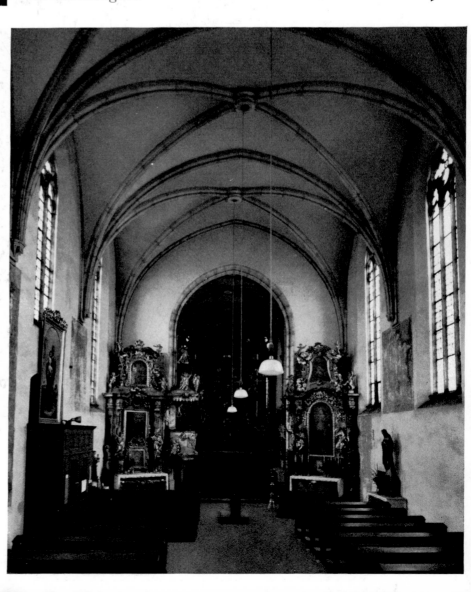

45 *Church of St Castulus, Prague. Hall-type double nave. Before 1375*

46 *Church of the Assumption at Karlov, Prague. Late Gothic vaulting. After 1351*

48 *Church of St Apollinaire, Prague. After 1362* ▶

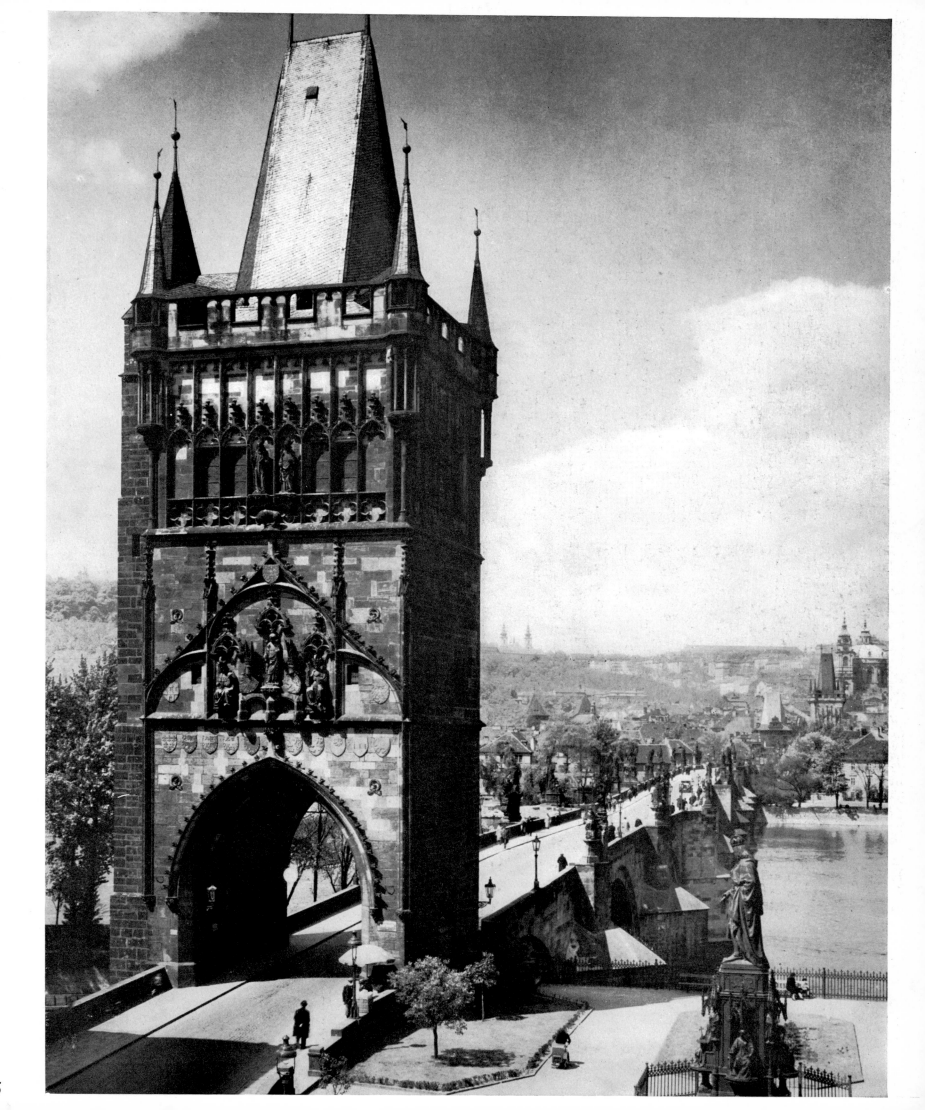

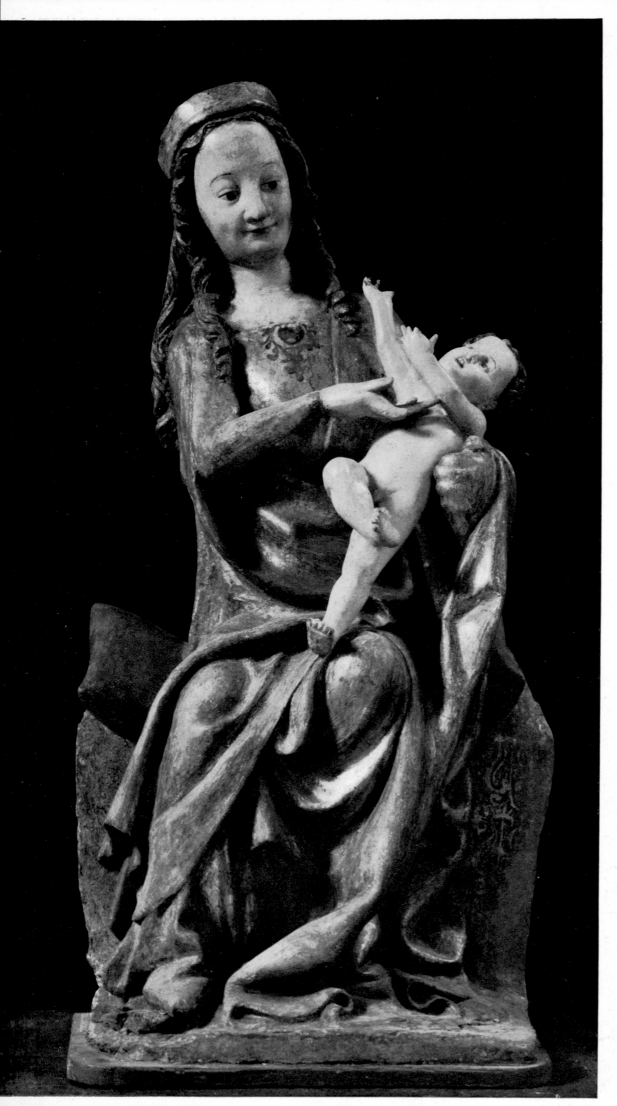

50 Madonna. 1370–1380. Wood with original polychrome. h. 95 cm. Bečov church
◄

52. Virgin and Child. After 1350. Limewood with original polychrome. h. 160 cm. Broumov parish church
►

51 Detail of Saint from the church of St James, Brno. 1350–1375. Limewood with fragments of old polychrome. h. 126 cm. Moravian Gallery, Brno
▼

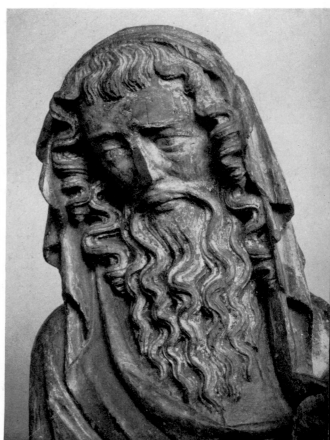

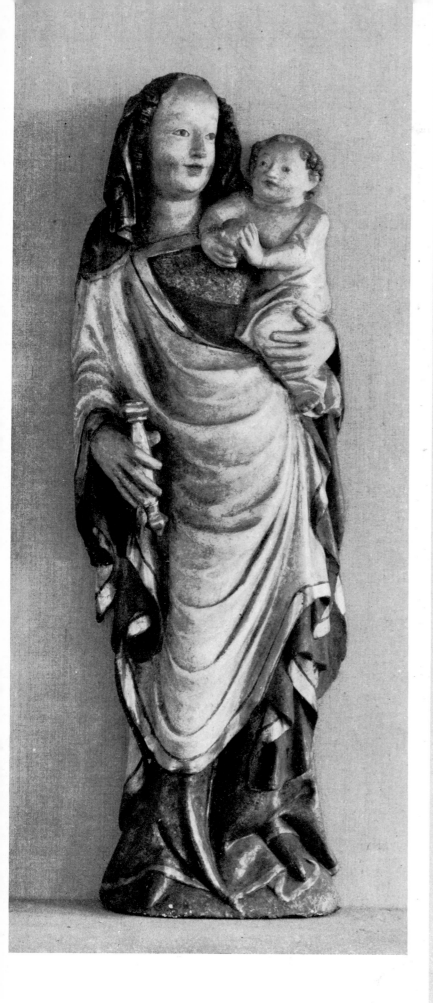

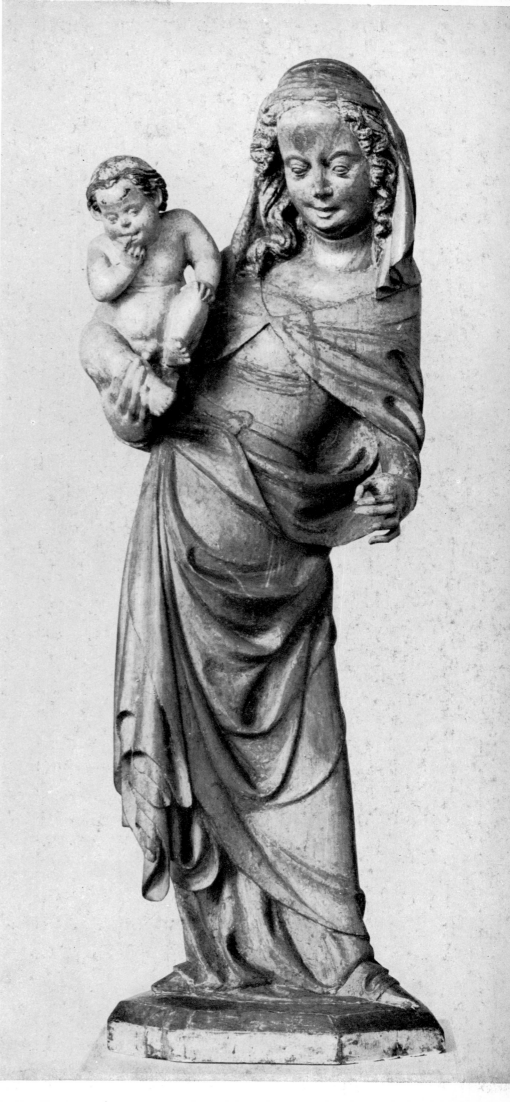

*53 The Madonna of Zahražany. 1370–1380. Limewood with
fragments of original polychrome. h. 84 cm. Parish church, Most*

▶

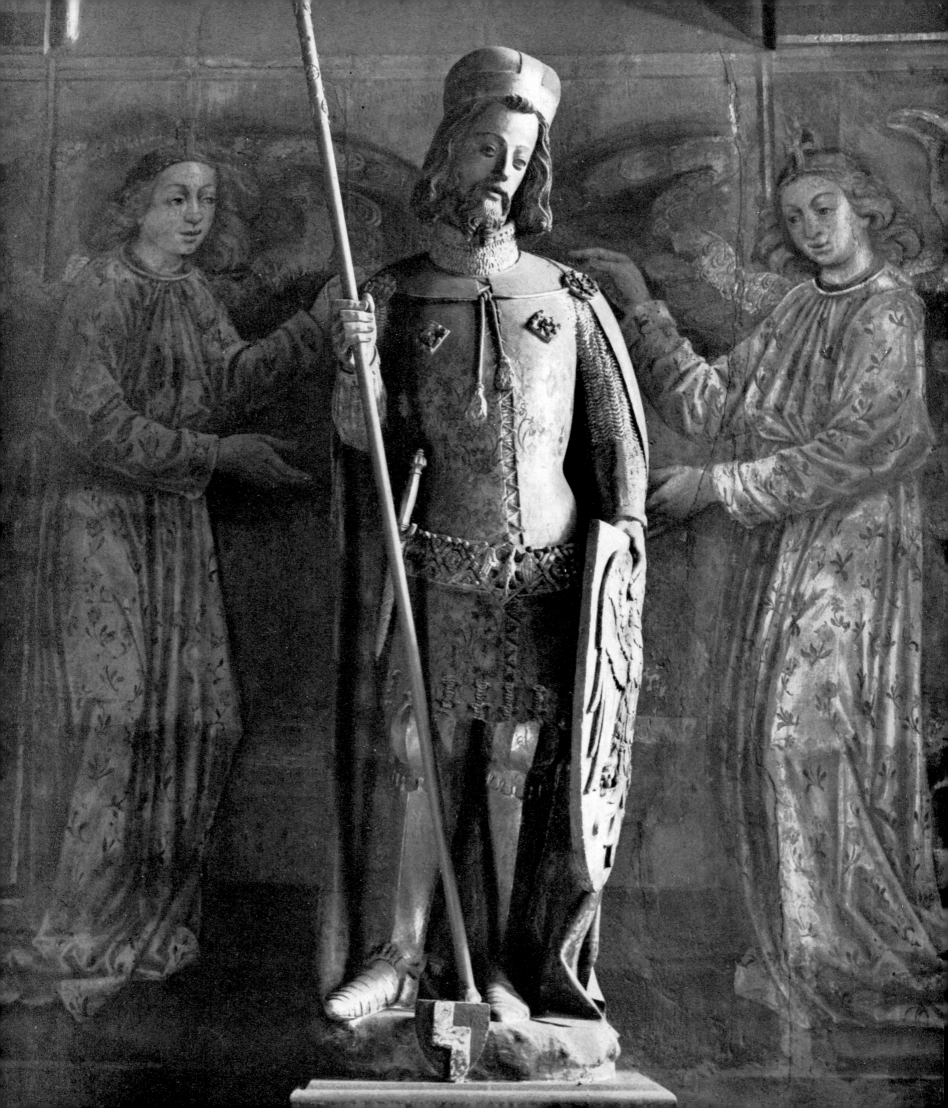

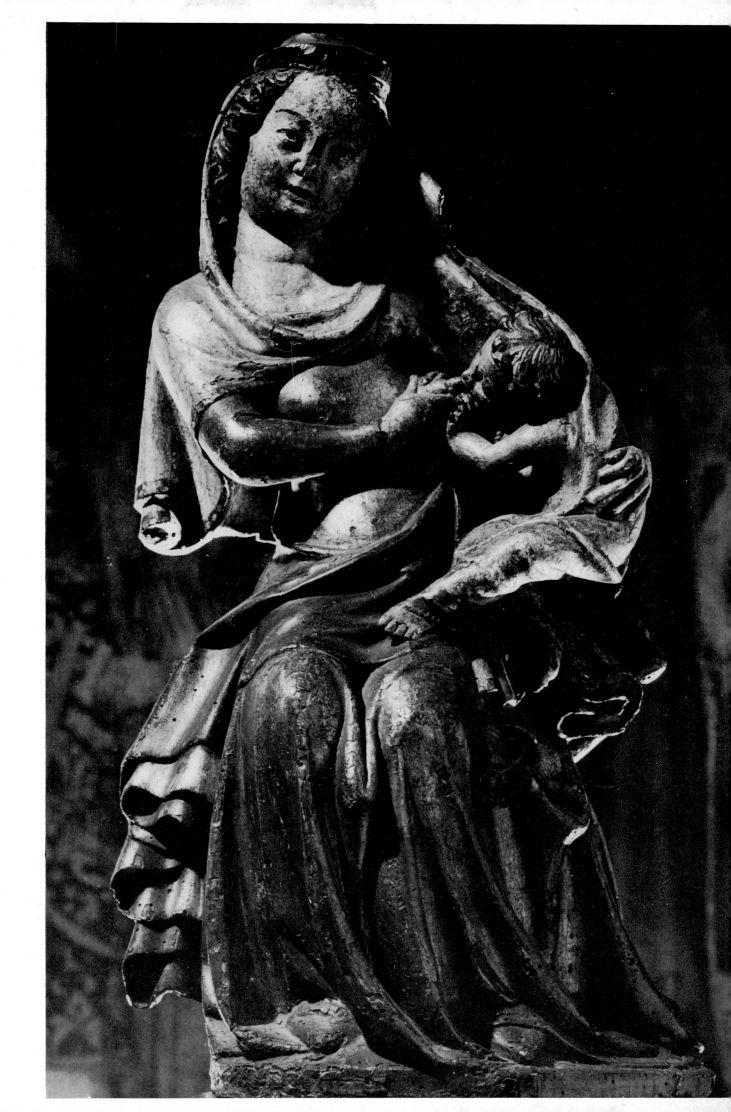

54 St Wenceslas. 1373.
Limestone with new poly-
chrome. h. 210 cm. St Vitus's
Cathedral, Prague

55 The Madonna of Kono-
piště. c.1380. Pearwood with
original polychrome.
h. 50.5 cm. National Gallery,
Prague
▶

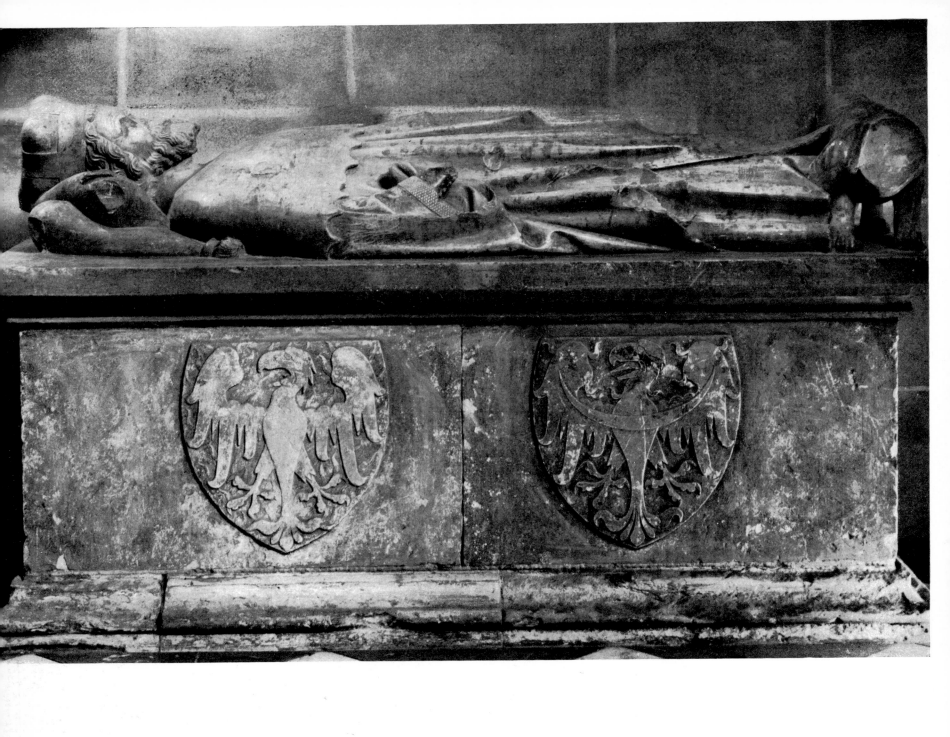

56 Tomb of Spytihněv II. 1375–1380. Limestone. Panel 192 × 76 cm. St Vitus's Cathedral, Prague

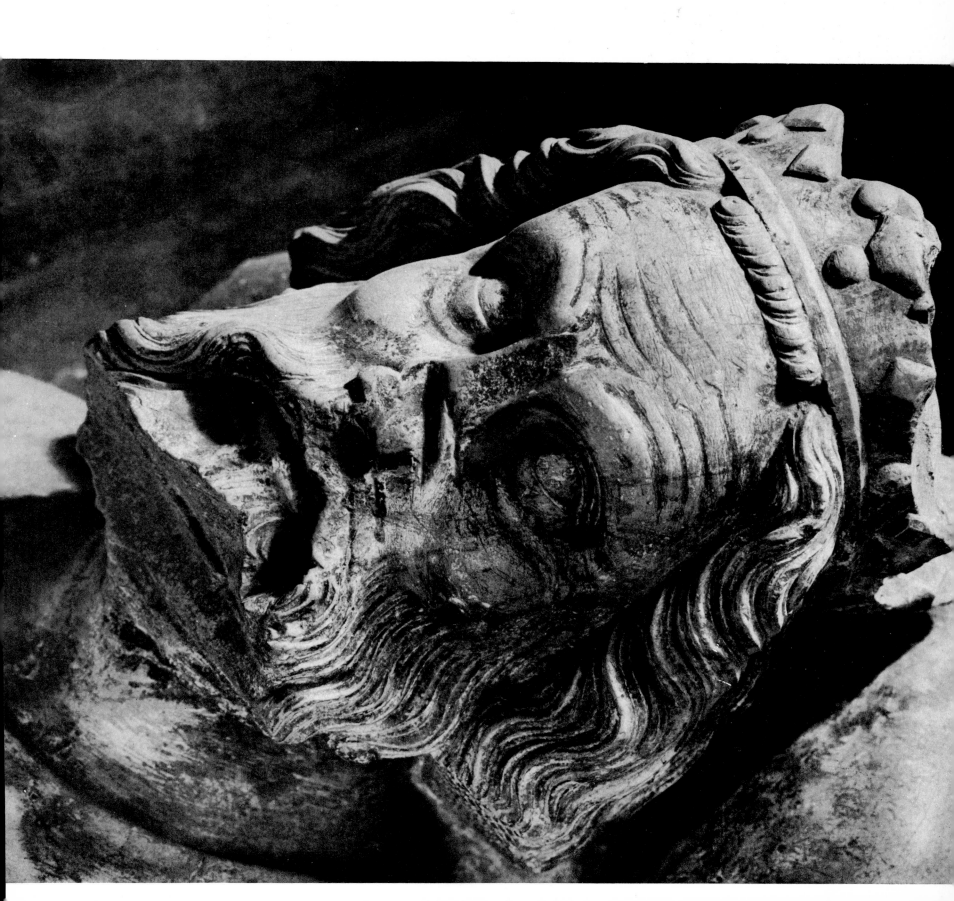

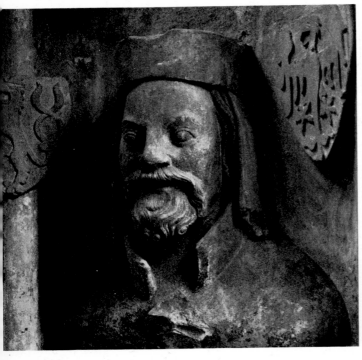

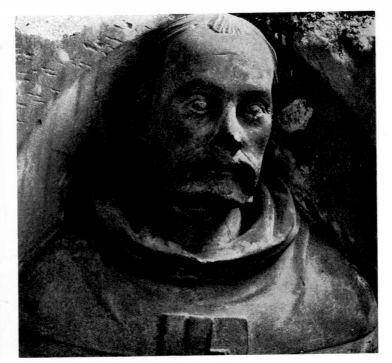

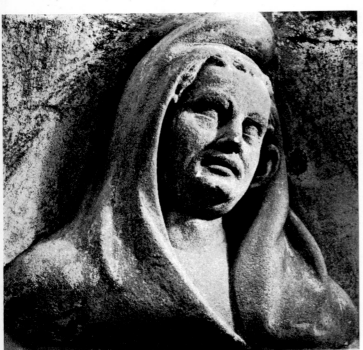

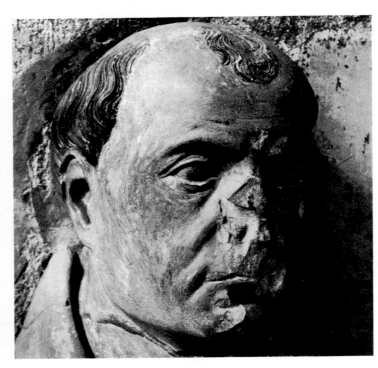

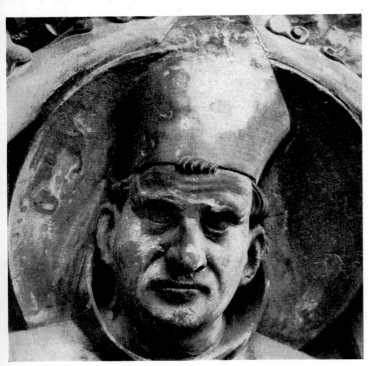

58 Charles IV. 1375–1378. Sandstone with remains of old polychrome. w. 55.5 cm. Triforium, St Vitus's Cathedral, Prague

59 Peter Parler. 1378–1379. Sandstone with remains of old polychrome. h. 46 cm, w. 49 cm. Triforium, St Vitus's Cathedral, Prague

60 Nicholas Holubec. 1378–1379. Sandstone with remains of old polychrome. h. 52 cm, w. 52 cm. Triforium, St Vitus's Cathedral, Prague

61 St Cyril. 1380–1385. Sandstone. h. 40 cm, w. 48 cm. Upper triforium, St Vitus's Cathedral, Prague

62 Wenceslas of Radeč. 1380–1385. Limestone with remains of old polychrome. h. 48 cm, w. 41.5 cm. Triforium, St Vitus's Cathedral, Prague

▶

63 Anne of Swidnica. 1375–1378. Sandstone with remains of old polychrome. w. 48.5 cm. Triforium, St Vitus's Cathedral, Prague

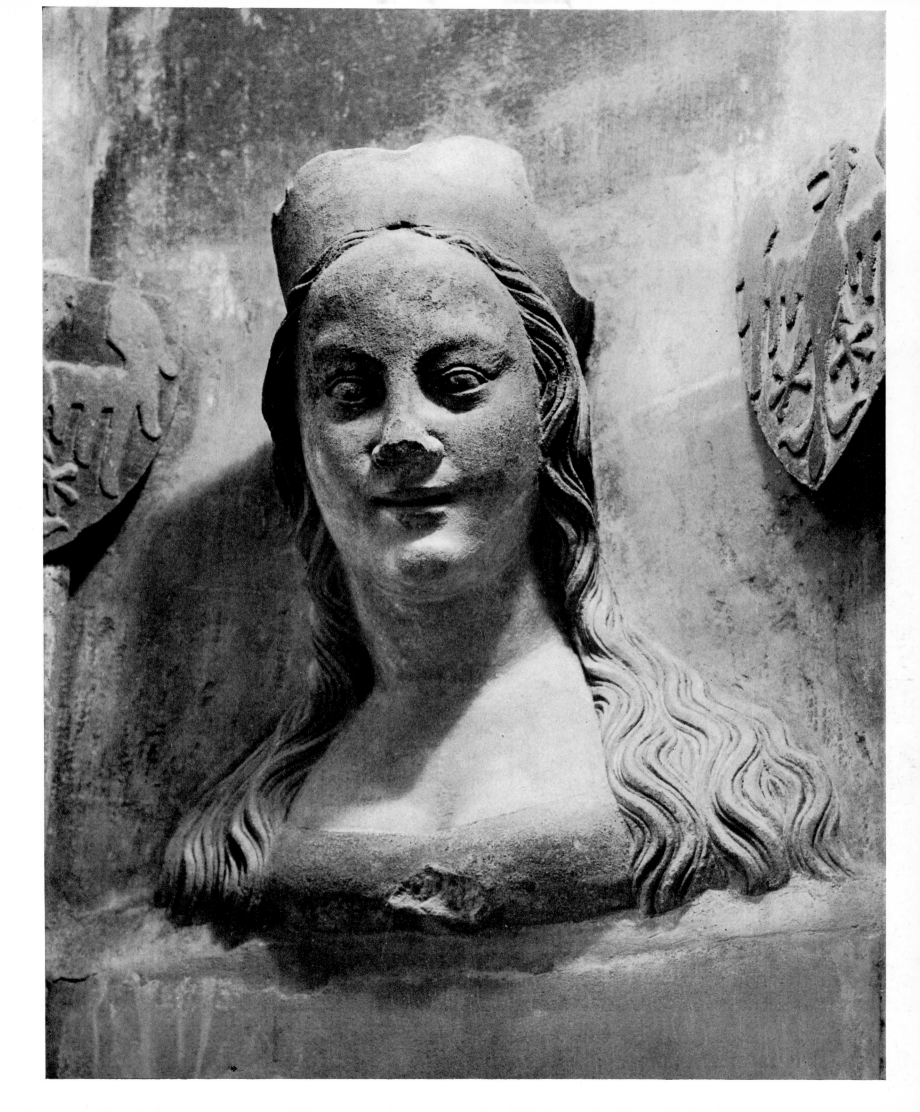

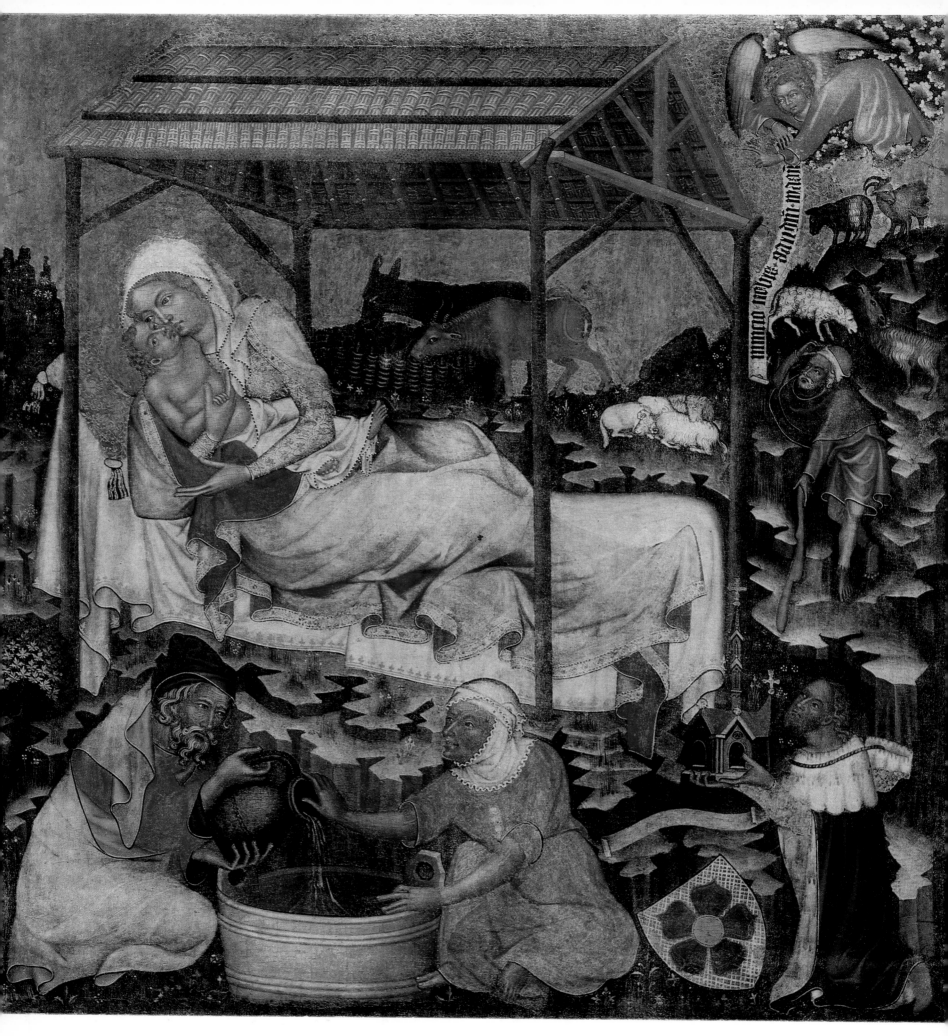

64 The Nativity. Vyšši Brod Altarpiece. c. 1350. Canvas on maplewood panel. 99×92 cm. National Gallery, Prague

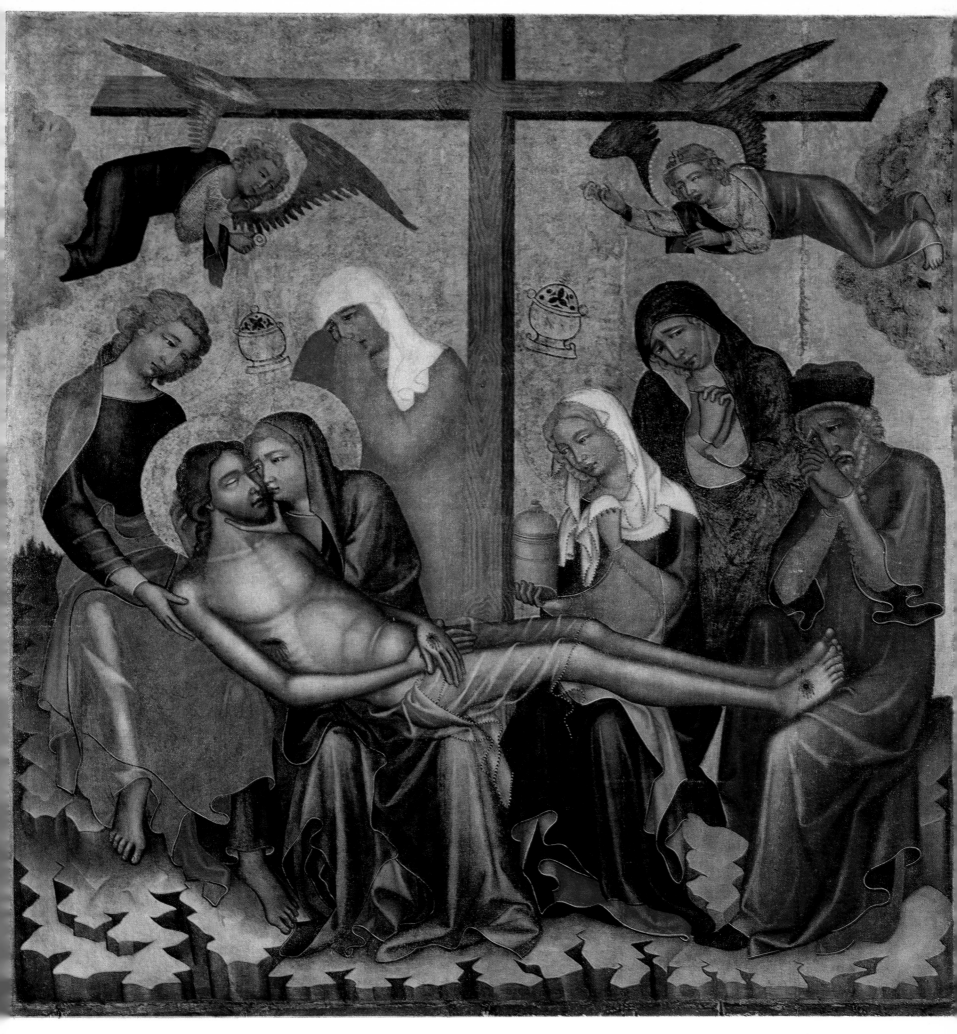

65 *The Lamentation. Vyšší Brod Altarpiece. c. 1350. Canvas on oak and maplewood panel. 99.5 × 92 cm. National Gallery, Prague*

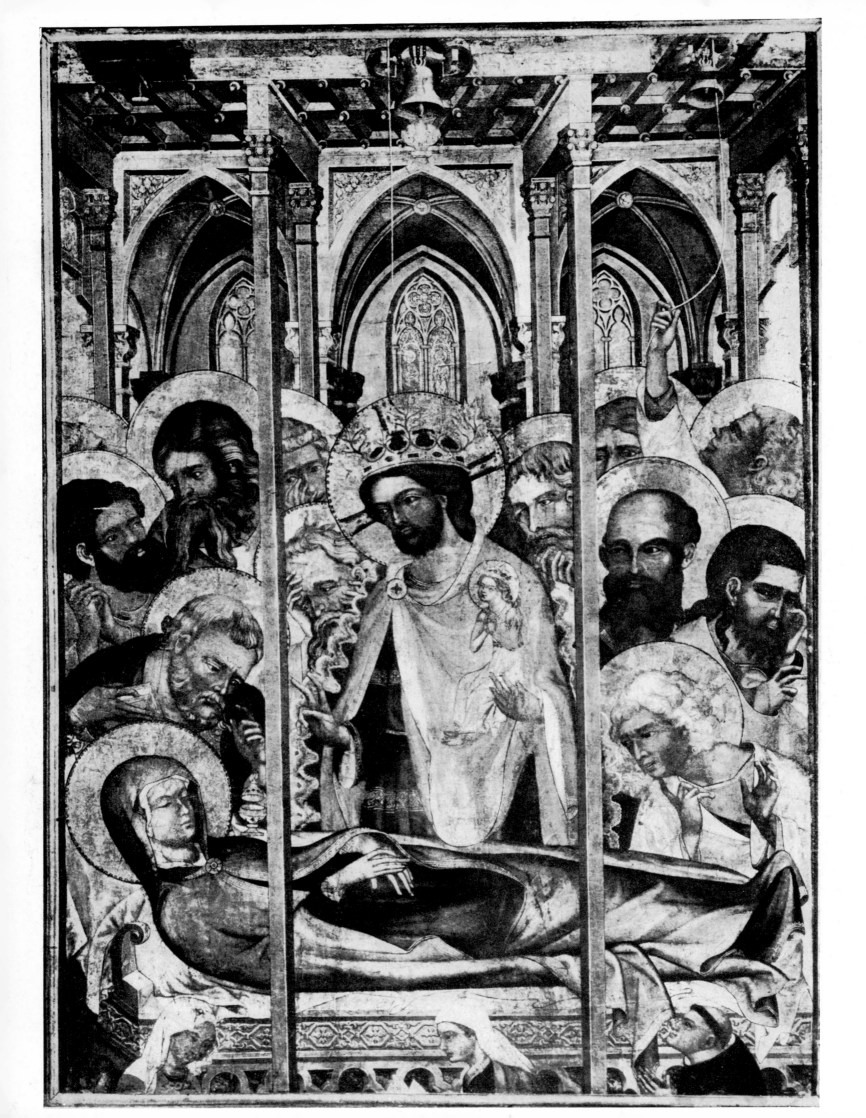

86

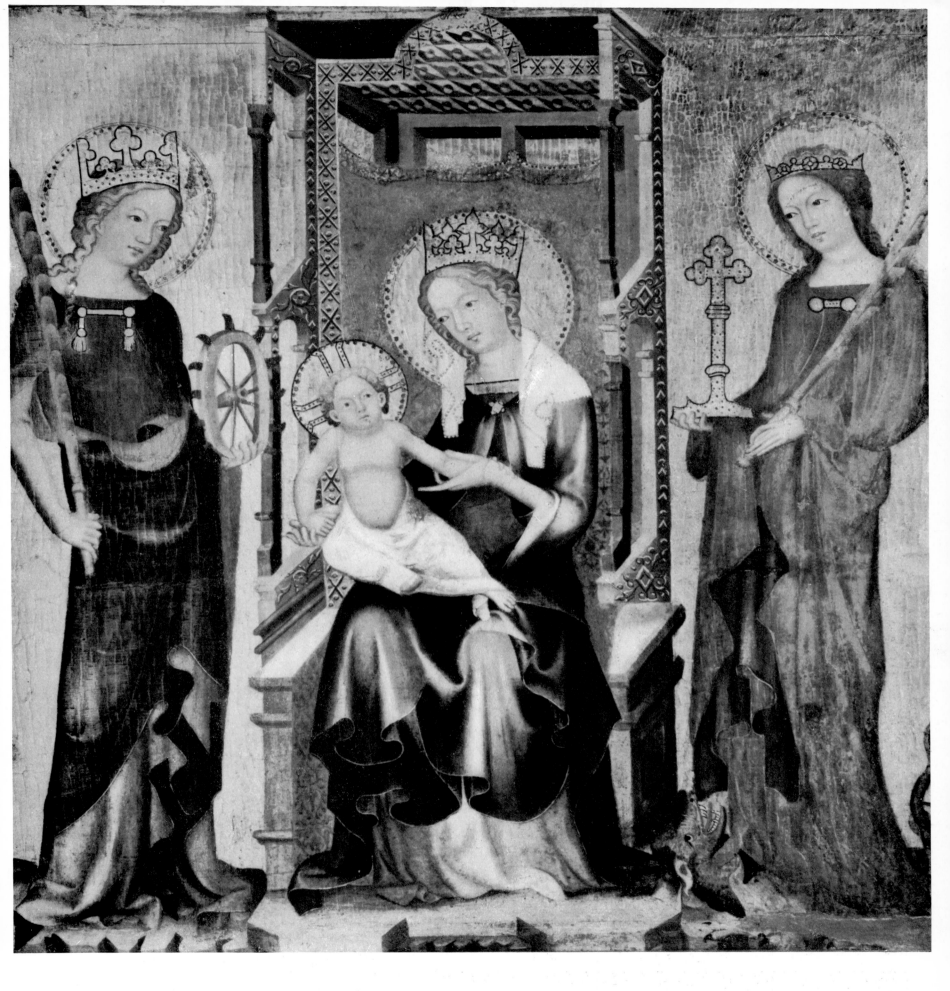

67 The Madonna between St Catherine and St Margaret. c. 1360. Canvas on pine panel. 95×101 cm. Hluboká Gallery

◄

66 The Death of the Virgin from Košátky. 1350–1360. Canvas on oak panel. 100×71 cm., cut along the sides and lower edge. Museum of Fine Arts, Boston

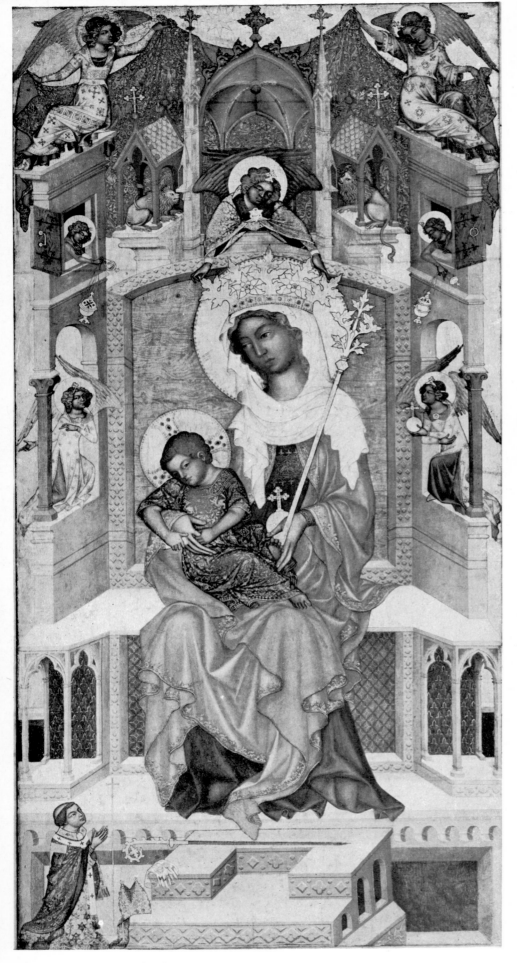

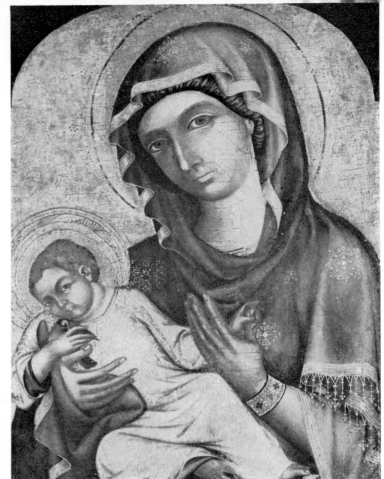

69 The Madonna of Most. Before 1350. Canvas on poplar panel. 53×40 cm. Deanery, Most

71 The Madonna of Veveří. c. 1350. Canvas on pine panel. 79.5×62.5 cm. National Gallery, Prague ▶

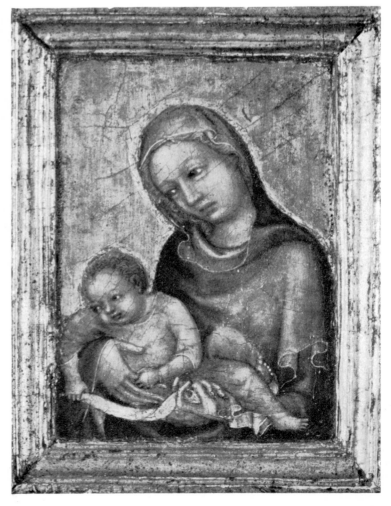

68 The Madonna of Klodzko (Glatz). Central panel of an altarpiece whose wings have been lost. c. 1350. Canvas on poplar panel. 186×95 cm. Staatliche Museen, Berlin-Dahlem

70 The Boston Madonna. c. 1360. Canvas on wood panel. 8.5×6 cm, including the original frame. Museum of Fine Arts, Boston ▶

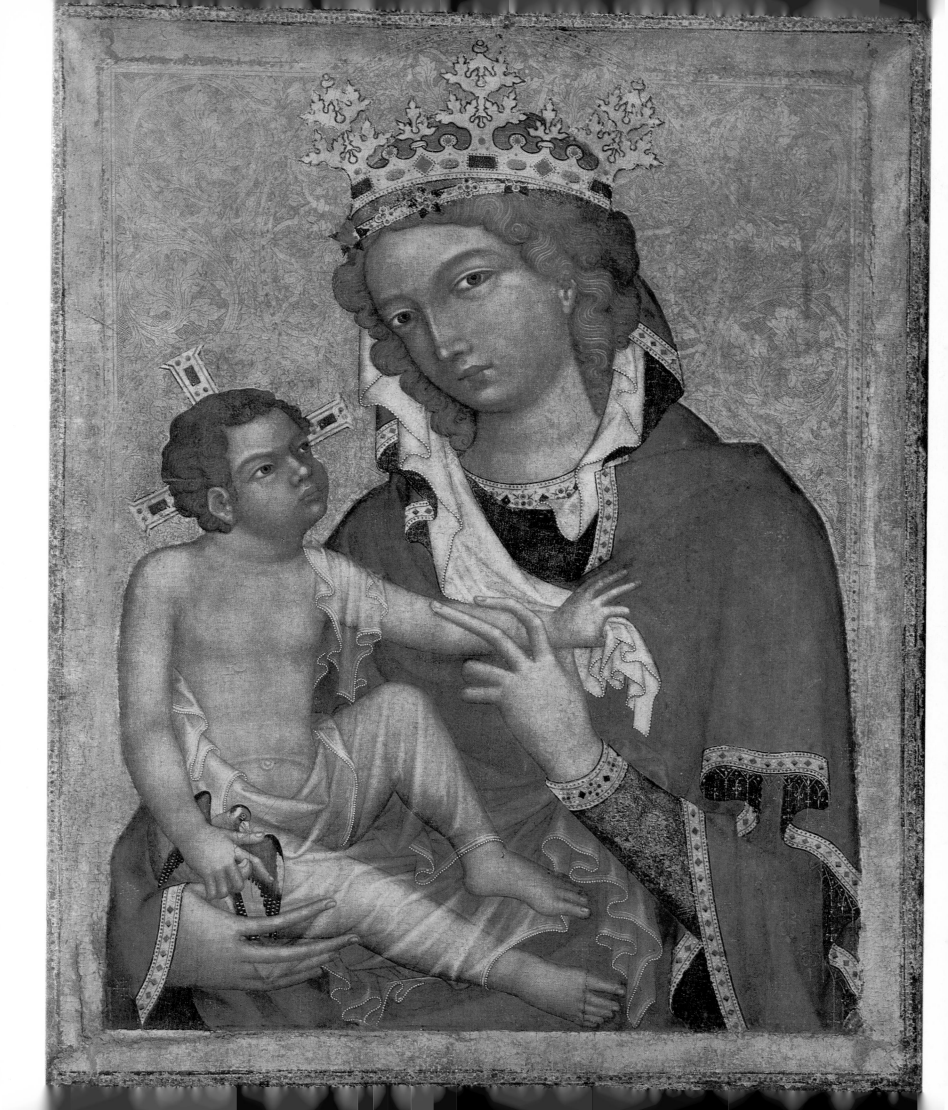

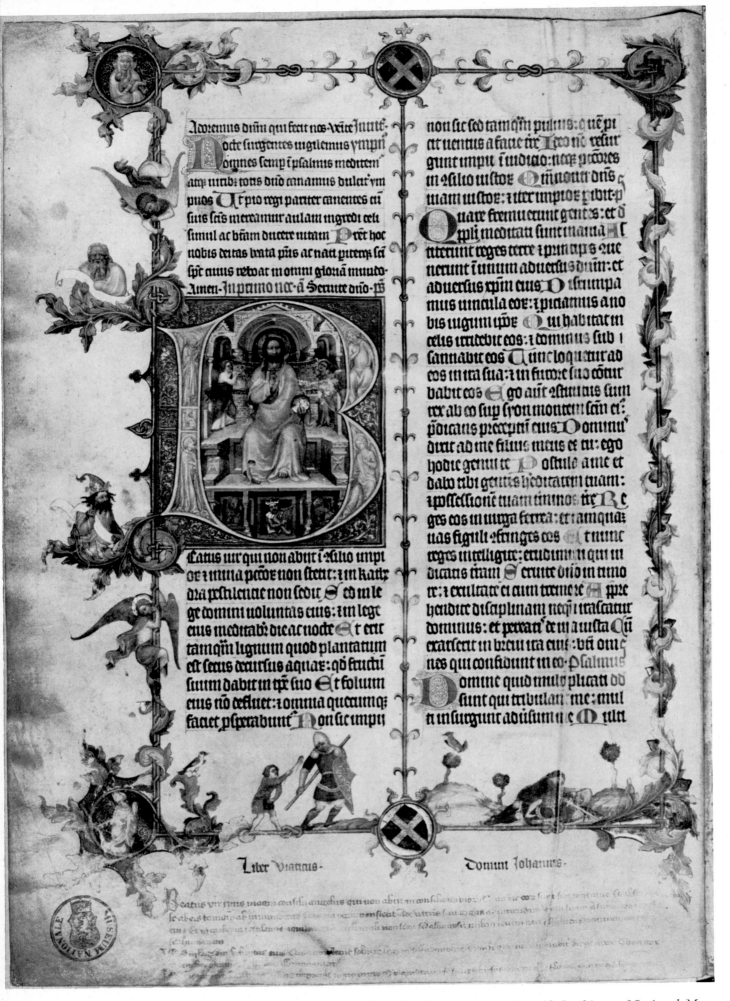

72 *The Liber Viaticus of John of Středa (folio 9). c. 1360. Parchment manuscript. 43.5×31 cm. National Museum, Prague*

73 *The Adoration of the Magi, from the Liber Viaticus of John of Středa. c. 1360. Parchment manuscript. 43.5×31 cm. National Museum, Prague*

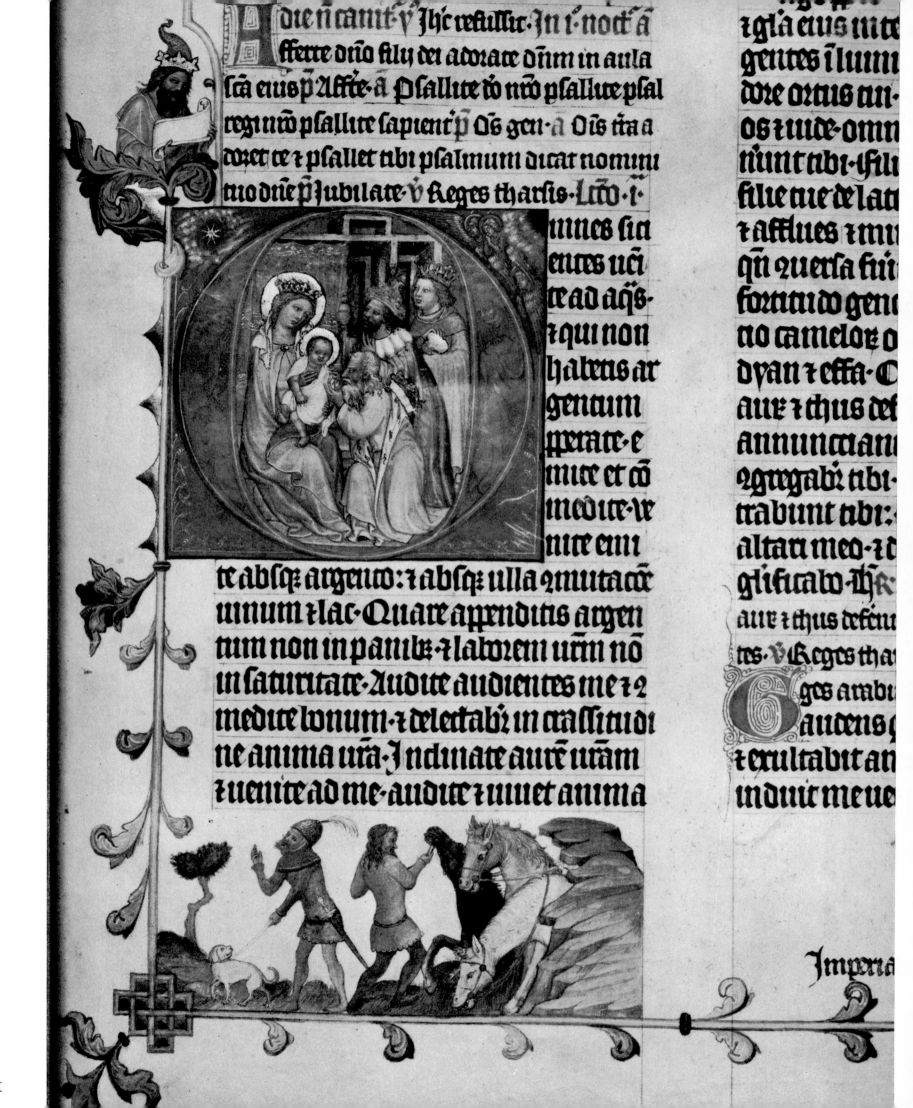

91

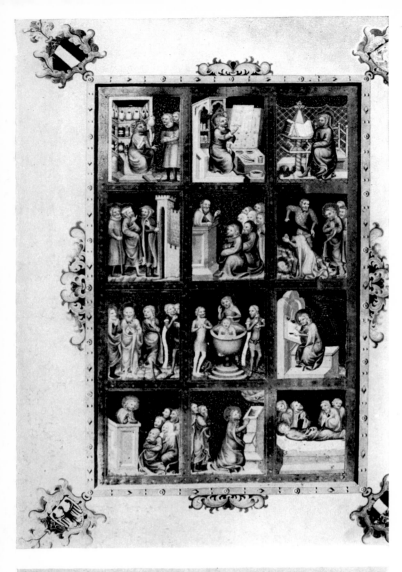

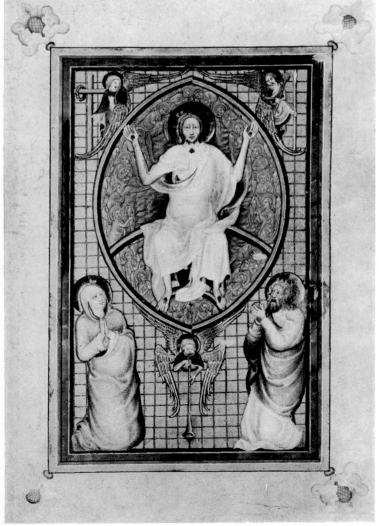

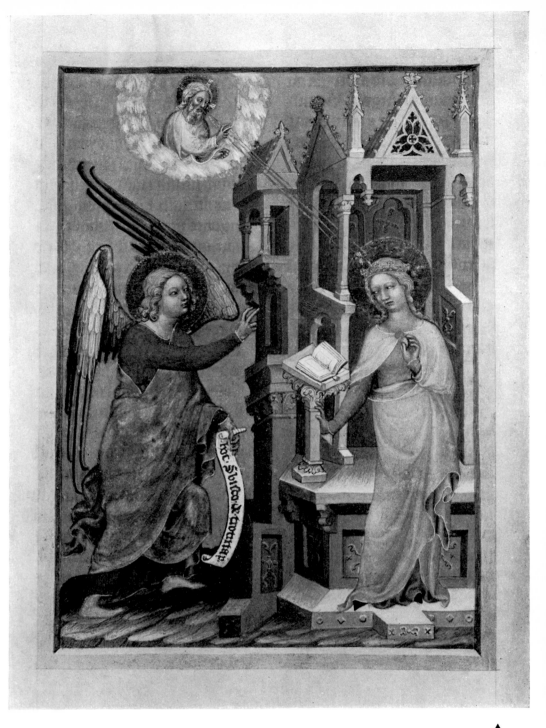

76 *The Annunciation, from the Laus Mariae. Before 1364. Parchment manuscript. 30×20 cm. National Museum, Prague*

◄

74 *Scenes from the Life of St Luke, from the Gospel Book of John of Opava. 1368. Parchment manuscript. 37.5×26 cm. Nationalbibliothek, Vienna*

75 *Christ in Majesty, from the Gospel Book of John of Opava. 1368. Parchment manuscript. 37.5×26 cm. Nationalbibliothek, Vienna*

►

77 *The Woman Clothed with the Sun. c. 1360. Mural painting. Lady Chapel, Karlštejn castle*

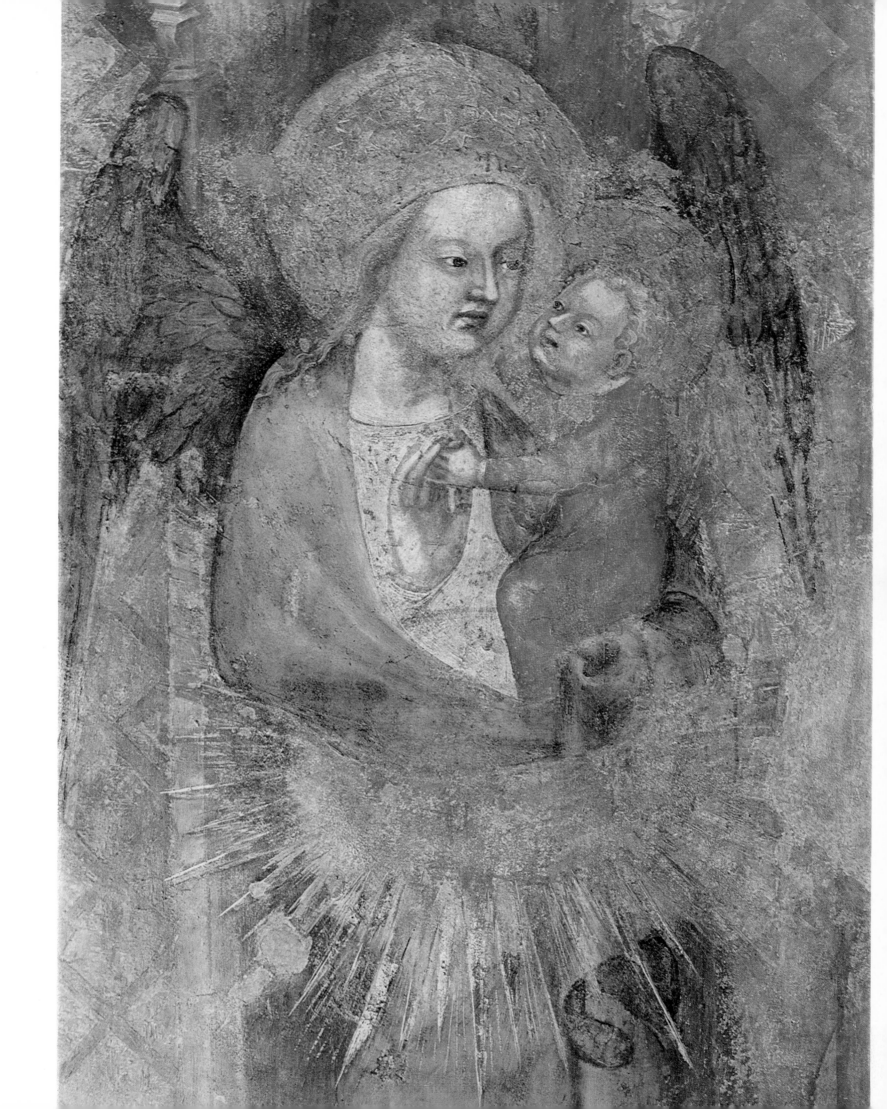

93

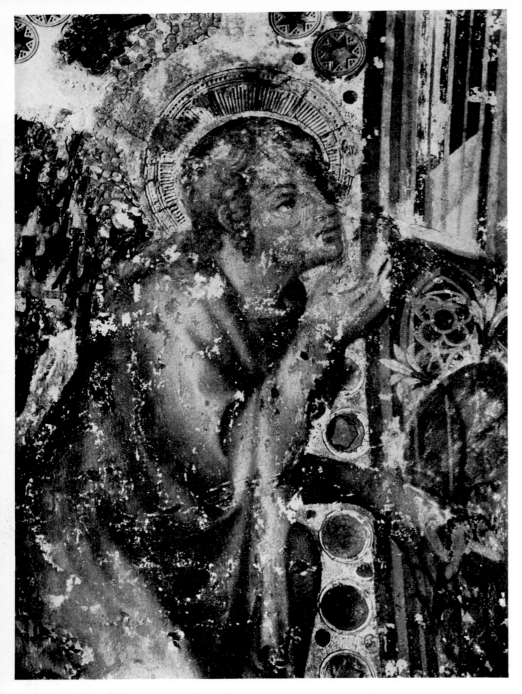

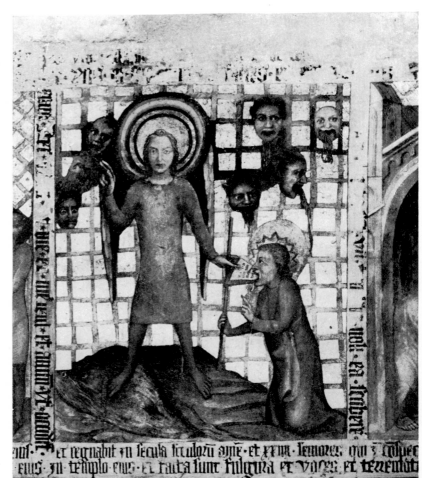

▶

80 *Relics Scenes (detail). Before 1357. Mural painting. Lady Chapel, Karlštejn castle*

78 *Master Theodoric. The Annunciation (detail). Before 1365. Mural painting. Chapel of the Holy Cross, Karlštejn castle*

79 *John Swallows the Book (detail from the Apocalypse). c. 1360. Mural painting. Lady Chapel, Karlštejn castle*

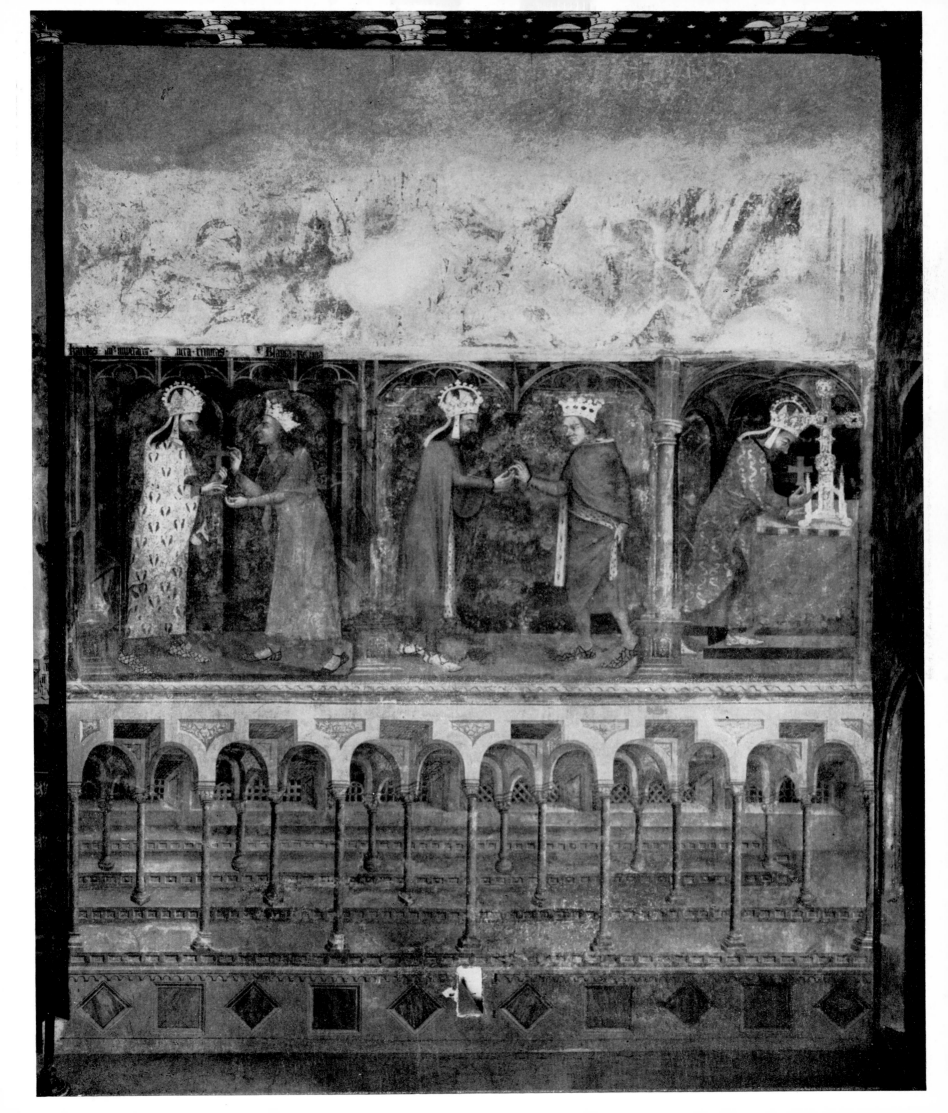

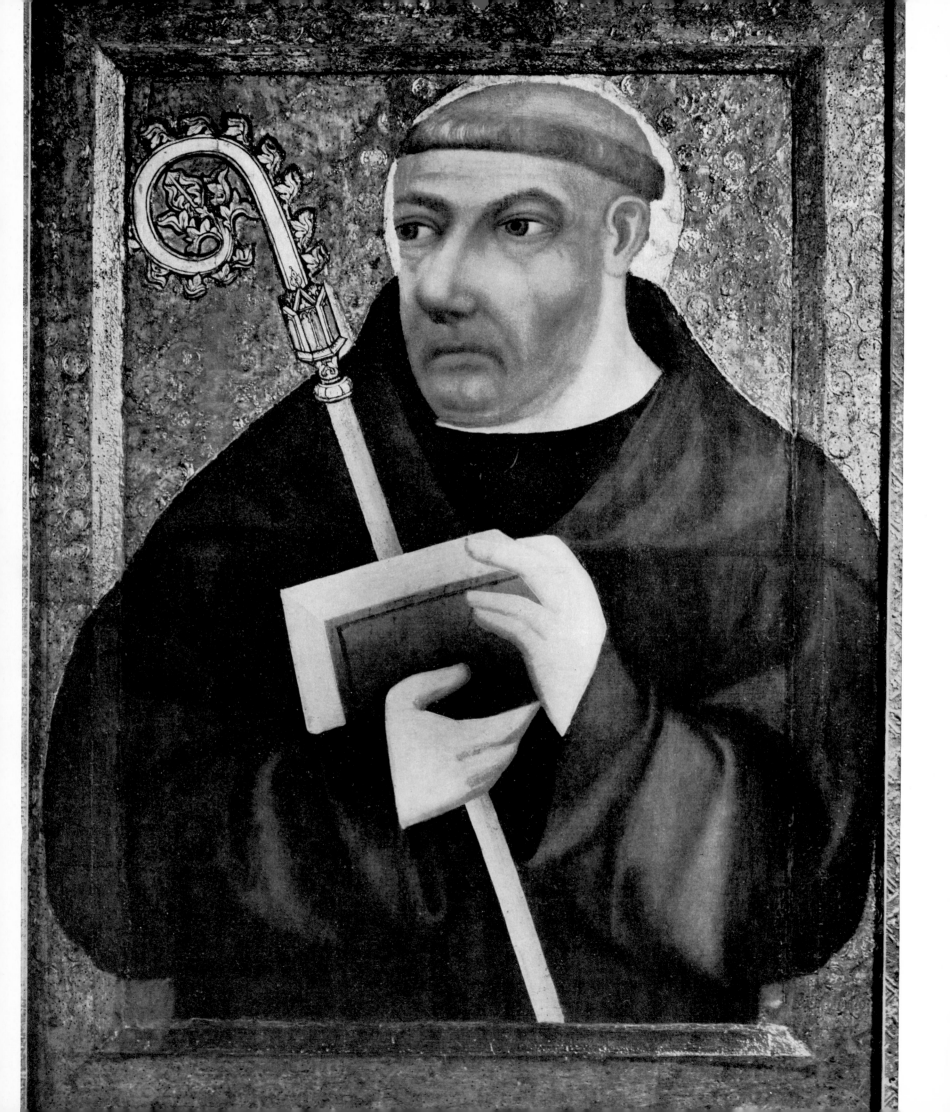

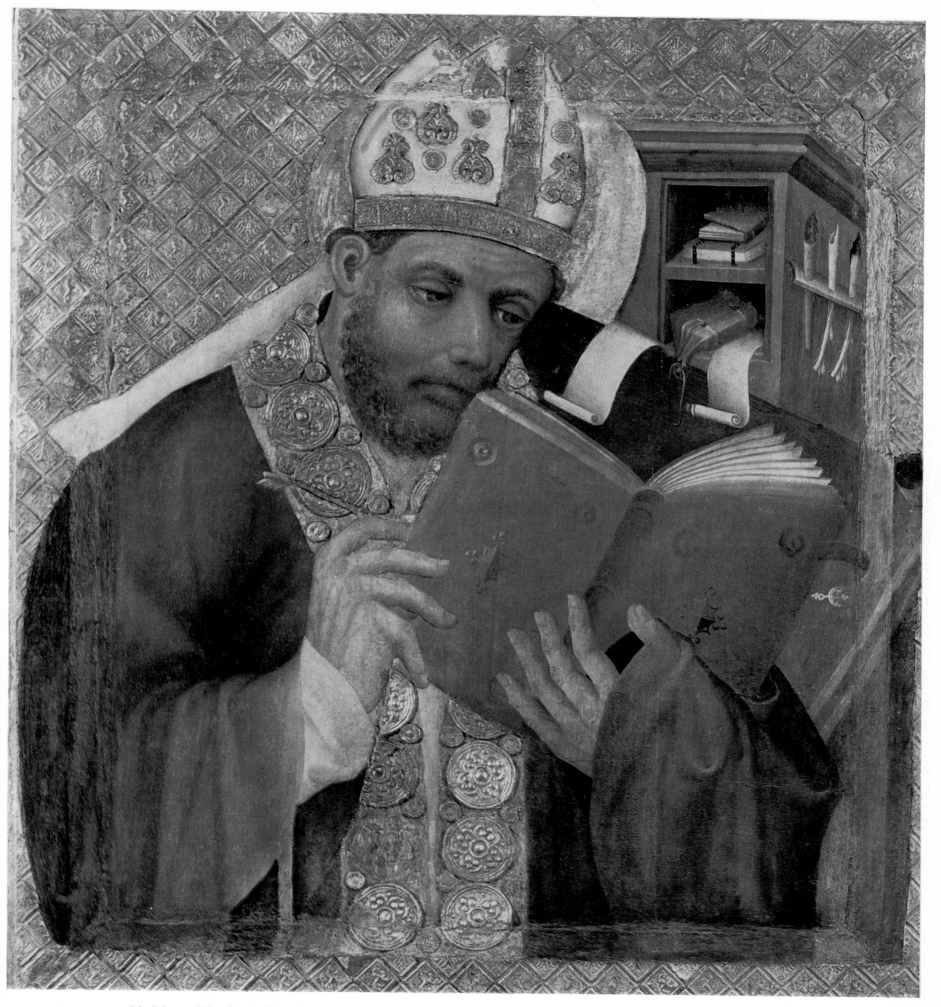

82 *Master Theodoric. Church Father. Before 1365. Wood panel. 114.3×103.4 cm. Chapel of the Holy Cross, Karlštejn castle*

81 *Master Theodoric. Benedictine Abbot. Before 1365. Wood panel. 115×85.5 cm. Chapel of the Holy Cross, Karlštejn castle*

83 *Chus. Detail from the Luxembourg Family-tree in the Codex Heidelbergensis. Original 1356–1357, this copy is from the second half of the sixteenth century. National Gallery, Prague*

84 *Meromungus. Detail from the Luxembourg Family-tree in the Codex Heidelbergensis. Original 1356–1357, this copy is from the second half of the sixteenth century. National Gallery, Prague*

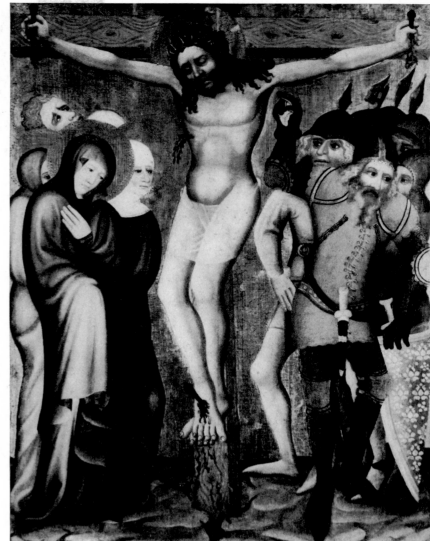

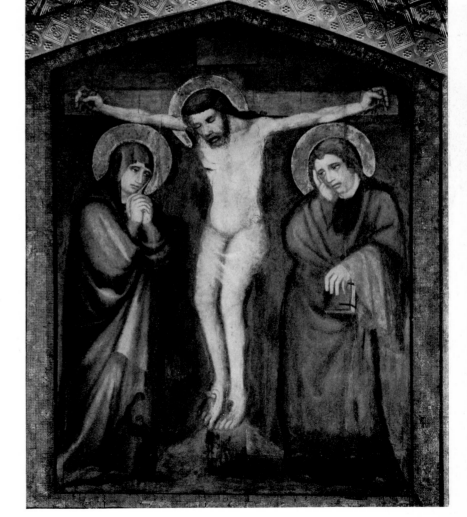

85 *Philosopher and Astronomer. 1370–1380. Pen and brush drawing on parchment. 13.8×13.5 cm. University Library, Erlangen*

86 *The Crucifixion from the Emmaus monastery. c. 1360. Canvas on pine panel. 132×98 cm. National Gallery, Prague*

87 *Master Theodoric. The Crucifixion. Before 1365. Wood panel. 221×175 cm. Chapel of the Holy Cross, Karlštejn castle*

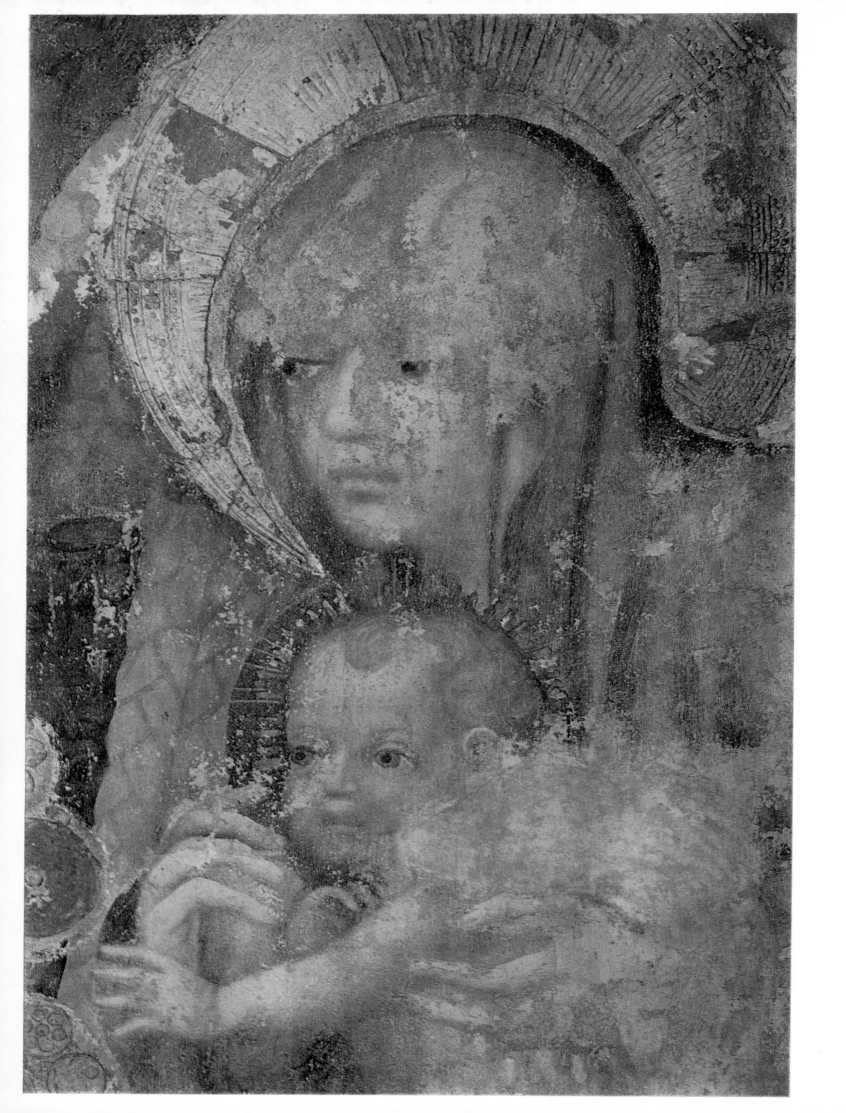

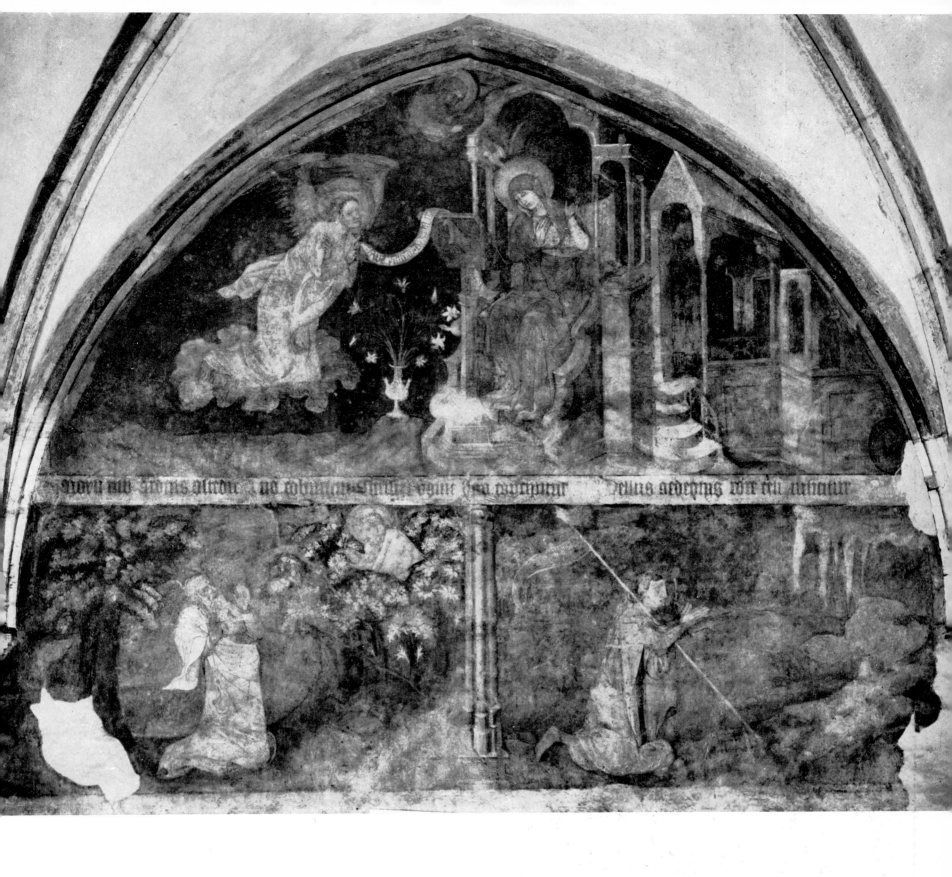

*92 The Annunciation. c. 1360. Mural painting. Cloisters of the Emmaus
monastery of the Slavonic Benedictines, Prague*

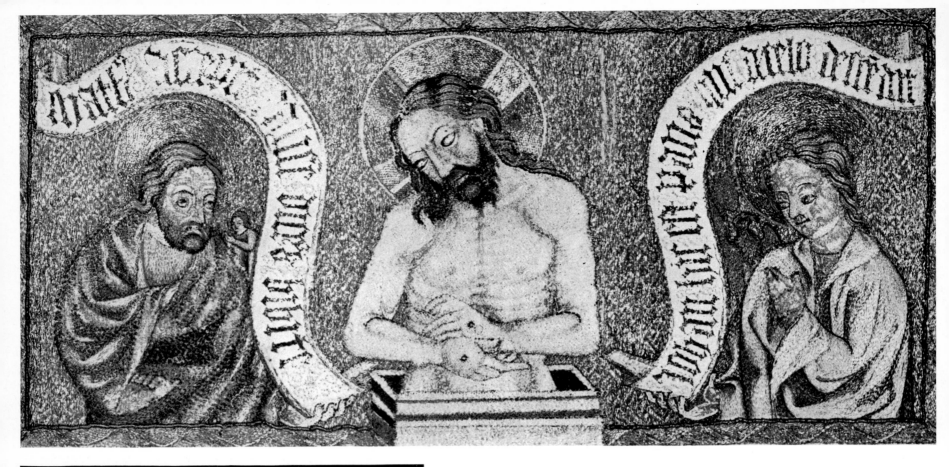

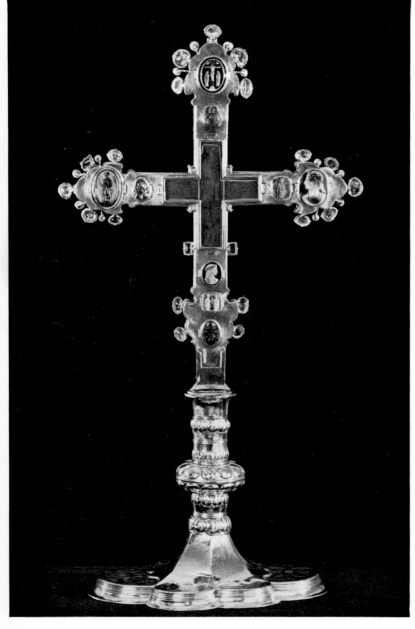

93 The Rožmberk Antependium (detail). c. 1370 and c. 1400. Embroidery on silk. Present size 60 × 120 cm. National Museum, Prague

94 Reliquary Cross. Third quarter of the fourteenth century, foot of more recent origin. Gold, precious stones and cameos. 62.5 × 41.5 cm. Treasury of St Vitus's Cathedral, Prague

104

The pictures, therefore, rather suggest a trend related to Theodoric, which was less concerned with the definition of space and the visually truthful reconstruction of the event and more intent on the spiritual content of the pictures. One might with greater probability attribute to the Master of the Family-tree the *Crucifixion* from the Emmaus monastery (National Gallery, Prague), since the commission came from someone who had direct contact with the painters of the cloisters and who could, therefore, request them to carry out the embellishment of the church for which, in all probability, the picture was originally intended. But not even this identification of the painter of the panel picture and the mural paintings is certain and here, too, certain features point towards the Theodoric school. For example, the group of women below the Cross has certain close parallels to the *Three Maries at the Sepulchre* in the chapel of the Holy Cross. Besides, in some of the later works by Theodoric, it seems, the thick-set proportions became slender so that not even this feature can prove the authorship of the Master of the Family-tree.

The trends towards more spiritual forms, which were rapidly overcoming the influence of Italian rationalism, showed clearly in the votive painting of *John Očko of Vlašim* (National Gallery, Prague), which once belonged in the chapel of the Archbishop's country residence at Roudnice. As the donor is not depicted as a cardinal, an office to which he was appointed in 1378, the picture must have been painted prior to that date. It may have been finished by 1371, when the chapel was consecrated to the Czech patron saints depicted in the painting. The strict symmetrical composition is divided into two horizontal strips, for which there is no objective justification. On the upper strip one can see Charles IV and Wenceslas IV kneeling in front of the Madonna in Majesty, and accompanied by the patron saints, SS Sigismund and Wenceslas. The ground they are resting on is indicated so imperceptibly that the figures seem to be floating in front of the gold background and the golden canopy of the Virgin's throne. The throne is shown as an almost undifferentiated flat space without any attempt at perspective. The lower part depicts the kneeling Archbishop between SS Adalbert and Vitus, Procopius and Ludmilla. The narrow strip of land is almost completely covered with the figures. This spatial vagueness corresponds to the slender weightlessness of the figures, among which only the Virgin retains some of Theodoric's robustness, and to the colour-scheme, which seems very light due to the application of white, resembling techniques used in miniature painting. Although the picture has three portraits, among which the ones of Charles IV and Archbishop Očko show efforts at individualisation, the picture appears unreal, fantastic, making an irrational Northern impression. The late work of the Court workshop at St Vitus's Cathedral had a related character. In book painting, too, we can find similar features (for example, the *Pontifical of Albert of Šternberk* of 1376).

These same trends appear, to a lesser degree, on the *Mühlhausen Altarpiece* (Staatsgalerie, Stuttgart), which was made in 1385 for the little church of St Vitus in Thuringian Mühlhausen, built by the Prague burgher Reinhart, who was the donor of the altarpiece. By the time of the *Mühlhausen Altarpiece*, this charmless style of painting which lacked the mystical atmosphere of earlier works of this type, had been overcome. Moreover, the Master of Třeboň, the major initiator of the International Style in the Czech Lands, was already active.

Similar close links to those which existed between mural and panel painting in the third quarter of the century can also be traced to book illustration. This is hardly surprising if we consider the importance of the Court workshop and the fact that no firm borderline can be drawn between illuminators and painters of panel or wall paintings. The wave of Italian influence appeared in book illumination, first as a compilation of Western and Southern motifs. This method was used, for instance, by the workshop working for Archbishop Ernest of Pardubice. Elsewhere, Italian inspiration appeared more forcefully, but without suppressing elements of Western or earlier, local origin. This can be seen in the *Breviary of the Rajhrad Provost Vitek*, c. 1342, and particularly the *Breviary of the Grand-Master Leo of the Order of the Knights Hospitallers*, 1356. Around 1360, however, this process of synthesis reached its climax in a group of manuscripts, which was inspired by the magnificent *Liber Viaticus of John of Středa* and in the illuminated books concentrated around the *Vyšehrad Antiphonary* in the monastery library at Vorau.

The *Liber Viaticus of John of Středa* (National Museum, Prague) was perhaps made in the fifties,[24] for the enlightened humanist and Imperial Chancellor, the Bishop of Litoměřice and of Olomouc, a friend of Petrarch's. It is one of the most beautiful manuscripts of the time, and one that shows Italian influence most consistently. The figural compositions presume a knowledge of Sienese types, and the ornaments can likewise be traced to Siena or possibly to Perugia. At the same time it can be seen that the main illuminator of the manuscript was in contact with Czech painting and knew both the work of the Master of Vyšší Brod and that of the *Morgan Panels*. And he used the Italian types only after a thorough transformation. The decorative system combines local elements with those derived from Italy. There are even Romanesque motifs. But the whole work possesses a character of its own. The individual Italian motifs, for instance the acanthus, are used loosely with a good deal of naturalism. The figural miniatures have a strong Italian accent. Some of them might be taken straight from the work of some Sienese master, yet they are the result of creative endeavours which assimilated them into the Czech environment. Even at that time there were close ties with the West. Some of these miniatures give the impression of variants of surviving panel paintings, and others make it possible to presume the former existence of paintings now lost.

The links with Italy can be seen even more clearly in the *Misssal of Provost Nicholas* (City Archives, Brno). This missal is closely connected with the *Liber Viaticus*.

The trend towards softer form and more unified shape, seen in the *Liber Viaticus*, appeared even more strikingly in other manuscripts of this group: the *Laus Mariae*, the *Orationale Arnesti* and the *Missal of John of Středa* (National Museum, Prague, and Chapter Library, Prague). The miniatures in the *Missal of John of Středa* show a progressive vagueness concerning anatomy, and a weakening effort at constructing a spatial set-

ting, which, in the *Liber Viaticus*, had been among the most typical Italian features.

This departure from the Italian style reached its climax in the grandiose *Gospels of John of Opava* (Nationalbibliothek, Vienna),[25] finished in 1368 for the Austrian Duke Albrecht III, the husband of Charles IV's daughter Elizabeth. Apart from its outstanding artistic quality it is interesting for having full-page initials at the beginning of each Gospel. This was very unusual at the time. These initials were greatly influenced by Ottonian and Carolingian examples, from which the miniaturists also derived other ideas. Although this historicism was probably due to political reasons, it was at the same time an expression of a romantic return to the past. One of the remarkable things is the depiction of a painter's workshop, given in a series of scenes from the *Life of St Luke* who, perhaps for the first time, is depicted here as a painter. New iconographic motifs are as apparent here as the painter's liking for narrative. The decoration included all motifs current at the period. They are used on full-page pictures which they frame in lavish extravagance. The large figures dressed in heavy, drooping garments have many realistic features. Where the subject required it, they are given in a detailed setting. But even here, in comparison with the *Liber Viaticus*, there was less interest in depicting space; at the same time shapes lost their definite form and light subdued the colour. Here and there slimmer, less robust figures appear, which slightly recall the saints in the votive painting of John Očko. This was the beginning of a development that can be further traced to the illustrations in the *Six Books on General Christian Matters* by Thomas of Štítné, of 1376 (University Library, Prague). Here too, architectonic elements vanished almost completely, and the draperies came to exist on their own in new forms, a feature which was to be of great importance for further development.

The canonic folio in the *Missal* (No. 12) in the St James's Library in Brno, in which the calligraphic tradition is revived, is a precursor of the trend in painting in the eighties, of which the Master of Třeboň became the leading artist. The new trend appears here the more strikingly, since the painter followed up the *Missal of Provost Nicholas* of about 1360, likewise of Brno origin. The difference is of basic character: the proportions of the figures changed, the small heads set on elongated figures acquired a distinct Mannerist character, the draperies became independent and returned to the old linear and rhythmical arrangement, colour lost its relativity, and the visual relationships between the figures and the setting weakened. Everywhere one can observe a turn away from the rational logic of shapes and relationships typical of Italian art. We are already dealing with an incunabula of the Czech International Style which, at the end of the century, turned into the Beautiful Style.

While in book painting of this type the Italian orientation was decisive, even though its intensity weakened by degrees, in another group of Czech illuminated books of the period we can trace relationships to Western painting. In the figural parts of the decoration we can trace a close analogy with the trend whose representative is the Maître aux Bouqueteaux. But the ornamentation assumes a knowledge of Italian painting, acquired perhaps from imported manuscripts. The main representative of miniaturists of this group, with a characteristic tendency towards slightly crude naturalism, is a master who made the second part of the *Antiphonary of Vorau* (Vorau Monastery Library), the *Bible* (A, 2–3) in the Chapter Library, Prague, and part of the *Latin Bible* (Cod. 78) in the Széchényi Library in Budapest. The remarkable similarity between these miniatures and the paintings at the Emmaus monastery in Prague proves how intensively the influence of the Court workshop spread. It can hardly be assumed that there was any closer contact between the miniaturists and the painters of the Emmaus cycle. The sense of spatial relations, shown at Emmaus, is less strong in the miniatures. A tendency towards the reduction of three-dimensional values to lines can also observed. These have nothing in common with French calligraphy and suggest both volume and emotional excitement, but they do greatly reduce modelling.

The decisive influence, which in the sixties was spread by the Court workshop, lessened in intensity in the following decade. The grandiose mosaic over the south portal of St Vitus's Cathedral was a kind of epilogue to their work. This mosaic was completed in 1371. The peculiar technique, unusual north of the Alps, was used to depict the *Last Judgment*. Charles IV's passion for collecting, known in other spheres, was shown here, too. The Czech patron saints appear here as intercessors, and there is a portrait of the Emperor and his wife Elizabeth of Pomerania in adoration. The execution of the iconographically interesting picture, in which the Lost Souls are not balanced by the Blessed, was entrusted to Italian mosaic makers, probably from Venice. They used a cartoon made by the Czech painters but probably also contributed to the general design of the vast picture.

Among the works influenced by the Court mural painting is the cycle of the *Life of the Virgin* in the chapter-house of the Benedictine abbey at Sázava. It has only partly survived as its second half was destroyed during Baroque alterations. Around 1370 painters were working there who, in all probability, followed up the work of those who produced the cycle at the Emmaus monastery. But they altered its spirit in accordance with trends that were to gain the upper hand in the last few decades of the fourteenth century. This applies in particular to the painter who made the sculpturally conceived figures of the Virgin on the window wall. There he showed his tendency towards firm, rhythmically designed form and a lyrical, intimate treatment of the subject. There also, Italian orientation appears very clearly. On the other hand, the painter who made the *Nativity* and the *Adoration of the Magi* on the northern wall belonged to a trend that aimed at overall unarticulated form.

IV. *The End of the Fourteenth and the Early Fifteenth Century*

COURT OF WENCESLAS IV; ST VITUS, ČESKÝ KRUMLOV; THE KRUMLOV LODGE; HEINRICH PARLER; THE TÝN CHURCH, PRAGUE; THE BEAUTIFUL STYLE—THE MADONNA OF KRUMLOV, THE TORUN MADONNA, THE TÝN CALVARY; THE MASTER OF TŘEBOŇ AND HIS CIRCLE; THE ST VITUS'S MADONNA; THE ROUDNICE ALTARPIECE; MANNERIST BOOK ILLUSTRATION; THE RAJHRAD ALTARPIECE; THE ST JAMES'S ALTARPIECE

Italian influences were strong around the middle of the fourteenth century. Then followed a withdrawal from Italian rationalism. This was a sign of crisis. Europe north of the Alps had roots sunk deep in the traditions of medieval symbolism. It objected to the influx of the Mediterranean outlook based on Antiquity. The crisis reached its peak in the last decades of the fourteenth century and around 1400, and continued far into the fifteenth century. But it did not have the same intensity in all spheres of art. It appeared most clearly and rapidly in painting, while stone sculpture, with its close links to the masonic lodges, for a time at least partly maintained a rational basis and an objective attitude. Finally here, too, relative visual considerations made way for a subjective world outlook.

Even in architecture, least influenced by Mediterranean trends, the visual and spatial tendencies developed in similar manner. To a certain extent this can be conceived as a continuation, or rather return, to the Gothic, whose spiritual conception of the universe was, for a time, hidden or obscured by the urge to know the objective world, that is, the world which exists outside of Man and is not bound to the religious, anthropocentric system of knowledge.

This process was in no way limited to the Czech Lands. Italian art around the year 1400 was undoubtedly more Gothic than at the time of Giotto. In the West, too, these irrational tendencies were very strong at the end of the fourteenth century, even though they partly appeared as a development of visual experiences.

Czech art closely followed the general European trends, but deduced more radical consequences. The abandonment of the rationalism and empiricism of the time of Charles IV was hence more noticeable in the Czech Lands than elsewhere in Europe. To a greater degree than in other countries, advancing scepticism broke down the generally valid and therefore objective model of the universe, as established by scholastic philosophy and theology. The social system was undermined by growing class antagonism. The contemporary world grew more and more uncertain. This led to an escape into private contemplation, personal experience and pleasure.

King Wenceslas IV, who ascended the throne on the death of his great father in 1378, became a representative of this new psychological attitude. His interests differed entirely from his father's. His private pleasures meant more to him than the official duties, administration and matters of international policy. He paid greater attention to the building of his own castles than of churches. He took pleasure in collecting books, from which he derived personal enjoyment, rather than relics of saints, which might add glory to his realm. With the exception of the Old Town Bridge Tower, whose foundations had been laid by Charles IV, no building erected under his rule and with his encouragement had the same official character as those his father had commissioned. Pastimes, it appears, were an important part of his private life. Such pastimes included the newly established Orders, for example the Order of the Hoop and Hammer, whose member he probably was. The Court ceremonial embraced perhaps an Order not unlike the Order of the Bath, the foundation of which is ascribed to Wenceslas' brother-in-law Richard II. For the motif of the Bath Attendant appeared on many royal manuscripts, and on public buildings, for example the vault of the gateway in the Old Town Bridge Tower.

It has been suggested by Panofsky that such Orders came into being in the second half of the fourteenth century to rally the highest strata in society to the idea of keeping power within their own hands. The importance of the Orders lay in their exclusiveness. They give us a picture of the state of the society that gave rise to them. Uncertainty, and social unrest which threatened to break out, and, indeed, did so from time to time, encouraged the longing for social exclusiveness, founded on artificial rules of social behaviour rather than on real power. The artificiality of the way of life can be traced even in the arts.

In life there was a longing to make full use of all its sensual gifts, mingled with an apprehension of the vanity of all things human, and fear of the after-life. In the arts, too, the trend toward sensuousness revealing new aspects of life mingled with irrational mysticism, and a withdrawal from sensuous values. It is no mere chance that the concept of melancholy acquired a new meaning and the romantic idea of the dance of death assumed its typical form. Simple life as a theme penetrated into poetry and the arts. This discovery, too, was of a romantic character. In the *Wenceslas Manuscripts* the Queen appeared as a bath attendant, a typical expression of this romanticism. This was nothing but an escape from reality, infringing upon the protected social privilieges, foreboding the approaching tempest.

When this tempest broke out in the Czech Lands with great force in the Hussite Revolution, the existing social system was uprooted. But first Czech art reached the period of the Beautiful Style. This developed out of the art of the eighties, bringing some of its features to their logical culmination. But at rockbottom it differed. Typical of the art around 1400 is the abatement of conflicting views of the world. The contrasts of the

sensuous and the spiritual, the real and the ideal, the ugly and the beautiful, the good and the bad came closer to one another, forming some kind of idealised picture of a world that barely knows contradictions. The dramatic accent of the art of the eighties disappeared and gave way to idealism, a languishing sweetness, too passive to retain any of that ironic attitude to the world fostered in the preceding period. Art was based on the principle of paradox, attempting to reconcile two irreconcilable contradictions: the real and the unreal, the natural and the artificial, the sensual and the spiritual, the traditional and the new, the conventional and roaming fantasy. These antitheses became mutually fused, creating an inner tension, which appeared as wilfulness, ingenious peculiarity, playfulness.

At the same time this tension was an expression of the contradictions of the world Man lived in, which could no longer be explained by an all-embracing system of ideas. The all-comprehensive idea was replaced by perfection of execution. In the early Middle Ages, precious material was considered beautiful, for it referred to the abstract sphere of ideas. Now beauty of execution became admired, something that was only vaguely connected with ideal values.

It is probably no mere chance that the statues of the time were often called 'beautiful'. One can understand the opposition to this art voiced by religious reformers. John Huss, for example, criticised the pictures of the holy Virgins which people admired for their beauty and which roused sensual excitement in men. He similarly disapproved of contemporary fashion as it stressed the erotic function of dress far too much. Much of this is reminiscent of the situation which occurred in the sixteenth century. And indeed the Beautiful Style is, among others, an ingenious reaction to the naive realism of the earlier period of the reign of Charles IV. Its character was typically Mannerist.

Mannerist features appeared in all the arts. Architecture had lost its unifying and determining function and continued to move towards unified interior space. The bare and unarticulated wall enclosed a space of equal disposition, spreading freely in all directions. The architectural members became released from structural subjection. Similarly, walls and vaulting became separate entities. In extreme cases there was a complete separation of these two basic constructional elements where the design of the vaults did not fit in with the ground-plan. This shows that the vaulting patterns, mostly of intricate character and often breaking into the rhythm of the supporting members, had their own aesthetic value. As we shall see, they were appreciated as such. The constructional elements lost their structural function, or at least this function became hidden, for example the cylindrical pillars upholding the vault became so slender that it seemed impossible for them to uphold the thrust of the roof. Elsewhere the ribs entirely disregarded the structure and their consoles adopted fantastic, irregular shapes. The subjective, almost arbitrary fantasy, the liking for surprising solutions resulting in uncertainty and instability expressed the basic feelings of that unstable period with remarkable precision. The initial steps taken here were later used in Central European and particularly south German architecture of the late Gothic period.

These inclinations can be traced in a developed form on the buildings made for Wenceslas IV by a masonic lodge set up specially for this purpose. The buildings were universally of private character, serving the King's private needs. This is just as typical as is the newly gained freedom and creative liberty which appeared here. This even affected the builders who continued work on the Cathedral. The lodge was run partly still in Peter Parler's lifetime by his sons, Wenceslas and John, and after them by Peter, called Petrlík. To cite a typical example: the laying of the foundation stone of the nave, in 1392, was only of symbolic significance. All energy was devoted to the high tower which was to crown the ceremonial south porch. It remained, however, incomplete when the Hussite wars broke out.

Similarly, after the grandiose initial building phase the immense cathedral church of St Barbara (sv. Barbora) at Kutná Hora remained a shell and was finished of necessity and prematurely only in the sixteenth century. It was a sequence to Parler's choir of St Bartholomew's church (sv. Bartoloměj) at nearby Kolín. St Barbara's, however, was not a royal building, but a symbol of the status of the Kutná Hora burghers. The royal Court had lost interest in large, representative buildings. They became the concern of the towns and of certain powerful aristocratic families, mainly the Rožmberks.

At the time of Charles IV Prague had been a centre of feverish building activity, one in which new architectural features were being invented. Now the city lost its leading position and its example was taken up and generally applied not only in various provincial centres of Bohemia and Moravia, but far beyond its borders. Most of the important buildings of the time came into existence outside Prague, especially near Kutná Hora and in southern Bohemia.

The builders of St Vitus's Cathedral were occupied mainly with the big tower. It was apparently begun soon after 1392. Its ground-floor had probably been designed by Peter Parler, but its upper two storeys and the south front wall of the transept were designed by his successors. The growing decorative effect is an outer sign of the advancing changes in style leading to a concealment of the structure itself and the suppression of structural function. The traceries of the corners of the south wall of the transept continue without regard to the cornice upwards to the balustrade where they are bound by three semi-circles, facing downwards. The side ones are unfinished and in the imagination can continue beyond the given architectural frame. These traceries cover the balustrade set in the second plane. The central semi-circle placed in contrast to the already steep pointed arch of the window breaks up the upward thrust. On the other hand, the lateral quarter arches form an upward-rising ogee arch ending in a finial. All this proves that the logical structure was suppressed for the benefit of formalist intentions. This is equally true of the canopies on the flying buttresses of the tower, which hang from the shafts and are not placed on them. The endeavour to avoid sudden clashes of architectonic forces and to make the dramatic Parlerian form more lyrical is reminiscent of painting and sculpture in the Beautiful Style. This refined Parlerian art had its continuation in the tall tower of St Stephen's in Vienna. In all probability

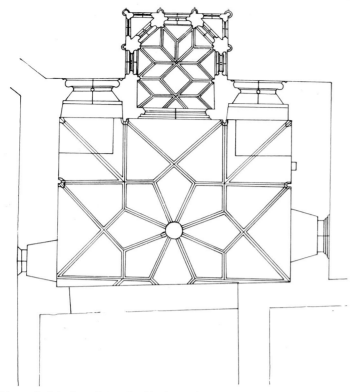

13 Plan of the chapel in the Italian Court at Kutná Hora. c. 1400

the master's son, Wenceslas Parler, worked on this tower several years before his death.

The builders of St Vitus's tower were still bound by the orders of monumental architecture and the necessity for adapting their work to the older phases of the building. But the masons who worked on the secular buildings going up on the King's commission and on some churches for Queen Sophia did not have to bear in mind any such considerations. Thanks to Menzel we know today what liberties they took with the architectural system they inherited. Subjective tendencies reached a radical point where the old order was breaking down; for example the oriel chapel at Krakovec castle, consecrated in 1384, the hall of Točník castle, the Hall of Columns of Prague castle, and especially the most important building of the kind, the royal chapel of the Italian Court at Kutná Hora. There occurred a complete alienation of wall and vault, which came to be considered an autonomous, aesthetically effective element, unconnected with the ground-plan. The vaulting pattern exceeded the size of the room and continued beyond it in the spectator's mind. The ribs were attached away from the capitals of the rounded shafts which were used only to give stress, by their structural form, to the non-structural vaulting system. And there were a number of other means which aimed at breaking down logical links between architectural members.

The external appearance of the building likewise included remarkable novelties. The oriel-type presbytery of the chapel covered by net vaulting of the type used in St Vitus's had a polygonal apse. This is externally visible only in the upper part, while the square lower part is hidden under blind arcades and canopies; their shape can be derived from the canopies of the tall tower of St Vitus's. This fictitious square ground-plan, analogous to Parler's liking for squares, is of purely aesthetic importance. It is of the same origin as the regular square

star vault of the nave placed above the irregular oblong ground-plan of the interior. The ideas expressed in St Vitus's further developed, for example in the inner windows of the canopies corresponding to the inserted windows of the St Vitus's choir. Reports have survived that the last of Wenceslas' castles, Nový Hrad near Kunratice, built in the years 1411–1417, is the work of the builder Kříž. It is, therefore, probable that he was the head of the King's masonic lodge, which also worked on two churches built for Queen Sophia, the basilican parish church at Chrudim and the parish church at Dvůr Králové with two naves of equal length and height.

The example of St Vitus's penetrated far beyond the Court circles. It made itself felt especially in south Bohemia. The builders working for the Rožmberks had grown up in the local tradition with the Augustinian church at Třeboň as a good example. They adopted Parler's vaulting system and produced variants of it. Parler's influence in south Bohemia was promoted through the parish church of St Giles (sv. Jiljí) at Milevsko. Its double nave was vaulted in the Třeboň manner, while the vaulting of the presbytery is a variation of the net vaulting of the gateway of the Old Town Bridge Tower. It was designed in a way to attain a series of mutually interspersed six-pointed stars. In the sacristy they used the vaulting scheme of the St Vitus's choir. In Menzl's view the pattern for the Milevsko choir vault was derived from the All Saints' church (Všech svatých) at Prague castle.

The Milevsko church is closely connected to the most important building in southern Bohemia at the time, the church of St Vitus (sv. Vít) at Český Krumlov. This was built on the site of an older church. The new one was built on the initiative of a Krumlov parish priest Hostislav. The contract for the church vault is dated 1407, by which time the walls must have been completed. It contains the name of the builder John, and his brother Kříž, the nephews of Master Staněk (that is, a whole family of builders). It also includes a report of how the Parlerian vaults spread through southern Bohemia. For the contract states expressly that the vaulting of the choir was to be done on the Milevsko pattern, as indeed it was. It is quite likely this family of builders, which may have been connected with the St Vitus's masonic lodge, had participated in building the church at Milevsko. At Krumlov the Parlerian elements can be found mainly in the vaulting, which, in the choir, is identical to that found at Milevsko. In the nave it is a variation on the St Vitus's choir: lozenges made by the interpenetration of two pairs of parallel diagonal ribs are of equal size here. In the sacristy the vaulting pattern came into being by the interpenetration of two eight-pointed stars. This scheme, which is genetically connected with the older Cistercian vaults, was used by this lodge also in the building of Krumlov castle, particularly the sacristy in the St George's chapel (sv. Jiří). It was the intention that these vaulting patterns should overlap the borders of individual compartments and give unity to the interior space. In the nave of the Krumlov church of St Vitus these patterns form a sort of infinite strip from which as much was cut off as was needed for the given length of the place. Furthermore, the flamboyant traceries were of Parlerian origin, while the spatial layout of the nave, the aisles and the choir dates back

to the Třeboň tradition, for example, in the vertical character of the proportions and the softness of the dignified slender forms that rely on light effects.

The Krumlov lodge seems to have been of considerable importance in spreading Parlerian and south Bohemian architecture along the Danube basin. If Fehr is right – in assuming that Hans Krummenauer was a relative, or even a son of the Krumlov builder John mentioned above – we should have here a rare direct example of how a Czech family of builders left an important mark on the history of architecture in the Danube basin. In the first half of the fifteenth century a reverse movement began to take shape, and late Gothic architecture of the Danube region began to affect the Czech Lands. Not only in south Bohemia but also in other parts of the country architecture of great value was coming into existence. Everywhere the specific preceding development reached unusual refinement and perfection of form. Many of the buildings are of smaller size, where this could be easily applied. They suited the preference for small, perfectly executed form, characteristic of the time. Typical examples include the cemetery chapel at Sedlec, which even today, when its original vaulting is lost and the chapel is partly adapted to Baroque style, still gives an impression of balance with its refined proportions and purity of masonry work. Another example is a small church of the Holy Trinity (Nejsvětější Trojice) in nearby Kutná Hora. Everything in its centralised interior of almost square ground plan that might give it direction or subdivide it has been suppressed. Four fragile columns, out of which the ends of thin ribs run, give an impression of spatial unity rather than breaking this up.

Even if there is no direct contact with the Parler tradition here, his influence can be quite clearly traced elsewhere, for example, in the monastery church at Panenský Týnec whose construction was interrupted in 1410, the church being left incomplete. The broad hall-type triple nave contrasts with the elongated choir, the shafts of which were still composed in the traditional linear style. The Parler influence can be felt in the south portal, whose connection with the north doorway of the Týn church in Prague (see later) emphasises the advancing non-structural function of architectural members and the picturesque surfaces of the building material. We can find proof of the paradox formulation of relationships and the liking for instability in the broad pedestals of the vanished figures on the jambs of the doorway supported by slender columns on which the pedestals form structurally unstable capitals.

* * *

In sculpture, too, the eighties were an exceptionally complex time. The realistic style of the preceding decades was still in force. But opposition was arising to the descriptive manner, which restricted the meaning of works of art and limited their function to the depiction of the physical world. This opposition had, in fact, always existed while artists were acquiring more experience; now it set forth its own programme comprising several aspects: grotesque caricature which perhaps contained underlying scepticism; poetical idealisation which sought in the stylisation of natural forms a means both of conveying and of embodying reality in the total religious image of the world; the fantastic which sought meaning in the world without the

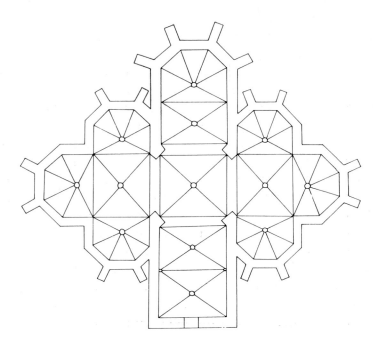

14 *Plan of the destroyed Corpus Christi chapel in Prague. After 1382*

aid of rational control; and non-committal capriciousness, in which reality was merely an object of manipulation according to rules set down. It is difficult to distinguish them precisely and often they fused, one or the other aspect rising to the fore. Their common denominator was romantic unreality.

Some of these features of the eighties pointed to the past. Others pointed to the next period which they foreshadowed. Among the former were the realistic qualities, sometimes tending to rational articulation, sometimes to sensuous unification. The latter include the trends towards stylisation of different kinds. The strength of their mutual impact became a characteristic feature of the period, so that one can truly speak of a style of the eighties. This contradiction becomes clear in any examination of pictorial art. In the last decade the situation became simplified as one of these poles assumed a dominant position.

Out of the complex and confused background of contemporary sculpture there appeared one group of works, in all likelihood associated with the name of Heinrich Parler. He has been mentioned as the artist, or co-artist who made the statue of St Wenceslas in 1373 and possibly that of Wenceslas of Radeč. The same full, self-contained, precisely defined form based on a geometrical pattern can be found in the outstanding *Pietà* in the Augustinian church of St Thomas (sv. Tomáš) in Brno. It was made at a time when Heinrich Parler worked there for Margrave Justus, the son of Charles IV's brother John Henry, as the 'magister structurarum lapicida et familiaris' (1381–1387). The work is related to Heinrich's sculptures made in Prague. Moreover, the monastery of St Thomas had close contacts with the Moravian Luxembourgs, Heinrich's employers. The St Thomas's *Pietà* is above lifesize and its grand conception shows links with architectural sculpture. It is the most outstanding example of the horizontal type which came into being in the Parlerian circle in Prague or Brno and rapidly spread over Europe from the Rhine to the eastern Baltic states and from the Baltic Sea to central Italy. In each place transformations were made according to local conditions and the time of origin.[32] It was an important step in Parlerian sculpture when,

after the vertical type, connected, in form and composition, with the expressionist trends of the first half of the fourteenth century a new type emerged. The new horizontal type was concerned with the correspondence between art and the material world. The perfect balance between the vertical Virgin and the horizontal figure of Christ, the compact solidity of form, the precise, even though simplified description of the bodily parts, the restrained stylisation of the draperies, and the reserved, though impressive facial expression and gesticulation, together with the strict geometrical layout represent a self-contained type of sculpture. It differs thoroughly from the emotionally shapeless vertical type whose centre of idea and movement lies beyond the sculpture itself. The geometrical design, based on a precise square and on predominantly right-angles, in itself expresses the secular aspects of the subject and its close links with the real world, although, at the same time, it contributes to its representative character, withdrawn from the course of time and therefore static.

Other sculptures on this subject follow the same principles. Most of them are connected with the St Thomas's *Pietà*; some were obviously made in the same workshop: the *Pietà* in

15 Plan of the church of St Giles at Milevsko. Romanesque foundation, rebuilt in c. 1390

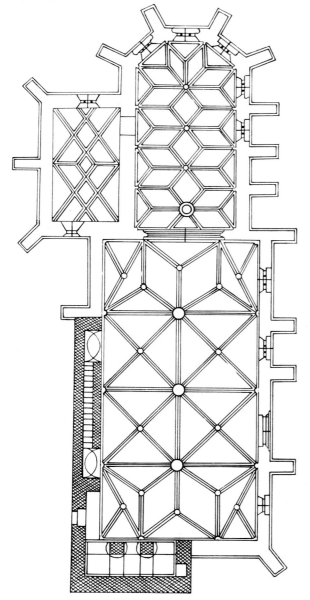

St Mary Magdalene's at Wroclaw (Breslau), today destroyed, or another from Lutín near Olomouc, today at Šternberk castle. A few stone and wooden Pietàs in the Bohemian countryside and in Prague, partly made by other, non-Parlerian sculptors, show that this type was widespread even there. It can be assumed that it originated in the St Vitus's lodge. The fragmentary *Pietà* in St George's in Prague shows that Parlerian sculptors even produced the vertical type. But they changed it by introducing elements of the real world. Historically the origin of the new type is important since the 'beautiful' Pietàs of the following decade derive from it.[33]

The sculptures on the Old Town Bridge Tower also belong to this current of sculpture. The tower construction had been begun under Charles IV, but the ornaments date from the eighties. They have survived only on the eastern side, while the western ornaments were destroyed during the attacks of the Swedish troops in the seventeenth century. As the building stood along the royal route taken by the Kings of Bohemia during their coronation procession, the iconographic programme was related to this act. Charles IV and Wenceslas IV sit under a canopy by the side of a model of the Charles Bridge. Between them stands St Vitus on a raised dais, surrounded by the coats-of-arms of Bohemia and the Empire. The figures of other patron saints of Bohemia, SS Adalbert and Sigismund, are placed on the upper, window zone of the tower. The others were probably to be found on the destroyed western side. Surprisingly enough, there is no St Wenceslas. He is represented only by the spread-eagle on the top of the gable above the main group with the two kings. Wenceslas IV's private coat-of-arms, the kingfisher in the love-knot is repeated over and over again, and the roof of the gateway has pictures of bath-attendants, well known from the King's manuscripts. The figures are typical for work associated with the name of Peter Parler. But he can hardly be held personally responsible for the sculptural decorations of the tower. It can be seen that some figures are looser in construction, the folds are less moulded and the forms lighter, smaller and in some cases more mobile. St Sigismund, in particular, has an uncertain posture and an undulating rhythm of draperies, indicating a departure from Parler's strictly realistic approach.

Another trend in Prague Parlerian sculpture, which we met in the busts of the upper triforium of the St Vitus's Cathedral, is found in the eighties on the sculptural ornaments of the Týn church. Outstanding is the relief tympanum of the north porch with the theme of *Christ's Passion*. The overall design was given by a geometrical layout, with the square and the circle as basic elements. But the conception of the subject differs from all that we met within the circle of Heinrich Parler, and the sculptor also used different means. In Heinrich Parler's circle we saw attempts at depicting objective reality in its basic features and an attempt to set them apart and give them a permanent, changeless form, whereas here an effort was made to depict current events, dependent on a given moment in the course of time. The result is movement, which relaxes only in the central strip where Christ appears three times. The figures give full expression to their emotions, ranging from ridicule and anger to desperate pain. The modelling avoids

closed, rounded volume and breaks it apart by profound incisions, with shadows and lit-up sections. The impression is one of crowded movement, in which only the figure of Christ forms an island of calm. The sculptor was not afraid to exaggerate movement into caricature and to intensify facial expressions, turning them into grimaces with a touch of irony. He was interested in the detailed description of fashionable garments. He had a feeling for spatial planes in movement and for light effects. He knew how to fashion psychological differences. These qualities place him among those Parlerian sculptors who aimed at an overall shape. At the same time, they place him close to the romantic trend of the eighties, shown especially in painting: in the earlier illustrations of the *Wenceslas Manuscripts*, the *Brunswick Patternbook* (particularly close to the Týn tympanum) and, in certain respects, to the work of the Master of Třeboň and his circle.

Related to the Týn tympanum to a certain degree is the *Virgin and Child* of the Old Town Hall, probably made just before 1381, when the Town Hall chapel, on whose corner it stood, was

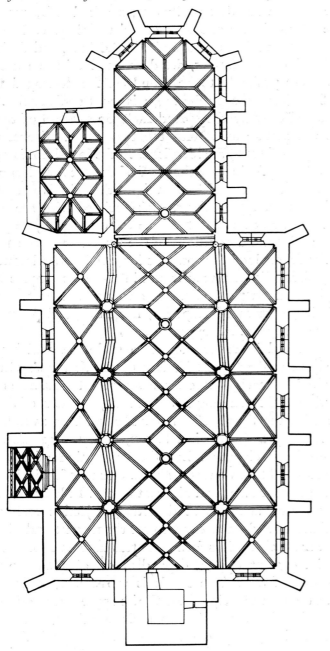

16 Plan of the church of St Vitus, Český Krumlov. Before 1407–1439

consecrated. It is related in the uncertain manner of modelling, where form is built up out of the coherence of the parts rather than by differentiation between them. But the mighty bulk of the figure, the balanced contraposto, the logical build-up founded – as was current in the Parler circle – on a precisely elaborated geometrical pattern, and certain aspects of the draperies, show other connections. These lead, on the one hand, to the Bohemian wood sculpture in the third quarter of the fourteenth century, on the other, to the Franco-Flemish region where a certain analogy can be found, as for example in the *Virgin and Child* of the south-west portal of the pilgrimage church at Hal near Brussels.

The rather unusual, 'pelerine', type of the Old Town Hall *Madonna* undoubtedly originates from the Ile de France. It was known in Bohemia at the beginning of the sixties and later penetrated as far as Austria.[34] The *Madonna* in the chapel of St Giles in St Stephen's, Vienna, is remarkably close to the Old Town Hall statue, even though the manner in which the almost identical motifs were treated differs greatly. It has never been exactly determined which of the two statues was the earlier, but it is clear that each of them derives from a different tradition in sculpture.

The *Virgin* from the Old Town Hall in Prague has sensuous form hiding the geometrical design and hidden linearisation though, at first sight, it seems almost spontaneous. What is more important is the continuous movement in all parts of the statue. The sculptor possessed a feeling for organic composition, and this, together with the monumental function of the statue, prevented this movement from becoming a determining, organising force, as happened in the *Virgin* from Zahražany. The latter of course was made of wood. The wood-carvers, not being dependent on architecture, were freer in the selection of means, more willing to express radical trends, and found it easier to take over stimuli from painting, so close to carving. That is why the carvings of the eighties clearly show this renewal of linear stylisation, which, at the end of the century, was to lead sculpture and painting out of the sphere of empirical knowledge towards poetical metaphors. Very few good works of this type have survived. Those that do still exist originate from the borderlands of Bohemia while in central Bohemia, and particularly in Prague, stormy historical events and the destructive attitude of later styles led to the almost complete destruction of the former wealth of examples. The few surviving pieces of good quality show the remarkable level of this sculpture. The monumental *Virgin and Child* in the parish church at Žebrák, *John the Evangelist* in the Augustinian church at Třeboň, a remnant of a *Calvary*, from which we also possess the *Crucifix* (Hluboká Gallery) or the *St Nicholas* from Vyšší Brod (National Gallery, Prague) show the feeling for beautiful, rhythmically moving lines, with garments flowing in long, smooth, overlapping folds, some of which reach down to the ground. Although the surface of the statue remained softly flowing, the linear organisation affected the formal structure and even determined it. While the expression of the Žebrák *Madonna* retains some of the seriousness of the earlier fourteenth century, other statues of this time show clear trends towards a more lyrical form, a softening of the

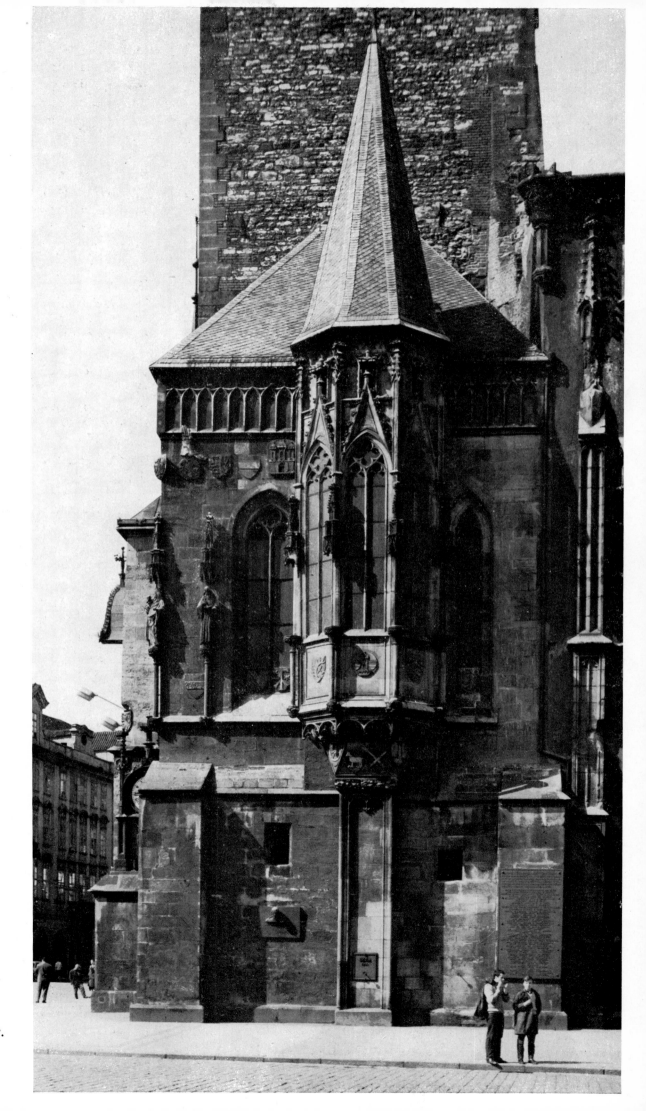

95 *Old Town Hall, Prague. Oriel window.*
Before 1381

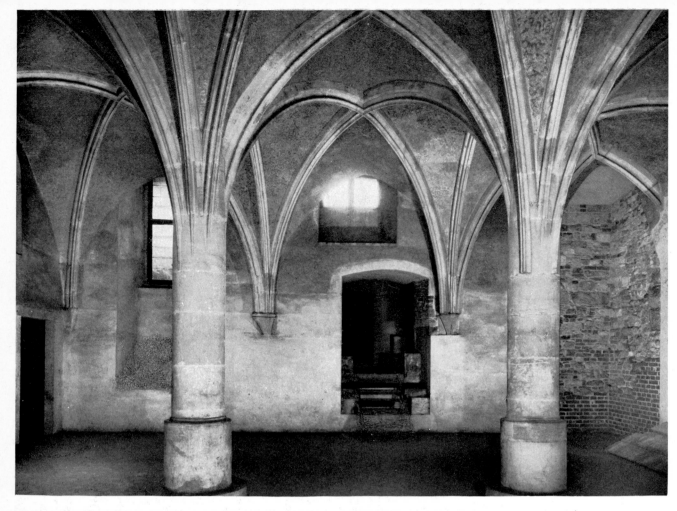

96 Royal palace at Hradčany, Prague. Hall of Columns. c.1400
◄

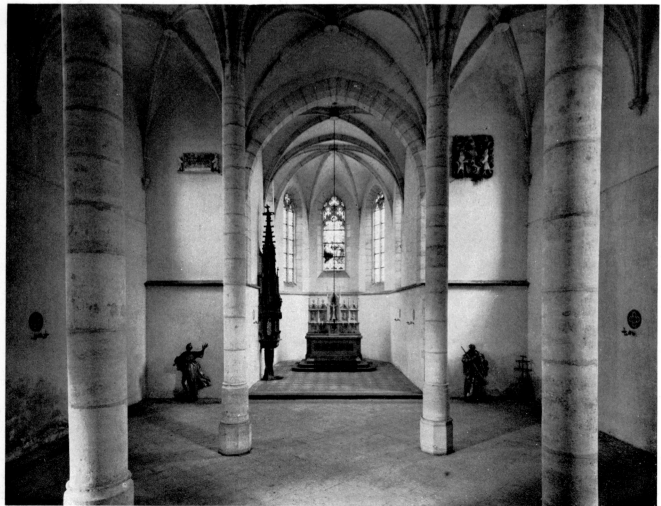

97 Holy Trinity church, Kutná Hora. Early fifteenth century
◄

98 Church of Our Lady before Týn, Prague. West façade. End of the fourteenth century, towers finished in the second half of the fifteenth and early sixteenth centuries
►

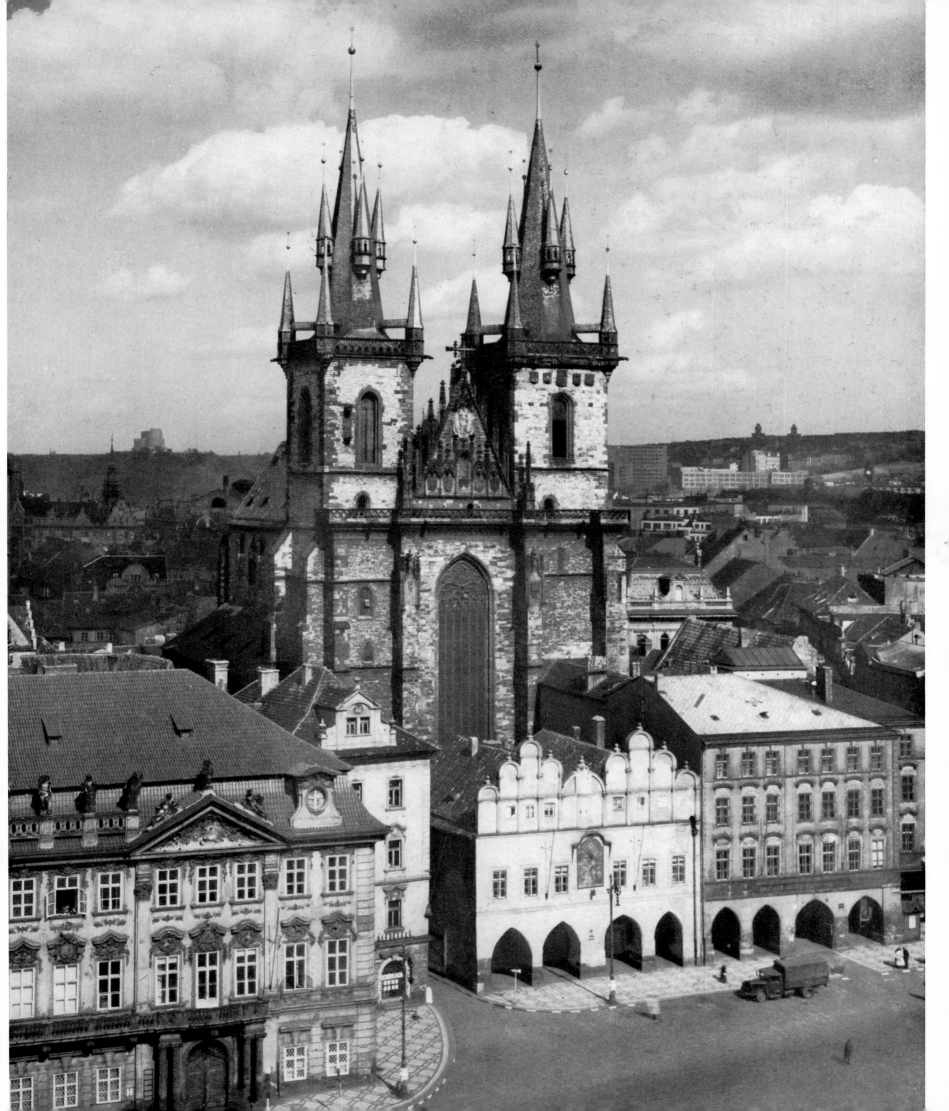

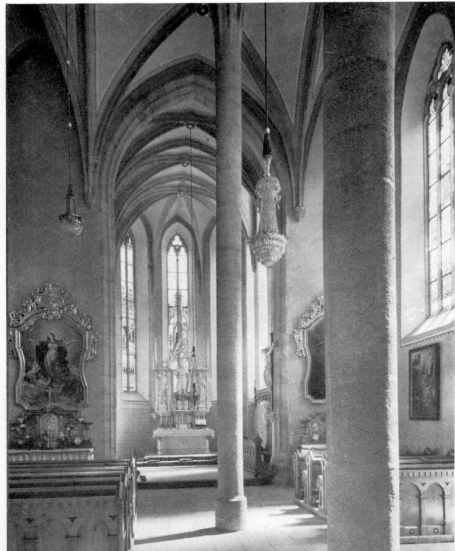

99 Italian court, Kutná Hora. Oriel window of royal chapel. End of the fourteenth century

100 St Vitus's church, Soběslav. Nave. Last quarter of the fourteenth century
◄

101 Church of the Augustinian monastery, Třeboň. Monastery founded in 1367, church finished after 1380
▶

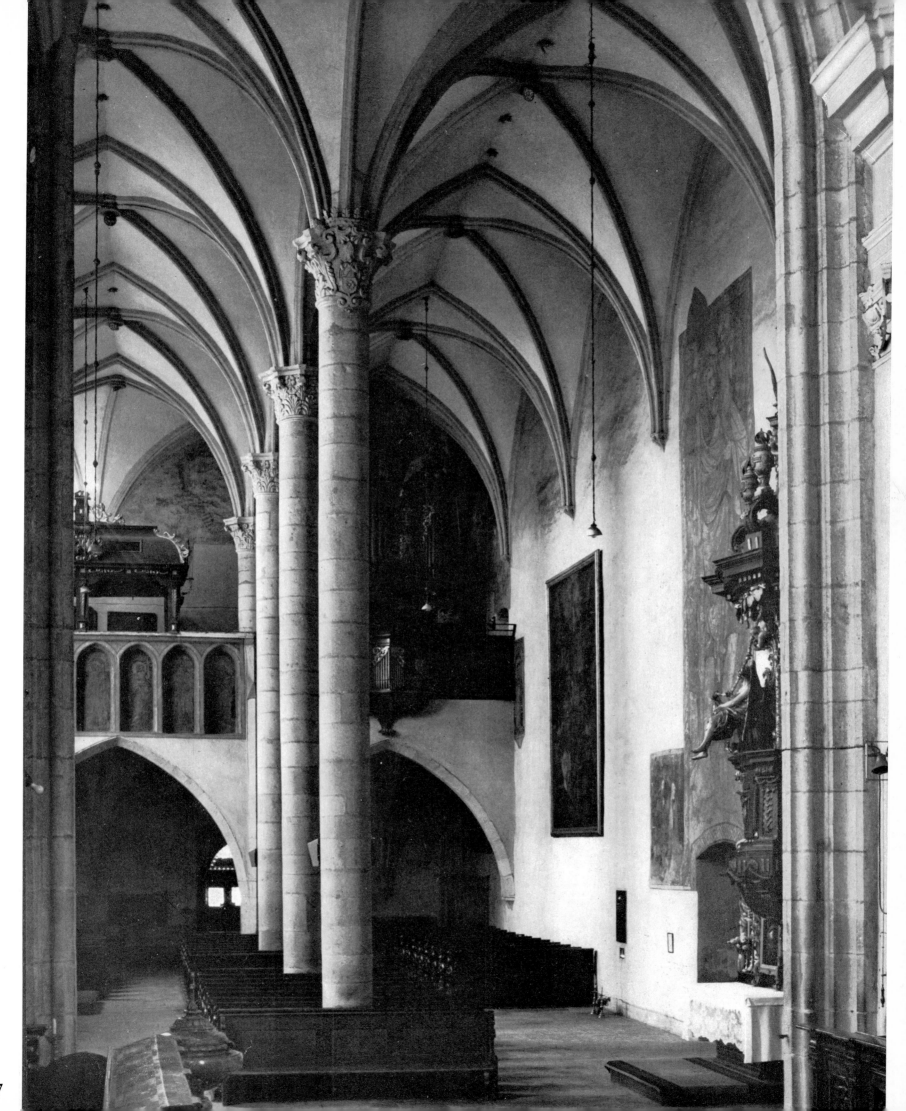

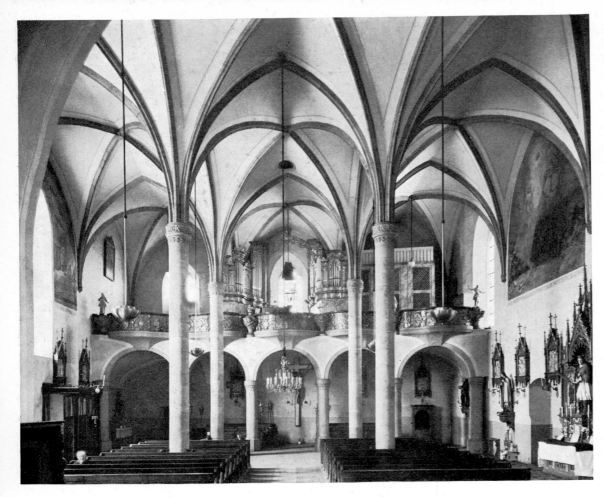

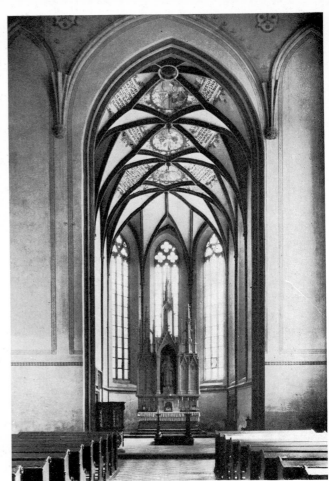

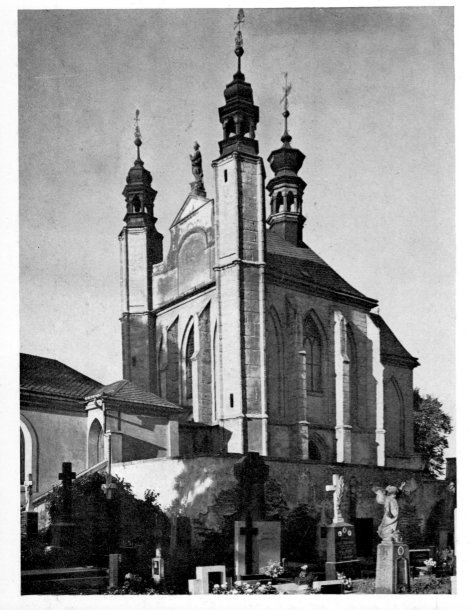

102 *Parish church, Dvůr Králové. Nave and aisles. c. 1400*

103 *Church of St Giles, Milevsko. Presbytery. End of the fourteenth century*

104 *Cemetery chapel, Sedlec. c. 1400*
◄

105 *St Vitus's church, Český Krumlov. Before 1407–1439* ►

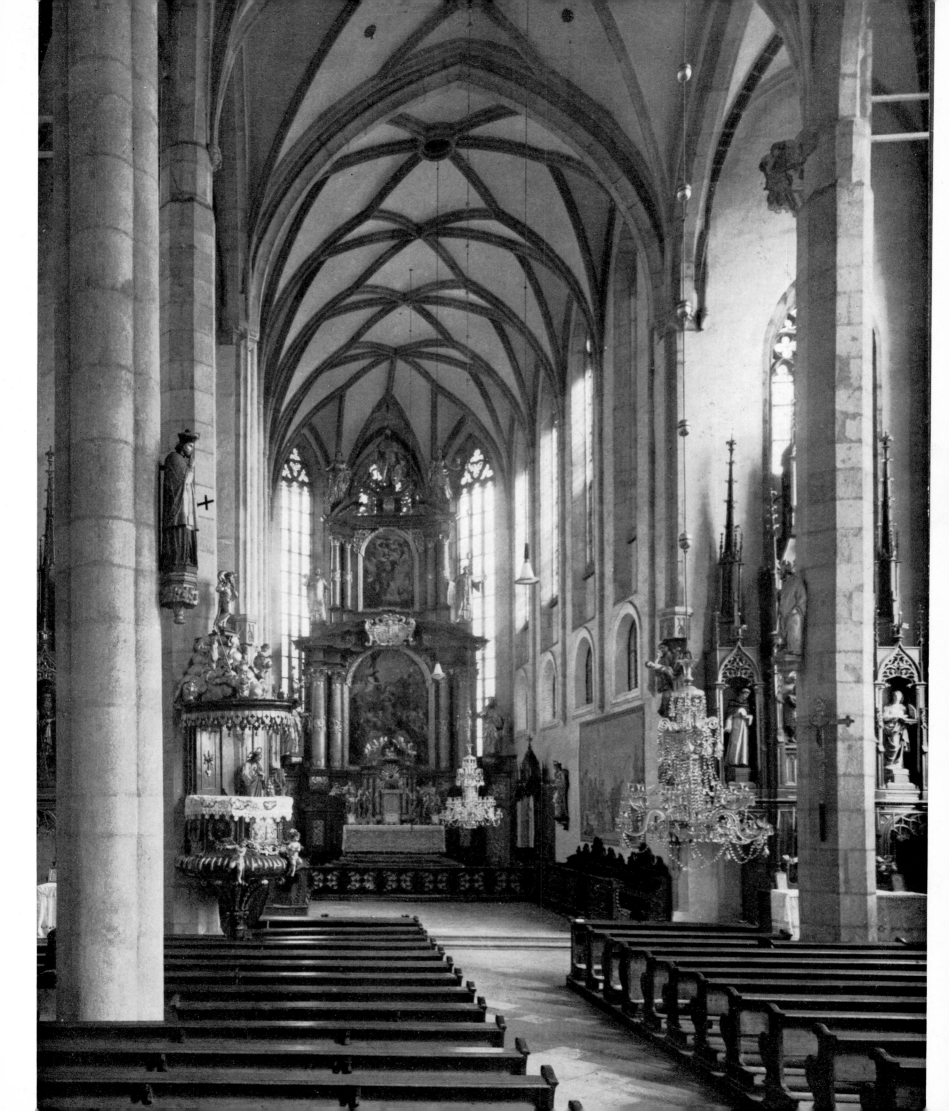

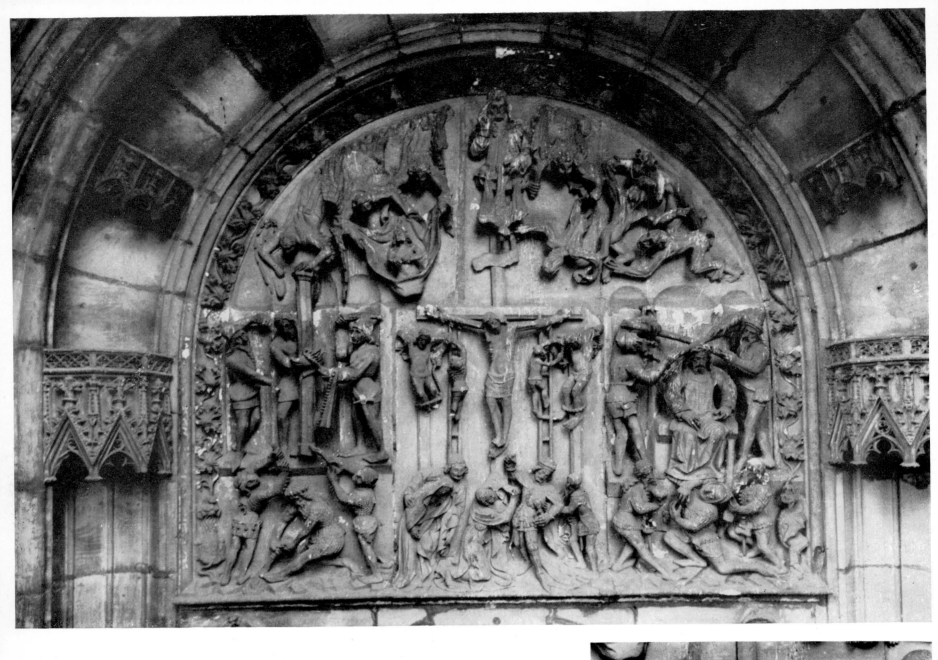

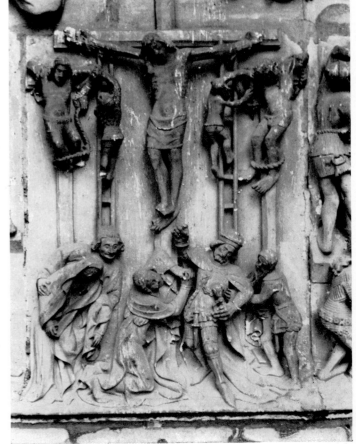

106 Church of Our Lady before Týn, Prague. North portal, tympanum. 1380 to 1390

107 Church of Our Lady before Týn, Prague. North portal, detail of tympanum. 1380–1390

psychological content in which passive melancholic resignation replaced the resourceful energy of Parlerian sculpture of the seventies. This resignation of Man to the forces beyond him was a sign of a Gothic revival which was taking place at the time. Many of these features recall the work of the Master of Třeboň and may be the result of his direct influence. Some of the heads on these carvings are very close to his painting in type. This is true especially of the charming bust of a Female Saint from Dolní Vltavice (Hluboká Gallery), whose face gives the impression of having been copied from the Master of Třeboň's female faces. This development can be well observed if we place by the side of the Žebrák *Virgin* the *Madonna* from the church at Kozojedy, which appeared on the threshold of the Beautiful Style.

* * *

At the end of the century the situation grew simpler. The variety of aims and means which we have been able to observe in the art of the thirteen eighties gave way to a unified style. It still contained some contradictory elements, but there was a definite unification of aesthetic norms. Artists no longer tried to depict a visual and spiritual unity, where individual things had a meaning only in relation to it. On the contrary, the individual figure, isolated from its environment, became the subject of this art. The tension between intensity of visual experience and the conceptual and emotional transformation of real elements, between chiaroscuro uniformity of space and the renewed stress on line, between the ability to depict the variety and contradictions of the visible world and the transcendental idealism of the overall concept (which had given the works of the Master of Třeboň the peculiar charm of something uncertain, incomplete, mysterious) all this was now replaced by a turn towards clear, even if intricate organisation, towards precise definition and the isolation of figures from their visual and meaningful context. This isolation, which produced a style of individual figures, led the way to refined virtuosity. As in all late phases of a style, certain features that had previously expressed a given meaning became independent and took on their own meaning. In the eighties, solemnity was necessary to express religious and human truths. Now this serious attitude changed to capriciousness. Yet this capriciousness, too, had its human significance. It was an expression of Man's position in the world, and his uncertainty among collapsing social and spiritual values. The consequence was subjective fantasy, which disregarded objective conditions and established its own conventions. These conventions, strangely enough, acquired ornamental regularity. They became generally valid because they were easily understood and because their emotional content befitted the social and psychological mood of the time. This art was at its best when representing the emotional sphere of youth and childhood whose natural capriciousness suited its basic principles. The Virgin, the most frequent theme of the time, always appeared as a girl or young woman even where she holds her thirty-three-year-old dead son on her lap.

Fragility, as if threatened by a shock from outside, appeared not only in the predominance of sculptures representing women – for most statues were devoted to the Virgin or female saints – but also in the striking effeminacy even of the male figures. The passivity of the figures is visible in their relaxed postures, which are, however, the result of careful calculations. It is equally visible in the faces, particularly those of women, which have a refined innocence, out of place in these tragic scenes. But then this art did not set out to be truthful. Only the faces of the men, particularly old men, retained some attempt at characterisation. This characterisation intensified with the increase in technical skill, which was appreciated as an aesthetic value. It was applied mainly in the figures of children, a motif which, in itself, comprised sufficient poetical tension to appeal to the emotions without needing intensification by formal metaphor. The children of the beautiful Madonnas are among the most natural, if not the most natural sculptures of children since Antiquity. This is more striking since they are part of an artificial organism, in which each body movement and the folds of the robes were carefully calculated and stipulated *a priori*, that is, without regard to natural relationships.

The folds of the draperies were one of the main features of this style. They move with an undulating rhythm in long beautiful curves, the overlapping course of which sometimes reaches right to the ground. Like the parts of the body, these folds were worked out with minute precision. They rely on the effect of the shadows that penetrated the deep incisions. This contrast between the impermeability of the parts and the spatial differentiation of the whole is one of those paradoxical contradictions often found in this art. Furthermore, its clearly historical trend, its capriciousness, its lack of stability and disregard for the law of gravity, its fairy-tale unreality and melancholy nostalgia are remarkably similar to sixteenth-century Mannerism, which grew out of similar social and psychological conditions. It should be borne in mind that it had a similar canon of proportions. The sixteenth century Mannerist *figura serpentinata* has many analogies here.

The linear character of the art around 1400 for which the term Beautiful Style has been coined was not at all in keeping with its time. In spite of retardatory trends in the International Style, European art at that period was more and more approaching a visual image of the world. In Northern Europe, painting was assuming a dominant role. But in Bohemia the process taking place ran counter to all of this. To be more precise, these trends appeared more consistently than elsewhere in the Czech Lands even though, as we shall see, there existed here, too, a second pole of contemporary Northern European art. It was natural that at first the tone was set by sculpture and the main sculptors of the time became leading figures of the style.

The Beautiful Style in its advanced form is represented by two groups of sculptures. One is centred on the popular *Madonna of Krumlov* (Kunsthistorisches Museum, Vienna); the other on the *Virgin and Child* from the church of St John at Torun (now lost). In the first group, the principles of the style were developed down to the details, and Mannerist features are clearly noticeable.

The second group, though closely related, was more restrained in expression. The style retained some of the solidity and grandeur of Parler's sculptures. While the first produced many compositional variations, where each statue, in fact, became a prototype, later freely copied, the second produced very

homogeneous compositions, so that the one type was repeated without many variations. The compositions of the first group derive from crossed double diagonals, forming a rising zigzag line, enclosed, at the sides, by folds. The second group was composed asymmetrically, with broad curves that encircle the artistic and spiritual centre of the composition, the apple. This motif was important compositionally and is significant for the Torun group; it played little part in the group of the *Krumlov Madonna*. The posture of the latter group of figures was highly stylised, at times showing a highly sophisticated preciosity, as if it were a dancing figure. But it never exceeded the basic principles of contraposto: the burden (the Child) is always placed above the weight-bearing leg. The statues of the Torun group consistently denied this principle, for here it is the free-standing leg that bears the weight. This solution, an isolated case in the Middle Ages, was probably due to a desire to be different. Such an approach was hardly surprising at a time that enjoyed novelty and peculiarity.

The characteristic features which can be seen in the Madonnas from both groups apply to statues of all themes, made in workshops which we can only imagine must have existed. The repertory of subjects was not very extensive. Apart from Madonnas, most of the other works were Pietàs. Figures of saints were made in smaller numbers. There were hardly any portraits or narrative reliefs. The situation was similar in panel and mural painting. Only book painting retained some of its old narrative approach. The most reliable dates for the sculptures of the Beautiful Style can be deduced from painting. In panel painting we can find its typical features on the *Epitaph of John of Jeřeň*, produced in 1395 or shortly after. Clear influences of the *Krumlov Madonna* on book painting are found at the turn of the century, for example, in the *Korček Bible*, of 1400.

We possess a record of what is probably the oldest work in the Krumlov style, the *Madonna* in the pilgrimage church at Altenmarkt near Salzburg. It was already standing where it is today in 1393. From this we might deduce that the statue was of local origin.[35] However, the style of the statue is closely related to the Bohemian, not the Salzburg, sculptures of the last decade of the fourteenth century. Its Bohemian origin is, moreover, confirmed by certain external circumstances. In particular, the fact that an Indulgence dated 1393, which contains the first mention of the *Altenmarkt Madonna*, was issued in Prague (Vyšehrad) by Archbishop Ubaldinus Cambio of Florence, the papal nuncio and collector in Bohemia and consiliarius regis Venceslai. This probably coincided with the acquisition of the statue. In this connection it is significant that the Archbishop of Salzburg, Pilgrim, had close contacts with the Court of Prague for which he fulfilled certain diplomatic tasks. He paid several visits to Prague, the last in 1392, that is a year before the issue of the Indulgence. Since we have ample records that statues and pictures were exported from Bohemia to England, Strasbourg, Mainz and East Prussia,[36] it is more than likely that the *Altenmarkt Madonna* was acquired in the same manner from some Prague workshop.

The work is identical with the circle of the *Krumlov Madonna* in the decorative composition, the stylised, careless posture, the manner in which the Virgin holds her son with her two hands, the way her fingers press into the soft skin of the strikingly big Child, the sweet and sorrowful expression and the virtuosity of treatment. But certain differences can be observed. First, there is the soft treatment of the surface, which, to some extent, was conceived as a visually unified entity. The similarity to the female figures of the Master of Třeboň is very striking. The composition has certain traits that connect it with an earlier tradition. A comparison with the *Woman Clothed with the Sun* in the Lady Chapel at Karlštejn castle shows this clearly. Art from the time of Charles IV still exerted some influence and even at this late date attracted sculptors and painters.

It seems that close to the *Altenmarkt Madonna* is the *Pietà* in the St Elizabeth's church at Marburg. It probably was one of the first Pietàs of the Beautiful Style. It can be seen that its starting point is the Parler *Pietà*, but the solemn expression and terse monumentality of composition has given way to softer emotional and formal aspects. It was probably made for export, like certain other West German Pietàs. This can be assumed with certainty in the case of the *Pietà* in the Liebfrauenkirche in Frankfurt-am-Main. It is not certain where the statue of *St Anne with Virgin and Child* in the monastery at Nová Říše derives from as it has been spoilt by new overpainting. The latter is more restrained in expression and more sober in the decorative layout of the draperies and therefore more monumental. But in form and emotional content it belongs to this group. Another that undoubtedly belongs here is the statue of *St Peter* from the church at Slivice (National Gallery, Prague). The head continues the Parler tradition of characterisation as shown on the heads of the Přemyslide portraits in St Vitus's Cathedral. Their expressive strength and mighty pathos were changed on this statue, in accordance with common trends, to an expression of languid melancholy, while the posture of the figure shows resignation.

The direction of development inside the group is portrayed by a *Madonna* from the church of St Bartholomew (sv. Bartoloměj) in Plzeň,[37] which is one of the culminating works of the time. The soft, indefinite form had given way to clear articulation and a precise definition of volume. The composition, based on early French types, enhances and completes the compositional system of the *Altenmarkt Madonna*. The affected posture gives the statue a character of capricious stylisation. It is analogous both in the decorative design of the robes, with their undulating rhythm, and in the slim hands and careful treatment of the Virgin's head. Her almond-shaped eyes look lovingly and with melancholy at the Child, as if she had an inkling of His tragic fate. In this stylised, artificial composition only the Child remains completely natural. By contrast to the *Altenmarkt Madonna* this composition is enclosed by two symmetrically designed cascades of pipe-like folds along the sides. This gives impulse to the frontal layout of the dominant sculptural features, a trend that developed fully at a later stage, without restricting the spatial definition applied by the sculptor. The cascades are not placed on one horizontal plane so that the frontal appearance of the statue has a lively asymmetrical character.

All these features appeared in fully developed form on the *Madonna of Krumlov*. The posture of the Virgin has been even

further removed from natural balance. The torso has become completely lost in the wealth of folds. The gesture of the slim hands with spider-thin fingers is unnaturally elegant. The small, girlish head on the long thin neck, resembling a withering flower on a stalk, is bent towards the Child. The expression is painfully loving. The *Krumlov Madonna* can be considered a forerunner of the '*Madonna con collo lungo*'. Emphasis was given to the front but the layout in width was such that volume was largely broken down. A new feature was the lengthening of the overlapping folds, reaching as far as the ground. This motif did not appear on earlier statues of the group. It may have been adopted from the Torun Madonnas, where it was one of the regular features. It must have originated in the West. The Child shows the climax of natural form, with features and gestures typical of a child's mentality. Nevertheless, His figure fits smoothly into the artificial composition of the draperies.

There are some records from 1400 which may refer to the *Krumlov Madonna* (Müller).[38] Mention is made of a beautiful Madonna – *de pulchra opere* – at Krumlov castle. If this could be confirmed, it would be significant for the chronology and sociology of that art. The Rožmberks, the owners of Krumlov castle, belonged to the highest social strata in Bohemia and ruled almost like monarchs over their territory. It is very likely that this art had numerous patrons among this class of society. Its source is likely to be closely linked with the Prague Court circle. But it was far more widespread. Both monastery churches and town churches owned statues of this kind.

Close to the *Krumlov Madonna* is the fragile and elegant statue of *St Catherine* in the church of St James (sv. Jakub) in Jihlava. It was probably made with the participation of the sculptor's assistants, like certain other remarkable statues where one cannot say with certainty whether they were the work of the leading master himself or of his workshop, for instance, the *Virgin and Child* in the church at Vimperk, which in complexity of design is closest to the *Krumlov Madonna*, but whose draperies are treated more freely and show a weaker rhythm; the *Virgin and Child* in the Augustinian church at Třeboň where one can observe a stiffening of volume, a flattening of spatial relationships and a certain stiffening of the linear rhythm; the *Madonna* of the pilgrimage church at Chlum nad Ohří, where there are even stronger ornamental trends.

As the style progressed, the trend towards regularity became less and less counterbalanced by the sensuous emotional aspects, which were very strong in the first phase. These Mannerist features became even more noticeable on some Pietàs, which, in all likelihood, belonged to the circle of the Master of the Krumlov Madonna, for example, the *Pietà* in the church of St Ignatius (sv. Ignác) at Jihlava. The Jihlava *Pietà* is, as it were, the quintessence of the principles of the Beautiful Style taken to the extreme. The unusually large elongated figures of Mary and Christ move in curves that lead in diagonals and cross over; extended into an intricate system of folds they do not leave any part of the statue at rest. Christ's body, placed in a steep diagonal, extends far into space. It is hardly credible that Mary's hand with her slim fingers could support it. The whole composition gives an impression of lack of stability, at

variance with the tersely static Parlerian Pietàs. It seems that Italian and particularly Sienese painting of the Trecento was of great importance to this lively composition. There one can find the analogy for the backward movement of Mary's head, found not only on the painted Pietàs, but also the Annunciations. At the same time this movement included the principle of a reverse ogee curve which played an important role in architecture at the time. The Virgin's slim figure is just as subjected to inorganic forces as are tracery bars, which form a flamboyant pattern or an ogee arch. The emotional content of the statue has shifted from tragic seriousness to intense emotion and perhaps affectation, to which it would not be incorrect to attribute an underlying eroticism. While the Virgin on the Parlerian Pietàs had been a throne on which the Son of God was exhibited,[39] now she became a '*sponsa verbi*', the Bride of Christ.

There are good reasons for including the Jihlava *Pietà* in the Krumlov circle. The same is true of the Baden *Pietà* which came from a Viennese antique shop to the Staatliche Museen in Berlin. It was damaged during the Second World War, but the two heads have survived reasonably well. Its Baden origin cannot be proved. One cannot, therefore, dismiss its possible Bohemian provenance since it is a simpler variant of the Jihlava statue to which it is very close.[40] But it is a little earlier.

The *Pietà* in the Hermitage, Leningrad, also of unknown origin, is closer in time to the Jihlava statue. It is broader, the draperies are composed somewhat differently and the Virgin's broad face is of a different type than that on the statues in Jihlava and Berlin. All three Pietàs are connected by the striking similarity of the figure of Christ, whose long body projects outwards. They are also alike in execution. It should be mentioned that the veil worn by these three Maries is an exact copy of the St Vitus's *Madonna*, a typical work of the Beautiful Style in painting, made before 1397.

The growing breadth of the Leningrad *Pietà* is even more noticeable on the *Pietà* at Kretzenstein castle, also of unknown provenance. It is the most perfect example of this theme. The draperies are treated in a more grandiose and dynamic manner and Christ's body, placed in an almost horizontal position, is far shorter. The statue is more compact in outline than any of the other three, but otherwise alike to them in the treatment of the figure of Christ. Descriptive trends come to the fore. The motif of three hands is given daring shape, revealing the unsurpassed virtuosity of the master. Something similar can only be found on the *Krumlov Madonna*, where the spiral twist of the Child's movement shows equally sovereign certainty. Mary's head is so close to the St Vitus's *Madonna* that one can hardly doubt that there must have been some connection.

In spite of all the features that link these Pietàs one to another and to the circle of the Master of the Krumlov Madonna, it is difficult to assert that they were all made in his workshop. Apart from the main master other outstanding sculptors might well have worked under his influence. The leading master must have had close contacts with St Vitus's Cathedral. There are threads that link his work to that of Parler in the seventies and eighties and numerous analogies pointing to the St Vitus's

17 *Facsimile page of the Book of the Prague Brotherhood of Painters with the record of the Prague Bachelors (Panici)*

together with the curved folds enveloping the core of meaning and art of the statue, the apple.

If our dating to the nineties is correct, the composition of the Düsseldorf *Madonna* served as a starting point for all consequent work of this kind and on this subject. It is repeated with minor alterations on the small *Virgin and Child* of pearwood, from the neighbourhood of Horažďovice (Bührle Collection, Zürich), probably a reproduction of a lost stone statue from the sculptor's early period.

The same applies to a stone *Madonna* from the church of St John at Torun, lost during the Second World War.[42] It was a representative work of this group, which clearly revealed the sculptor's principles. The broad and tall stone crown was similar, though larger and more solid, to the crowns made by the Master of the Krumlov Madonna. This in itself suggests a leaning towards more robust features, typical of the whole group. The compact figure with draperies designed in mighty circular, crumpled folds is composed around a central axis. The outline forms the static geometrical pattern of an isosceles triangle. It contrasts with the compositional principle of the Krumlov group, which is based on the geometrical pattern of a triangle with unequal sides with the left side upright. This layout, concentric and balanced on one side and lopsided and asymmetrical on the other, applies to all the works of each group, including the Pietàs.

One other feature typical of the two types of composition should be pointed out: the children of the Torun group are far smaller than those in the second group, and they play a different role in the composition. They conform to the circular folds centred on the core of the composition, while in the Krumlov group their striking diagonal position is an important part of the composition, based on the diagonal principle. In later works of both groups the mutual influence of these principles and motifs can be observed.

This trend towards the mingling of types had not yet affected the *Madonna* in the Landesmuseum in Bonn, of unknown, but probably Silesian or Bohemian provenance. It is a precise, probably a workshop replica of the Torun statue. Clear marks of this intermingling can be observed on the Šternberk *Madonna* (Šternberk castle), which probably came from the Augustinian monastery at Šternberk. The main features of the Torun group are adhered to, but the little figure of the Child assumes a diagonal position and the fingers of Mary's right hand are pressed into the Child's body. This was usual in a more logical sense in the Madonnas of the Krumlov group.[43]

An even clearer example of this merger is the *Wroclaw Madonna* (National Museum, Warsaw). The legs of the diagonally placed Child reach as far as the central axis of the figure of Mary. With them there emerges the semi-circular fold which in other Madonnas of this group is to be found over the left hip. This stress on the centre, which, it seems, increased in later works of this order, was the result of profound changes in composition. The big overlapping folds which had, up to this point, covered the free-standing leg were suddenly moved to the opposite side. This happened because the Child grasps the end of Mary's cloak to raise it. Functionally this is an empty gesture, because the end of the cloak is thrown over Mary's

Madonna. This *Madonna* holds a special place in the paintings of the Beautiful Style for its expressive and sculpturally effective modelling. The view has been expressed (Sterling)[41] that it was the work of a sculptor and it may actually have come into being in the workshop of the Master of the Krumlov Madonna. The Bohemian source of his work – which does not preclude intensive international contacts – is supported especially by links to the circle of the Master of Třeboň and to the early period of Charles IV. The comparison of his Madonnas with the pictures of Our Lady of Grace from around and after 1350 is sufficient proof.

The creators of this group possessed breadth of imagination. The other important group of sculptures of the time shows considerable consistency of type. Its compositional principles were already fully developed in the earliest works, among them, probably, the *Madonna of Venice* (City Art Collections, Düsseldorf), even though we find here clinging draperies and realistic faces, recalling the work of Bohemian sculptors in the seventies. Reminders of the *Woman Clothed with the Sun* from Karlštejn castle can be detected. For the first time there appeared the long overlapping fold that reached to the lower edge of the pedestal. This was to become typical of works of this group,

forearm and does not need raising. The motif was taken over from the *Krumlov Madonna* where it is justified since the end hung loosely in the air.

The connection between the *Wroclaw Madonna* and the Krumlov statue is important for dating. As the *Krumlov Madonna* can, in all probability, be dated to the second half of the nineties, the *Wroclaw Madonna* must have been made soon after, at the latest in 1408 when its composition was used on the tympanum of the portal of a church at Irrsdorf near Salzburg. This mingling of motifs and the centralising trend went even further in the *Madonna* of the Franciscan monastery at Salzburg, which is largely a studio work. Although it undoubtedly belongs to the Torun group, the Child is unusually large, following the Krumlov pattern.

The close contacts between the two groups can also be shown on statues with other themes. The *Pietà* in the St Elizabeth's church at Wroclaw, lost during the Second World War, repeated the motif of the Jihlava statue down to the details. Yet its artistic character was quite different. In accordance with the Torun group, the statue was self-contained and heavy, laid out symmetrically in width. Its proportions were shorter, broader, more impressive. Christ's body, shown with great accuracy, only slightly projects beyond the outline of Mary's figure. By stretching the folds of the Virgin's cloak below the right knee as far as the left corner of the pedestal, a very nearly exact isosceles triangle was achieved which is a well-known feature of the Madonnas of this group.

A similar difference exists between the *St Catherine* in the National Museum in Poznan (originally from Silesian Lubusz) and a statue on the same subject in the Jihlava church of St James (sv. Jakub). The former is of peasant robustness, while the latter has the fragility and elegance of the Krumlov type. This in spite of the fact that the two statues are very close as regards motifs, with the exception of the naturalistic rocks on which the Poznan figure stands. This motif is unknown in the Krumlov group and incompatible with its distinct affectation, but it does exist on occasions in the Torun group. It can be found on the *Kneeling Christ* which used to be in the Catholic church at Malbork, until it was removed to an unknown destination during the Second World War. The inspiration of the *Třeboň Altarpiece* or of the circle of the Master of Třeboň can be assumed here. The cruder, more realistic formulation of the motifs, however, derives from the Parler tradition.

A small statue of Mary from the *Annunciation* or the *Visitation* (formerly Torun Museum) is likewise attributed to this group. It gives an impression of refined elegance which is somewhat unusual in this setting. The small portrait head of the younger man on the pedestal is one of the few portraits in sculpture of the time. Although its source is Parlerian portraiture, the changes that occurred since the seventies and eighties are clearly seen. Frontal design and strict symmetry, already encountered on the portrait of Wenceslas of Radeč, were applied here with great consistency. They show that there was a general trend towards regularity, to a convention which restricted the irregularity and random aspects of physical reality. This trend became increasingly strong towards the end of the century. Yet individual features did not disappear entirely. They recall

the portrait of Wenceslas IV on the Old Town Bridge Tower. The Torun head may, indeed, represent Wenceslas IV. This is quite possible in view of the good relations between the Court in Prague and the Order of the Teutonic Knights. We even have records of the export of Bohemian works of art to the territory of this Order. There are close links between this Torun statue and the relief of the *Original Sin* on a console in the choir of St Vitus's Cathedral. Below the spreading boughs of the Tree of Paradise it depicts Adam and Eve in elegant posture, holding the Apple of Sin. This plays a role similar to that on the Madonnas of the Torun group. The old inventory of the Cathedral shows that a Madonna once stood on this console where the motif of the apple was probably repeated.[44]

It remains an open question whether the Torun statue and the Prague *Original Sin* are closer to the Torun or the Krumlov type. But both works show contacts with the St Vitus's lodge. This link becomes even clearer on the console with Moses, where the *Torun Madonna* once stood (St John's church, Torun). Although here also the trend towards ornamental regularity is visible, the relief retained sufficient expressive strength to reveal its source in the Parler heads on the Přemyslide tombstones.

The personalities of two sculptors stand out from among the mass of anonymous production. Their works are so characteristic that their authorship can be clearly recognised. At the same time they are related to such an extent that in extreme cases it is difficult to know where to draw the dividing line. The frequent exchange of individual motifs – yet maintaining certain constant distinctions – proves that there must have been close contacts between them. Both took their starting point in the Parler lodge and the art of Charles IV and of the early reign of Wenceslas IV. There exists a hypothesis that all statues of this group were the work of one sculptor.[45] This can be dismissed as unlikely, for the approach to the work was clearly different. Yet the undeniable relationship of their work suggests a common training ground, as well as long years of co-operation. The question who these sculptors were may well remain unsolved, but certain clues make one able to pronounce a fairly likely hypothesis.

Attention is centred on Peter Parler's two sons, who first worked as stone-masons in the St Vitus's lodge and then took over its leadership towards the end of their father's lifetime. Wenceslas did so for a short time, John continued to the end of his life, in *c.* 1406. Wenceslas went off to Vienna, if he is to be identified, as seems likely, with the Wenceslas who was in 1403 (or possibly before) building the St Stephen's church, and died in 1404. He is probably referred to in a request made by the masonic lodge of Milan Cathedral asking for 'maestro Wenceslao di Praga a ingegnere di Praga' to come to Milan and make an appraisal of building plans.[46] In view of Wenceslas' death this never took place, but he mentioned these plans in two letters. These contacts can be explained by the good relations between Duke Gian Galeazzo Visconti and Wenceslas IV, who granted him the title of Duke.

Nothing is known of later sculptural work done by Parler's sons, but the relationship of the Masters of the Krumlov and the Torun Madonnas to the St Vitus's workshop does not preclude such an identification. But the question of authorship

can be approached from yet another angle. Old records from the fifteenth and sixteenth centuries speak of the famous Prague Bachelors (Junkers, Panici), architects, sculptors and painters. It is known that in 1404 they supplied a statue of the *Pietà* to Strasbourg Cathedral. The inventory of Prague Cathedral from the later fifteenth century includes a picture of a *Madonna* painted by the Bachelors. This can probably be identified with the St Vitus's *Madonna*, whose relationship to the work of the Krumlov and Torun Masters is already known to us. In the last will of illuminator Paul from 1533 there are four pictures with portraits of three Bachelors and Charles IV, in which the canons of Prague castle are said to have been interested. A record of deceased members of the Prague Brotherhood of Painters, drawn up after the Hussite wars in the late fourteen thirties, includes three names, the only ones with the attribute Bachelors (Panici . They are Wenceslas, John and Peter. The last three architects of Prague Cathedral before the Hussite wars were called Wenceslas, John and Peter (in the city records the Czech diminutive Petrlík is used). Two of them were sons of Peter Parler and the third probably some relative. They were active in the order given and also died in that sequence. Are all these correspondences from such different sources merely coincidental? Or can one deduce the hypothetical conclusion that the Bachelors were the two sons of Peter Parler (his third son was a doctor and canon), and possibly one more relative? John Parler had an adopted son by the name of Peter. Does it follow that Wenceslas and John were the creators of the Krumlov and the Torun Madonnas? While the first of these conclusions seems very probable, the second remains in the hazy sphere of uncertain possibilities.

Around this core of sculptural works, there arose a large number of works, which are scattered throughout the Czech Lands and the whole of Central Europe, in which one can conceive the participation, assistance or direct influence of the two main masters. Some are of an excellent standard and include works exported from Bohemia. They are copies and variations of the prototypes that came into existence in Bohemia, or they combine certain of their motifs, as was customary at the time. Some of these prototypes were repeated particularly frequently and their more or less precise replicas can be found in places often far remote from their place of origin. Whether these local workshops active in the early fifteenth century participated in creating this characteristic style remains undecided. The provenance of the prominent pieces, old records of the export of works of art and the overall cultural and political situation speak in favour of the Czech Lands, and possibly Silesia, which belonged to the Crown of Bohemia, as the centres and starting points. No less valid for this hypothesis is the complete identity of artistic expression on sculptures of this type with contemporary Bohemian painting, an identity which cannot be found anywhere else than in Bohemia. It is significant that not only works of art were exported from Bohemia but also artists, as shown by miniature painters of Czech origin in Austria, or the stone-masons, who around 1420 worked at the Ulm lodge (John of Prague, Nicholas of Legnica, Lawrence of Kroměříž).[47]

But the conditions which led to the creation of the Beautiful Style, or at least had a partial influence on its origin, existed elsewhere too. This is particularly true of Vienna. An outstanding tradition in sculpture existed there in the first half of the century. It continued into the second half when an environment with many initial features of the Beautiful Style was being created in the masonic lodge of the outstanding master who made the portal of the Minorite monastery, the sculptor who made the figures of the St Michael's church and mainly the excellent masons who worked on St Stephen's, some of whom had close contacts with the St Vitus's lodge. But with the exception of the statue of *Christ* from St Stephen's (Museum der Stadt Wien, Vienna) which probably belongs to the end of the century, we have no work which can give us proof of such an initiative. Nor are there any proofs that painting accompanied sculpture as closely as in Bohemia. No strata of Parlerian sculpture existed there, which we tried to link with the name of Heinrich Parler, and which is essential for the genesis of the Beautiful Style, quite apart from the fact that Austria has no *magnus parens* of the style, the Master of Třeboň. The Czech Lands, including Silesia, and Austria formed a fairly unified region in art beginning from the later fourteenth century, but it is probable that in Bohemia there was a concentration of efforts which led to the Beautiful Style. The fact that the great majority of important works of art in the Beautiful Style are associated with Bohemia cannot be overlooked.

Large numbers of sculptors who adapted their work to the demands of the radical trend of the Beautiful Style, both in the Czech Lands and elsewhere in Central Europe, were inspired by the Masters of the Krumlov and the Torun Madonnas. But by their side there existed workshops which adopted the style with a certain restraint. It seems that beneath the radical current with its brilliant decorative magnificence one can detect a second current which continued the old Parler tradition of monumental realism. This becomes particularly evident in the iconographic sphere of Pietàs, but perhaps also explains works like the *Madonna of Amiens* in the Budapest Museum of Fine Arts which, with the exception of the Child, is a replica of the Torun composition, transposed to Parlerian voluminous and static form. The numerous Pietàs of this type show time-conditioned modifications of Parlerian treatment of this theme, particularly its heavy solidity. Only the figure of Christ was affected by the Beautiful Style. The type spread throughout Central Europe. It penetrated to the West, where we can encounter it in the work of the Master of Rimini, and the South, where in popular form it found echoes in Umbria, the Abruzzi and elsewhere in Central Italy. There, many features of the new local environment were added to the basic Parlerian form.

* * *

Two movements thus existed side by side in the period around 1400. One was radical in character and left a mark on development. It was predominant. The other was subordinate and more conservative. It continued the Parlerian tradition. The situation had a certain polarity, since work was done in between these two poles, which cannot be exactly distinguished and whose contradictions found expression in the extreme positions on either pole. Sociologically it is hardly possible to distinguish

them, since both probably originated at the Court in the aristocratic environment, and both rapidly spread to the burghers and among the common people. The two poles expressed two different attitudes to the world and to religion: capricious fantasy seemingly cut off from the problems of the time, but conditioned by its uncertainty; and profound solemnity, where art tried to embody and express religious and human truths. Social, national and religious contradictions were growing fiercer in the Czech Lands at the beginning of the century. Art, too, moved its emphasis from aesthetic effect and sensuous magnificence towards meaning, a testimony to the basic truths of existence. The meaning of words grew in the struggle of ideas, and the message of art became more and more intensive. It cannot be claimed that the art representing this change-over followed direct upon the Parlerian undercurrent in art from the period around 1400. But it is close to it in idea and emotion. Although it retained most of the formal features of the classic phase of the Beautiful Style, its meaning had changed considerably.

This process can best be observed on the work of the most outstanding of Czech sculptors of the early decades of the fifteenth century. His main work is the *Calvary* on the Týn church in Prague. He was perhaps called Nicholas, since one of his works can probably be linked to that name. He was both sculptor and painter.[48] Since several artists of that name lived in Prague at that time, this in itself says very little. Fortunately quite a lot of his work has survived so that it is possible to judge both the character and the development of his work. The individuality of this wood-carver was discovered by Erich Wiese, who called him the Master of the Dumlose Family on the basis of the *Crucifixion* in the chapel of that family in the Wroclaw church of St Elizabeth,[49] except that he did not work in Wroclaw, but in Prague.

His apparently early works, the *Crucifix* of Prague Cathedral or the *Man of Sorrows* of the Old Town Hall[50] still have some of the weightlessness, the uncertain, slick balancing of the late fourteenth century. But the harmonious composition included certain expressive elements which appear even more strikingly in the small *Calvary* from the Dumlose chapel (National Museum, Warsaw). Two of these works, made as late as the first decade of the fifteenth century, are of small dimensions, in conformity with the liking for small size. All of them are executed with the virtuosity which is typical of the period.

The solemnity of conception increases in works from the second decade. A typical example is the sober, matter-of-fact *Pietà* from Všeměřice (Hluboká Gallery). The connection with the Parler tradition is clear. The formal means of the Beautiful Style retained its validity – especially in the design of the draperies – but the meaning of the work had drastically changed. The sculptor was not trying to capture the sentimental aspects of the event, nor was he aiming at sensuously magnificent form, but wanted to give truthful expression to the idea beneath the phenomenon. This longing for the truth, which encompassed even strikingly descriptive tendencies, and broke down the decorative system of the preceding period, is even more clearly visible in *The Man of Sorrows* from the New Town Hall in Prague (City Museum, Prague). It is probably the one referred to in

the report that Painter Nicholas had been paid a score and a half groschen in 1413 for work on an image ('in labore imaginis') for the Town Hall. Czech Gothic sculpture here reached intensity of description which was not surpassed even by contemporary Italian art. But the statue lacks the rational logic of form and composition which are typical of the Italian Renaissance. Knowledge was still derived from simple experience. Moreover, the artist held the truth of the idea to be more important than the natural laws of the human organism that symbolise it.

The whole effect of these changes appears in the monumental *Calvary* of the Týn church in Prague. It is greater than lifesize. In my view it came into existence shortly before 1420, that is before the outbreak of the Hussite Revolution, which, for a long time, restricted activity, particularly in the centres of the revolutionary movement. Christ's figure still follows the old scheme of the Beautiful Style, but the secondary figures, and particularly Mary, show how the conventional charm formerly used for this theme had been fully overcome. Volume was reduced, the spatial differentiation was less strong, and the outline was determined by two terse verticals, as before, in the first half of the fourteenth century. The faces are solemn. A comparison with the *Dumlose Calvary*, which was probably made a decade earlier, shows the distance that had been spanned in this short time of revolutionary events. The very size of the statue indicates the growing appeal of this art, which no longer tried to evoke emotional gentleness and delight derived from beautiful and perfect form, but appealed to all and sundry in the name of the idea. It is perhaps no mere chance that while before, in the early stage of the Beautiful Style, the major theme was that of Mary with the Child, now we have mainly scenes from the Passion.

Apart from this sculptor, many others were active in pre-Hussite Bohemia. Some of their names are known while others have left us works which cannot be associated with any names known to us. Among them were sculptors of outstanding quality, for instance the artist who made the *Madonna of Nesvačily* (Nesvačily church). In a stiffer and heavier form it continues the compositional scheme of the classic phase of the style. Then there was the artist who made the remarkable seated *Madonna* in the Týn church in Prague where the layout of draperies typical of the Beautiful Style has been broken down to give a softer appearance. Her Christ Child has all the sensuous charm and naturalness of a Child of the Beautiful Style, but the figure does contain certain aspects typical of the late stage of this style. The Child no longer depends on the composition of the draperies, which have now lost the continuous lines typical of the early period, and break down into smaller, spontaneous shapes lacking the unity of a rhythmical layout. All these works are made of wood. The works of the earlier period were mainly of fine-grain limestone, which facilitated modelling to almost filigree precision. Since attention was no longer centred on virtuosity of execution and precious appearance but the conveyance of meaning, it became possible to use wood, which lent itself to easier treatment, was cheaper and could be transported without difficulty. Moreover, the almost exclusive use of wood indicated that sculpture in masonic lodges was decreasing and workshops were growing in importance.

While the sculptors of the first generation of the Beautiful Style were linked to masonic lodges in view of the material they used, the second generation of sculptors dealt almost exclusively with wood-carvings.

* * *

In painting, the main personality who exploited the growing trend away from realism either rational or empirical was an anonymous painter who lived around 1380. In view of the panel paintings he made, which probably once formed part of the altarpiece in the Augustinian monastery at Třeboň, he is called the Master of Třeboň. The leading representative of this style was no longer a painter of monumental murals but of panel paintings. This is as typical as the fact that his altarpiece was meant for an Augustinian monastery. Just as monumental open-air sculpture was giving way to more intimate sculpture used indoors, meant for private devotion, so also mural painting was losing its leading position and began to be replaced by panel painting. This trend away from monumental and representative work and the concentration on works to satisfy people's private spiritual needs is typical of all the art in the last two decades of the fourteenth century.

It is a mere chance that part of the altarpiece of the Master of Třeboň survived in an Augustinian monastery, since the painter probably carried out commissions for many other religious institutions and high-ranking personalities in the Church and the State. Nevertheless, it is not without significance. The order of the Augustinian canons had enjoyed the patronage of the Luxembourgs and was given preference by the most educated among the high clergy. Their monasteries were centres of the religious movement of *devotio moderna*, which favoured matters of aesthetics. Both the architecture of the monastery church in Třeboň and the altarpiece for it expressed this devotion, which was not oblivious of the beauties of this world. In spite of losses that must be assumed, the set of paintings made in the workshop of the Master of Třeboň or by his circle remains fairly extensive. In the first place, we possess three pictures showing *Christ on the Mount of Olives*, the *Resurrectiou* and the *Entombment*. On the reverse side they each have three figures of men and women saints. They are probably remnants of the *Třeboň Altarpiece*. After its disintegration they were assigned to chapels in the vicinity of the town. The *Crucifixion* from Svatá Barbora (National Gallery, Prague) is closely connected with them. It should be considered a studio work, while the *Adoration of the Child* (Hluboká Castle), almost identical in size with the first picture, turns out to be an original work of the Master. (This was confirmed by the recent restoration.) The provenance of the *Adoration* is unknown, but the village of Svatá Barbora is not very far from Třeboň so that even in this case the origin from the Třeboň church is certainly possible, even probable.

Other works by the Master of Třeboň come from central Bohemia: the *Roudnice Madonna* (National Gallery, Prague) was found in the local Capuchin monastery; but, in all probability, it was originally made for the local Augustinian monastery or the chapel in the Archbishop's residence. In the local church at Církvice the *Madonna of Církvice* has survived. The village is close to Kutná Hora, from where it perhaps derives. The *Madonna Aracoeli* (National Gallery, Prague) is of unknown provenance. But as its central part is a copy of a picture on parchment in the Treasury of St Vitus's Cathedral, which, tradition says, Charles IV received as a gift from Pope Urban IV, it is likely that this painting has connections with Prague Cathedral. This type is itself a copy of a painting of the *Virgin* in the church of Sta Maria in Aracoeli in Rome.

More remote but related to the work of the circle of the Master of Třeboň in certain features is the *Crucifixion* from Vyšší Brod (National Gallery, Prague) which was probably originally intended for the Vyšší Brod abbey, founded by the Rožmberks. Its expressive stylisation, which pays little attention to the soft linear harmonies typical of the work of the Master of Třeboň, gives it a somewhat archaic character. Another somewhat later work is the picture of the *Madonna with SS Bartholomew and Margaret* (Hluboká Castle), formerly in the castle chapel at Protivín in south Bohemia. The formalism of its composition ranks it on the very threshold of the Beautiful Style though it contains many features linking it to the preceding tradition.

Nobody knows who the painter was who so decisively interfered in the history of Bohemian and central European art. A good deal of research has been accomplished without avail. To judge by the geographical position of the places where his work has survived, it could be assumed that he worked somewhere in south Bohemia. But the relatively frequent appearance of his work in that region may be due to historical chance which protected south Bohemia from the ravages of the subsequent Hussite wars and later prevented radical Baroque alterations. Both these factors affected central Bohemia and particularly Prague so that very little, if anything, has survived of pre-Hussite panel painting and carving. All the more important is the existence of three paintings by the Master of Třeboň in that region, especially as one of them was probably intended for the Augustinian monastery at Roudnice, the mother house of the Třeboň monastery, or for the Archbishop's country residence there. The second was, perhaps, made for St Vitus's Cathedral in Prague. Significantly, too, the patron of the Třeboň monastery was Peter of Rožmberk, who was Provost of the royal chapel of All Saints at Hradčany and maintained close contacts with Wenceslas IV. It is therefore highly likely that the Master of Třeboň was a resident of Prague and worked for the local cathedral. It would, indeed, be strange if among the many altarpieces made for St Vitus's Cathedral in the last decade of the century there were not a single one by the most important painter of Bohemia at the time. The insignificant fragments of a pre-Hussite inventory of the Cathedral render proof of the care devoted to its interior fittings and the emphasis placed on artistic quality.

The work of the Master of Třeboň is exceptionally complex in structure. It contained a good deal of the descriptive realism of the preceding generation. He had a great gift of observation so that he managed to portray not only individual likeness, but also the mental state of the persons depicted. The heads of saints on the reverse side of the *Entombment* show a perceptive analysis equal to the almost contemporary late Parlerian busts in the upper triforium. The head of St Augustine (or St Greg-

ory) is no less a portrait than the sculptured busts of SS Methodius or Adalbert. The detailed heads of SS Giles or Jeronymus recall the analytical style of the North Italian painters of the Quattrocento.

The three female saints on the reverse side of the *Mount of Olives* are also facially distinguished even though women's faces tended towards uniformity. This exact description was not achieved by linear abstraction but by means of colour. Colour, the painter's main means of expression, was freely used, especially in the landscape and bird motifs which are not isolated, but form an essential part of the whole picture. Patches of colour and strokes of the brush were applied to break up their compactness. The trees are disproportionately small; the plants are only an approximation, but the large numbers of birds are distinguished as to kind. The landscape sections still serve as a setting for the figures and do not exist independently. Similarly the architecture merely accompanies the figures who stand below, or rather in front of it. Visual experience plays little role in the construction of the landscape, certainly far less than in the fifties and the sixties. It is not a landscape constructed empirically, nor one depending on laws of perspective and a rational manner; it has conceptual significance. Yet the spatial effect is remarkable, achieved by three specific features of the artist's work. There is a predominance of colour over drawing. The scenes are set in a diagonal wherever possible, except in the *Crucifixion*, where the very form of the cross and its spiritual meaning forced the painter to select a frontal design. The figures (given either frontally or in profile) tend to stand in planes parallel with the surface of the picture. But the material objects built diagonally into the picture give an impression of depth, even though they do not follow the laws of perspective.

The size of the figures and objects is not determined by perspective, but by their spiritual significance. Since the diagonals are repeated several times, and are not sufficiently balanced in the opposite direction, the result is a one-sided movement which gives the picture an element of uncertainty. This is not the only feature analogous to sixteenth-century Mannerism. The spatial effect was achieved, furthermore, through chiaroscuro out of which softly emerge the figures, the objects and the brilliant patches of colour in the tree-tops and on the bodies of the birds. This intensifies the mystery of the scene, and acts as a unifying element. Recent restoration has shown that this homogeneity is slightly less striking on the reverse side of the panels with the standing saints. Their shape is exact enough to give an impression of polychrome sculpture, but the colour treatment is of delicate finesse, and the chiaroscuro forms gradual transitions between the partial shapes and their setting. The figures with their comparatively small, gentle heads stand in loose, slightly affected postures. They are robed in rich garments with intricate folds running in beautiful curves which take little account of any functional connection with the torso. An atmosphere of supernatural harmony is created by the long gracious lines, the gentleness of the solemn faces turned inward as it were and the refined, almost symbolic rather than real colour-scheme, which like the linear design of the composition avoids all contrasts. The descriptive elements conform to this mood. These new features differ from the slightly crude realism of the preceding period. They

are to be found mainly on the figures of women, whose gentle charm makes them direct predecessors of the Beautiful Madonnas.

It can hardly be doubted that from this workshop came the decisive inspiration which led to the emergence of the Beautiful Style. There, the remarkable synthesis of precise observation and bold imagination, profound characterisation and generally idealised types, the approximation and stylisation, was even more intensified, attaining ingenious contrasts. Means that, in the works of the Master of Třeboň, were to serve the glorification of religious mystery and convey their depth and solemnity, came in the Beautiful Style to acquire an expressly formalist character.

This grandiose cycle of paintings was one of the most important in Europe at the time. But there are no reliable records of the date of its origin. We know that the statues and paintings of the Beautiful Style, which was already quite distinct in the middle nineties, followed the *Třeboň Altarpiece*. This leads us to judge that the work of the Master of Třeboň is of an earlier date, in all likelihood from the eighties. This dating seems the more probable as that decade saw the origin of several dated sculptures and book illustrations which are comparable with the work of the Master of Třeboň. The Old Town Hall *Madonna* is connected with the year 1381. The oldest miniatures in the manuscripts of Wenceslas IV were made, or at least begun, in the second half of the eighties. The date usually put forward is the eighties or *c*. 1380. But why ignore a record from 1378 about the consecration of an altar and reliquary of Mary Magdalene, other Virgins and Widows and of St Augustine in the same Augustinian church at Třeboň as the altarpiece panels which gave the painter his name? The record cannot be ignored since the consecration is connected with the themes depicted on the outer side of the surviving panels, where Mary Magdalene and probably St Augustine hold places of honour.

The work of the Master of Třeboň extends over a longer period. It is likely that the *Roudnice Madonna* was made in a later period, possibly in the early nineties. It is very close to the Beautiful Madonnas and is, in fact, one of them. It seems to have influenced the origin of one of the types. On the other hand, the *Církvice Madonna* probably dates from an early period in the Master's activity. This is confirmed by a recently discovered half-length figure of *St Christopher*, on the reverse side, the colour scheme of which forms a sort of bridge to the preceding period of Czech painting, particularly the Emmaus *Crucifixion*. Part of the large-sized panel was cut off after the middle of the fifteenth century and the *Dead Christ* was added to the *Virgin of Sorrows* on the front.

The *Crucifixion* from Vyšší Brod, which belongs outside the scope of the workshop of the Master of Třeboň, also has certain features linking it with the earlier Czech tradition. It was painted by a master who had come under the influence of his great contemporary but did not adopt his calligraphic style of draperies. He is closer to the realistic tradition and his lumpy angels follow predecessors from the fifties. The terse symmetrical composition does not avoid crudity which adds to the expressive effect of the painting. But in comparison with the simple human Crucifixions from the third quarter of the century

here there are more supernatural beings, symbolic motifs and a more solemn atmosphere.

In spite of clear relationships that bind the work of the Master of Třeboň to the earlier period in Czech painting, it was not derived from it entirely. It can be taken as proven that the painter personally knew Franco-Flemish painting. But he was too closely associated with development of the arts in Bohemia and fits too convincingly into contemporary changes in style for us to assume that he may have been of foreign origin.

Book painting, it seems, did not take over the initiative. It tended to reflect events happening in panel-painting, even though it held a favoured place at the Court where book collecting had become a social 'must'. Only fragments of the royal library have survived. They reveal a passionate interest in book collecting and show that standards were high. The miniaturists worked also for other classes of society, including the burghers. Numerous scribes worked on the royal manuscripts. They belonged to various generations and had different approaches to their art. The main master of the *Willehalm* (Nationalbibliothek, Vienna) followed upon the south German – Bavarian – tradition of World Chronicles, even though in the acanthus ornament he furthered the local tradition.

Several painters, with strikingly contrasting styles, worked on the largest manuscript in Wenceslas's library, the *Bible of Wenceslas IV* (Nationalbibliothek, Vienna). Its incomplete illustrations number over six hundred. Among the masters were several of a conservative nature, like the main master of the *Willehalm* (called the Master of Genesis) or the Master of the Balaam's History, who followed Czech painting of the sixties. Others belonged to the younger generation, who approached their work with a knowledge of the achievements of the eighties. Among them was Master Frana (the Master of Exodus). He adopted certain compositional features of the Master of Třeboň, but changed them in his impulsive brushwork and improvisations to make the paintings strongly expressive and give them a fantastic, unreal character. Later he adjusted to the trend favouring a firmer, more clearly defined form which became dominant towards the end of the century. Records on his property in the city archives indicate his relations with the King. They show that he died sometime before 1416. Other miniaturists of the Bible knew what was going on in contemporary Franco-Flemish painting, especially in matters of spatial treatment. Particularly important is the Master of the Book of Ezra who was entrusted with the task of completing the *Willehalm*. His work shows a new conception in landscape painting and a clear shift towards the aesthetics of the Beautiful Style. The manner of painting, outstanding in colour quality, is soft, as was typical for all miniaturists of the period in which the principles of the new style were crystallising. An outstanding personality of this phase, when the long lines of the Beautiful Style were already coming into being, but the old tradition of colour could still be felt, is the painter of the title page of the 'Alfons Table' in the *Astronomical Book of Wenceslas IV* (Nationalbibliothek, Vienna). Like the painters of other astrological manuscripts belonging to Wenceslas IV he could make use of earlier works of the kind in the possession of the kings of Bohemia at whose Court this science was fostered over a long period.

The Beautiful Style reached its mature form in the work of one of the painters of the *Munich Astronomical Manuscript* (Staatsbibliothek, Munich) and on the title page of the *Tetrabiblion of Ptolemy* (Nationalbibliothek, Vienna), which is close to the title page of the *Golden Bull* (idem). In conformity with the new aesthetics, it was a matter of finesse of execution rather than vigorous brushwork and ornamental regularity of design rather than improvisation. At the same time one can observe a remarkable knowledge of nature, for instance the birds, which are not only individually distinguished, but also characterised as to species. The change from immediacy to precise definition of shape and its arrangement did not occur only in the King's manuscripts. Other works of the transitional or the early phase of the Beautiful Style include: the *Book of Hours* (VH 36) in Czech (National Museum, Prague), which was probably once in the possession of the Queen of Bohemia; the miniature works of Archbishop John of Jenštejn (Vatican Library); part of the miniatures in the *Missal of Wenceslas of Radeč* (Chapter Library, Prague), whose author was very close to the painter of the *Book of Hours;* the canonic folio in the *Brno Missal* (No. 19) (City Archives, Brno); and many other manuscripts, in which some of the ornaments were made by painters working for the King. Some of these manuscripts date from the period when the Beautiful Style was fully developed.

* * *

As we have already seen, sculpture contributed most to the origin of the Beautiful Style. There is much to show that sculptors were the first to react against the uncertain situation of the eighties and set up ideals and types, which were then taken over into painting. That sculpture led the arts at the end of the fourteenth century is no mere chance. Parallel to sculpture, painting was moving away from relative and spontaneous, improvised and uncertain form to precisely defined, smooth and regular shape. And as in sculpture, so in painting the main subject matter was no longer the narrative set at a given place and time but the individual figure, isolated and passive. These trends can be observed on the figures of saints on the Třeboň Altarpiece. They became fully developed at a slightly later date when colour again acquired its objective material character and when its association with light became less strong.

The trend towards firmer form, harder colour treatment and ornamental regularity appeared in a mature version on the *Epitaph of John of Jeřeň*, today divided into two parts (National Gallery, Prague). All the qualities of the Beautiful Style are fully developed here. This picture is of outstanding quality. It is important to us since its inscription reveals not only the name of the deceased, who was a canon of Prague Cathedral where he was buried, but also the date of his death: 1395. The painting, therefore, originates from Prague Cathedral and was made during that year or immediately after. It gives us the chance of judging the quality of the large number of altarpieces, paintings and statues which are mentioned in old Cathedral inventories, but which have, with very few exceptions, completely vanished. The donor, whose figure has disappeared, once knelt in front of the Madonna. The composition of the picture used the layout from the Adoration of the Magi. Nonetheless the composition

is based on individual figures, among which the Christ Child alone shows his participation in the event and is turning to the vanished petitioner. The heads and hands of the saints are described with quite unusual precision, using linear rather than painterly means. But their figures are lost beneath the abundant draperies, gathered into a wealth of folds and hems, running in soft, calligraphically executed curves. The composition of the garments is still rather confused, but the figure of Mary has all the gentle softness of the Beautiful Madonnas and their sophisticated regularity. The Virgin's broad face can be traced back to the *Vyšší Brod Altarpiece*. It is also related to the faces of women made by the Master of Třeboň, but what it most closely resembles are the faces made by the Master of the Torun Madonna. Other features of the *Epitaph* also speak of this same influence: the restless Christ Child, the wrinkled faces of the saints, resembling the Torun Moses, the drapery with smooth and wide planes, the picturesque shapes of the 'Bohemian knee' and finally the relatively soft treatment of the surface. It is possible that there were closer contacts between the sculptor and the painter than simply adherence to the same generation and style. Though small in size and private in its function, the *Epitaph* exerted an influence that went far beyond the borders of the Czech Lands. The *Epitaph of the Styrian Chancellor Ulrich Reichenecker* (Joanneum, Graz) cannot be imagined without the Prague pattern.

While certain features link the *Jeřeň Epitaph* to the circle of the Master of the Torun Madonna, the St Vitus's *Madonna*, likewise from Prague Cathedral, is linked, as we already know, to the Master of the Krumlov Madonna. The precise, linear, sculptured form is shown here in a way that differs from sculpture only in the medium. The St Vitus's *Madonna* is important for a good many reasons: first, it set the type for a devotional picture which was frequently copied and is to be found even in southern Bohemia. It provides proof of how the religious and artistic centre of Bohemia radiated its influence throughout the country. (This radiation cannot be proved for sculpture, as the entire interior sculptural decorations of the Cathedral and other Prague churches fell victim to the ravages of time.) Similarly, the *Roudnice Madonna*, probably made in connection with the Prague Archbishopric, inspired a multitude of copies and replicas destined for various places in the lands of the Czech crown, including Silesia. Secondly, the St Vitus's *Madonna* confirms the thesis of the historic, retrospective tendencies of the Beautiful Style. For the St Vitus's *Madonna* follows up an earlier type from the fifties, which is today represented by the Boston *Madonna*. This is the reason why, contrary to the manner of the culminating Beautiful Style, it shows reverse orientation. It was also influenced by the *Vyšší Brod Altarpiece* as can be seen from the design of the folds over the left arm. Thirdly, it shows a close relationship with the *Krumlov Madonna*. And finally, it can be dated fairly precisely if today's frame, which fits exactly, is indeed the original one, as is highly likely. It is the only frame which is adorned not with painting, as was then current in Bohemia, but with reliefs. The magnificent and costly frame, no less perfect than the picture itself, shows the height of the standard demanded for works intended for the Cathedral. The bishop petitioning the Madonna on one of the medallions is, most prob-ably, John of Jenštejn so that the picture must have been made before the Archbishop's definite departure to Rome in 1397.

The St Vitus's *Madonna* is in every respect a representative work of the Beautiful Style. The decorative features have reached a degree that is unsurpassable. The draperies follow their own laws independent of natural causes. In spite of insignificant remnants of chiaroscuro, colour has become harder and was no longer of relative character. Shapes are worked out with a precision which does not lag behind that of the glass painters of Florentine Mannerism. Movement is shown with a sophistication that magnifies the expression of emotional gentleness and charm to the very limits of possibility. The St Vitus's *Madonna* was not only widely copied, it penetrated into works on other themes and later even into narrative pictures. It was used by painters of different orientation, as shown by the little *Madonna of Jindřichův Hradec* (National Gallery, Prague). Here the decorative features were developed into a broadly based and intricate design of draperies, without weakening the sensuous charm of the bodily parts and the intimate emotional content. By contrast the *Dubeček Panel* (National Gallery, Prague), with six figures of the Czech patron saints and two other saints, shows linear aridity both in the heads, depicted in great detail but schematically, and in the draperies which, in spite of a wealth of motifs, make a sober impression and lack the usual dynamic force. If among these early works in the Beautiful Style we include the *Triptych* with the *Crucifixion*, recently published by Cibulka,[51] the differences in Czech painting of the nineties appear clear enough, even though the surviving works are only fragments of their original state. This triptych is the work of an eclectic and conservative painter, perhaps from the early nineties, who had still not abandoned the chiaroscuro method of the Master of Třeboň and retained some forms of expression otherwise unknown in Czech panel painting. Even in this triptych, we can find certain retrospective features: the painter did not hesitate to draw on various sources, but leant heavily on the *Crucifixion* of the *Vyšší Brod Altarpiece*. The anti-naturalist leanings of the Beautiful Style found many common features in the Italianate style of early painting under Charles IV. Even though the appreciation of sensuous qualities survived to the beginning of the new century, and here and there the fresh realism appeared together with personal touches, especially in small pictures on the frames, they ran counter to the conventions of the period. Development led to an increasingly consistent isolation of objects and to absolute form and colour. One can observe this even on copies of the famous *Roudnice* and St Vitus's *Madonnas* as well as on pictures on other themes, for example, the important *Crucifixion* (Staatliche Museen, Berlin), even though its painter devoted a good deal of attention to the vegetation on the narrow strip of land. The trend towards established facial types was becoming more and more apparent. Conventional motifs for draperies were used, with occasional variations or combinations. Movement became repetitive, delightful, but lacking all energy. Facial expressions showed languid charm. This is even true of the male faces, which show no trace of energy.

The *Capuchin Cycle* (National Gallery, Prague) of fourteen busts which forms an incomplete cycle of the Deesis, is, in fact,

a collection of types of saints which were widely in use. Their predecessors were the paintings of the eighties, particularly in the circle of the Master of Třebǒň, probably the source of some of them. But they had lost all their freshness and the immediacy of direct relation to reality and had become a kind of crystalline, pure, linear and precise ornament in which all spontaneous features had been subjugated to strict regularity. The more striking is the obvious Byzantine influence which in no way counteracts the non-sensuous Mannerist character of the paintings. Perhaps they were connected with older Byzantine or Italo-Byzantine works extant locally which probably existed in far greater numbers than surviving examples lead us to assume. The *Capuchin Cycle* is very close to the *Ambrass Pattern-book* (Kunsthistorisches Museum, Vienna), a collection of patterns of types, on which the painters probably relied in their work. If it were not made by the same workshop, as is sometimes assumed, then it belonged to the same stylistic circle. The drawings appear freer in technique and richer in expression. This can be explained by their use for study, undefined purpose and patterns which the painter had at his disposal.

A representative work of this level of painting is the *Roudnice Altarpiece* (National Gallery, Prague), which originated in the local Augustinian church of Our Lady (Panna Marie). The central painting depicting the *Death of the Virgin* clearly shows the aims and character of the style. The story is set against a background of fragile theatrical architecture. All objects are adjusted to be seen from the front. Everything that might spoil the two-dimensional design has been suppressed or at least weakened. Christ, the Apostles, the dying Virgin and even the bed are seen face-on so that the idea predominates over visual appearance. Hard drawing adds to the abstractness of the composition which is ruled by the long lines of the folds shown in descending curves. The female faces have a lifeless, visionary expression. The inner sides of the wings with the *Madonna the Protectress* and the *Man of Sorrows* are similarly conceived. The reverse sides with the *Virgin of Sorrows* and another version of the *Man of Sorrows* are given more freely and expressively. But here, too, the group portrait of the donor and his family shows how little the painter was interested in physical likeness.

This anti-naturalism reigned supreme in panel painting in the early fifteenth century; it was entirely devoid of direct contact with visual reality. The surviving pieces, however, are only a fragment of the original wealth so it is possible that they give a wrong impression. The real situation may have been more complex than we assume today. We are lead to this opinion by the fact that in book painting, which has been better preserved, differing tendencies appear, some of which are contradictory. In this field, too, Mannerist trends made themselves felt and reached a stage that could hardly be surpassed. A typical example is the *Hasenburk Missal* of 1409 (Nationalbibliothek, Vienna). Its canonic folio epitomises the principles of the radical Mannerist works in the Beautiful Style. The slim figures with small heads and affected postures are robed in richly gathered, voluminous garments. Bright colours form a rich, flat pattern in which the question of homogeneity and continuity of space is entirely disregarded. Its effect is achieved simply through decorative areas of colour and pattern.

The same master made the title-page in the *Golden Bull of Emperor Charles IV* and the *Bible of Scribe Korček* (Nationalbibliothek, Vienna; Landesbibliothek, Karlsruhe). Both are dated 1400. As in his other works, the influence of figural types used in sculpture can be clearly observed. This trend is equally well represented by some manuscripts which originated in Brno. The canonic folio of *Missal* (No. 8) of the St James's Library (City Archives, Brno) went perhaps even further in the abstraction of the figures and the denial of organic relationships. While the Virgin is a variant of the *Hasenburk* John, John's garments show how the rhythmical linear system was disrupted by means of sudden breaks which strikingly contrast with the formalist structure of the figure. Later this disruption of the continuous linear composition became a sign of resistance to the formalism of the Beautiful Style.

This trend was closely related to the circle of sculptors gathered around the Master of the Krumlov Madonna. By its side there existed another current in Czech painting, which was also closely bound up with local events in art and maintained certain links with the radical works in the Beautiful Style. But it also kept contact with Franco-Flemish painting and similarly aimed at depicting real visual and spatial values. In this way it continued the tradition founded by the painters at the Court of Charles IV and the Třebǒň Master. The direct influence of the latter can be found in the work of younger miniaturists engaged on the decoration of the *Wenceslas Manuscripts*, among them Frana (the Master of Exodus), the Master of the First Book of the Kings and the Master of the Book of Ezra. They were acquainted with French book illumination in the seventies and eighties, but did not manage to solve the contradiction between meaning and the visual layout, between flat design and the cautious endeavour to achieve depth. Spatial depth was imagined rather than depicted and only the Master of the Book of Ezra managed some illusion of receding space by differentiation of light.

A new approach to the visual world can be found in the work of one of the illuminators of the magnificent *Bible of Conrad of Vechta*, finished in 1402 (Plantin-Moretus Museum, Antwerp), called the Third Master. Its ornamentation follows up that of the *Bible of Wenceslas IV*. His most remarkable contribution is the *Encounter Between David and Jonathan*, where the landscape is of convincing depth, even though the planes are presented like wings in the theatre. The flora is shown with great truthfulness and there is a natural landscape background with blue sky, which grows lighter towards the horizon, replacing the usual wallpaper effect. Attention to light factors, particularly noticeable on the night scenes, was a progressive mark of this illuminator, who otherwise kept to local customs, for example in the draping of the garments, and the types of faces. Nor did the diagonal layout of planes advance beyond the achievements of the Master of Třebǒň and the illuminators of the *Wenceslas Manuscripts*; not even where he tried to give an illusion of space with the aid of variously twisted bodies of horses, did he go beyond the achievements of Charles IV's painters at Karlštejn castle. But the most advanced features in his work confirm contact with French painters, among them with the Master of 1402. The works of the Third Master of the Bible of Conrad of Vechta can be found in other manuscripts, too. There his links

with the Mannerist works of the Beautiful Style are more evident. A decisive step towards mastering the outcome of Franco-Flemish naturalism was taken by a painter close to the Third Master of the Antwerp Bible, who was among the most outstanding book painters in Bohemia in the early fifteenth century. He is usually called the Master of the Martyrology, according to the manuscript which used to be kept in the Dietrichstein library at Mikulov and is today deposited in the Diocese Museum at Gerona in Spain. On the impulse of O. Pächt,[52] it has been possible, in the last few decades, to gather together quite an extensive set of works made in his workshop. Among them, apart from the miniatures in the Gerona *Martyrology*, are the illustrations, or part of the illustrations of the Sedlec *Antiphonary* of 1414, eight miniatures in the Museum of Fine Arts in Budapest, the *Boskovice Bible* in the University Library in Olomouc, the *Olomouc Bible* of 1417 (idem) and perhaps also the *Mandeville Manuscript* in the British Museum, the miniatures of which were executed in grisaille. The figures on the miniatures are firmly rooted in the Czech artistic milieu, but many features show the painter's links with French book painting around 1410: the manner in which the figures fit into the landscape; the way the landscape, which plays an important role here, is given in depth with the aid of different planes; the way the illusion of depth is created by means of aerial perspective, softening the linear certainty of objects as they recede; the fact that frequently a view into the distance is enclosed by blue sky, above the still high horizon. The association with French book painting is further confirmed by the use of circular medallions along the margins of the folios of the *Martyrology*, the system of decoration and the multitude of careful studies from the world of fauna and flora. Analogies could be found in the work of the Master of the Boucicaut Book of Hours, who is a pioneer of perspective painting and miniature realism, and the related Master of the Bedford Book of Hours. These masters were active from about 1405. Since the manuscript of the *Rules of the Metten Monastery* of 1414 undoubtedly follows the work of the Master of the Martyrology, part of his work must be earlier. This means that contacts with Paris painters of this school must have taken place almost at the time of its origin. The Master of the Martyrology belongs to the group of Northern European painters who paved the way for the situation from which Jan van Eyck was to shortly emerge.

* * *

The influence of the Master of the Martyrology can be felt in book and panel painting. On the whole, however, painting and particularly panel painting was under the influence of the Mannerist trend, where visual experience was not of great importance. In the second decade a serious crisis broke out, which affected its significance and structure. It was not so much concerned with attitude to the visual world as with intensity of expression which was to enhance the truth of the message contained in the event depicted. Thus the narrative function of the picture increased. This change, which has close analogies in the sculpture of this period, is represented by the *Rajhrad Altarpiece* (National Gallery, Prague; Moravian Gallery, Brno). Five panels of the altarpiece have survived, depicting *Christ's Passion* and the *Finding of the Holy Cross*. The painter worked

in Moravia, probably in Brno. He took as his starting point the art of the Master of Třeboň, even though a whole generation lay between the two artists. A high degree of similarity can be observed in the spatial design of the setting, the relation of figures to their surroundings, the composition of landscape elements, the detailed description of the flora, the use of chiaroscuro and the general principles of composition. It is, therefore, not surprising that we can also find echoes of the *Brunswick Pattern-book*. This relationship is particularly clear on the *Rajhrad Mount of Olives* which is only a variation of the painting by the Master of Třeboň. This connection is undeniable even though the composition spread more widely and appeared at roughly the same time in works by Ghiberti and Lorenzo Monaco. Yet the artistic character of the *Rajhrad Altarpiece* differs from the Třeboň Master. It has none of the veil of unspoken mystery. This is replaced on the Moravian altarpiece by sophisticated gentleness and the precise depiction of the flora and natural objects. The feeling for spatial relationships is more advanced, distinguishing what is 'in front' and what 'at the back'. Observation helped to distinguish objects, for instance the flora. Some of the sensuousness of French-orientated book painting made itself felt here, but the scenery is still less important than the figures and its layout pays attention to concept rather than to visual appearance. Careful examination shows that the harmony between the figures and the landscape is not as smooth as on the work of the Master of Třeboň where the landscape was a kind of continuation of the figural part. Here the two aspects stand in opposition. The unity and continuity of movement on the flat surface was disintegrating and the smooth rhythm of the robes was breaking down. The painting of the *Bearing of the Cross* is crowded with onlookers so that each individual figure plays only an insignificant part. The subsidiary, drastically naturalist, scenes complement the narrative, given in great breadth. The rotting and smelling corpses of the crucified, the grave-diggers at work and the playing children form an effective contrast to the sublime gentleness of Christ's friends, on which the conventional elements of the classic Beautiful Style survive, though lessened in effect by the multitude of objects depicted, for which the surface of the painting was not really big enough. The picture made its impact largely by this throng of objects and people, covering its hidden geometrical composition.

This composition becomes clearer on the *Crucifixion* panel where the numerous figures are gathered into groups and individuals lose their independence. In the work of the Rajhrad Master, progressive and conservative elements stand in sharp contrast. On the *Resurrection* panel astute observation, shown in the group of mercenaries, contrasts with the generalised upper layer, in which all attempts at facial and psychological differentiation have been abandoned. Yet one can detect the changed atmosphere of the time. Christ's cloak is broken down into folds that meet at sharp angles and are far removed from the gentle harmonies of the classic phase of the style. The fairy-tale idyll of art at the turn of the century gradually gave way to its reality, full of contradictions.

The tradition of the Beautiful Style had, at that time, been accepted by all strata of the population with the exception of

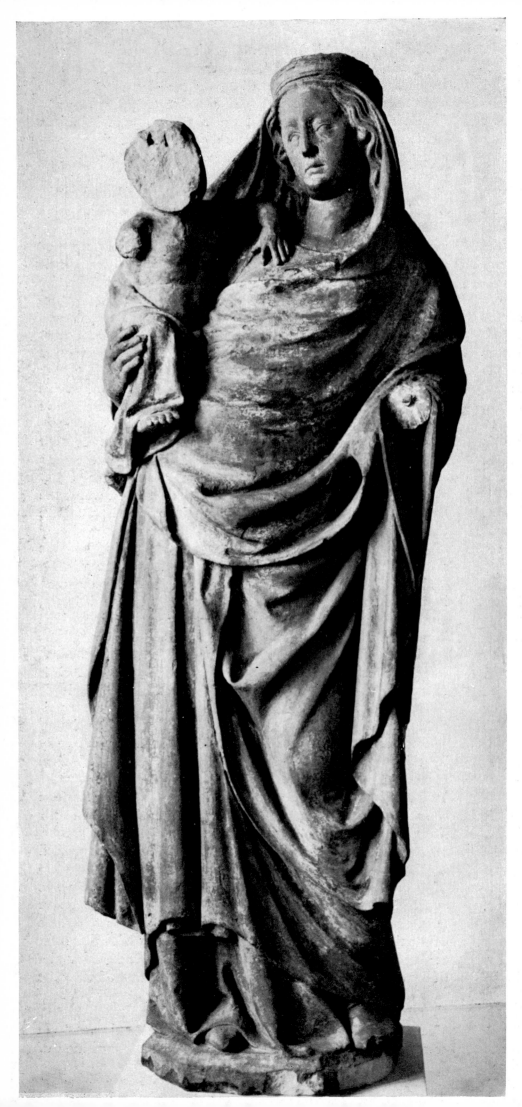

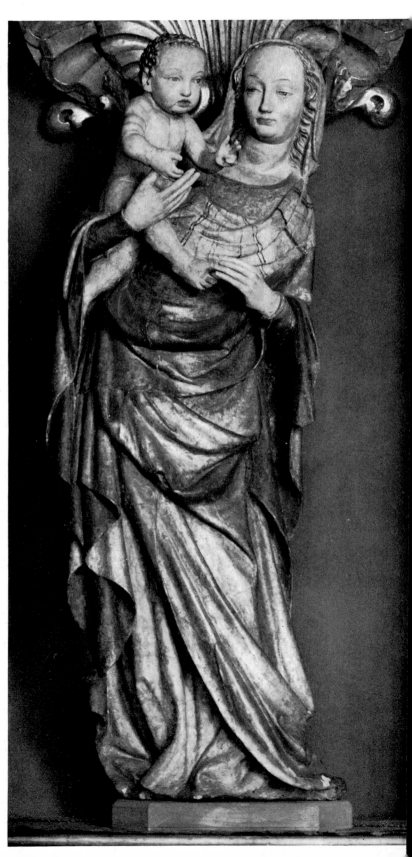

108 *The Madonna from the Old Town Hall, Prague. Before 1381. Limestone with remains of old polychrome. h. 154 cm. City Museum, Prague*

110 *St George. 1373. Bronze, probably originally gilded. h. 196 cm. without spear, w. of plinth 177 cm. Prague castle* ▶

109 *Virgin and Child. 1380–1390. Wood; later additions: the Virgin's hair, veil and the Child's hair. h. 135 cm. Žebrák parish church* ▼

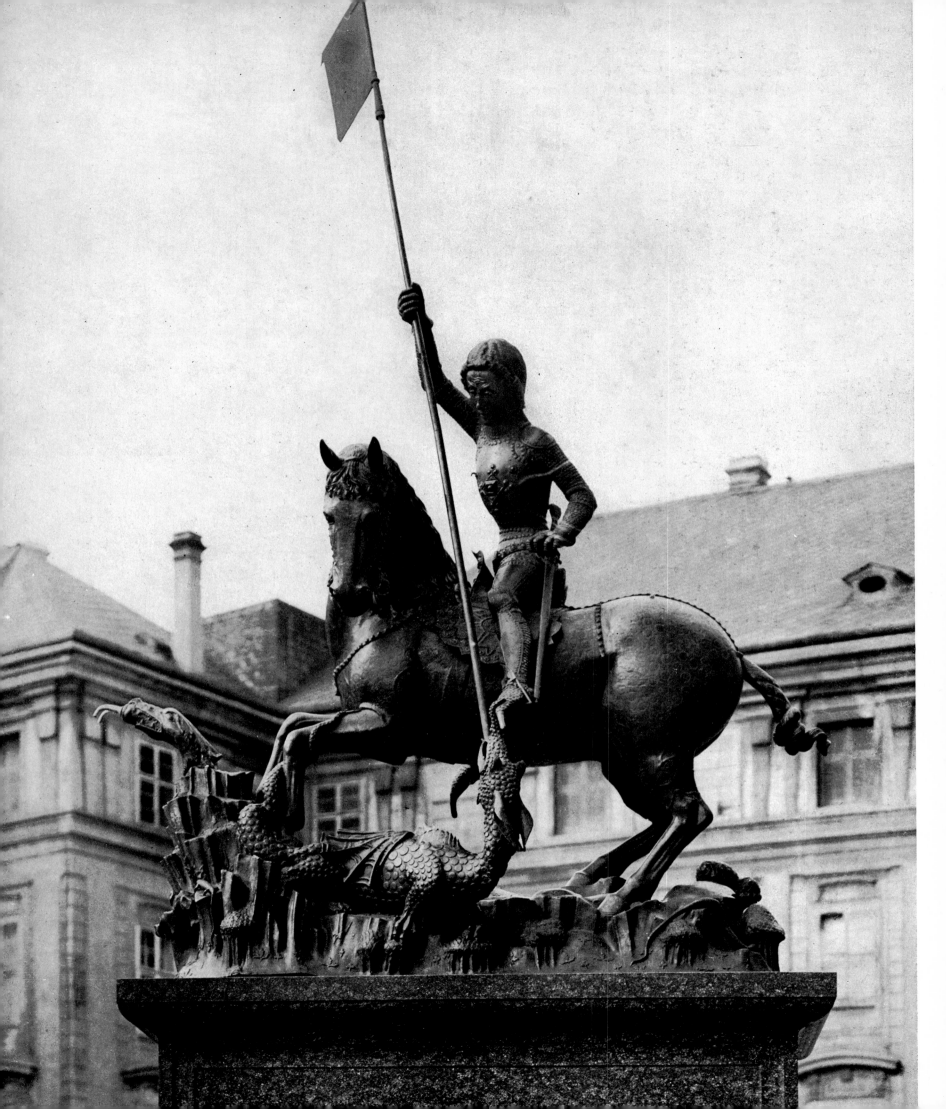

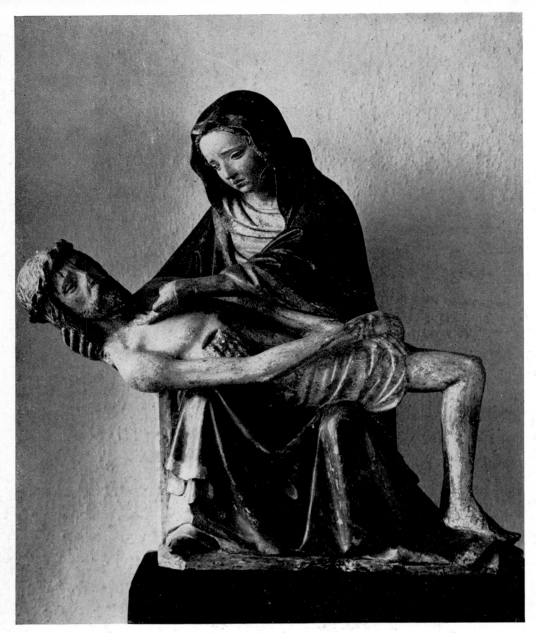

111 *Pietà. Early fifteenth century. Plaster (?) with old poly-
chrome. h. 56 cm. Český Krumlov Museum*

◄

113 *Pietà. c. 1385. Limestone with original polychrome. h.
140 cm. w. of plinth 145 cm. Parish church (formerly
Augustinian) of St Thomas, Brno*

►

112 *Pietà. 1380–1390. Limestone with old polychrome. h.
about 75 cm. Formerly in the church of St Mary Magdalene,
Wroclaw, destroyed during the Second World War*

▼

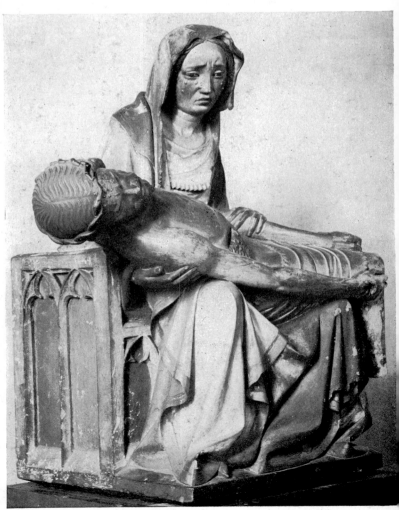

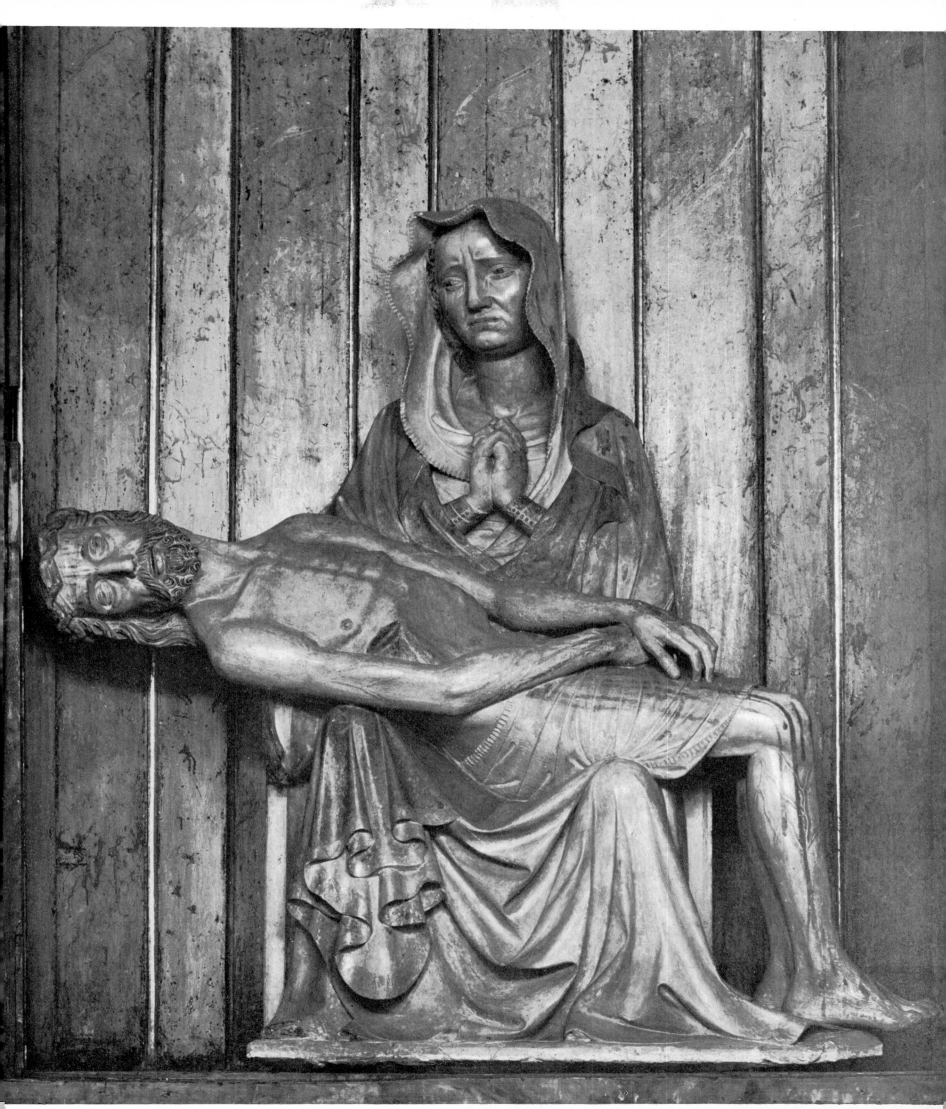

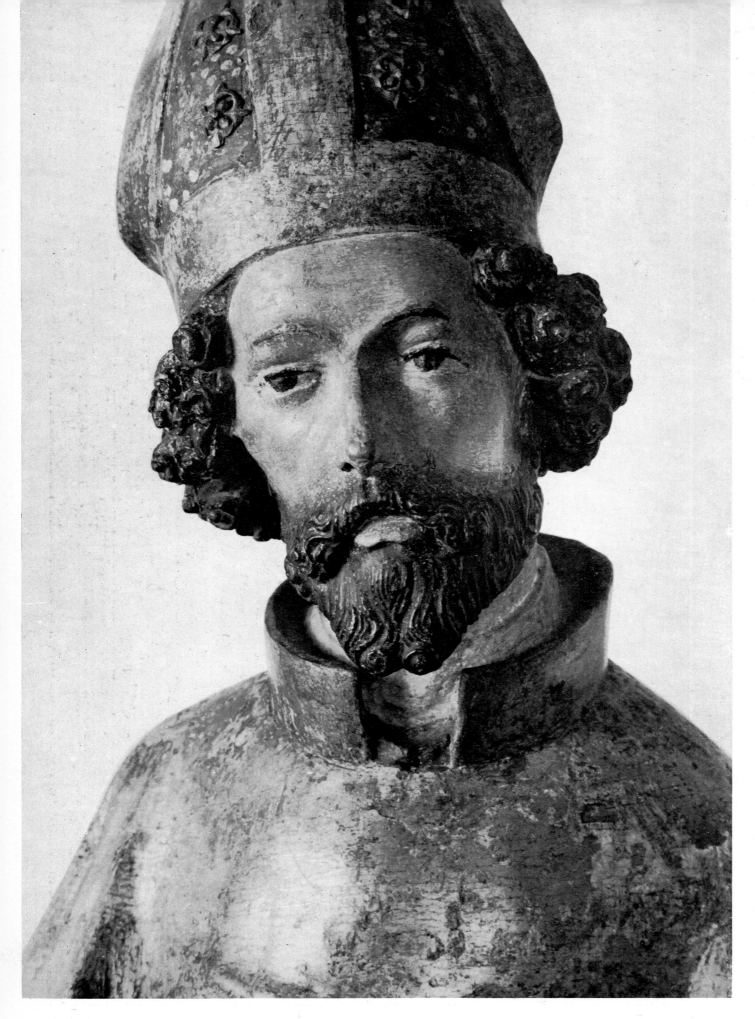

114 *St Nicholas of Vyšší Brod. 1380–1390. Limewood with original polychrome. h. 144 cm. National Gallery, Prague*

115 *The Resurrection from the Třeboň Altarpiece. c. 1380. Canvas on fir panel. 132×92 cm. National Gallery, Prague*

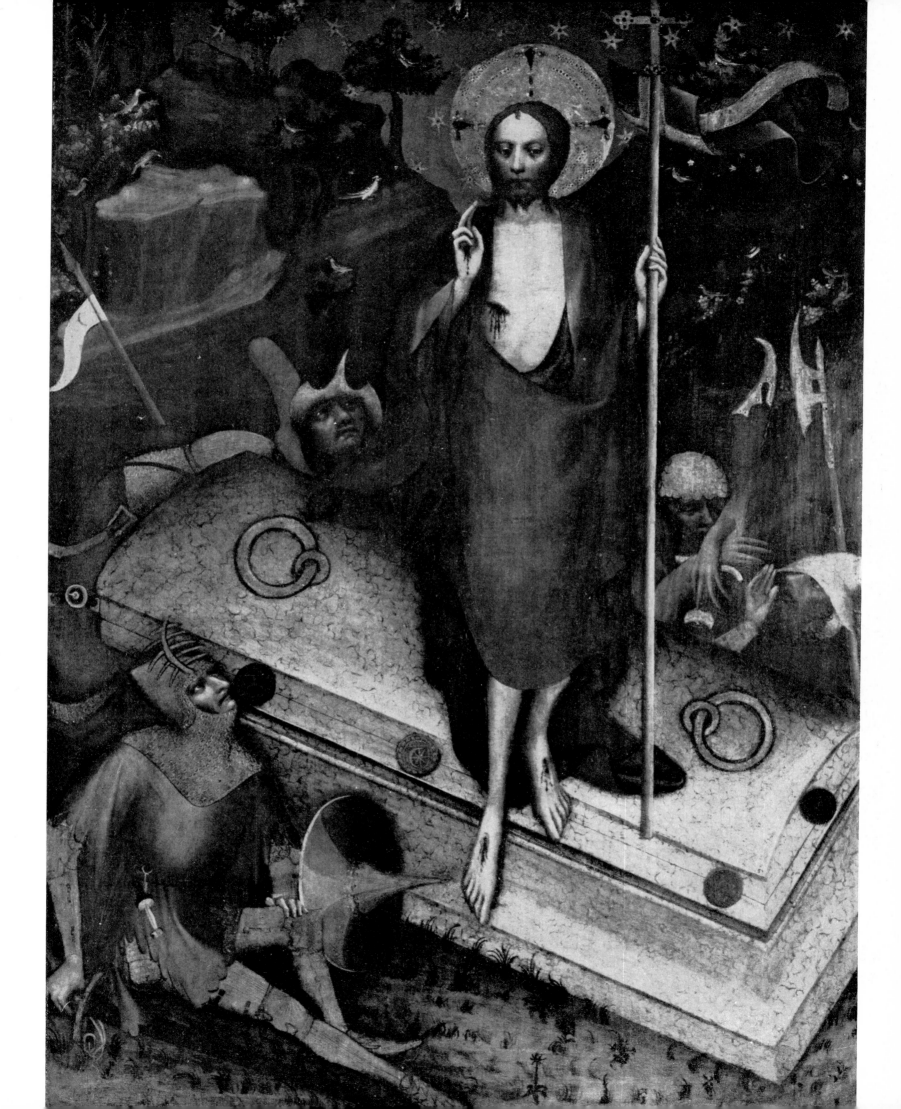

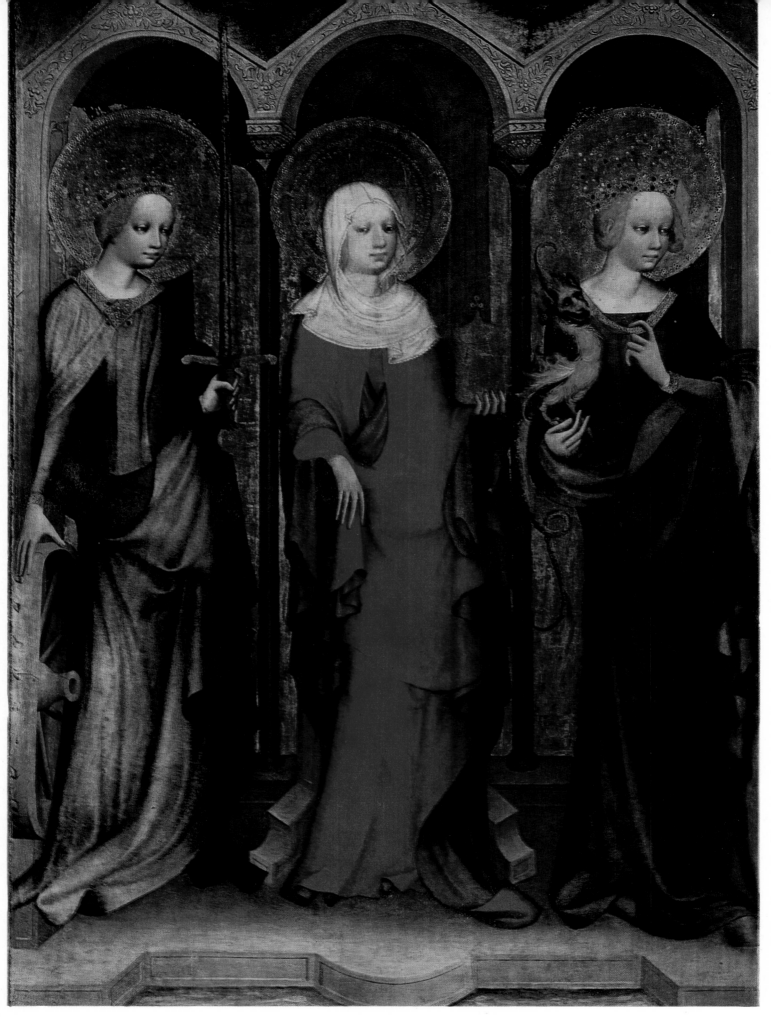

116 Three Saints from the Třeboň Altarpiece. (Reverse side of The Mount of Olives). c. 1380. Canvas on fir panel. National Gallery, Prague

117 The Mount of Olives from the Třeboň Altarpiece. c. 1380. Canvas on fir panel. 132×92 cm. National Gallery, Prague ▶

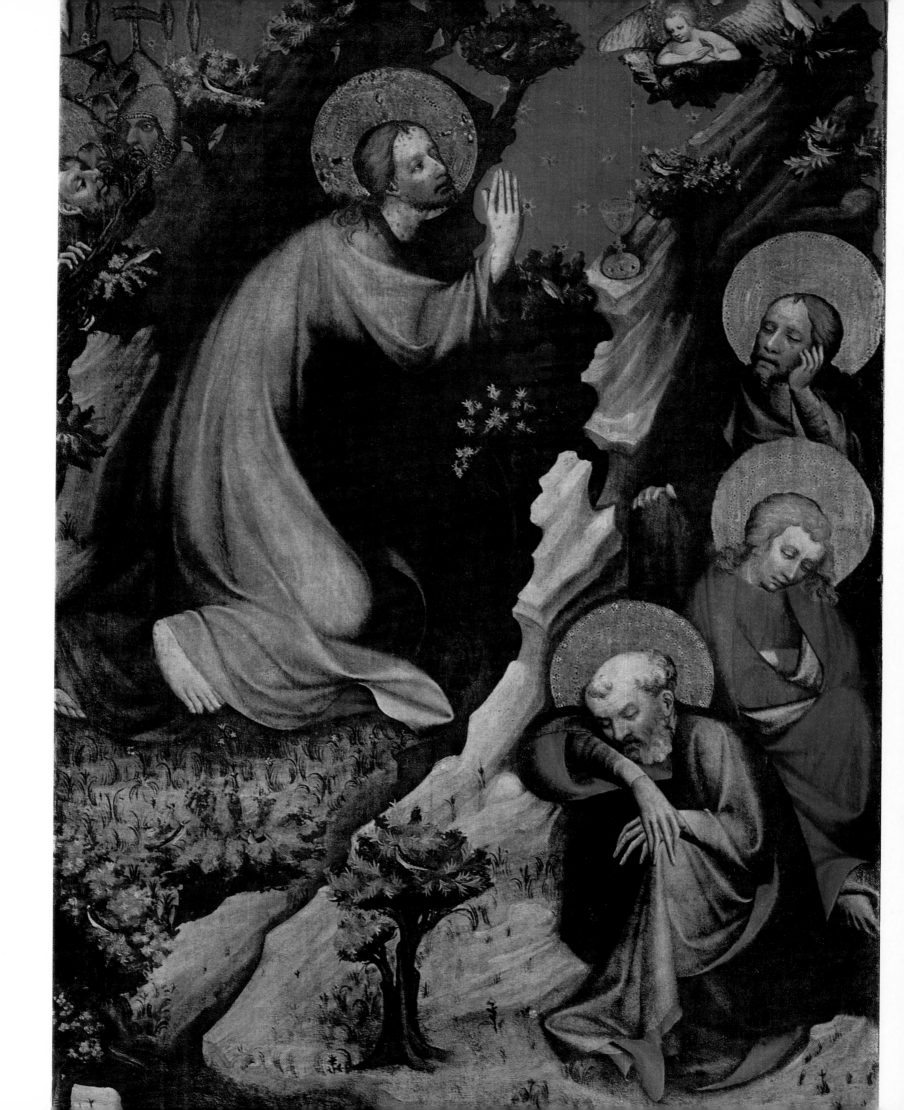

141

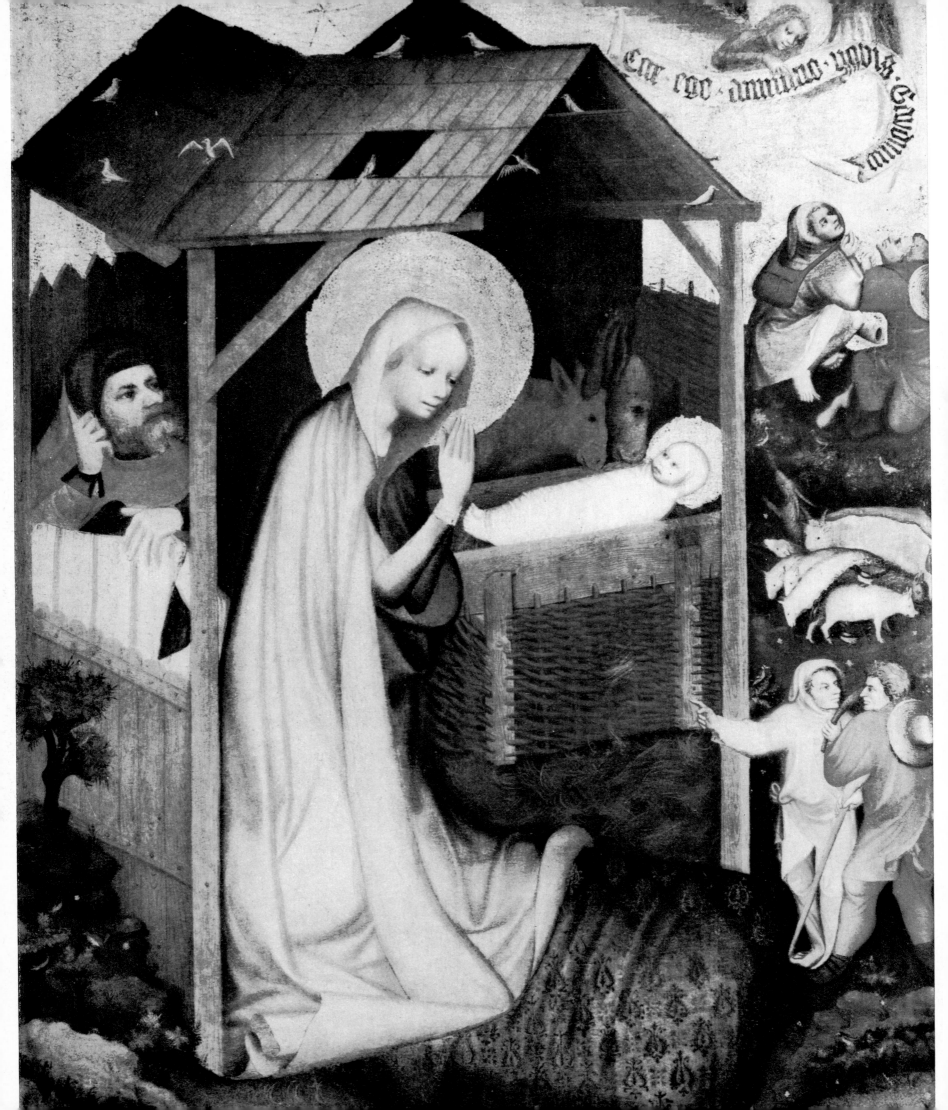

118 *The Adoration of the Child. c.1380. Canvas on wood panel. 125.5×93 cm. Hluboká castle*

◀

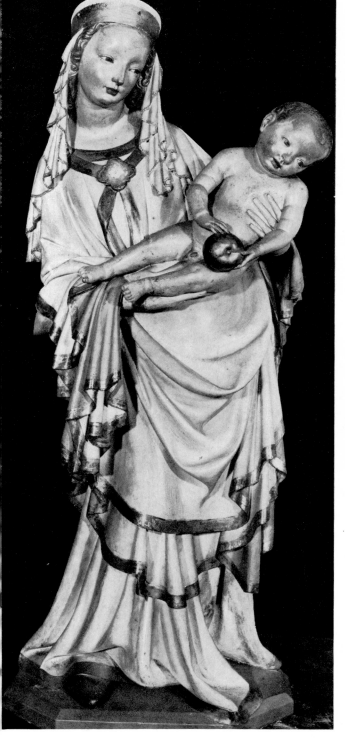

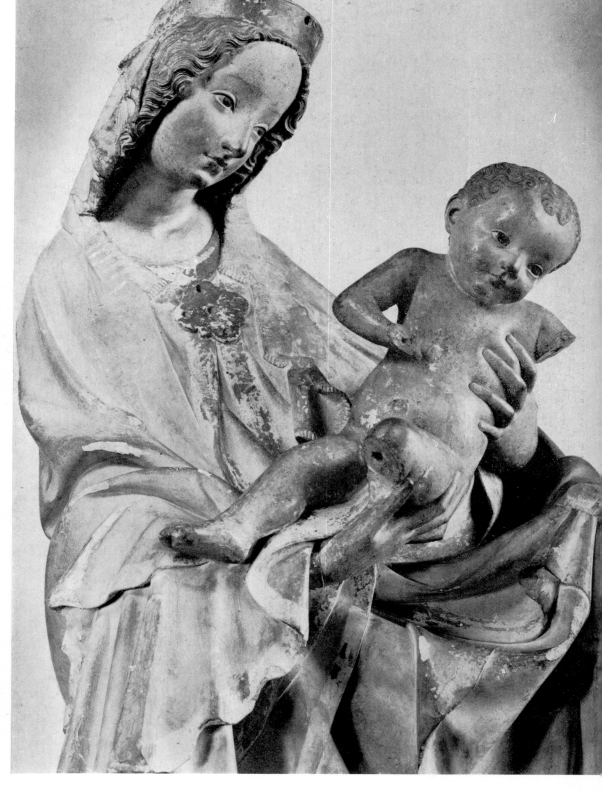

120 *The Krumlov Madonna. Before 1400. Limestone with parts of the original polychrome. h. 112 cm. Kunsthistorisches Museum, Vienna*

◀

119 *The Plzeň Madonna. c. 1395. Limestone. h. 125 cm. Church of St Bartholomew, Plzeň*

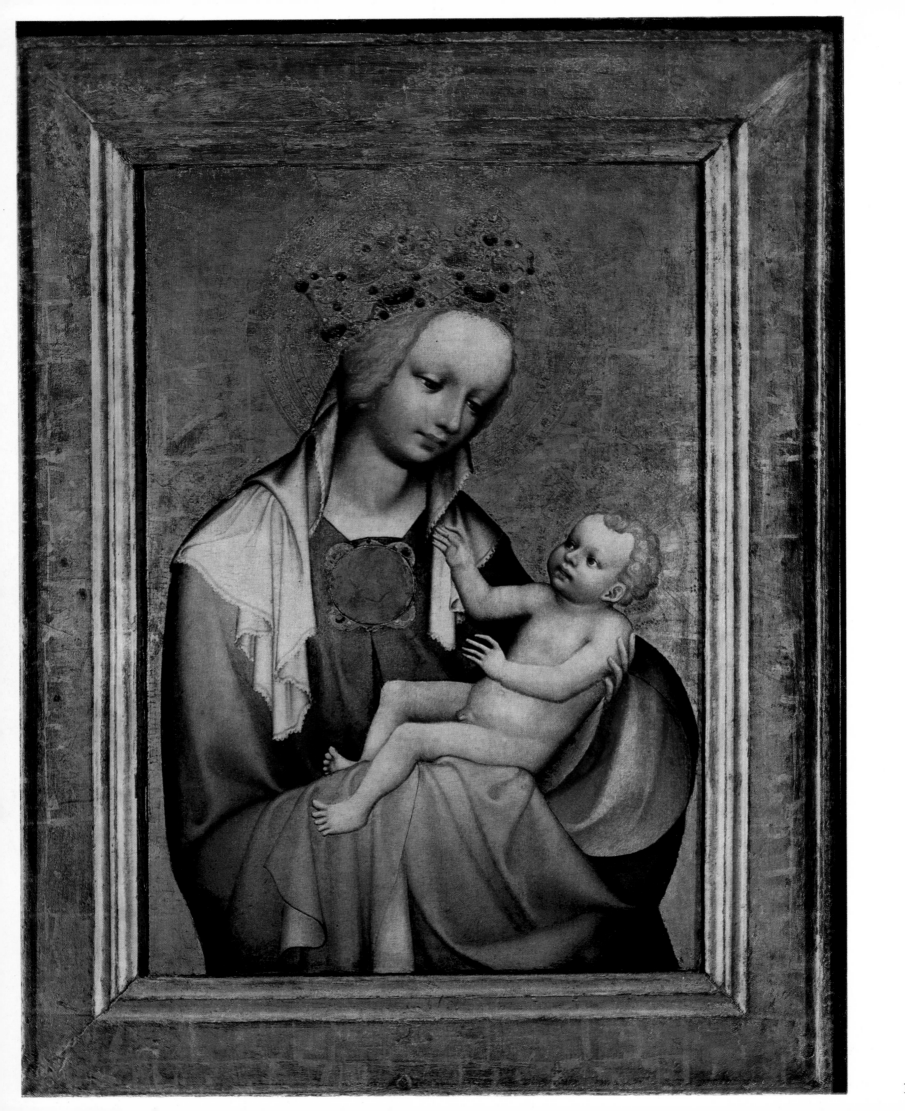

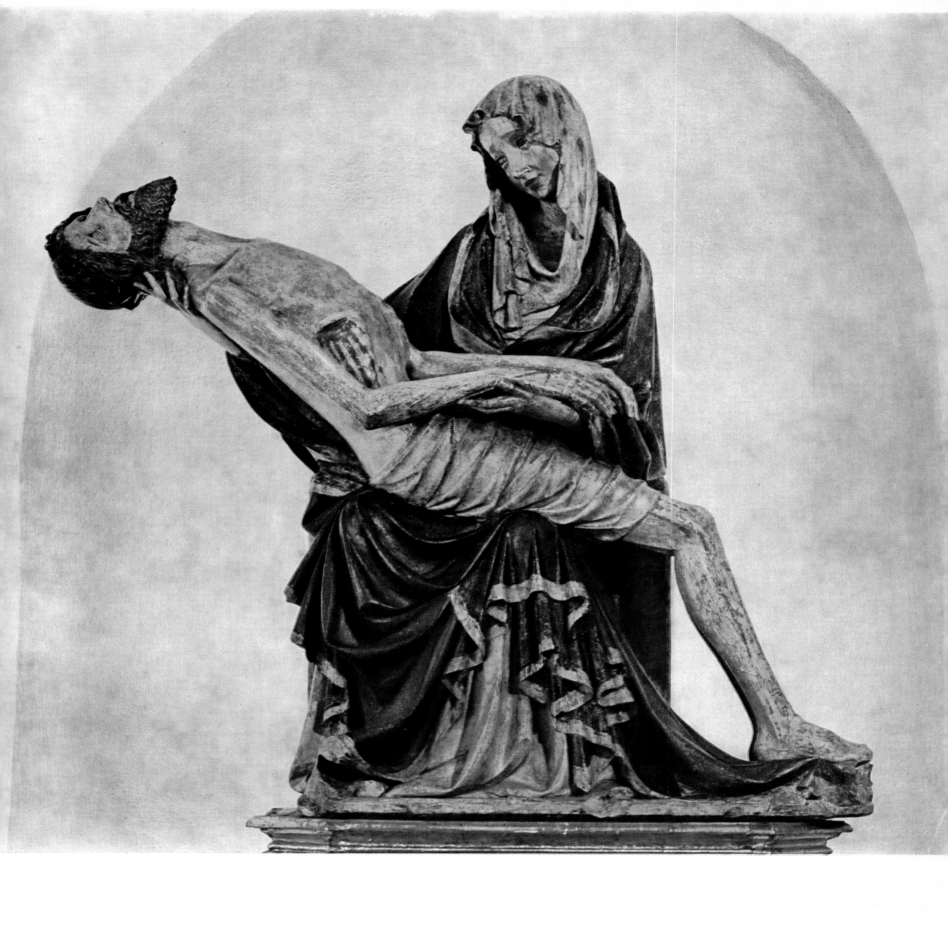

122 *Pietà. Early fifteenth century. Limestone with parts of the original polychrome. h. 121 cm. Church of St Ignatius, Jihlava*

◄

121 *The Roudnice Madonna. c. 1390. Canvas on limewood panel. 90×68 cm. National Gallery, Prague*

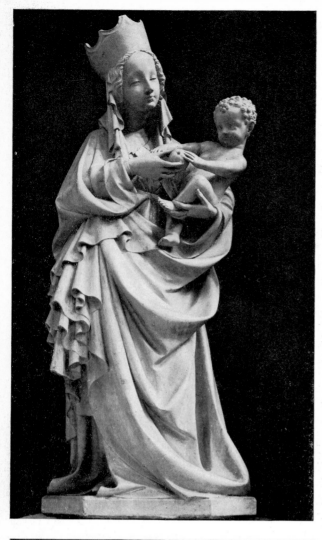

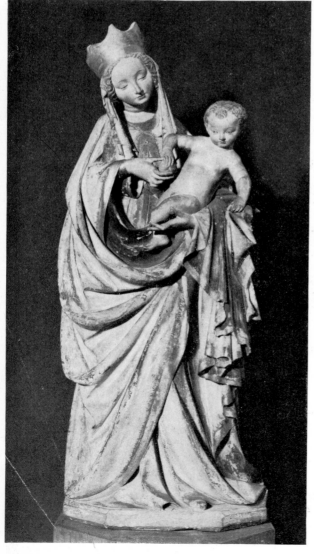

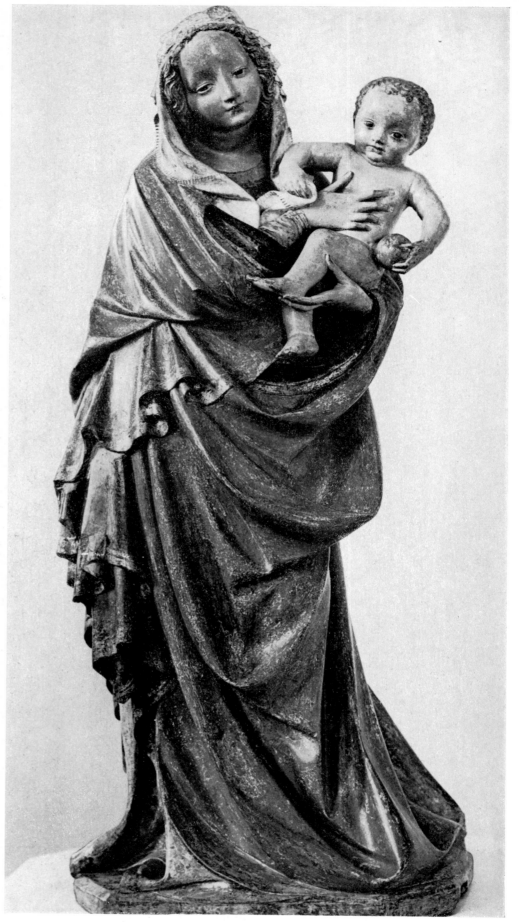

125 *The Madonna of Šternberk. c. 1400. Limestone with old polychrome. h. 84 cm.* ▲
Šternberk Castle

123 *The Madonna of Torun. c. 1400. Limestone with traces of the original polychrome. h.*
115 cm. Formerly in the church of St John, Torun, lost in the Second World War

◄ 124 *The Madonna of Wroclaw. c. 1400. Limestone with original polychrome. h. 119 cm.*
National Museum, Warsaw

126 *St Peter of Slivice (detail). c. 1395. Limestone with small fragments of old polychrome.*
h. 91.5 cm. National Gallery, Prague

▶

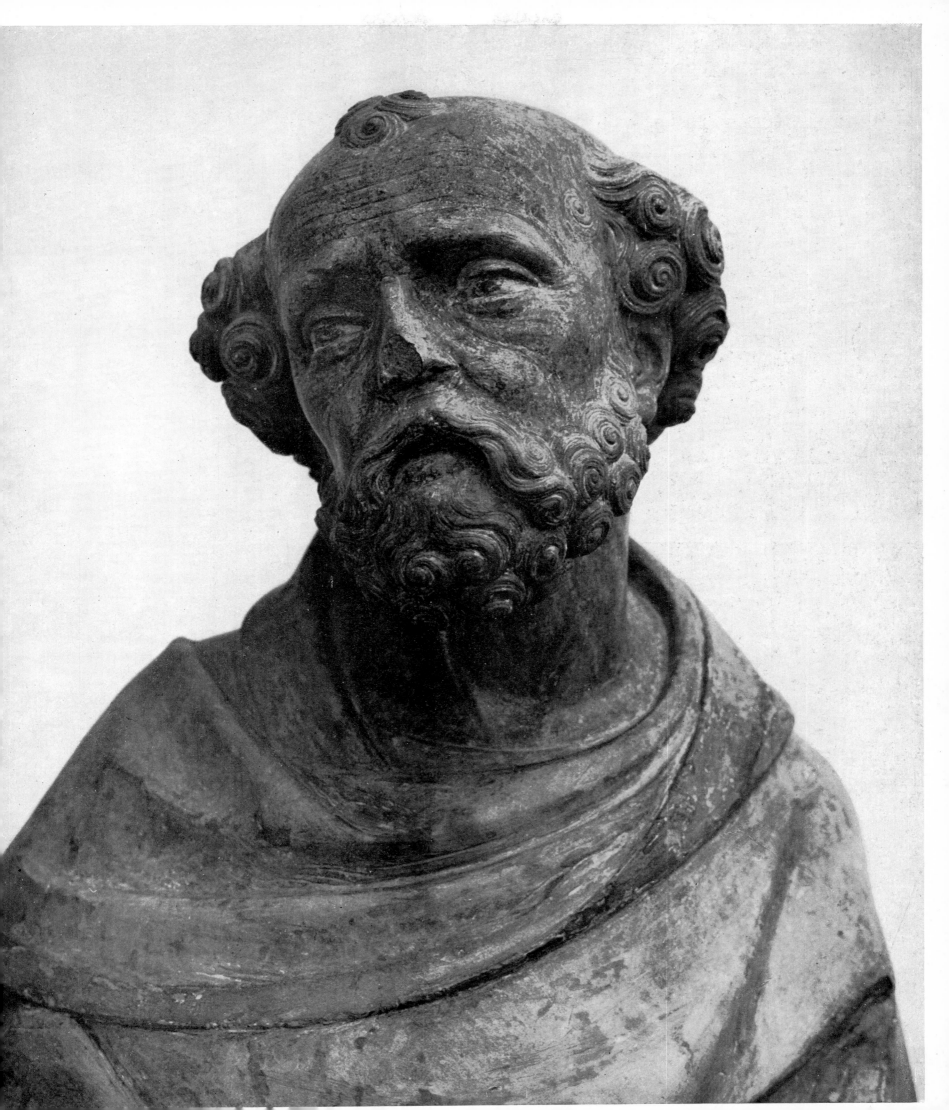

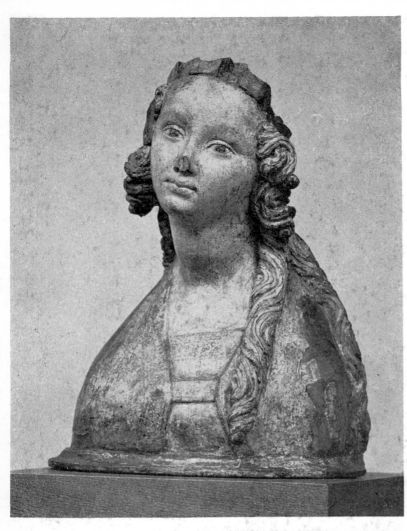

127 *Female Saint from Dolní Vltavice. c. 1390 or earlier. Limewood with original polychrome. h. 32 cm. Hluboká Gallery*

128 *Pietà. c. 1400. Limestone, no polychrome. h. 100 cm. The Hermitage, Leningrad*

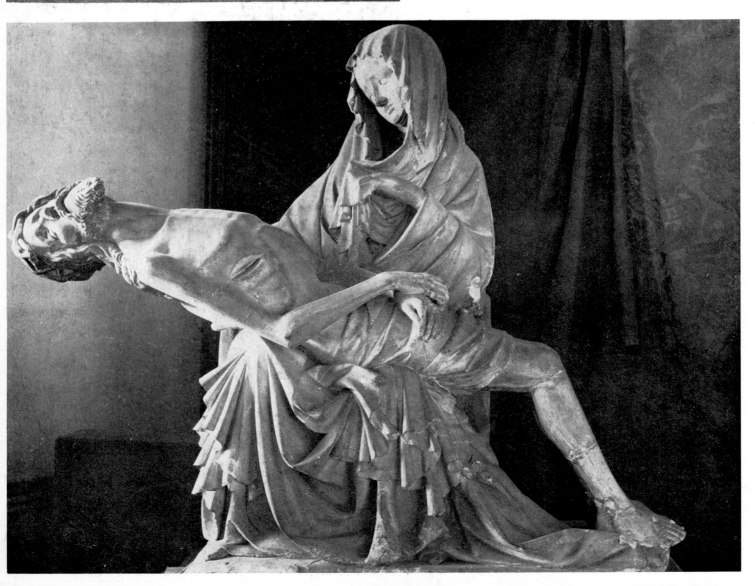

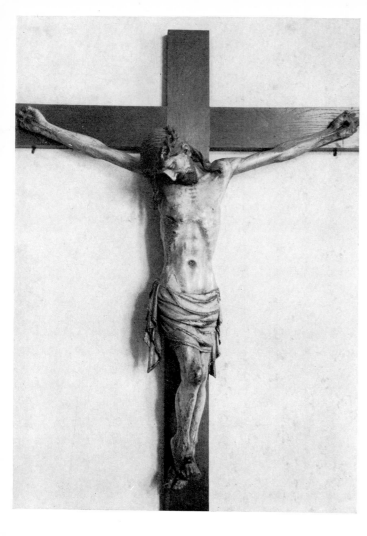

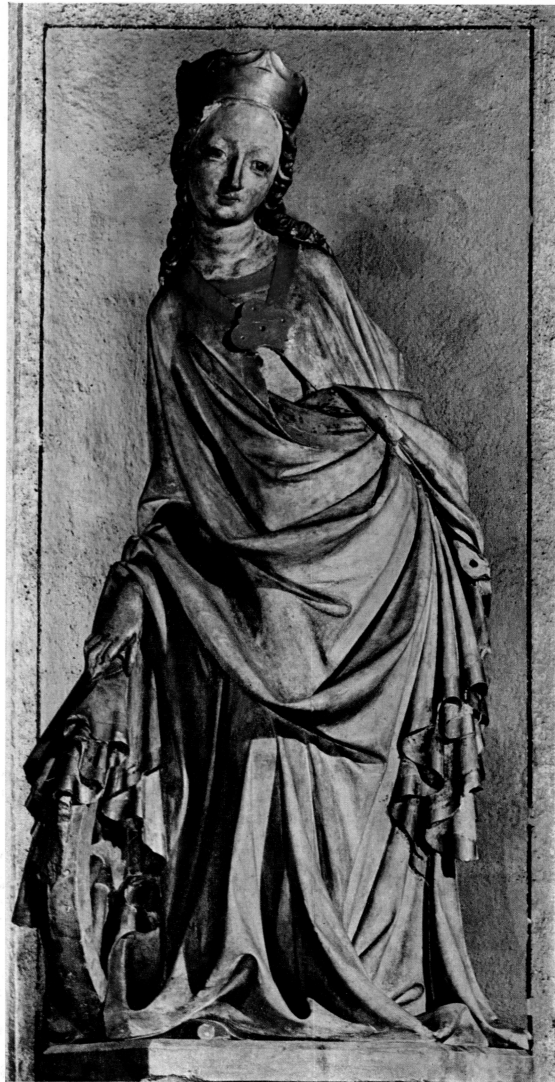

129 Crucifix. Early fifteenth century. Limewood with original polychrome. h. 80 cm. St Vitus's Cathedral, Prague

130 St Catherine. c. 1400. Limestone with parts of the original polychrome. h. 116 cm. Church of St James, Jihlava ▶

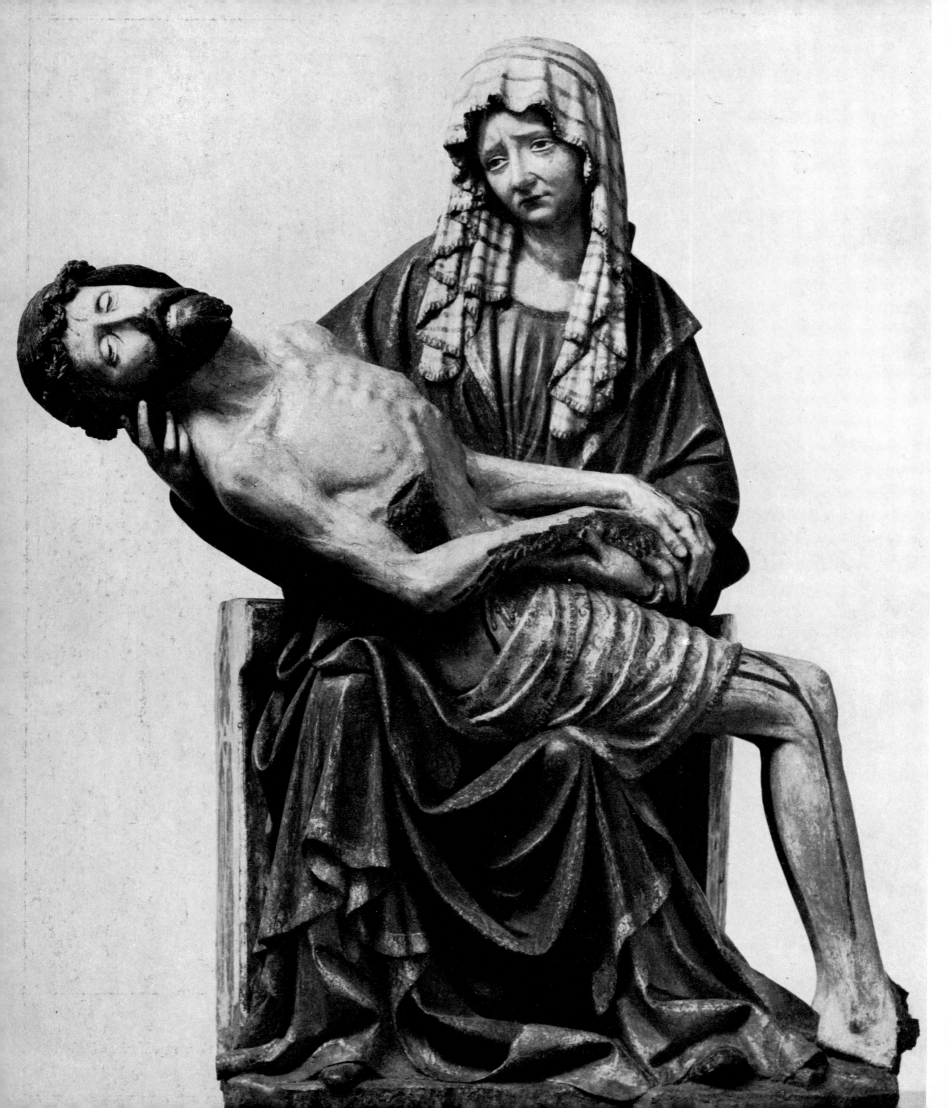

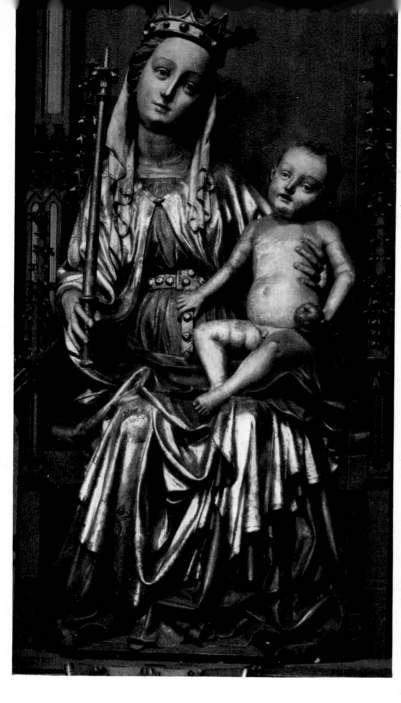

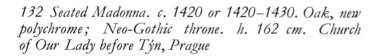

132 Seated Madonna. c. 1420 or 1420–1430. Oak, new polychrome; Neo-Gothic throne. h. 162 cm. Church of Our Lady before Týn, Prague

131 Pietà from Všeměřice. c. 1410. Limewood with partly original polychrome. h. 118 cm. Hluboká Gallery

◀ ▶

133 The Man of Sorrows. Probably before 1413. Limewood with original polychrome. h. 136 cm. City Museum, Prague

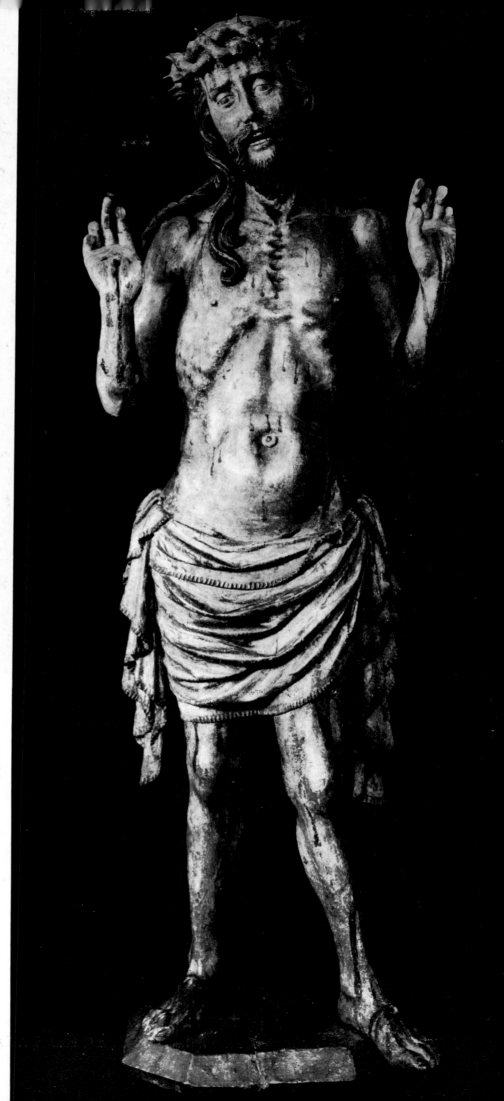

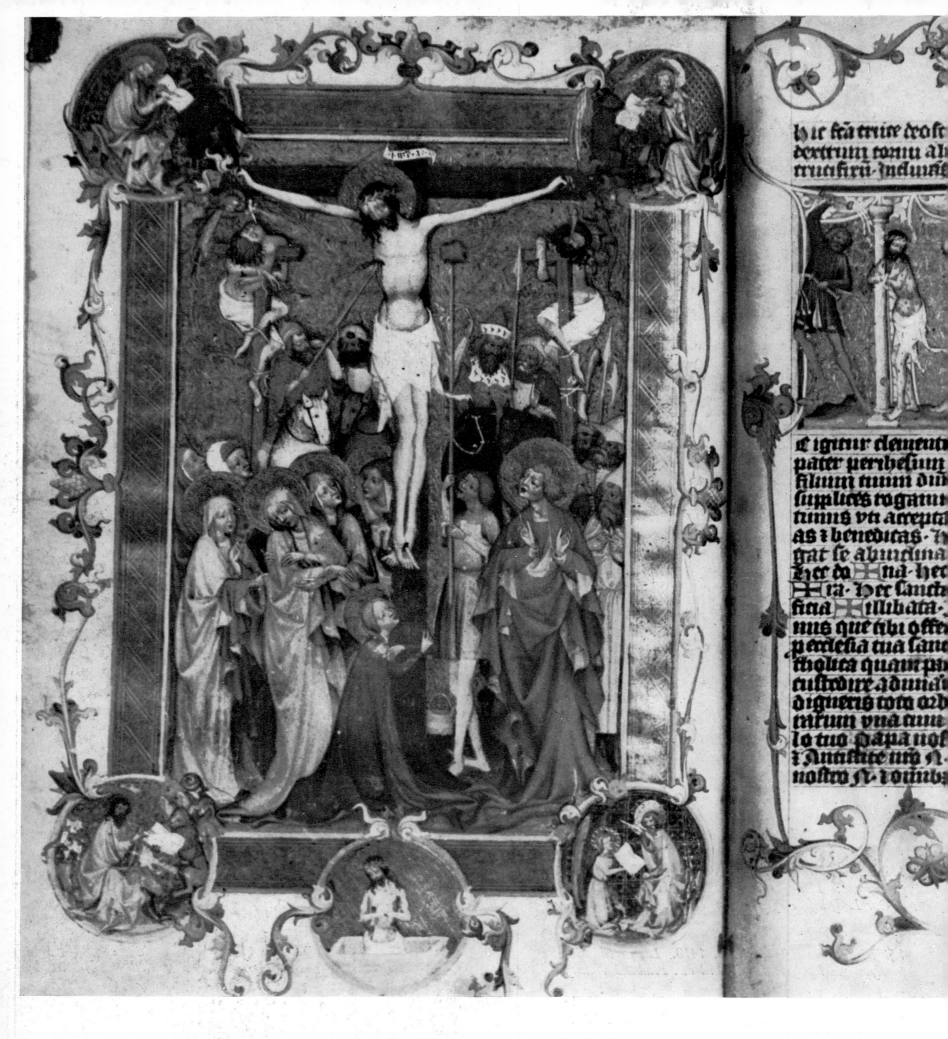

134 *Canonic folio from the Hasenburk Missal. 1409. Parchment manuscript. 24×17 cm. Nationalbibliothek, Vienna*

135 Initial from The Astronomical Book of Wenceslas IV. 1392–1393. Parchment manuscript. 29.5×21 cm. Nationalbibliothek, Vienna
136 Title page of The Golden Bull of Charles IV. 1400. Parchment manuscript. 42×30 cm. Nationalbibliothek, Vienna

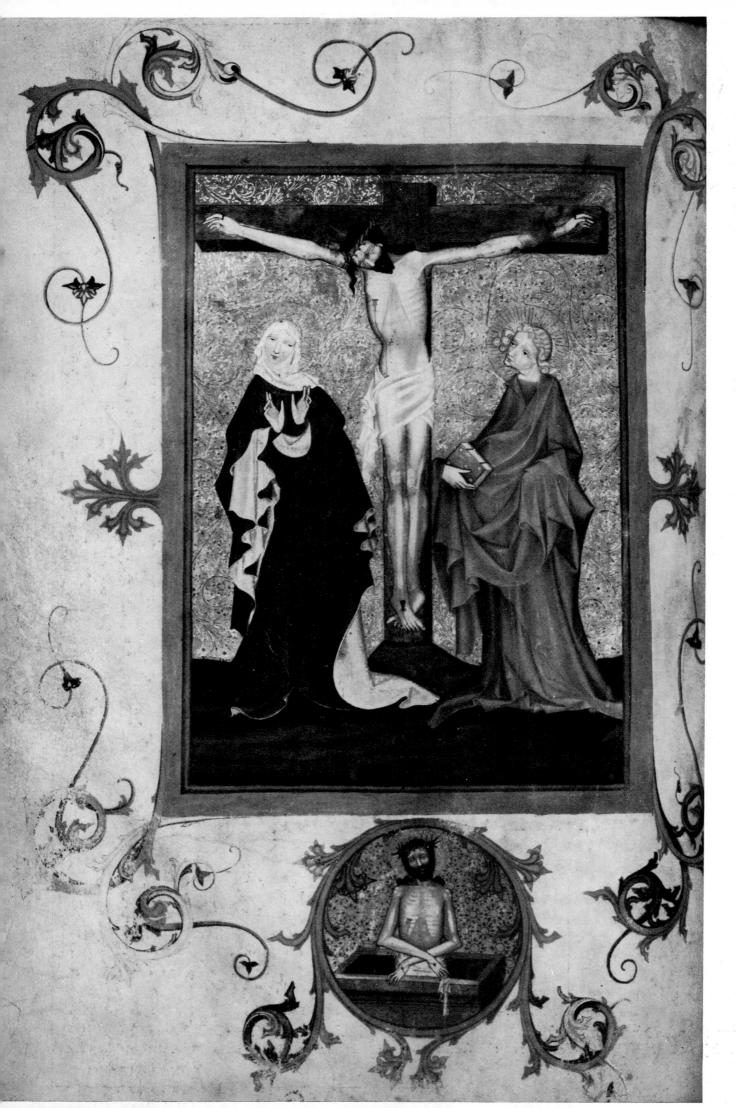

137 Canonic folio from Missal
No. 8. c. 1413. Parchment
manuscript. 41.5 × 29.5 cm.
City Archives, Brno

138 Epitaph of John of Jeřeň
(right-hand side of a severed
panel). Dated by the death
of John of Jeřeň to 1395.
Limewood. 64.5 × 49.5 cm.
National Gallery, Prague

▶

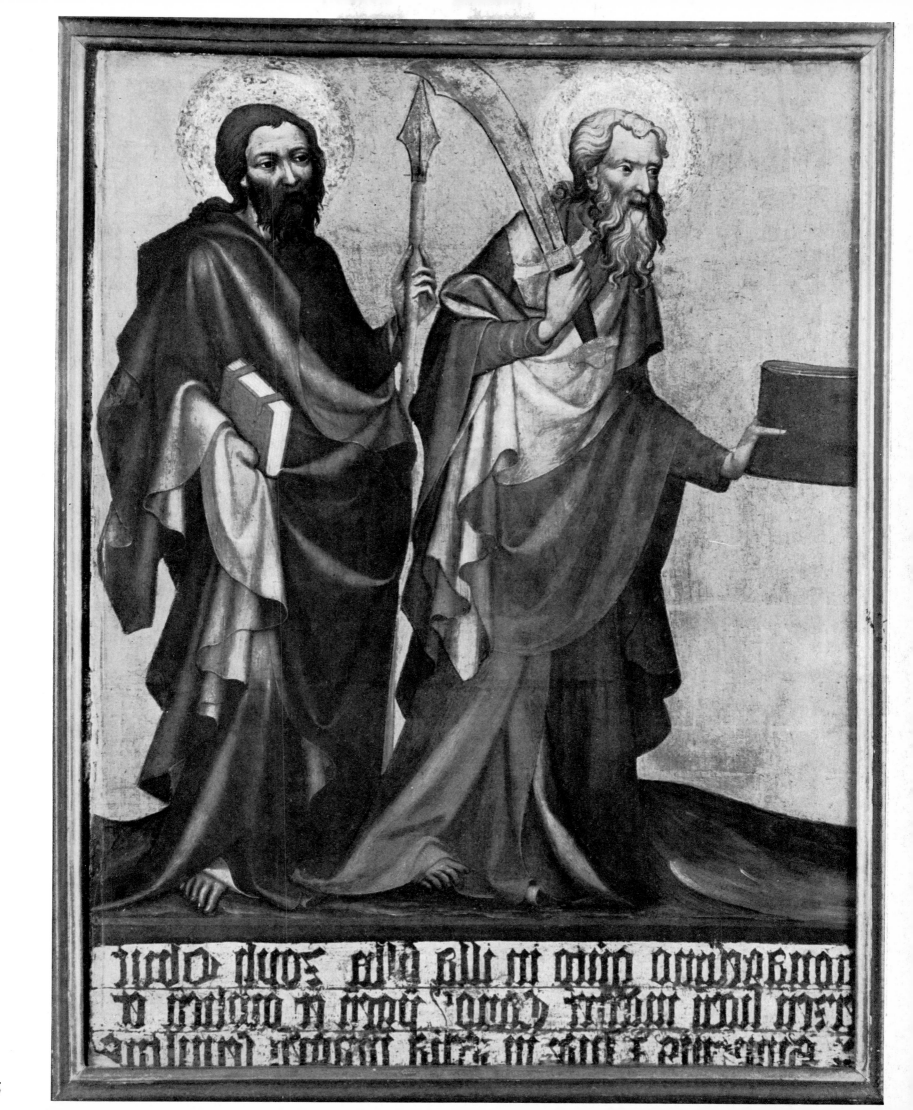

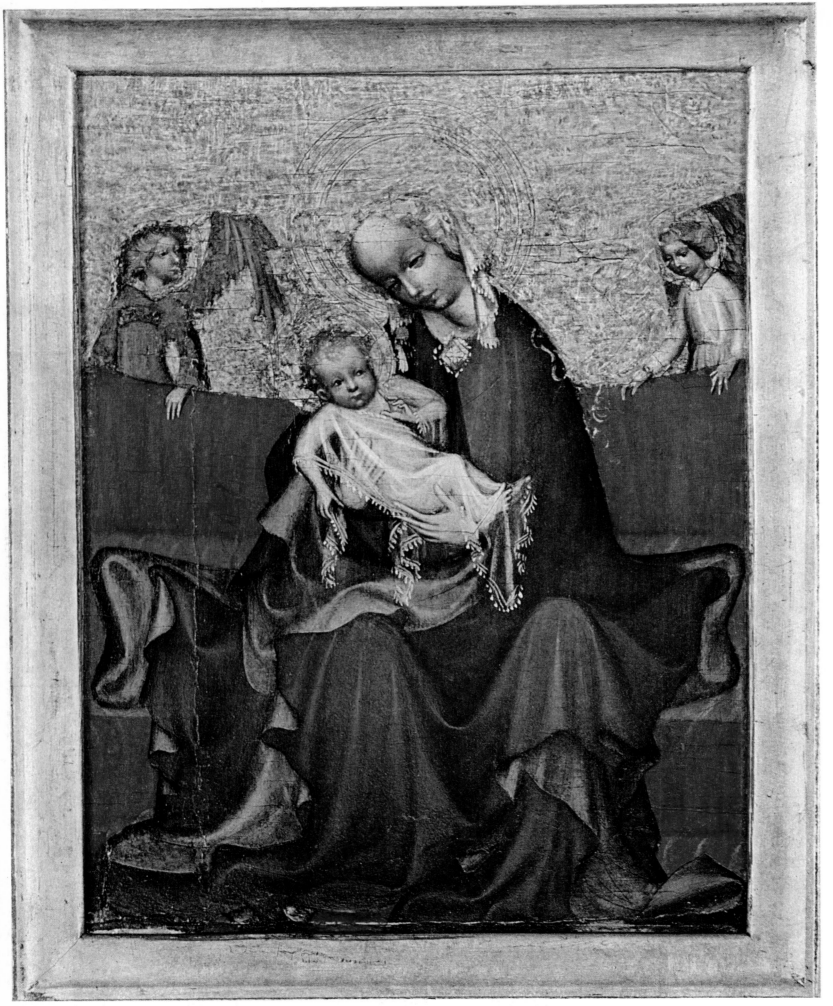

139 *The Madonna of Jindřichův Hradec. c. 1400. Canvas on limewood panel. 25 × 19 cm. National Gallery, Prague*
140 *The St Vitus's Madonna. Before 1400. Canvas on limewood panel. 51 × 39.5 cm. Limewood frame with original polychrome also before 1400.*
National Gallery, Prague

▶

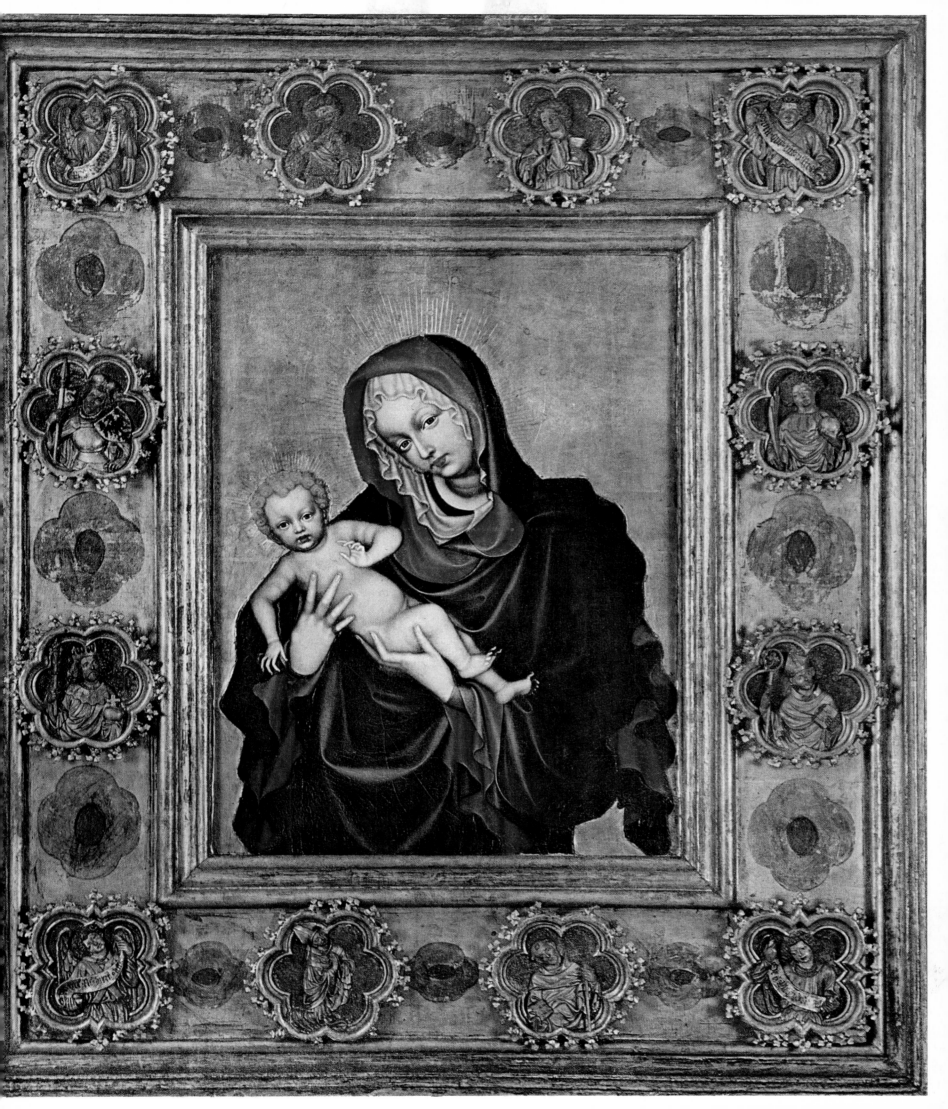

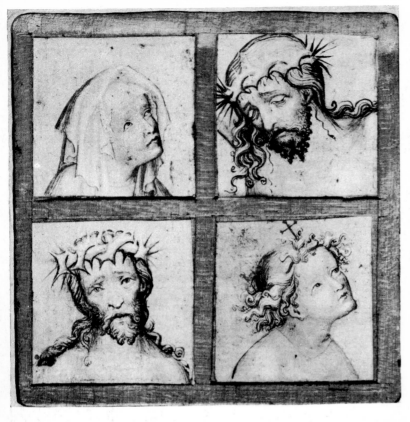

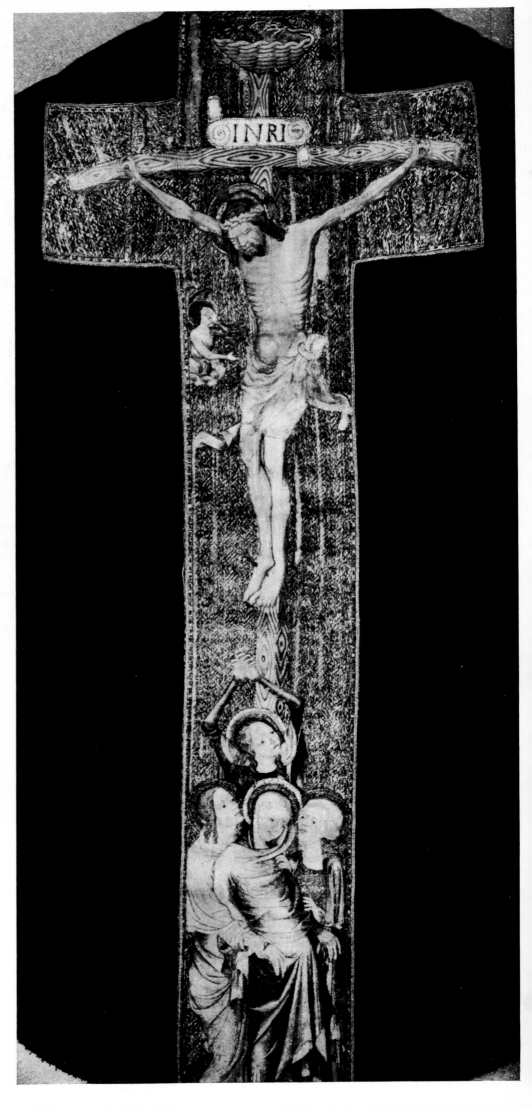

141, 142 *Heads from the Ambrass Pattern Book. Early
fifteenth century. Drawing in silver pencil on paper. Maple
plates. 9.5×9 cm. Kunsthistorisches Museum, Vienna*

143 *Chasuble with the Crucifixion (detail). 1370 to 1380.
Silk and gold embroidery. 112.5 cm. Moravian Gallery, Brno*

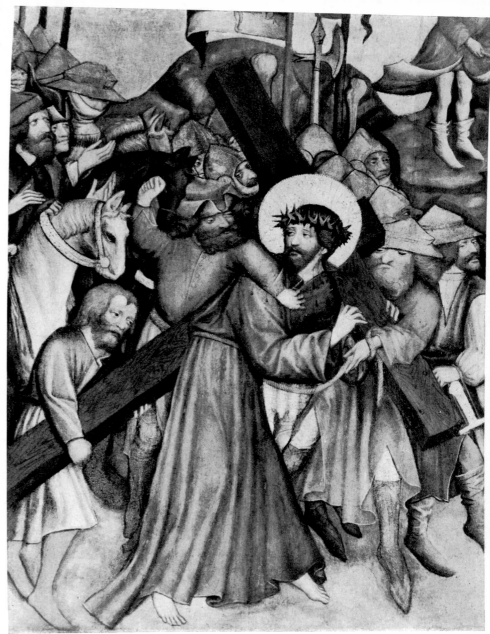

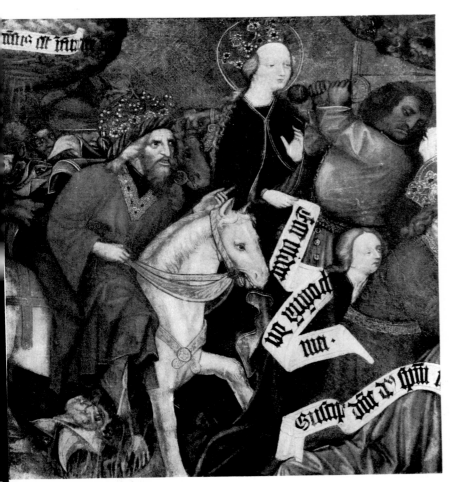

144 *The Master of the Rajhrad Altarpiece. The Way to Golgotha (detail). Before 1420. Canvas on fir panel, 99×147 cm. Moravian Gallery, Brno*

145 *The Circle of the Master of the Rajhrad Altarpiece. The Martyrdom of St Catherine (panel from Náměšť). Canvas on wood panel. 87.5×95 cm. Moravian Gallery, Brno*

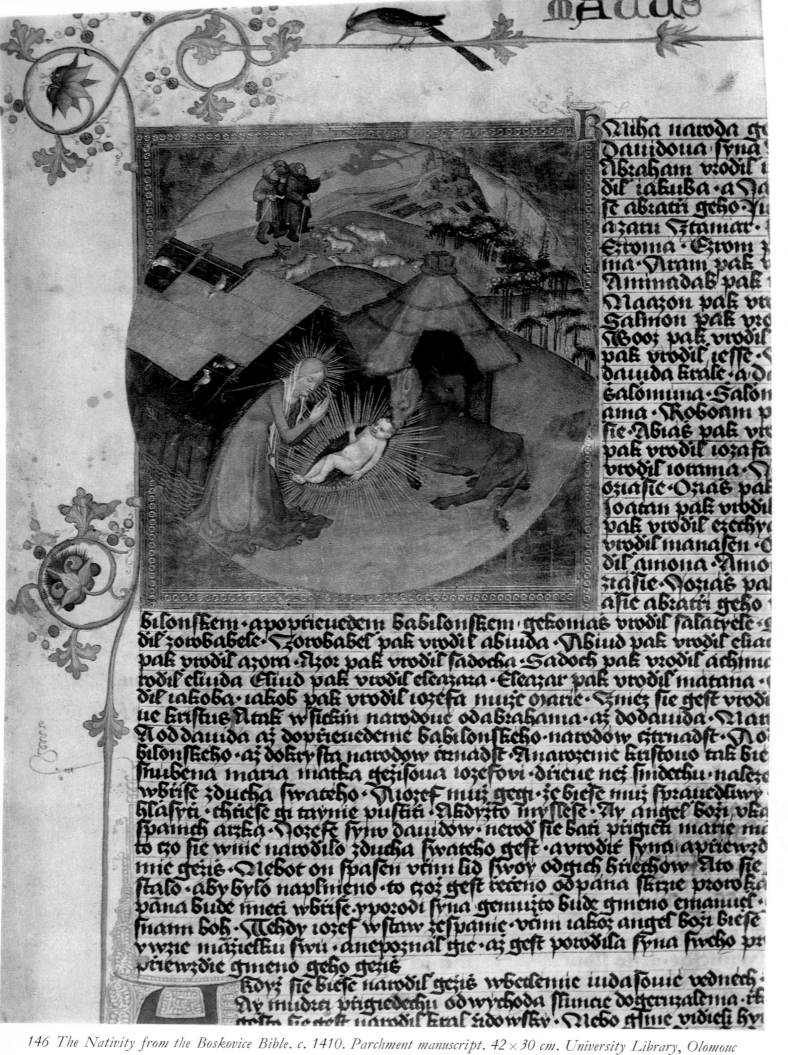

146 The Nativity from the Boskovice Bible. c. 1410. Parchment manuscript. 42×30 cm. University Library, Olomouc

those who were opposed to its sensuous secular aspects. Its strength was such that several decades were needed, and in book painting more than half a century, before it was overcome. It persisted in particular on paintings of individual figures, mainly Madonnas, which repeated the earlier types, for example the *Vyšší Brod* or *Wroclaw Madonnas* (National Gallery, Prague; National Museum, Warsaw). They imitated the *Roudnice Madonna* with great accuracy,[53] or they combined various elements from different patterns, as, for example, *St Thomas's Madonna* in the Moravian Gallery, Brno. Such combinations of elements from various sources in this advanced period are accounted for by painters and sculptors turning to the past when they did not possess strength enough to overcome the tradition and therefore sought refuge in the safe values of times past. An important factor to be reckoned with is the respect the originals enjoyed, whose effective force was to be extended to yet other places. In spite of attempts to get as close as possible to the original pattern, its meaning and form changed with minor shifts in proportions, a decreasing feeling for the complexities of linear composition and the deteriorating technical quality. The old style disintegrated even more noticeably on small pictures appearing on the frames, particularly when individual figures were replaced by narrative scenes. This process was speeded up on narrative pictures showing the Passion or Martyrdom, whose importance was growing at the time. The Crucifixion of the *Reininghausen Altarpiece* and that of the *Zátoň Altarpiece* and the picture on that theme from Skalice (National Gallery, Prague) from the fifteen twenties and thirties give a clear idea of this process. The pictures are thronged with an increasing number of persons crowded close to the foot of the Cross and reaching high up to the Crucified as if the painters were afraid of empty spaces on their pictures. This, together with the drastic depiction of suffering, greatly heightened the expressive effect. Spiritual meaning prevailed over perfection of execution. The ability to express an idea with a limited number of means and through symbolic references was replaced here by a multitude of objects described. These features also determined the character of the outstanding panel from Náměšť with scenes of perhaps the *Martyrdom of St Apolonius and St Catherine* (Moravian Gallery, Brno). The large, massive figures completely fill the surface of the picture whose golden background can only be seen on a narrow strip at the top. Geometrical layout, noticeable particularly in the painting of St Catherine, brings order into the crowded composition, but does not weaken the expressive effect aimed at by the painter. It is no mere chance that the ability of these painters is best shown in the pictures with the themes of suffering and death while lyrical scenes and individual figures based on the Beautiful Style lost their former delightful poetry.

The *Cycle of the Virgin* of the *St James's Altarpiece* (National Gallery, Prague; Moravian Gallery, Brno), with scenes from the life of St James on the other side links up with the art of the beginning of the century. The changes that had taken place there were a kind of petrification of the old principles. Their disintegration can be better observed on the *St James's Altarpiece*, where a more convincing rendering of space began to appear. But the painter, who may have been an assistant to the Master of the Cycle of the Virgin, did not contribute anything new that rivalled or even exceeded the landscape painting by the Master of the Martyrology. If we consider that the altarpiece was probably made in the thirties, the time when the *Ghent Altarpiece* came into being, we can clearly see the gap between Czech painting clinging to tradition and the progressive currents running through Western centres of painting. The long years of endeavours aiming at a realistic depiction of the world, to which Czech painting had at one point made a considerable contribution, were reaching a climax there. In the Czech Lands, however, the political and religious isolation brought about by the Hussite wars was beginning to be felt. The *Rajhrad Altarpiece*, the Náměšť panel and the *St James's Altarpiece* came into existence in Moravia. It is highly likely that they all belong to one workshop or one school. It is due to the Hussite wars that a considerable number of works of art can be found in Moravia. The Hussite movement ousted systematic production of works of art to marginal regions less affected by the revolutionary struggle. The outbreak of the Hussite Revolution caused Prague to lose its leading and style-setting position. In some ways this foreshadowed the state of disintegration and lack of unity of style, typical of the final phase of Czech Gothic art. Up to that point the surviving tradition gave Czech Gothic art a semblance of unity.

South Bohemia was in a similar position to Moravia. The mighty family of the Rožmberks maintained an enclave of relative calm. For several decades, contact with the tradition of art under King Wenceslas continued. We might mention the *Reininghausen Altarpiece*, which is closely connected with the *Madonnas of Vyšší Brod* and of Wroclaw, probably of south Bohemian origin. In the same group is the altarpiece from Hýrov, the *Bearing of the Cross* from Vyšší Brod (National Gallery, Prague), whose master is said to be identical with the one who painted the *Ringhoffer Visitation* (National Gallery, Prague) and the *Adoration of the Child* in the Szépművészeti Museum, Budapest. Also in south Bohemia expressive trends were on the increase. Compare, for example the altarpiece from Zátoň and in particular the *Mater Dolorosa* from Kreuzberg near Český Krumlov (Kunsthistorisches Museum, Vienna), whose expression is among the most moving of the works made in the twenties. Quite often we can meet remarkable analogies to contemporary south Moravian painting so that one must assume that there had been contacts between the two regions.

In the mid-century, the style of the beginning of the century was revived in south Bohemia. The *Lanna Assumption* (National Gallery, Prague) retains much of the charm of the Beautiful Madonnas and their formal system. The stiff frontal figure of the Virgin, however, shows lack of understanding of the old system. Its spatial conception and the exaggeratedly small body of the Child reveal that the conventions regarding the proportions which were applied throughout the century had been forgotten.

The *Madonna of Deštná* (National Gallery, Prague) has lost even the long and flowing lines. They have been replaced by terse straight lines and sharp angles which, together with the hesitant realism on the faces of the donors, was the only concession to the new period.

V. *The Second Half of the Fifteenth and the Early Sixteenth Century*

THE HUSSITE REVOLUTION; LATE GOTHIC ARCHITECTURE IN SOUTH BOHEMIA – THE ROŽMBERK LODGE; VLADISLAV II AND BENEDICT RIED; ST BARBARA, KUTNÁ HORA; ARCHITECTURE IN MORAVIA; LATE GOTHIC SCULPTURE – ANTHONY PILGRAM; NETHERLANDISH AND RHENISH INFLUENCE IN PAINTING; THE MASTER OF THE LITOMÉRICE ALTARPIECE

In the fourteenth and early fifteenth century Czech art reached a high level, and took the leading position in Central Europe. But all of this came to a sudden stop with the outbreak of the Hussite Revolution. Art was not completely discontinued. It was kept alive in the border regions, and a few important artists managed to keep up with what was going on in the neighbouring countries. But a period of stagnation followed when the heritage of the past was repeated over and over again. Gradually the isolation of the Czech Lands from the rest of Europe lessened and artists caught up with achievements which had originated elsewhere. The result of the long years of civil war and foreign military intervention was economic crisis and a new social set-up that did not prove favourable to art. The three social classes which had so far wielded a decisive influence on art were removed from positions of power and their impact lessened considerably; the Court, the Church and secular aristocracy, and the rich burghers.

In the course of the fifteenth century the towns underwent rapid consolidation and a relatively high standard of living was achieved. But since the guilds were in charge of all economic life they maintained small-scale production, which prevented the accumulation of capital and the resurgence of the burghers who, in the rest of Europe, were playing an important role as patrons of the arts.

Only Kutná Hora, a town rich in silver, used its wealth to encourage art on a grand scale. It even surpassed Prague, where pride in its former greatness also stimulated remarkably enterprising projects, surprising in so poverty-stricken a town with such a restless atmosphere. Yet in the later fifteenth century the aristocracy moved to the fore economically; with the introduction of new forms of private enterprise they entered into sharp rivalry with the towns. And in the sphere of art their patronage played a considerable role. Towards the end of the fifteenth century, the Court in Prague once again assumed significance in the history of art and it seemed as if the city would once again become a centre of art in the country. Its collapse was one of the most unfortunate consequences of the Hussite Revolution. But now it was too late. The great cultural epoch was drawing to an end. There were no sufficiently rich and creative hinterlands in towns. They were too involved in religious disputes to give active support to art. Yet at the turn of the century Bohemia rose to achievements in architecture whose significance was felt beyond the borders of the Czech Lands and sculpture at least equalled the production of the neighbouring countries. Continuity of development was interrupted most in painting;

although several outstanding individual painters emerged, the general level remained provincial.

The highly specialised art of the late Wenceslas period had renounced its function to discover the world while, at the same time, withdrawing into the ivory tower of specific problems. During the confusion of the Hussite Revolution its existential basis vanished completely. Art had been attacked for its secular sensuality even before this period. And it was too closely linked with the Church, the aristocracy and the burghers to be able to resist the religious and social reformation where the return to the original purity of the Church was closely linked with the struggle for a more just social order. Everything that was sensual, refined and formalist was rejected. What tended to ornament showed greater tenacity as it was able to express ideas through symbols. The country was economically exhausted. Political uncertainty reigned. There was a constant struggle between the Utraquists and the Catholics, who attempted to restore the old order. The Utraquists' opposed to magnificence in divine services and ornamentation and the emphasis was on the meaning of words over sensuous pictures. All this stifled the development of art for a long time. This uncertainty continued throughout the reign of George of Poděbrady, even though willingness to compromise had long blunted the edge of the iconoclastic fervour, and the rigorous attitude to things secular even among the reformers.

The image of the time which we get from surviving art distorts the real situation since the Counter-Reformation destroyed everything that gave as much as an inkling of the revolutionary era in Czech history: for example all monumental sculpture from the time of King George. Nonetheless, the poverty of the revolutionary and post-revolutionary period can be judged from the fact that no building of any artistic importance was erected for a long time.

* * *

Artistic activity that was somewhat remarkable could be found only in places less affected by the wars. In south Bohemia the continuity of the Rožmberk estate brought uninterrupted development. Soon after the middle of the century the Rožmberk masonic lodge turned to building activity. It resumed efforts towards achieving unified space, partly by using means from the pre-Hussite period, mainly net vaulting. The builders were well-informed about events beyond the borders of Bohemia, particularly in Austria and on its borders with Bavaria. The former soft forms and fluid rhythm of architectural members were replaced by hard linearism and jerky movement.

The church at Trhové Sviny was begun before 1485. The parish church at Dolní Dvořiště dates from 1488–1507. Both show a surprising standard of architecture. The church at Dolní Dvořiště, which was built by the Rožmberk masonic lodge, has a lofty nave and aisles and slim columns, supporting the net vaulting. In this it follows the pre-Hussite tradition. But the fluted piers where light catches the edges and other features show that the building belongs to a later period. Its masons worked on many buildings on the Rožmberk estate, among them the church of St James the Great at Prachatice. They had close contacts with the lodges in the Danube basin.

Another important building is the single-nave parish church at Chvalšiny. As in other south Bohemian churches of the time its choir opens out into the nave, being of almost equal width. The nave has remarkable vaulting; the ribs are cut into short, intersecting parts, some of which are already curved. The manner in which the ribs do not rise from their shafts is reminiscent of buildings by Wenceslas IV's lodge, the first to make radical inroads into the structural logic of the vaulting system.

Similar principles were applied in the presbytery of the church at Rožmberk. There are definite links with the Danube region of Austria, particularly the church in nearby Freistadt, whose vaults perhaps also influenced the Špulíř chapel in the church of the Assumption (Nanebevzetí Panny Marie) at Jindřichův Hradec. The date of the Austrian vaults is still disputed.

The tradition of double-nave churches survived in the pilgrimage church at Kájov, whose presbytery has a Milevsko-type vault, and in the Minorite church at Bechyně, whose two naves are covered with diamond-patterned vaulting. This was the final stage in the history of Gothic rib vaulting. The surface of the vault is split up into crystalline shapes where each surface is bent to a different angle to cause a play of light and shade that breaks down the solidity of the vaulting. It forms a striking analogy with the 'broken' style in painting and sculpture. Diamond-patterned vaulting, in all likelihood, came to the Czech Lands from Saxony. It can be found in the Albrechtsburg at Meissen, from whence it came to Chomutov and Kadaň (the Franciscan monastery) and then to south Bohemia. There we can find it in the churches at Blatná, Soběslav and Tábor. It also appeared on the estate of the powerful Pernštejn family (for instance at Pardubice and Pernštejn).

A similar example of the disintegration of the Gothic structural system is the transformation of its supporting members into naturalistically shaped forms, designed to give expression and create an atmosphere. A typical example is the hall of Bechyně castle with a pillar in the shape of a tree with branches taking the place of the ribs. The introduction of naturalist elements into architecture is a sign of the weariness of the style and the search for new means of expression. But it also points to a romantic search for escape from mundane everyday life. Another phenomenon that frequently appeared in south Bohemia is of similar social and psychological origin: it is usually called the Romanesque Renaissance. It appears, for example, in the castle at Jindřichův Hradec, where elements of Romanesque architecture were revived. It represents a typical example of the romantic return to the past.

The standard of late Gothic architecture in south Bohemia was very high. Some of the buildings from that time rank among the most remarkable in the Danube region. But there was no longer the same initiative that had existed before the Hussite wars, when architectural ideas originating in Prague were passed on to Austria and Bavaria and stimulated a wealth of important and varied architecture. Although even at this stage south Bohemia still kept up contacts with earlier local developments, it was already coming under new influences radiating from the Danube region. An outward sign of the changed situation can be seen in the fact that the Krumlov lodge, founded in 1497, followed the Passau rules and was later directed by Ulrich Pesnitzer, the former castle architect of Duke George the Rich at Landshut. Prague became more important towards the end of the fifteenth century. Its influence made itself felt throughout the Czech Lands and beyond their borders. This was not due to local development but thanks to an architect summoned from abroad. King Vladislav set him important tasks and gave him freedom of expression regardless of guild regulations. This architect was Benedict Ried. There now occurred a repetition of events at the time of Charles IV, except that the general situation in Bohemia was different. The land, exhausted by the immense effort of the Hussite Revolution, did not possess sufficient strength to give rise to a unified style in art. The Czech countryside dropped to the status of a province living on its past and passively adopting impulses from elsewhere.

Some towns, particularly Kutná Hora, did not completely abandon their ambition to carry out grandiose building projects. But these isolated endeavours did not find sufficient response in a wide scope of building activity. This was revived too late to create a local synthesis out of the varied stimuli coming to Bohemia. The days of Gothic architecture were numbered, even though the style existed far into the sixteenth century.

It cannot be said that Prague architecture did not achieve remarkable results prior to Ried. Building was limited though, and only Matthias Rejsek was given an important task when he continued the building of the Powder Tower after Master Wenceslas. The tower had been begun in 1475 in honour of Vladislav II. It is characteristic of Prague late Gothic architecture that this tower is connected with the name of Vladislav. It is equally typical that it was a secular building. Everything that is remarkable in Prague at the end of the Gothic period owes its origin to Vladislav's initiative and everything is secular in function. The Powder Tower is in many respects typical of the state of Czech architecture in the second half of the fifteenth century. Its pattern was derived from Parler's Old Town Bridge Tower, but in place of rigorous Parlerian structure there appears exuberant ornamentation, which ignored the logical relationships of surface to core of the building. The façade became merely a suitable surface for ornament. Rejsek commanded all the rules of the game. He was given an even more important chance when he received the commission to complete the double-aisle church of St Barbara (sv. Barbora) at Kutná Hora, where building had been interrupted by the Hussite wars. In 1481 it was continued under Master Hanuš, who built the vaults in the ambulatory and the two inner aisles and raised the choir to the height of the triforium, using St Vitus's Cathedral as an example.

Rejsek completed the walls of the choir, with wide windows using a complex system of flying buttresses, and roofed the presbytery with intricate net vaulting. Rejsek followed the Parler tradition but altered it to indulge his liking for decorative architectural sculpture. He paid little attention to spatial effects which were the chief preoccupation of the time. Consequently, the interior of the choir with its unusual height (33 metres) and comparatively narrow width (1:3.3) seems almost an anachronism for the time.

Benedict Ried was summoned to Prague by Vladislav II before 1489. His main concern was interior space. He was first given the task of building the fortifications of Prague castle. Ried had experience in this field, probably acquired at Burghausen where Duke George the Rich of Landshut, the brother-in-law of Vladislav II, carried out extensive work of fortification to counter the threatening danger of the Turks. Ried used a modern defence system. It included a barbican on the eastern side of Prague castle. In the early nineties Ried was commissioned to rebuild the royal palace which had been in a bad condition since the Hussite wars. Alterations were first made to the western wing where Vladislav was to have his audience hall, and the royal oratory in the Cathedral was given a boldly constructed hanging boss (an old Parler theme). The oratory, decorated with naturalistic branches, was probably executed by Hans Spiess of Frankfurt who also worked for the King, it is thought, at Křivoklát castle.

The Vladislav Hall bears all the features of Ried's dynamic conception of interior space. He used the outer walls of the three upper rooms of Charles IV's old royal palace and from 1493 on turned them into one of the biggest secular halls of the Middle Ages. Six pairs of immense supporting piers partly built into the old walls bear the immense vault which is not supported in any other way. It is the culmination of spatial construction in the late Gothic style. Curved ribs are used consistently. They link up at the apex of the vault to form six-pointed rosettes and give the vault an impression of restless movement. This movement begins on the surface of the vault and extends beyond it, since the ribs are cut off in mid-air and seem to stretch into space, where we can imagine their continuation. The concave piers are also affected by the surrounding space. They run right up to the ceiling without interruption. The piers are involved in the movement since the ribs merge into them at different heights and then project again as if the piers were only quantitatively distinct from space and therefore penetrable. The borderline between the support system and the burden upheld has almost completely vanished. Although the central rib rosettes keep to the rhythm of the supporting piers and maintain an echo of former bays, the spectator sees a unified interior with a fluctuating and vibrating rhythm kneaded by continuous curving ribs that are linked one to the other.

Thus in close proximity to the Hall of Wenceslas IV the process that began there and on other work initiated by Wenceslas IV reached its culmination. In a certain sense the Vladislav Hall can be considered the consistent elaboration of one of the basic principles of Gothic architecture, that a building should be a flow of forces. But the windows on the south and north sides sharply contrast with this whirling movement and the

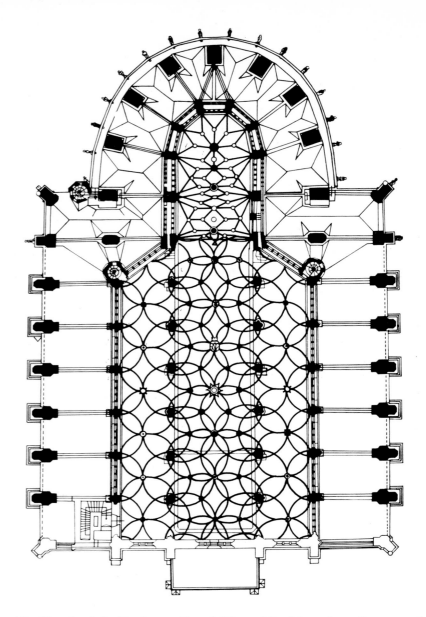

18 *Church of St Barbara, Kutná Hora. Vaulting plan of nave and presbytery*

solemn, articulated tri-partite window on the main east side even more so. The sharp right angles of the windows are slightly softened, when seen from within, by the concave segments of recesses. The pillars of the east window are set aslant, retaining some of the Gothic diagonal orientation and adapted to the mobile impression of the hall as such. Nevertheless, they differ strikingly, by their static appearance and their rational restraint, from the irrational environment that assaults one's sense of sight. Here for the first time in Bohemia we encounter the influence of the Italian Renaissance. In Moravia it had appeared a year sooner at the castle at Moravská Třebová. It was used especially on the fluted semi-pillars and pilasters with Corinthian capitals and on the lintels of windows, with Classical designs of architraves, friezes and cornices. The portals were constructed in a similar manner. Ried did not manage to suppress his appreciation of Gothic art entirely. For example, he twisted the fluting of the columns, semi-columns and even piers with a right-angled ground-plan and introduced into the static Renaissance construction elements of late Gothic dynamism. In spite of

this, these members are stylistically pure enough, which would indicate direct contacts with Italian architecture.

The mediation of Hungary seems likely. At the time of Matthias Corvinus several Italian artists were working there and Ried's employer settled permanently in Hungary in 1490 and visited Prague only occasionally. Two entirely different, contradictory traditions and two worlds of different attitudes met head-on here. This is best seen on the north façade of the building. There the Renaissance windows, of frontal design and ignoring all upward movement, are set between vertical and diagonal piers still built to a Gothic plan. The windows give the impression of having been inserted into the Gothic walls at a later stage, and they had been dated to a later period. Indeed, the true Renaissance forms were used by Ried as an addition that did not affect the Gothic core of the structure.

The Renaissance appeared more clearly in the Louis wing of the palace. Yet even here the proportions of the height of the building and the rib vaulting of the spiral staircase and of the later Bohemian Chancellory kept to the Gothic tradition. On the other hand, the servants' stairways, in spite of Gothic details, are given a right-angled twist in the Italian manner. The rib vaulting here, as on the Riders' Staircase, is of slightly different character than in the Vladislav Hall. The ribs run in short sectors

19 Plan of the church of St Nicholas, Louny. 1520–1538

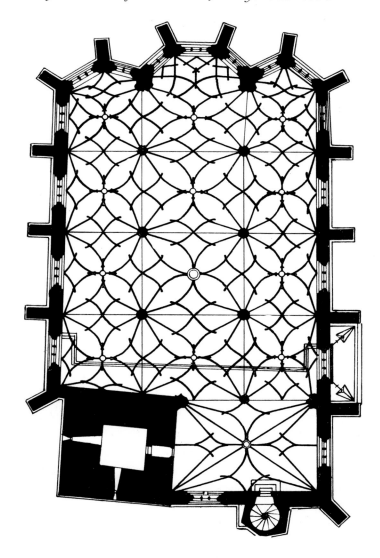

with a high profile, rising at various levels out of the surface of the ceiling. This gives rise to deep concavities which, as in diamond-patterned vaulting, produce contrasts of light and shade.

Ried used the experiences he gained in constructing secular buildings for the King also on churches built – characteristically – for the towns. The most important achievement is the completion of the church of St Barbara (sv. Barbora) at Kutná Hora. Ried concluded a contract with the Kutná Hora town council in 1512. He was obliged to follow the old ground-plan but made considerable changes in the spatial conception of the interior. He joined the three central naves above the arcade arches into a wide open, brightly lit hall. Its unity is stressed by having the ribs attached to opposite sides of the piers which they surround. Thus the borders between the individual naves are obscured. The complexity of the vaulting pattern makes one overlook the fact that the central rib rosettes correspond to individual compartments which, however, are not divided from one another. In spite of all the novelty of conception Ried managed to adapt himself to his predecessors: The shafts of his piers are convex like those built by Parler and the flying buttresses are linked with the part built by Rejsek. In spite of its original cathedral design the building is impressive for its widespreading architectural mass. Originally, though, it was intended to be far longer. It has no tower. The picturesque roof with three tent-like structures lightens the silhouette of the church. At the same time it centralises it since the central tent is the highest.

Later in life Ried made the church at Louny. Its slightly projecting tri partite apse merges into three short, hall-type naves. The ribs of the vaulting, cut into short intersecting parts, have less of the dynamic force of the master's earlier vaulting systems. The church is covered by a tri-partite tent-shaped roof, but the centralised composition is weakened by a tower on the façade. This was taken over from the preceding building which probably influenced the ground-plan of the church. It is reminiscent of the Augustinian church at Jaroměř and its Wroclaw patterns. In later years Ried often worked for the aristocracy who held political power in the country while the King was almost constantly abroad. His secular buildings show the Renaissance influence more consistently than the church architecture. He probably obeyed the wishes of his aristocratic customers, who, in their turn, followed in the King's footsteps. He may have considered Renaissance architecture of more secular character and not suitable for church buildings. For the powerful Švihov family, Ried built or designed modern fortifications at Švihov castle and perhaps those at Rábí castle. Zdeněk Leo of Rožmitál commissioned him to build a new wing in his castle at Blatná. Count Charles of Münsterberg, who followed Zdeněk of Rožmitál in the highest office of the Kingdom in 1523, commissioned Frankenstein castle in Silesia.

Ried's work is the last and, in a certain respect, the culmination of the late Gothic period in Central Europe. Characteristically it occurred in Bohemia, which had once been given a mighty impulse by the Parlerian and non-Parlerian buildings of the Luxembourg period. Ried's work found admirers; there are some buildings where one can sense his direct participation.

Others, like the church of Our Lady (Panny Marie) at Most, clearly show his influence. Its builder Jakob Heilmann, who, at one time, was Ried's assistant, erected it in the Master's typical manner. This same is true of Heilmann's second important construction, the church at Annaberg in Saxony. Both these churches have Renaissance details. The Renaissance elements originated at Prague castle and rapidly spread to Saxony and Silesia where Wendel Roskopf propagated Ried's and Spiess's ideas.

Elsewhere in Bohemia building construction dwindled. Most of the towns were under the domination of the Utraquists, whose culture was centred on books and music rather than the visual arts. In isolated cases interesting buildings appeared, such as the presbytery of the church at Mělník. It is brightly lit to contrast with the semi-darkness of the nave. But most building work was limited to repairs, reconstruction and alterations, at most minor additions that brought little new to architecture. Some of these alterations, for example the Šternberk chapel of the deanery church in Plzeň, had decorative charm.

The situation was different in Moravia. Its south-western part bordered on south Bohemia while the south was geographically linked with Austria. South Moravia shows close contacts with the architecture of the Danube Basin, such as the deanery church and chapel of St Wenceslas (sv. Václav) at Znojmo. Central Moravian buildings are of a higher level, particularly the church of St Maurice (sv. Mořic) at Olomouc and St James (sv. Jakub) at Brno. Both these buildings were begun before the Hussite wars but during the wars their construction stopped. Both are hall churches with long presbyteries. In Olomouc the apse has shallow chapels resembling some of the churches in Wrocław. In Brno there is an ambulatory without chapels. This church is, in fact, a simplified cathedral-type structure. The example of Matthias of Arras and Peter Parler can be detected in the Olomouc church. It shows the conservative attitude of the builder and the strength of the tradition of the St Vitus's lodge, which also left its mark on the oldest part of the church in Brno, with a pier in the axis of the apse and on the shape of the arcade pillars in the apse which are fashioned like a square set on its point.[54] The predominantly pre-Hussite presbytery is covered with net and rib tri-partite vaults. The vaulting in the nave and aisles, on which Anthony Pilgram worked from 1502, has an entirely un-Gothic character with its stucco ribs. Construction work continued until the very end of the sixteenth century.

A late example of Gothic architecture is the church at Doubravník which the mighty family of the Pernštejns had built as their burial church. Although Renaissance motifs can be found only in details, the choice of the material used for the three beautifully lit hall-type naves – marble – indicates that the period of Gothic architecture was drawing to an end. At the time when the Doubravník church was built, that is in the years 1539 and 1557, Gothic forms seemed already very archaic.

* * *

The Hussite Revolution meant a deep break in the history of Czech Gothic art. It was felt in sculpture no less than in architecture. With the stagnation of building construction there was far less demand for architectural sculpture which, at the turn of the century, already played a subsidiary role. Conditions for wood-carving were better only in border regions. Like architecture and painting, sculpture, too, suffered when distinguished masters emigrated to the neighbouring countries where they found a more favourable atmosphere for their work. But the continuity in sculpture was not entirely interrupted. It was renewed as soon as conditions calmed down. There was not a great deal of work, and the post-revolutionary era did not record much intensity of work. Yet there were some wood-carvers of outstanding quality. The crisis was also reflected in Bohemia losing its natural centre of art which meant that sculptors more easily succumbed to influences from abroad. Yet for some decades certain typical qualities stood out, owing to strong ties to the past which for emotional reasons played a greater role in Bohemia than elsewhere. We know that around the middle of the century there was a kind of renaissance of the Beautiful Style in painting. The situation was similar in sculpture. But research has not gone far enough for one to be able to pronounce final judgment. This applies, in fact, to the whole of late Gothic sculpture in Bohemia which has been investigated in detail only in certain areas. The following description, therefore, does not set out to give a continuous picture of sculpture in all its complexity and differentiation.

As the result of the crisis, sculpture became subdivided into several strata, caused not so much by changing generations as by differences in spiritual meaning and form. The same occurred also in the neighbouring countries, since it was a time of critical transition from a mainly aristocratic culture to one that suited the way of life of the burghers. But the sudden shift in the social situation in Bohemia led to striking contradictions between the world of the townspeople and attempts at restitution of the old aristocratic social order. This was accompanied by quite exceptional contradictions in the sphere of the arts.

Around the mid-century there existed two main strata of sculpture. One followed up the pre-revolutionary art, mainly the late Beautiful Style, which became Mannerist in character. The established standard was so strong that it prevented any new concept of the world and led to mere repetition. This involved a certain sterilisation of means which lost any connection with the original content. This exactly expressed the reactionary mood of the time, though it originated far back in the pre-revolutionary era. Form stiffened and drapery motifs multiplied, ceasing to be metaphors that conveyed a sensuous emotional message. A few examples help us to illustrate this process: the *Madonna* and *Pietà* in the church at Nesvačily, the *Madonna of Svéraz* (Hluboká Gallery), those of Droužetice, the Franciscan church in Plzeň, and of Kamenný Újezd (Hluboká Gallery). Some of them retain the robustness of the Parler tradition while others recall the first half of the fourteenth century.

A particularly clear example of the rigid traditionalism is the *Madonna* from the chapel of St John in the parish church at Kájov. Though it could not have come into existence before 1440 it follows up the type of the *Wrocław Madonna* and combines it with motifs from the Krumlov group. It was probably made from a pattern of a statue now lost, dating from around or after 1400, where this synthesis had already existed. In south Bohemia other statues exist of this type of composition but dif-

ferently conceived. This can be shown on the *Madonna of Kamenný Újezd*. Yet the posture of the Kájov figure is exaggerated in a Mannerist way, and the charm of the round faces cannot deceive us for we are dealing with sculpture that has moved far from the sophisticated simplicity of the culminating phase of the Beautiful Style. The peasant robustness replaced the delicate balance of a complex contraposto, which had given the statues at the turn of the century such a provocative charm. At the same time, below the shell of the old formal scheme there penetrated a kind of naive realism which in itself was not strong enough to create a new style and cast off the old conventions. The other current in Bohemian sculpture in the middle of the fifteenth century arose organically and without a marked break from late Gothic. It too followed upon the preceding period, but developed certain elements which, in the advanced stage of the Beautiful Style, had prepared the late Gothic phase. The linear system disintegrated. Its continuous rhythm split into spontaneous irregularities and sudden breaks which formed little surfaces bent in all directions and reflecting the light in various ways. The beginning of this process can be found on outstanding works from around 1420, for instance on the *Madonna in Majesty* of the Týn church in Prague. The linear and rhythmical, spatially differentiated style from around 1400 was broken down here, and its realistic aspects led to accurate description, where poetical metaphor had no place.

This development can be found more clearly on the Mary of the *Annunciation* from Svatá Majdaléna (Hluboká Gallery). The linear and rhythmical aspect was greatly weakened; the surface has a soft, irregular and indefinite shape which recalls certain works in Austria at the time. It probably dates from the forties. The links with the Beautiful Style continued on the type of face and the lyrical expression.

The same is true of the *St Mary Magdalene of Černice* (Hluboká Gallery) where the cloak still retains certain earlier compositional features even though they are blurred. The ties with the past clung firmly. This is proved by a torso of a Madonna in the National Gallery, Prague, which probably dates from the middle of the century. The profound changes taking place are clearly visible even though the old system of draperies persists.

The outstanding statue of *St Barbara of Suchdol* (Švihov castle) which originated probably in the late fifties, has much in common with the preceding sculpture but shows a radical break with tradition. It is closer to the style of Central European art after the appearance of the leading sculptors of the time, Kaschauer and Multscher, thus revealing contacts with Swabia.

A more advanced type of late Gothic style is seen in an excellent *Calvary* in the church of St Bartholomew (sv. Bartoloměj) in Plzeň, even though its Crucifix has distinctly outdated features and John's face reminds one of the *Calvary* in the Týn church in Prague. The sculptor, who made yet other works in the Plzeň region, must have known the Swabian sculptures of Multscher's time. The Plzeň *Calvary* should not perhaps be dated later than *c.* 1460.

These two main trends in sculpture overlapped. The *Madonna of Střížov* (Hluboká Gallery) adopted almost without changes the composition of the *Madonna of Kamenný Újezd* but includes

more that is spontaneous and irregular. The *Madonna of Kájov* was based on the same scheme of composition with visually unifying features. Although all these three statues are based on a common pattern they were made by wood-carvers of quite distinct temperament and approach. The strength of tradition made itself felt in the different ways it affected different sculptors. The monumental *St Nicholas* from the Minorite monastery at Český Krumlov is highly concentrated and has a compact outline. It did not cut ties with the past either, as the Parler tradition can still be felt. The variety of work of the mid-century and immediately after can be shown on a spatially composed, lively *Madonna in Majesty* from Sedlice near Blatná. New ideas penetrated only very slowly into this conservative environment, and it is difficult to place the grotesque figure of the *Tower Guard* on the top of the stairs of the Old Town Bridge Tower. The crude realism of this figure was almost certainly derived from the Franco-Flemish school. It has some of the vehemence of Sluter modelling, its faultless precision and spatiality. Parlerian sculpture, to which this statue is sometimes attributed, was static and restrained in comparison with it.[55] Even the tympanum of the Týn church, the most advanced work of the fourteen eighties in spatial concept and volume was far more dominated by a linear scheme than this brutally modelled statue. Perhaps the *Tower Guard* was not as isolated a work as it appears today. There are reports of a portrait of King George on the façade of the Týn church and rumours of an equestrian statue of this King on Charles Bridge suggesting that monumental sculpture was not entirely neglected at the time of the Hussite King. But everything was destroyed during the Counter Reformation. It is impossible to discover any direct continuation of the radically realistic trends as represented by the *Tower Guard*. Netherlandish realism was brought to Bohemia by devious routes.

The local tradition survived even as the century advanced. In the course of time it took the form of adherence to certain motifs and facial types which survived from the past. The posture of the Child on the *Madonna Protectress* outside Olomouc Cathedral from after 1470 derived from the Beautiful Madonnas of the Krumlov type, but the form and the composition were already late Gothic. The compact scheme was, to a certain extent, loosened. This indicated the direction in which Bohemian sculpture was to continue in the subsequent decades when it adapted itself to Central European usage and lost the deliberate links with its own past.

The statues of four female saints and two Madonnas in the monastery church at Ročov and the parish church at Charvatec in north Bohemia are proof of this adaptation. In them the endeavour to show spatial differentiation of matter is already quite distinct. But most of the statues from the seventies have compact outlines. The jerky movement remained on the surface; here and there items of clothing separated themselves from the core. Let us cite as an example the *Madonna* of the church of St Adalbert (sv. Vojtěch) in Prague.

It seems that the response to the reform introduced into Central European sculpture by Nicholas Gerhaerts of Leyden did not reach Bohemia until about 1480. This reform brought thorough individualisation of shape and spreading of the inherent move-

ment into space, with psychological motivation playing an important part. Gerhaerts crossed Germany from Strasbourg to Passau, Vienna and Vienna New Town, and influenced the sculptures in the whole of Central Europe. He was copied eagerly. But at the same time spatial values were gradually becoming independent of their organic relationships and were transformed in the sense of becoming more ornamental and expressive.

An early work influenced by Gerhaerts is the *Mount of Olives* next to the church of St Maurice (sv. Mořic) at Olomouc, which is among the most outstanding cycles of sculpture in Central Europe. Although the statues still show an unbroken outline and the details, particularly the heads, contain older features, physical movement extended in all directions and its mechanics were brought into harmony with anatomy to an extent that was, to say the least, unusual in that sphere. The logical relationships between the individual parts of the figures give a completely natural impression. The movement in many directions has none of the jerky discontinuity common even in Central European works influenced by Gerhaerts. The artist who made the *Mount of Olives* must have come into direct contact with the great Dutchman, or the Netherlandish environment from which Gerhaerts came. It is not certain whether he can be identified with Hanuš of Olomouc, who is recorded as staying at Constance and later working in Görlitz and Wroclaw.[56] The wood- and stone-carving attributed to him at Görlitz and in Silesia has none of the spatial spread one admires on the Olomouc group of statues nor its harmony between psychological perception and bodily mechanics. But it is tempting to connect him with the Hanuš of Constance and Zurich since we know that he returned to Olomouc in 1479, that is at the very time to which one would attribute the *Mount of Olives*. We know, moreover, that Gerhaerts made the main altarpiece for the Constance Minster.

In spite of the exceptional growth of production and the remarkable increase in quality of Bohemian sculpture in the last two decades of the fifteenth century and around 1500 one can hardly speak of an independent Bohemian school of sculpture. Bohemian sculpture of this period was characterised by contacts between individual regions and neighbouring or remote countries, and a wide range of different influences.

From what we know today Prague never resumed its former leading position in sculpture even though a number of sculptors lived there. The strong influence of Nuremberg can be detected on the *Madonna* from the altarpiece of Puchner (the Grand-Master of the Order of the Knights Hospitallers with a Red Star) of 1482. This will be discussed later in connection with painting. The influence of Saxony shows on the slightly later *Last Supper* from the Bethlehem chapel (National Museum, Prague). In west Bohemia Nuremberg apparently set the tone, as shown by a fine *Madonna* from the vicinity of Stříbro (Regional Museum, Plzeň), whereas north-west Bohemia was closer to Saxony. We possess better information about south Bohemia where Gerhaerts' influence shows for instance on the excellent *Archangel Gabriel* of Nedvědice (Hluboká Gallery). It may have come to Bohemia via Passau. One of Gerhaerts' followers was probably the leading master of the grandiose

altarpiece at Kefermarkt in Upper Austria, which influenced the *Female Saint* of Bližná in south Bohemia (Hluboká Gallery) and the *Death of the Virgin* from Vyšší Brod (National Gallery, Prague). They may have been made by one and the same hand. The *Seated Madonna* on the main altarpiece in the church at Kájov is of above average quality. It was probably made in *c.* 1502 by a wood-carver who had formerly worked at Kefermarkt.

At the same time, south Bohemian work shows links with Swabia, probably brought via Upper Austria. A typical example of work of this type is the carving on the Winged Altarpiece of Velhartice (National Gallery, Prague), which is probably related to G. Erhart. The analogies for the altarpiece reliefs that can be found in Upper Austrian Eggendorf suggest how Swabian features came to Bohemia. The Master of the Winged Altarpiece of Velhartice was important for further development in south Bohemian sculpture, as his work partly inspired the greatest late Gothic carver of the region, the Master of the Lamentation of Žebrák. But there were yet other contacts which lead from south Bohemia to the circle of Grasser at Munich.

South-western Moravia had links with southern Bohemia both in architecture and in sculpture, and the influence of Gerhaerts was considerable here too. Jihlava had grown into an important centre of sculpture as shown by the *Saint James*, and the remarkable *Mount of Olives* in the church of St James (sv. Jakub) in which the disintegration of matter reached its ultimate stage. Contacts with Vienna can be traced on the figure of St James. These contacts were particularly strong in Brno, where Anthony Pilgram grew up and later worked as a mature artist. Pilgram was one of Gerhaerts' most important followers, not only in the Czech Lands, but in the whole of Central Europe. He had learnt the principles of his art in Western Germany. At the beginning of the sixteenth century he returned to Brno and produced works in which penetrating descriptive analysis joined with a very personal interpretation of reality, containing striking features of self-stylisation. Mention should be made of the fragments of sculptural ornaments on the Jewish Gate (City Museum, Brno) and the portal of the Brno Town Hall and two wooden figures of saints in the Moravian Gallery. The bodies and especially the faces show a thorough knowledge which reveals the sculptor's great interest in individual life and his rejection of medieval attitudes. It may well be that he knew Italian Renaissance sculpture from a trip to northern Italy. It is, therefore, not surprising that portraiture is an important part of his production. Two self-portraits on the pulpit and the plinth of the organ in Vienna Cathedral, made at the end of his restless life, prove not only his mastery of facial expression but also the depth of his psychological perception.

Central Moravia had frequent contacts with another centre of the Gerhaerts tradition, the workshop of Veit Stoss in Cracow. This appears especially on a stone relief with the figure of St James in the parish church at Roketnice near Přerov. Its relationship to the work of Stoss in Cracow is so close that there may well have been closer contacts than mere influence. Stoss's influence penetrated even as far as southern Moravia, where we can see it on a *Madonna* in the Znojmo Museum. It also appeared

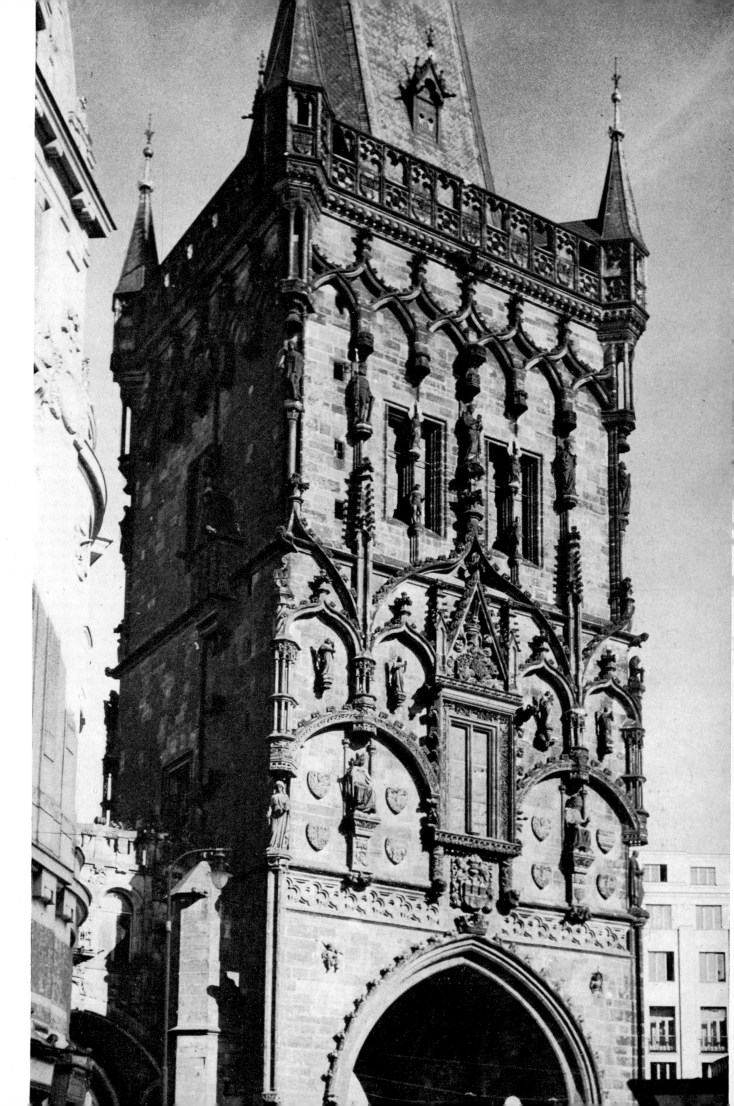

147 *Powder Tower, Prague.*
Wenceslas and Matthias Rej-
sek. After 1475

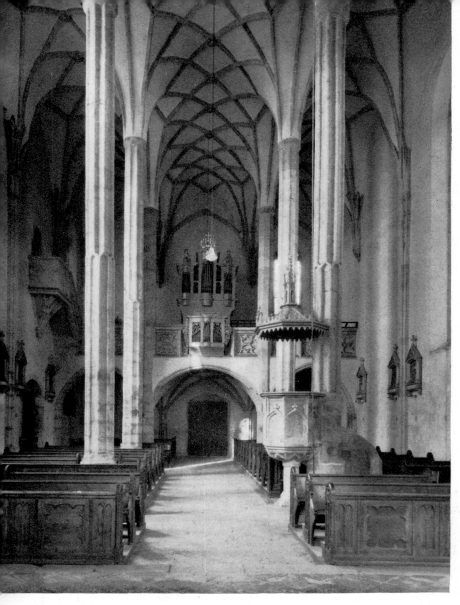

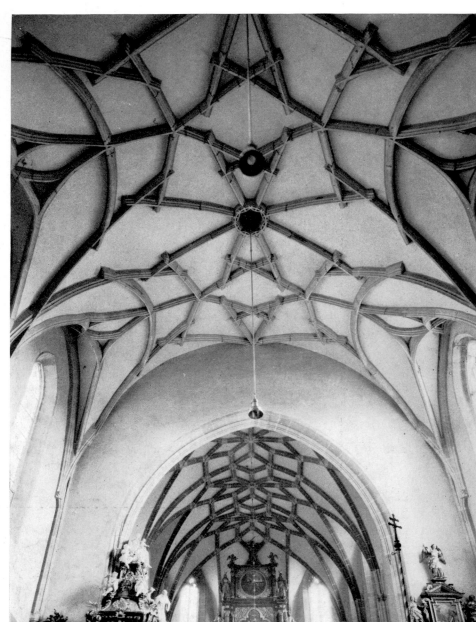

148 Parish church at Dolní Dvořiště. Nave and aisles. 1488–1507

149 Deanery church, Chvalšiny. Vaulting in the nave. Early sixteenth century ▶

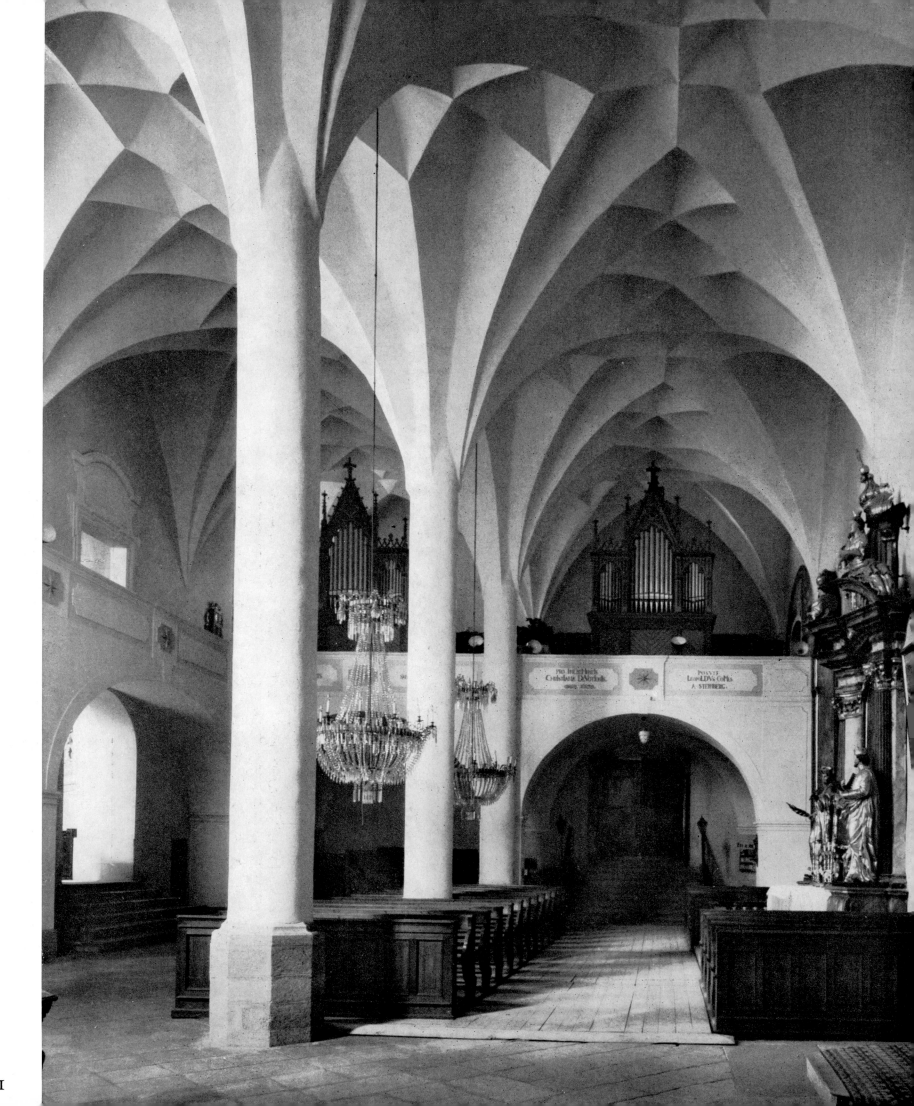

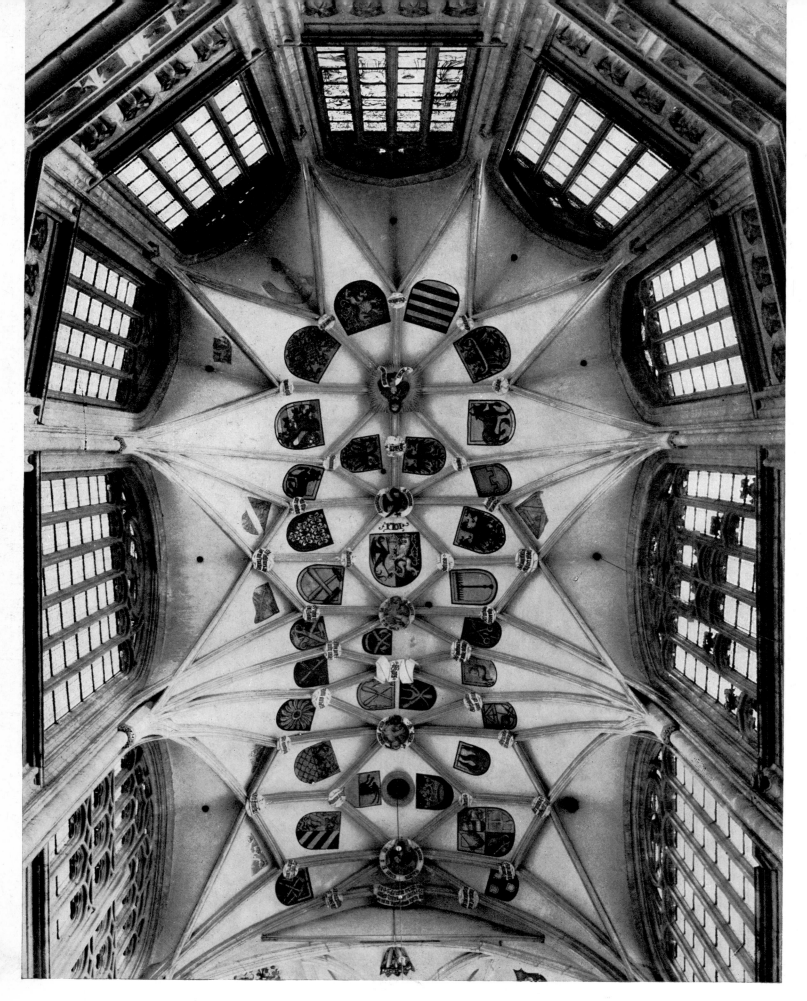

151 *Church of St Barbara, Kutná Hora. Vaulting in the presbytery. Designed by Matthias Rejsek. 1489–1499*

152 *Church of St Barbara, Kutná Hora. Choir. Peter Parler (?), Hanuš, Matthias Rejsek and Benedikt Ried. 1388–1548* ▶

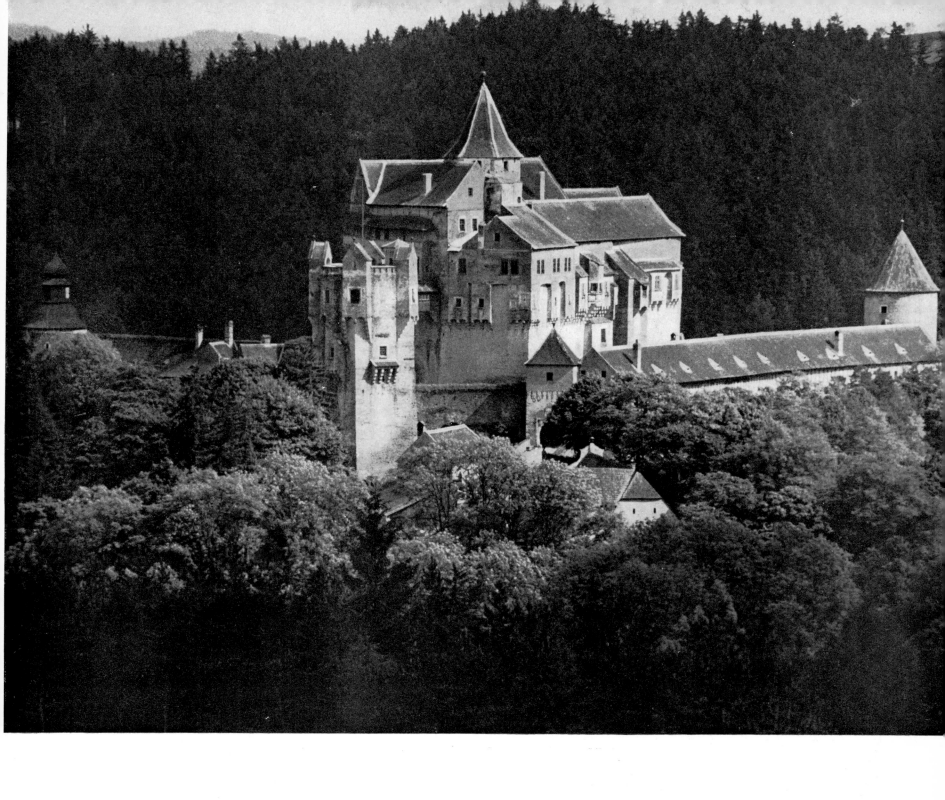

160 *Pernštejn Castle. Second half of the thirteenth century – first half of the sixteenth century*

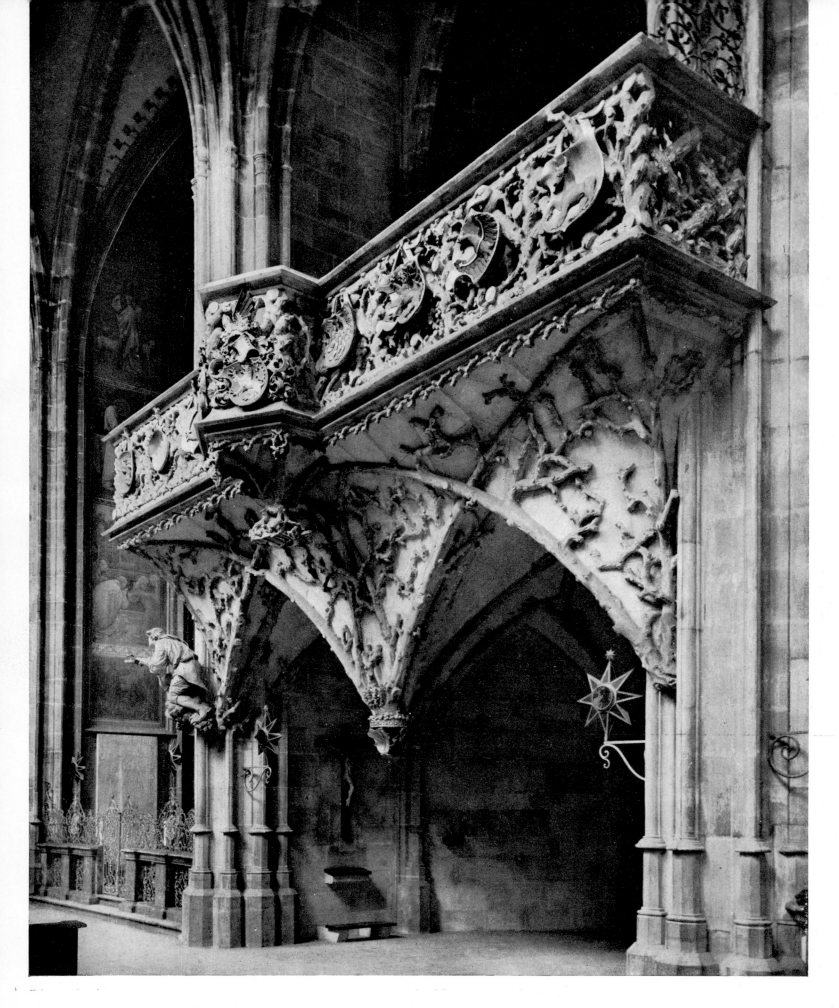

161 *St Vitus's Cathedral, Prague. The royal oratory. Hans Spiess. 1490–1493*

162 *Deanery church at Most. Interior. First half of the sixteenth century*

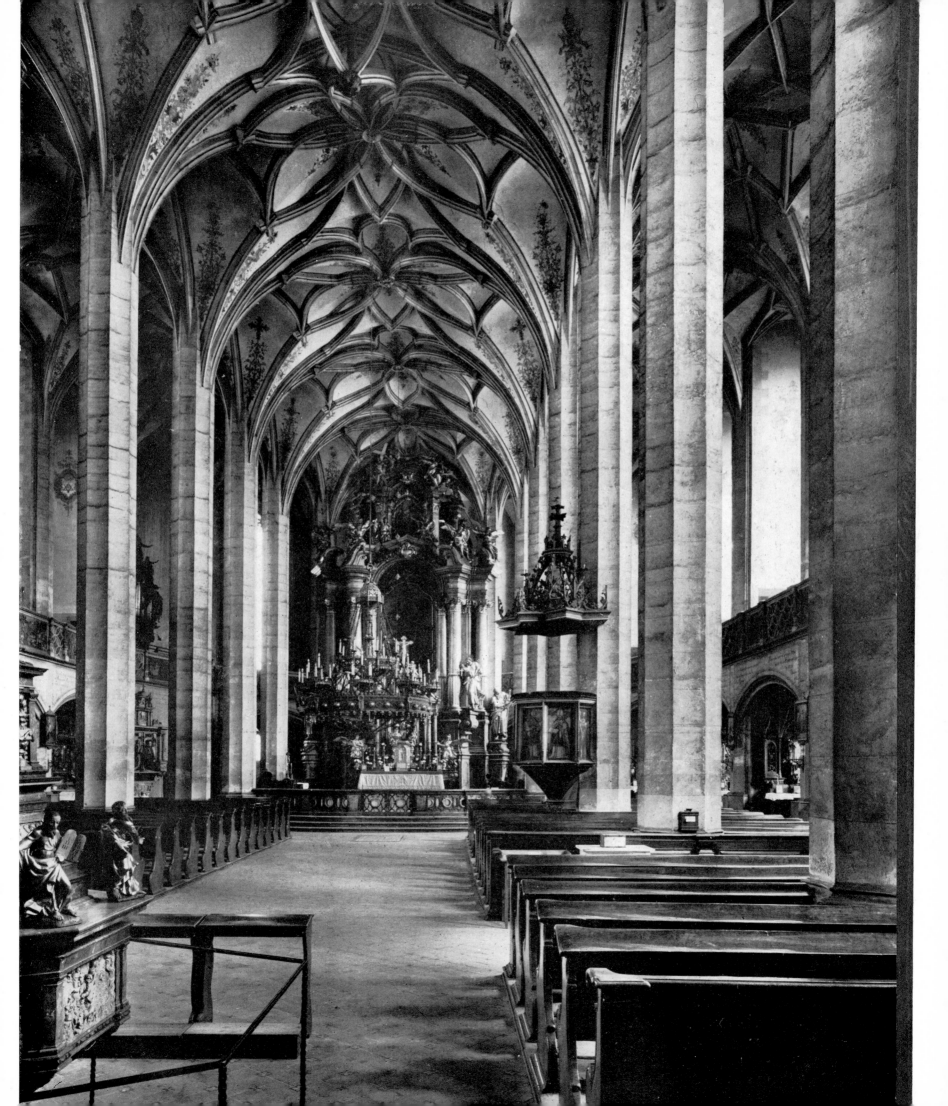

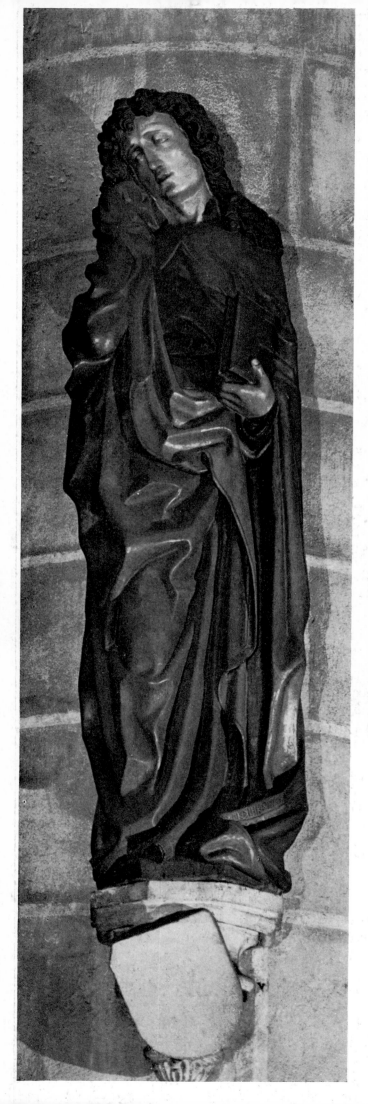

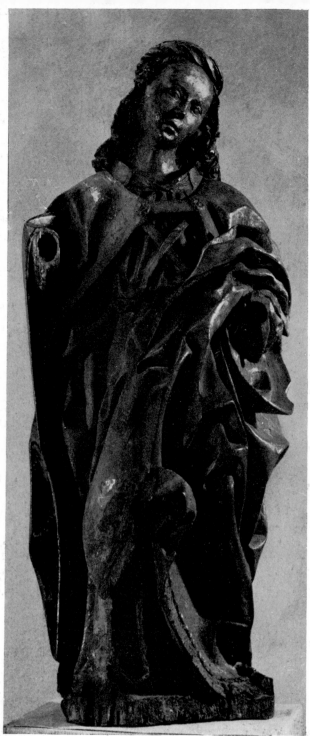

166 The Man of Sorrows. Signed HE 1511. Wood with original polychrome. 186 cm. Kutná Hora, chapel of the Italian Court ▶

163 St John the Evangelist from the Calvary. c. 1460. Wood with more recent polychrome. Larger than life-size. Church of St Bartholomew, Plzeň

164 The Archangel of Nedvědice. c. 1490. Limewood, no polychrome. h. 80 cm. Hluboká Gallery

165 Madonna. 1440–1450. Limewood with more recent polychrome. h. 148 cm. National Gallery, Prague

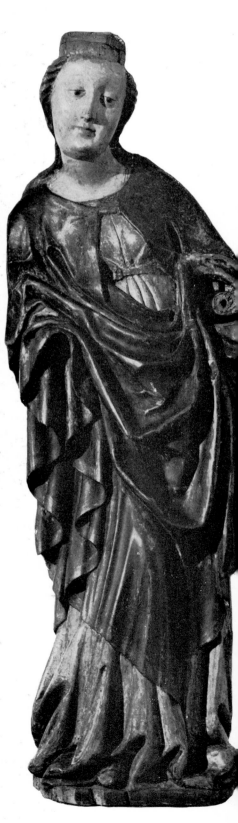

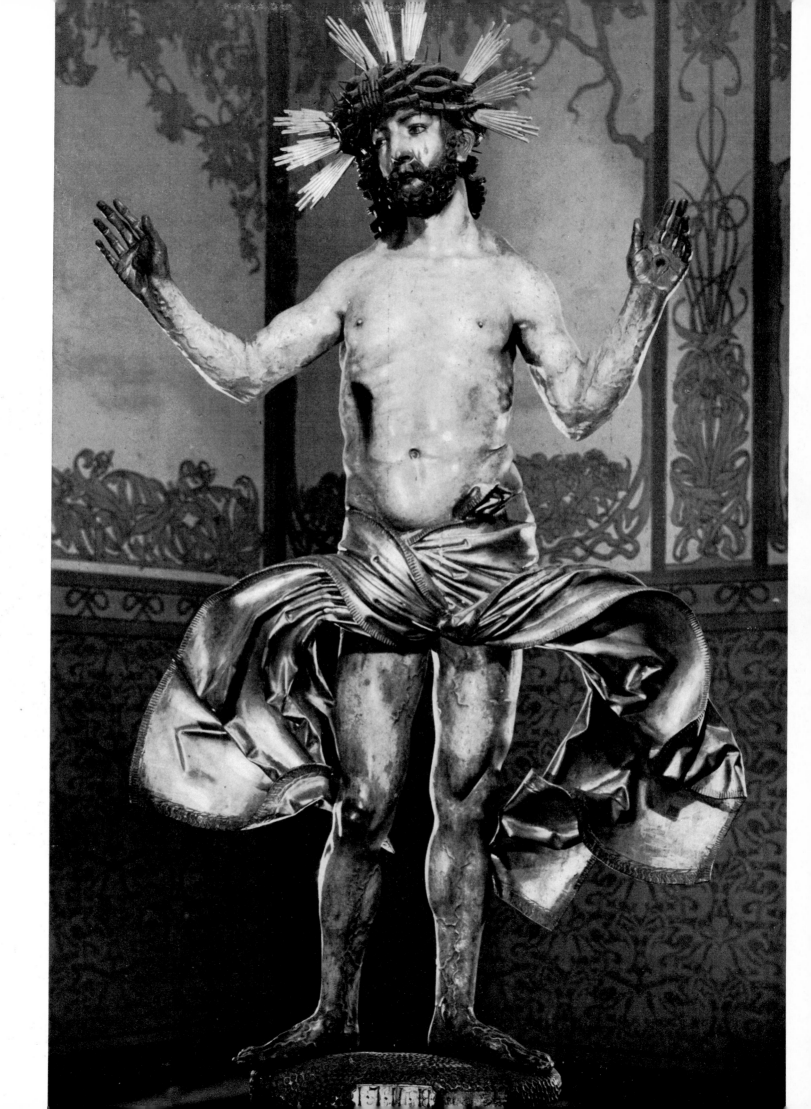

181

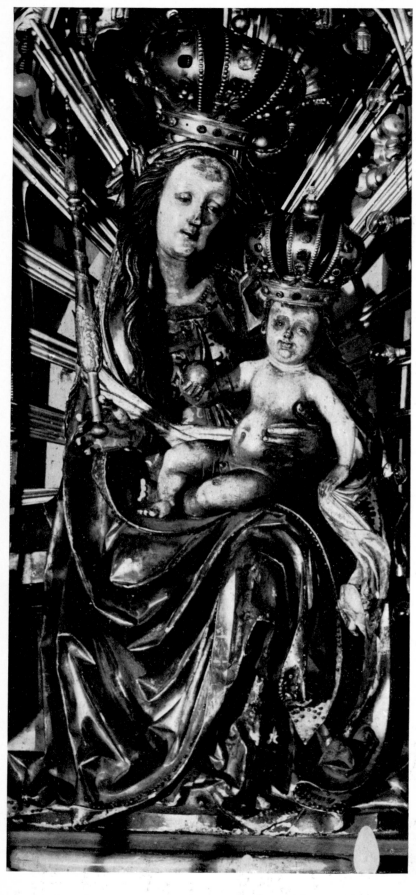

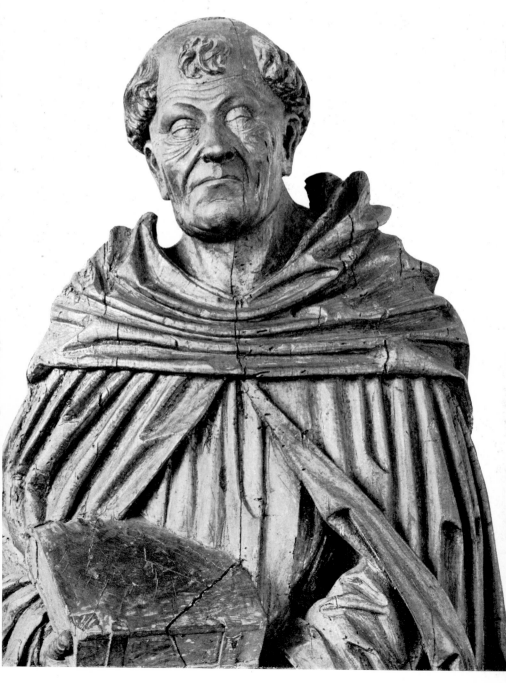

167 Seated Madonna. Before 1500. Wood with original
polychrome. h. 120 cm. Church of Our Lady, Kájov

▶

168 Anthony Pilgram. Saint of the Dominican Order.
Before 1511. Wood. h. 134 cm. Moravian Gallery, Brno

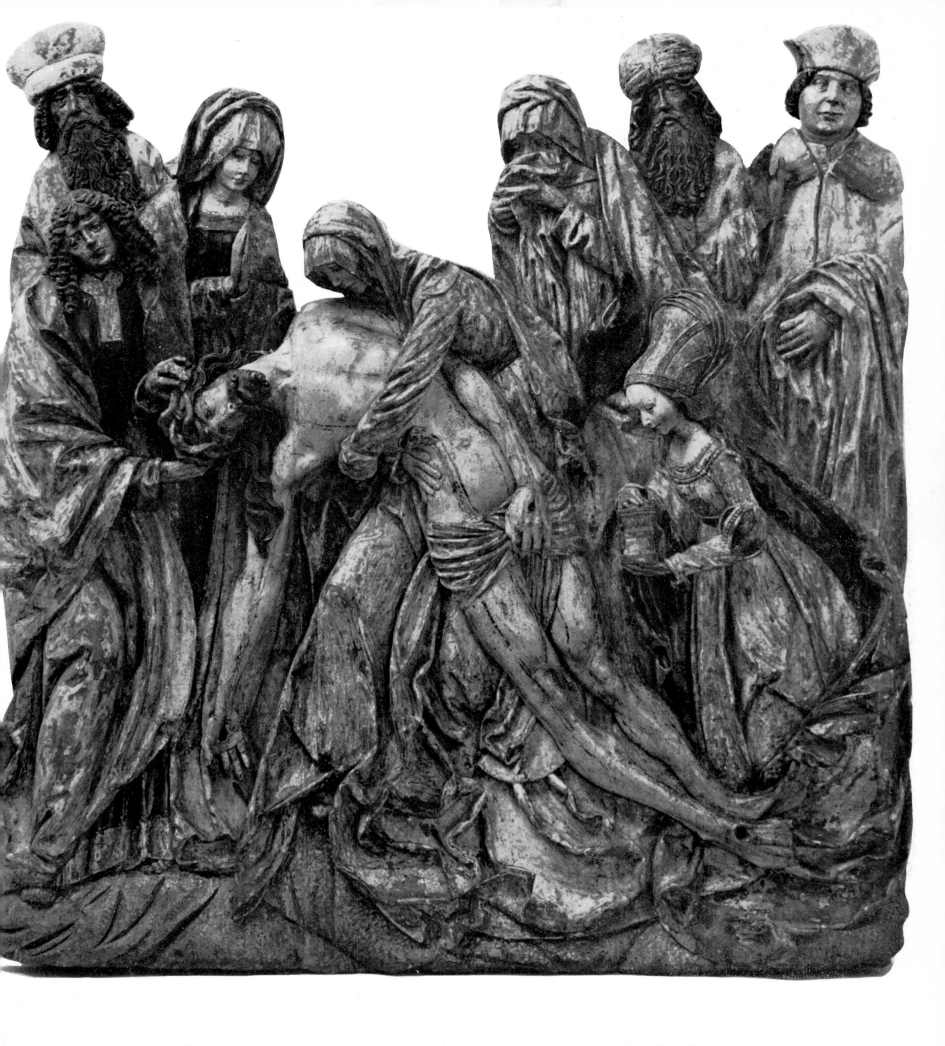

169 *The Lamentation of Žebrák. Limewood with remains of old polychrome.* 126×127 *cm. National Gallery, Prague*

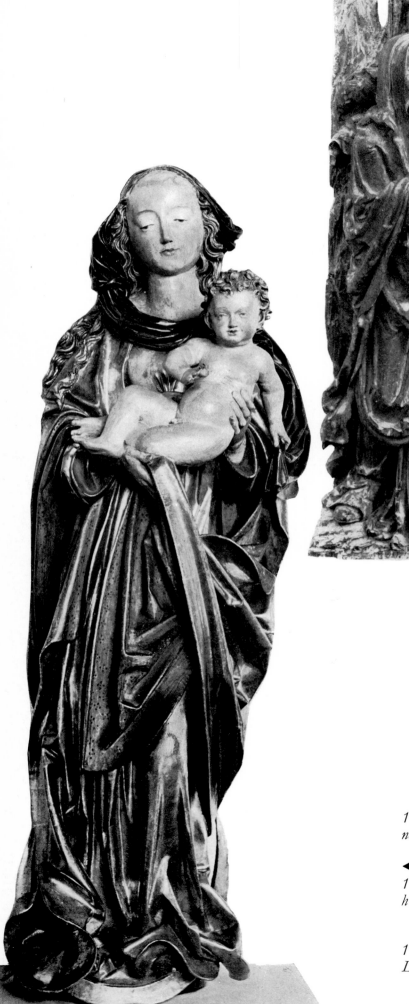

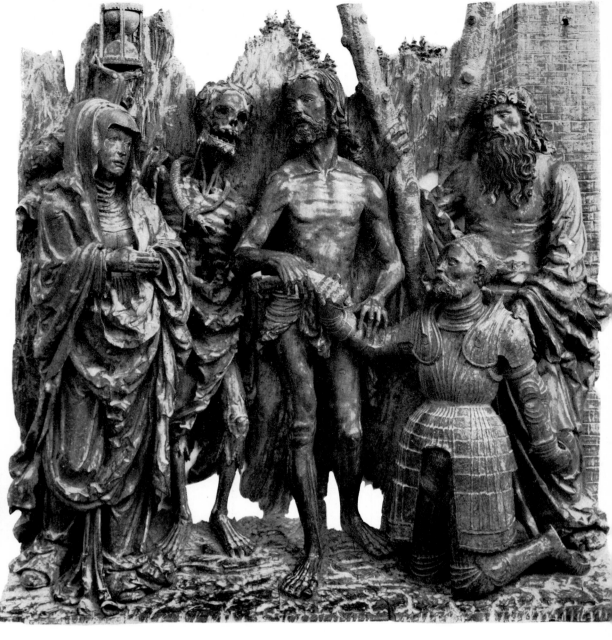

170 *The Epitaph of Zlichov (central part of an altarpiece). After 1520. Wood, no polychrome. 99 × 98 cm. National Gallery, Prague*

◀

171 *The Primavesi Madonna. Before 1500. Wood with more recent polychrome. h. 133 cm. Moravian Gallery, Brno*

▶

172 *Death of the Virgin. Central panel of the St George's Altarpiece. c. 1470. Limewood. 192 × 114 cm. National Gallery, Prague*

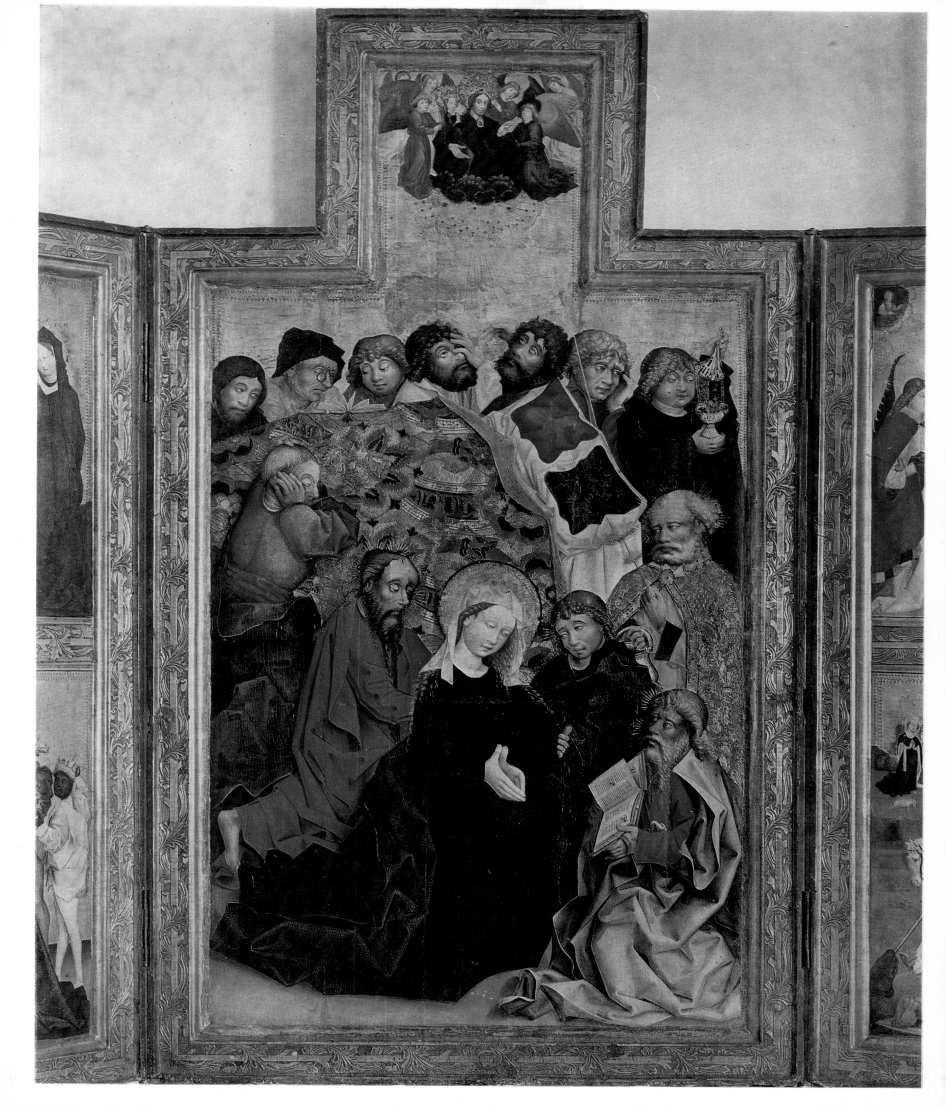

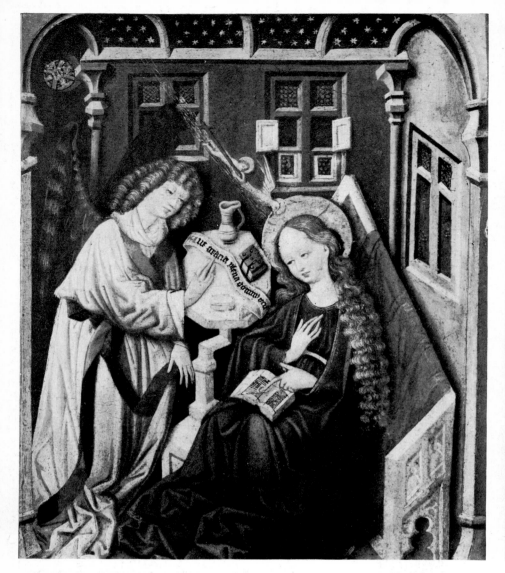

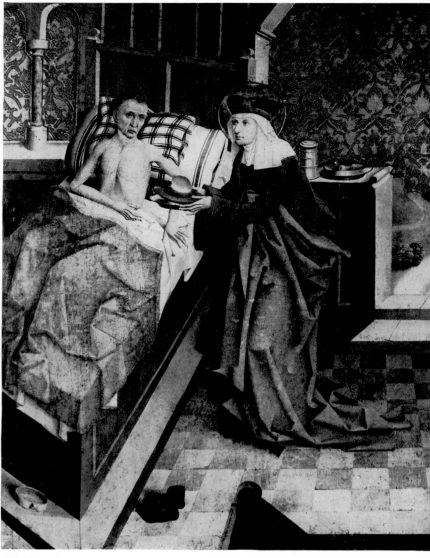

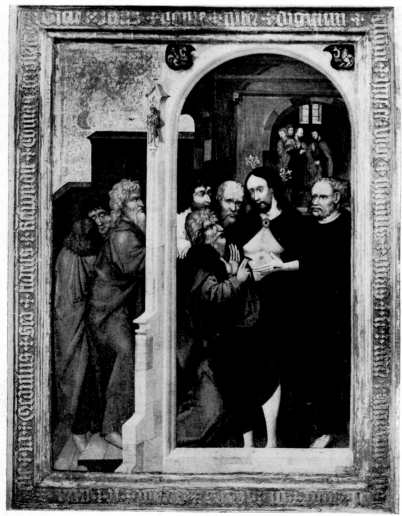

173 The Annunciation. After 1460. Pine panel. 43.5 × 35.5 cm.
National Gallery, Prague

174 The Blessed Agnes Tending a Sick Man. Part of the wing
of the Altarpiece of the Grand Master Puchner. 1482. Pine
panel. 124 × 96 cm. National Gallery, Prague

175 The Monogramist IVM. Doubting Thomas. c. 1470 to 1480.
Limewood panel, signed IVM. 105 × 67 cm. National Gallery,
Prague

176 The Birth of Christ. Part of a wing of an altarpiece.
After 1490. Wood panel. Wing 202 × 52 cm. Castle chapel,
Křivoklát.

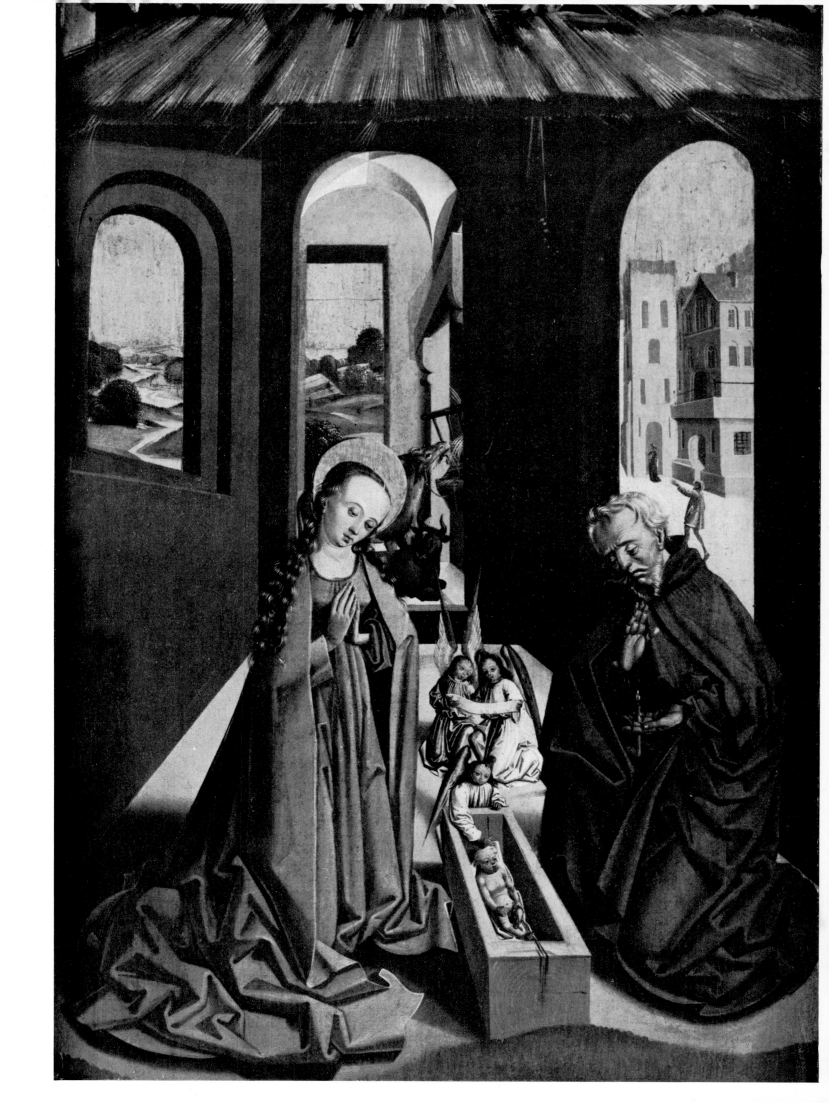

187

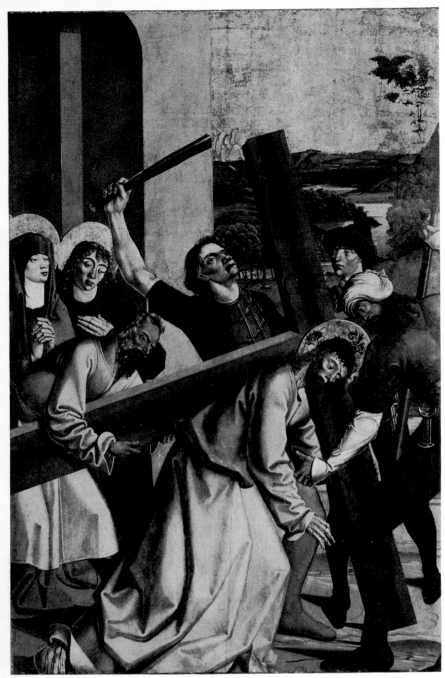

177 Master of Litoměřice. *The Bearing of the Cross. After 1500.*
Fir panel. 172×130 cm. Art Gallery, Litoměřice
◄

179 Master of Litoměřice. *The Crucifixion. After 1500. Fir panel.*
178×122 cm. Art Gallery, Litoměřice ►

178 Hanuš Elfeldar. *The Last Supper. 1515. Wood panel.*
123×284 cm. Křivoklát Castle
▼

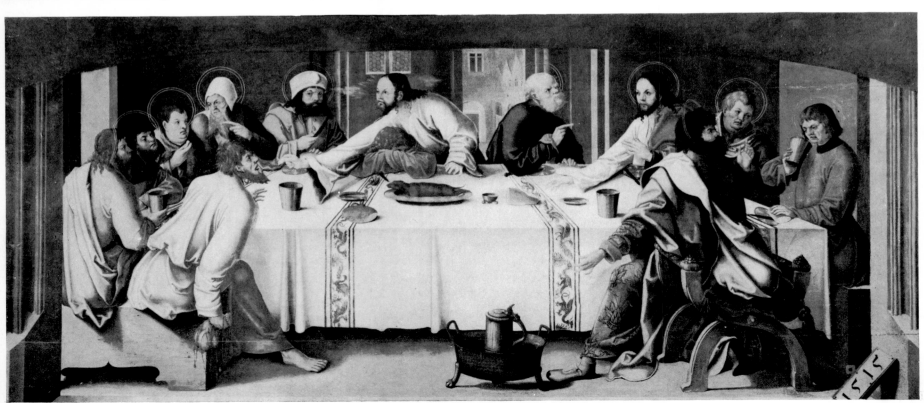

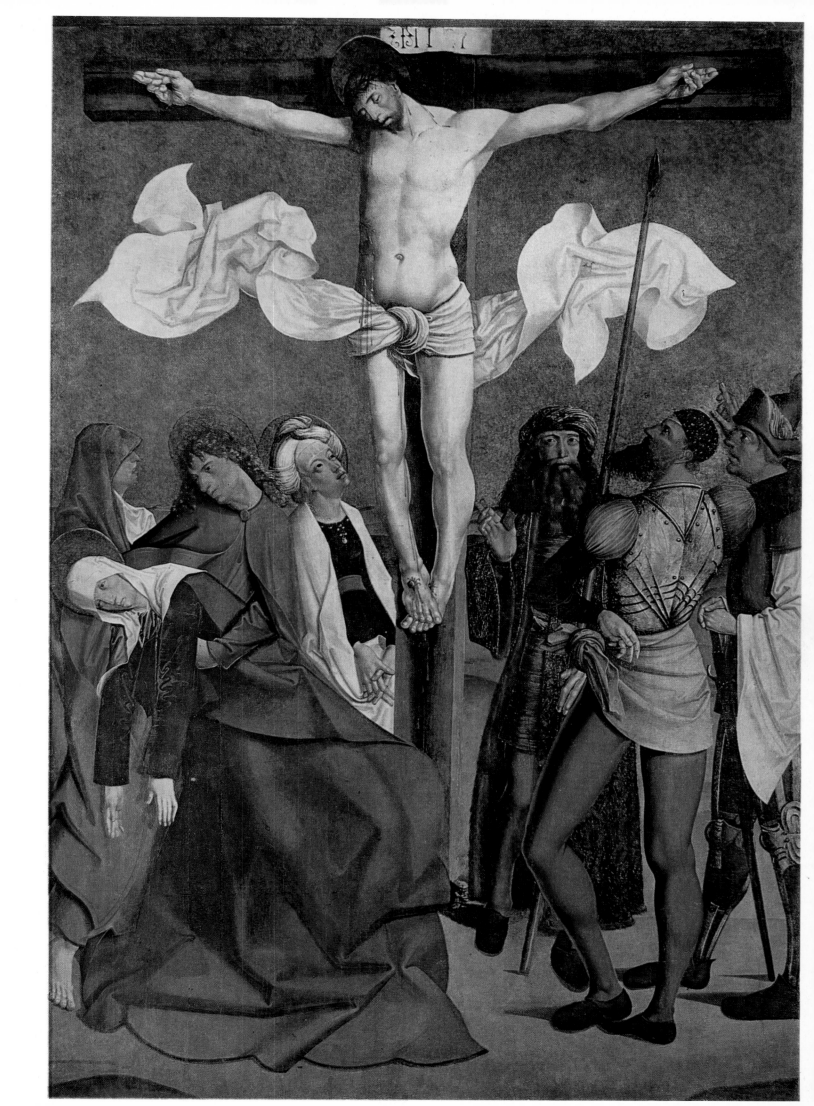

189

180 *The Mass of St Gregory (detail). Original frame dated 1480. Wood panel. 117×93.5 cm. Moravian Gallery, Brno*

181 *Mural paintings. c. 1490. Smíšek chapel in the church of St Barbara, Kutná Hora*

182 St George (detail). Mural painting. 1510–1520. Castle chapel, Švihov

in Olomouc, where there were also distinct links with Silesia, which is natural in view of the important role played by Hanuš of Olomouc in Silesian sculpture. It is sufficient to mention the *Calvary* in the church of St Maurice (sv. Mořic) and related works, for example the *Crucifixion* from Kunčice in the Opava Regional Museum.

This picture of Czech sculpture at the end of the fifteenth century and around 1500 was not a comprehensive survey as the state of research does not make this possible yet. It sets out to show the overall situation on a few characteristic pieces selected from the enormous number of surviving statues.

Nevertheless it becomes clear that sculpture in the Czech Lands grew in scope and intensity at that period. There were sculptors and works that belong to the climax of Central European production. But it must be admitted that the Czech Lands were not the initiators of Central European sculpture; they only shared in the work. They followed rather than set the pace. The specification of the typical features of this work and its inner continuity has yet to produce convincing conclusions. But it should be said that research is still in its initial phase, particularly in regard to Prague production which has survived in a sadly fragmentary state.

Pilgram's objective realism meant a break with medieval transcendental idealism and its anti-rational symbolism. The didactic and excitative function of art was abandoned in favour of comprehension. It is not by chance that the majority of the works Pilgram made in Brno were decoration of secular buildings. The thoroughness and ruthlessness with which he pursued his aims was exceptional in the Bohemian setting. Yet this thirst for knowledge of reality was an important aspect in advancing the style, though obscured by the strong tradition of symbolic thought and strong convention, which can be seen particularly in the treatment of the draperies. It rose to the surface where the naked human body appeared, on numerous Crucifixions and rarely on sculptures showing the Man of Sorrows. In the late fifteenth century, slender bodies were, as a matter of fact, merely bearers of abstract movement occurring in space, whose meaning rested in its expressive force. At the beginning of the sixteenth century the body became sturdy and real weight made itself felt. Two outstanding examples of central Bohemian wood-carving might be cited: the emaciated *Crucifixion* of Budeč dating from the end of the fifteenth century, where detailed observation served to express religious symbols. And the sturdy *Man of Sorrows* from the Italian Court at Kutná Hora of 1511 bearing the monogram HE, where description was a means of giving an objective portrayal of reality. The flying veil, a survival of the preceding century, served merely as a decoration. This sculpture belongs already to the Renaissance. It is all the more striking that in type and motif it depended on the Bohemian sculptures representing the Man of Sorrows, which, a hundred years earlier, were made, like this one, for council chambers.

Contacts with the Italian Renaissance must be assumed not only in architecture, but also in sculpture and painting. The earliest examples of the direct effect of Italian Renaissance sculpture have survived in Moravia, which, it seems, was more prone to adopt new trends. At the castle at Moravská Třebová there is a portrait medallion of Ladislaus of Boskovice and Magdalene of Dubá and of Lipá from the year 1495. They were certainly made by Italian artists who began to come to Bohemia via Hungary. It is, therefore, not surprising that works showing Classical Renaissance trends appeared in Moravia as early as in the second decade of the sixteenth century, for example the two stone reliefs in St James's (sv. Jakub) in Brno which cannot have come into existence without a knowledge of northern Italian sculpture. One of them, *The Crucifixion* of 1519, was probably made by the Master of the Potters' Altar at Baden near Vienna, while the other, showing *The Lamentation* and dated 1518, related to the first sculpture but more monumental and Renaissance in a Classical sense, is closer to Italian, Venetian examples. Augsburg probably served as the intermediary.[57]

Renaissance rationalism did not have many followers in Bohemia. Most of the sculptors conceived reality as an entity, not a matter of thought but one of sight and emotion. Indeed it can be observed that simultaneously with the first isolated indications of Renaissance objectivism there arose a wave of emotion aiming at more personal expression rather than knowledge. But even it, of course, contained elements of perception and did not avoid description. The main representative of this emotional art was a carver who for lack of a better name is called the Master of the Lamentation of Žebrák, after his main work, today in the National Gallery in Prague. He was active in the first twenty years of the sixteenth century, probably in České Budějovice. His starting point was the late fifteenth-century tradition represented by the Kefermarkt *Altarpiece*. The *Winged Altarpiece of Velhartice* was perhaps of even greater importance for this Master. But he soon developed his own style. Intense emotional experience seems to affect the material substance of the figures and distort their organic structure. Later he adopted a more restrained attitude and a more objective view of reality. This path from dramatic pathos with lyrical elements, recalling, together with a certain Mannerist arbitrariness, the Beautiful Style, to objective description which includes poetical transposition can be found on the following works: *The Lamentation of Žebrák*, whose elongated figures with small heads submit passively to an inorganic force stressing the expressive effect of the scene; a highly emotional *Mary Magdalene of Malý Bor* (Hluboká Gallery); the *Holy Trinity of České Budějovice* (Hluboká Gallery) with a balanced composition, objective bodily parts and a Baroque-like softness in the draperies; the *Malšín Madonna* (National Gallery, Prague) whose harmoniously flowing parallel lines enhance her lyrical expression; *Mary Magdalene of Čakov* (Hluboká Gallery), where the agitation of earlier works has given way to a simpler and more bourgeois conception; an excellent *Crucifix* in the Dominican monastery at České Budějovice, in which not even the symmetrically blown-up veil disturbs the impression of calm which hides below it a strong inner tension.

The Master of the Žebrák Lamentation had an assistant who perhaps later became his competitor. He was a wood-carver who derives his name from a relief of the same subject at Zvíkov castle. He may later have worked in south-west Bohemia (Homolka).[58] His style is close to his great contemporary, but less sophisticated, simpler in content and form. These two

carvers exerted considerable influence on south Bohemian sculpture. By their side worked several other remarkable artists. One of these made the *Adoration of the Magi* at České Budějovice (Hluboká Gallery). He was close to the Žebrák Master even though the style of his reliefs differed. Other carvers adopted more personal manners of expression. All the work produced in south Bohemia is related to sculpture of the Danube basin, but thanks to several outstanding personalities it has a characteristic, unchanging quality.

As far as one can judge from existing material and the present state of research, other regions of Bohemia did not have sculptors of such importance and originality in the early sixteenth century as the Master of the Žebrák Lamentation. Northwest Bohemia, where a good deal of research has been done, forms no exception. The outstanding personality there was Ulrich Creutz. He worked in the area for several years before returning to Germany, but his work is not above average. However his work, showing traces of contact with Stoss, had a character of its own, even though it was somewhat gross. Some of the work in that region was done by masters from Saxony, for example the Dresden artist Christoph Walther who was active at Jáchymov. Similarly the Master of the Annunciation from Týnec, who worked in west Bohemia in the first quarter of the century, did not surpass provincial standards.

The Baroque-like trends of late Gothic sculpture, aiming at visual unity and emotional effect, existed in other regions too, especially in Moravia. Brno did not lose its importance even after the departure and death of Pilgram. In the Museum at Vyškov there exists a *Madonna*, whose softness recalls that of a painting. Further examples are *St Nicholas* from Dolní Brtnice (Moravian Gallery, Brno) and outstanding reliefs of the *Nativity* and the *Visitation* (Moravian Gallery, Brno), with a high standard of carving. The proximity to Vienna made it possible for Moravian artists to keep up with contemporary development of Central European art. They also had contacts with art in south Bohemia which, in its turn, also leant towards the Danube basin. This orientation is confirmed in the above-mentioned reliefs of the *Nativity* and the *Visitation*, by the conception of the landscape and architectonic setting where events in the life of the Virgin take place, once given in a detailed, narrative manner, the other time in grandiose and monumental form.

A wood-carver who came to Prague around 1520 had close contacts with the romanticism of the Danube basin, where human beings merged with nature. He and his workshop produced several important works to be found in Bohemia: the *Zlíchov Epitaph* with four reliefs on the altarpiece wings (National Gallery, Prague), the *St John's Altarpiece* in the Týn church and the altarpiece with *St Anne* and the *Adoration of the Magi* at the castle in Český Krumlov. Contacts with the Danube school represent only one aspect of his work. He had been influenced by Dürer's and probably also by Mantegna's engravings. This gave his work a rational, constructive element which contrasts with the visually emotional attitude typical of Danube painting. This Renaissance aspect now appeared emphatically in Prague for the first time. It forecast the end of the Gothic era. Soon the influx of Italian stone-masons who

broke down the century-old tradition in local wood-carving was to begin; it was to survive for several decades in works of mainly average level and eclectic character.

* * *

The conditions under which Czech late Gothic painting developed are similar to those determining sculpture. New contacts were made with the rest of Europe, mainly through the mediation of Germany. Since painting also lacked a strong centre which would synthesise various influences into a locally conditioned form, Bohemian painting in the second half of the fifteenth century presents a heterogeneous picture. Painting reflected the loose political organisation that lacked a strong central government.

The middle of the century meant no break in the old attitude to art. The tradition continued in book painting and persisted in panel paintings for several more decades. For example the *Vyšší Brod Madonna* of the St Vitus's type where the Virgin is a stiff copy of the old pattern while the figures on the frame show the more advanced 'broken' style. They are, moreover, placed on plinths to justify their siting.

The situation is illustrated similarly on an altarpiece from Dubany (National Gallery, Prague), where the *Assumption* is but a variant of the Torun Virgin enriched by certain elements of different provenance. The elasticity of the old linear system vanished as the works became more representative in function. Characteristic of this new function are a symmetrical, ornamental layout of the background, and the Child wrapped in garments to cover His nakedness, as was usual in the period of the Beautiful Style.

But in the sixties some Bohemian painters already had contact with Western European painting, even if indirectly. The painter of the *Annunciation* (National Gallery, Prague) grew out of the local tradition but had seen, perhaps in an engraving, a picture on that theme by Robert Campin and transposed that composition to his naive though poetical manner of expression. But he did not grasp those features of the pattern that meant an advance in the depiction of the visual world; instead he stressed the spiritual meaning of the scene. Elsewhere traces of the old local tradition were overlaid with a new more realistic attitude, for example, the *Christ* which a late Gothic painter painted over the *Madonna of Církvice*, the altarpiece from Jeníkov (Duchcov Museum) and the votive picture of the *Squire of Všechlapy* (National Gallery, Prague). All these and other pictures are provincial work reflecting the remote Netherlandish influence brought through the mediation of various German centres.

It was not until 1470 that a work appeared which applied the Netherlandish lesson not only to details but to the overall concept. The altarpiece from the church of St George at Prague-Hradčany (National Gallery, Prague) has traditional features only in its colour scheme and perhaps also on certain types of faces. Otherwise the new realistic approach dominates everywhere. Characterisation of the figures was more important to the painter than poetical metaphor, firmly sculptured form more than elegant pose. Depiction is precise, and yet grandiose; rough expression does not avoid ugliness, the richly gathered draperies are given in a non-rhythmical broken manner. The

emotional atmosphere is one of sober reality and profound gravity. All this stands in flagrant contrast to the Beautiful Style. The principles of the first wave of Netherlandish realism as presented in the works of Robert Campin were thoroughly applied. The only exception is the spatial layout of objects, where figures prevail entirely over environment. On the central picture of the *Death of the Virgin* the environment was conceived conceptually, not visually. But the feeling for spatial depth increased as can be seen on the scene with St George or the *Adoration of the Magi*. Netherlandish art was probably introduced to Bohemia via Nuremberg, where before the middle of the century the Master of Tucher's Altarpiece represented the first wave of Netherlandish influence.

A large number of other altarpieces can be grouped around the *St George's Altarpiece*. They must have come into being in a flourishing workshop. What is remarkable is that, on one side, the painter showed increasing interest in space, on the other, he appeared less interested in characterisation, which is typical a feature of the *St George's Altarpiece*. Instead there was a return to the idealised types related to the tradition of the Beautiful Style. A certain process seems to have repeated over and over again; the painter in his youth – perhaps on travels – acquired a new attitude to art, but in his later work gradually adapted himself again to the local tradition.

The influence of the Master of the St George's Altarpiece was considerable. There are, for instance, the wings of the altarpiece from Senomaty (Křivoklát Gallery) where the old local tradition is combined with certain ideas derived from the Netherlands. Or the incomplete altarpiece of Master I. V. M. (National Gallery, Prague), where the links to the Beautiful Style are even more obvious, even though his spatial conception derived from Netherlandish examples.

The circle of the Master of the St George's Altarpiece belongs to the first wave of Netherlandish influence with but a few signs of more advanced Flemish painting. Around 1480 the style of Rogier van der Weyden became predominant. The earliest surviving example of this contact is the painting of the *Mass of St Gregory* (Moravian Gallery, Brno) which was made in 1480 on order of Perchta of Boskovice, the abbess of the Cistercian abbey in Old Brno. The painter had mastered the art of analytical description and probably knew Netherlandish painting of the second generation from close examination but in regard to perspective he followed older customs.

An important example of this new type of art is the altarpiece commissioned by Nicholas Puchner, Grand-Master of the Order of Knights Hospitallers with a Red Star for the monastery church of St Francis (sv. František) in Prague (National Gallery, Prague). Two wings are painted on both sides and two on one side only, bearing the pictures of *The Death of the Virgin, The Crucifixion, The Blessed Agnes Handing the Grand-Master a Model of the Church and Tending to the Sick, The Stigmatisation of St Francis, St Augustine Teaching the Knights Hospitallers* and several saints. The portrait of the Grand-Master appeared twice. Netherlandish naturalism of the Bouts type appeared in the restrained and careful drawing of the details, where the painter tried to depict the structure of materials. It can also sobe found in the stage-like layout of the landscape and interiors, and the absence of drama

in the scenes. But the forms are harder and more linear. The naturalistic trends are weakened by the inclination to use stereotypes. The convincing perspective is weakened by the absence of a single viewpoint. The visual truthfulness is denied by the ornamental gilt background. The painter who made the altarpiece for the Order of Knights Hospitallers went far west to learn his lesson. It seems that he visited Cologne and brought away with him from there, and particularly from the work of the Master of the Lyversberg Passion, his knowledge of Netherlandish naturalism. The Netherlandish orientation, mostly brought via the Rhineland, was not limited to this one workshop. It can be detected on a large-sized panel with the *Coronation of the Virgin* from Rybná near Moravský Krumlov (Moravian Gallery, Brno), showing knowledge of the work of the circle of the Flemish painter Rogier van der Weyden. Other centres of late Gothic painting in Central Europe exerted a similar influence on Bohemia, particularly nearby Nuremberg and neighbouring Austria, where Vienna, in particular, had early contacts with Netherlandish naturalism. Vienna painting made itself felt in Moravia, as shown on the excellent cycle of *The Virgin* at the Kroměříž Art-Historical Museum, whose painter had contacts with the Austrian Master of the *Winkler Epitaph*, the *Deposition from the Cross* of Rajhrad (Moravian Gallery, Brno), and other works made in Brno. In Bohemia, this type of work includes the wings of the altarpiece from Doudleby of 1494 (Hluboká Gallery).

But the most important influence was that of the Rhineland. This contact can be detected on an important series of paintings by the Master of the Hradec Králové Altarpiece (Hradec Králové, Church of the Holy Spirit), of 1494. The painter probably lived in Chrudim. Even in the smaller towns of Bohemia a good deal of painting of high standard was carried out. The Master of the Hradec Králové Altarpiece must have known the work of the Cologne Master of the Laus Mariae, and recently his contacts with Bavaria have been discovered.[59]

An especially important painting under Rhenish influence is the altarpiece in the chapel at the royal castle of Křivoklát. This brings us back to Court art, where in architecture too, we were able to observe renewed interest towards the end of the century. The painter of the altarpiece also had contacts with the Cologne painting, particularly with the Master of the Life of the Virgin, whose Netherlandish features he adopted and introduced to Bohemia with remarkable purity of style. Several important painters were trained in his studio: the Master of the Rakovník Altarpiece from 1496 (Křivoklát Gallery), the painter who made the altarpiece in the church at Rokycany, and, in particular, the Master of the Litoměřice Altarpiece, which will be discussed later. The quality of the *Křivoklát Altarpiece* shows that great demands were made on Court painters.

The demands of the rich burghers were no less exacting. Compare the decorations at Žirovnice castle and the mural paintings at the Smíšek chapel in St Barbara's at Kutná Hora. The donors of these two cycles were members of the burgher Smíšek family of Vrchoviště who were also patrons of book illuminations. The artist who made the St Barbara paintings revealed such a remarkable knowledge of the principles of Netherlandish painting on the scenes of *Trajan's Justice, Augustus and the Sibyl, The Arrival*

of the Queen of Sheba, The Crucifixion and illusive paintings of plinths, that it must be assumed that he had been in direct contact with the Netherlands. He also contributed to the history of European still-life and moralistic genre painting. He took his starting point in the circle of Dieric Bouts, where he found the stimulus for the undramatic, slightly solemn note of his art. The rational composition indicates that he also knew Italian painting. This is hardly surprising if we consider that in 1488 the Italians painted the chambers in the Italian Court, and in the nineties Renaissance elements appeared in the decorative paintings at Hrádek, a small castle in Kutná Hora. There are records that in the first few years of the sixteenth century a mural painter, Roman Vlach (Roman the Italian), worked in Kutná Hora.

It seems that from the end of the fifteenth century the Italian influence affected mural painting, where it was in some manner connected with the royal Court. Panel painting does not show any signs of radical changes. Its basis, even in the early sixteenth century, was the Northern European tradition with only timid elements of the Italian Renaissance. Stress was placed on the physical aspect of objects, their volume and weight. There was an endeavour to show the relationship between figures and the ground. An effort – not always consistent – was made to achieve static balance and give objective depiction if not of the whole then of the details. The outstanding panel with Three Apostles (National Gallery, Prague) shows a striking precision of observation in the parts of the bodies. The work of the Master of the Winged Altar of Chuděnice of 1505 (Chuděnice parish church) shows the new style meeting head-on with late Gothic Mannerism.

The new style appeared fully in the work of the Master of the Litoměřice Altarpiece. He derived his name from the six panels on the wings of this large altarpiece, probably made for the church of St Stephen in Litoměřice. The elongated figures of the cycles of the Virgin and of the Passion have full bodily dimensions and are firmly set in their environment. The foreground is constructed with considerable visual truthfulness, particularly where the scenes are given in an architectural setting. The background seems to recede rapidly as it is divided from the foreground by a barrier of architecture or heads wherever spatial depth was not achieved by the introduction of landscapes. The attention the painter paid to details of nature and architecture and the care he devoted to the form and mechanics of the human body and to the physical aspects of the surface of objects did not take him into the sphere of naturalistic description. Everywhere one can observe a liberal simplification, a suppression of details, concentration on the most important elements of the composition and of the spiritual content. There is a trend towards geometrical form and stereometric shape. The architecture is composed of clearly defined cubes set in space. The figures are static, in spite of the physical dynamism of the Passion scenes. The individual figures resemble regular stereometric blocks. The impression of static forms is enhanced by the deliberate choice of certain postures, so the figures are shown either at rest or at the final poise of a movement. This regular static composition does not weaken the emotional effect of the pictures. On the contrary the geometrication which on the *Mount of Olives* adapts the figures of the Apostles to stereometric shapes and which in the group of *Mary below the Cross* distorts the organic structure, adds quite exceptional pathos to these scenes. The Master of the Litoměřice Altarpiece was undoubtedly one of the most eminent painters in Central Europe at the end of the Gothic period.

As a pupil of the Master of the Křivoklát Altarpiece he will have travelled in the Danube region and particularly lower Austria to study painting. It is quite possible that he went as far as northern Italy where he may have come into contact with Venetian painting and the work of Mantegna. Yet, as the *Litoměřice Altarpiece* shows, he remained basically a Gothic painter of the Northern European type who had studied but not been convinced by Italian art. Surprisingly enough, his later work shows an intensification of Renaissance features. The monumental conception increased on *The Visitation* from the *Strahov Altarpiece* (National Gallery, Prague). On the votive painting of *John of Wartenberg*, which survives only in a copy (National Gallery, Prague), the painter's ability to show rationally arranged space and his knowledge of the mechanics of the human body had improved. He was in charge of the painted decorations of the chapel of St Wenceslas in Prague Cathedral. They show how profoundly he had comprehended the principles of Renaissance painting. With the aid of assistants he made a vast solemn cycle of *The Life of St Wenceslas*, symbolising the political ideas of the Court of Prague under Vladislav. It is so strongly under the influence of North Italian painting that one can assume that he paid another visit to Italy, and probably to Venice. The painting in the chapel of St Wenceslas came into being before 1509,[60] the year that Vladislav II visited Prague and his son Louis was crowned. Prior to that, in 1506, the painter tested his skill in portraiture by making a portrait of Albrecht of Kolovraty, the High Chancellor of the Kingdom of Bohemia (private collection, Meersburg). It shows that he lacked experience in this field. All these works seem to have been made for members of the Church establishment and secular aristocracy. Later the painter also worked for the burghers, as shown by large wings for the altarpiece of the Týn church (National Gallery, Prague). His work in the second and third decades of the sixteenth century did not bring much that was new. It did not advance the development of Bohemian painting, which not even then had found its own way. The Court of Prague was without a monarch, who in 1490 had settled in Buda, and the capital, lacking financially strong burghers, was unable to stimulate conditions under which art could flourish as it had done during the time of the Luxembourg dynasty. This was so in spite of efforts to follow up the great epoch of Charles IV who remained an unattainable example for the King, his Prague representatives and the people in general.

Even at that time it is difficult to trace any continuity in Czech painting. There were pictures that followed up Nuremberg work, for example the expressive *Crucifixion* in the provost's church at Mělník or the altarpiece with the *Visitation* in the church of Our Lady at Kutná Hora (Panna Maria na Náměti), remarkable for its landscape romanticism, freely based on Dürer. Elsewhere there was contact with Swabian painting, for example in the work associated with the name of Hanuš Elfeldar, and

particularly his predella with the *Last Supper*, dated 1515, in the St James's church (sv. Jakub) at Kutná Hora. The Swabian orientation can also be seen on the altarpiece with the *Assumption of the Virgin* and the *Virgin and Child with St Anne* in the church of Our Lady at Kutná Hora. They can be attributed to Master Michael who, like Elfeldar, moved from Prague to Kutná Hora in search of employment.

The influence of the Danube school exerted itself not only in panel but also in book painting. Here one might cite the high-quality *Altarpiece from Čimelice* (Prague Cathedral), whose painter decorated the *Litoměřice Song-book* (City Museum, Litoměřice) with miniatures of the Danube type, and the altarpiece with the *Coronation of the Virgin* from Osek (National Gallery, Prague). Mural painting of this trend includes the decoration of the castle chapel at Švihov and *Passion Scenes* in the Minorite monastery in Brno. These paintings show intensive interest in landscape and colour values, applied temperamentally. Yet another broad current of Czech painting was Saxony-oriented. These smooth and careful paintings show the craftsmanship rather than the temperament of the painter. A large portion of Czech painting from the twenties followed this trend. It derived from the late work of Lucas Cranach the Elder, and was transmitted via north-east Bohemia which had close links with Saxony economically and where there was a recent wave of German colonisation. The most important representative of this trend was Master I. W., who was probably trained in the Wittenberg workshop of Cranach and then settled in Bohemia, where we can trace his work throughout the second quarter of the sixteenth century. Not even his best works, the *Želina Altarpiece* of 1526 (Kadaň Museum) or the votive picture of 1530 from Šopka parish church, can hide the fact that they are no more than technically efficient derivatives.

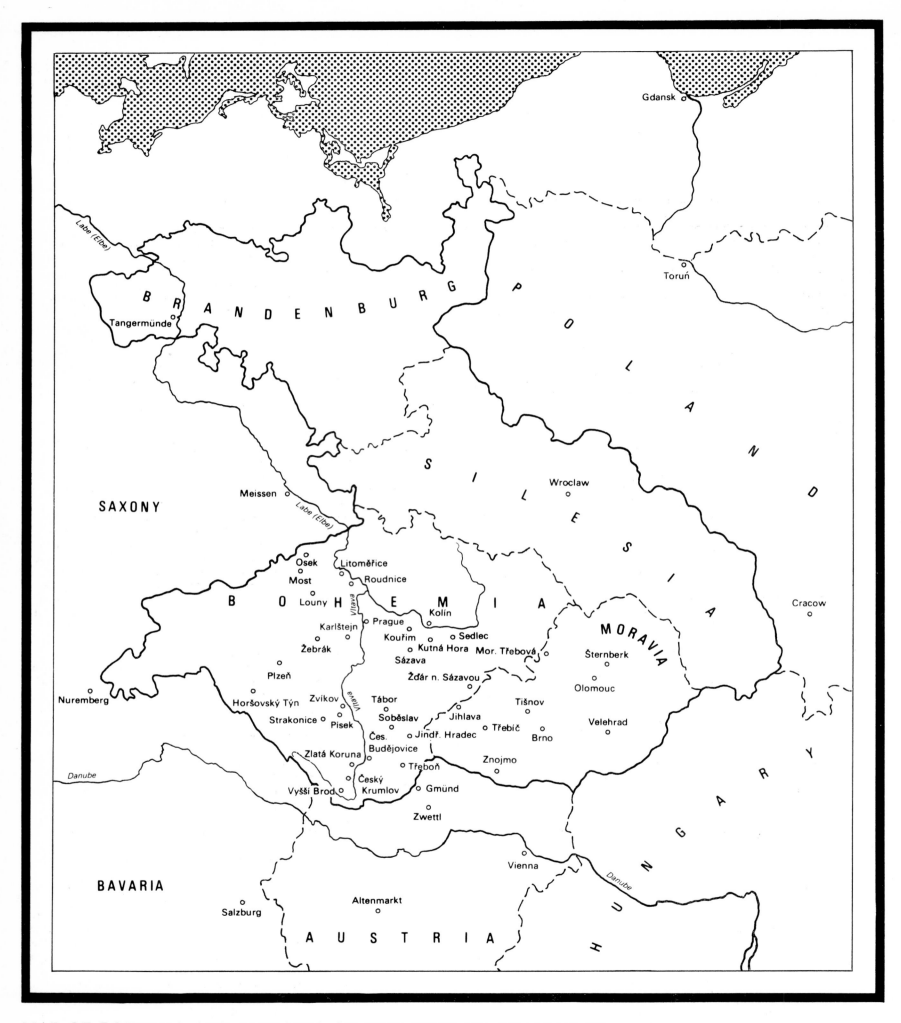

MAP OF BOHEMIA AND MORAVIA AT THE TIME OF CHARLES IV

NOTES

1. This growth can be well observed in the Prague Brotherhood of painters. Artists of Czech origin were represented in large numbers from the beginning, but they gained dominance at the beginning of the fifteenth century.

2. J. Joachimová, 'On the stylistic origin of the St Agnes's Convent', *Umění XIV*, 1966, pp. 189 ff.

3. J. Joachimová, 'The Foundation of Queen Constancia and the Prague Estates of the Teutonic Knights', *Umění XIV*, 1968, pp. 495 ff.

4. D. Líbal (A. Kutal, A. Matějček), *Czech Gothic Art I*, 1949, 17.

5. J. Mašín, 'On the Problems of Romanesque Sculpture in the Czech Lands. Notes on the reliefs of the Judith Bridge Tower', *Miscellany compiled in Honour of Jan Květ*, 1965, pp. 76 ff.

6. F. Kieslinger, *Zur Geschichte der gotischen Plastik in Österreich*, Vienna, 1923, pict. 6.

7. Records of a chapel of the Corpus Christi near St Peter's church at Vyšehrad exist from 1328 (W.W. Tomek, *History of the City of Prague*, II, 1871, p. 258). As the chapel and the altarpiece seem to be related to the theme of the Pietà, it can be assumed that a statue of that subject stood in the chapel.

8. K. Stejskal, Pešek and Ulrich, 'The painters of Queen Elizabeth', *Dějiny a současnost IX*, 1967, 9, pp. 34 ff.

9. K. Stejskal, 'Evaluation of Artists in the Gothic and Renaissance Periods', *Dějiny a současnost IX*, 1967, p. 11–20.

10. J. Květ, *The Illuminated Manuscripts of Queen Elizabeth*, 1931, pp. 241 ff.

11. G. Schmidt, F. Unterkircher, *Der Krumauer Bilderkodex*, 9 ff. 31.

12. V. Mencl, *Bohemian Architecture at the Time of the Luxembourgs*, Prague, 1948, p. 73.

13. The church at Karlov influenced the building of churches of a centralised type: the church of Our Lady at Nové Město n. Váhom and the chapel of St Catherine at Kateřinky near Opava.

14. V. Mencl, op. cit. p. 83.

15. V. Mencl, op. cit. p. 110 ff.

16. P. Frankl, *Gothic Architecture*, Harmondsworth, 1962

17. H. Bock, 'Der Beginn spätgotischer Architektur in Prag (Peter Parler) und die Beziehungen zu England', *Wallraf-Richartz-Jahrbuch XXIII*, 1961, pp. 191 ff.

18. W.W. Tomek, *Elements of Old Prague Topography*, III–V, 1872, p. 107.

19. A. Friedl, *Master of the Karlštejn Apocalypse*, 1950, p. 7 ff.

20. This document refers to the obstacles that would prevent the canons from entering the Lady chapel. This might be related to the proposed paintings in the chapel of the Relics of the Lord's Passion.

21. K. Stejskal, The Painters of the Mural Paintings in the Slovany Monastery, *Umění XV*, 1967, p. 4 ff.

22. J. Krása, in *Gothic Mural Painting in Bohemia and Moravia, 1300–1378*, O.U.P. 1964, pp. 124 ff.

23. K. Stejskal, op. cit. pp. 22 ff.

24. A. Friedl, *Mistr Theodorik nebyl matematikem (Master Theodoric was no Mathematician)*, Umění XVII, 1969, pp. 339 ff.; the author dates this manuscript between 1353–1354, but generally it is dated c. 1360.

25. G. Schmidt, 'Johann von Troppau und die vorromanische Buchmalerei, Vom ideelen Wert Altertümlicher Formen in der Kunst des vierzehnten Jahrhunderts'. *Festschrift für Karl Hermann Usener zum 60 Geburtstag*, 1956, pp. 257 ff.

26. E. Panofsky, *Early Netherlandish Painting, its Origin and Character I*, 1953, p. 68.

27. V. Mencl, op. cit. pp. 152 ff.

28. V. Mencl, op. cit. pp. 142 ff.

29. V. Schmidt, A. Picha, *Urkundenbuch der Stadt Krumau in Böhmen*, I, 1908, no. 565.

30. V. Mencl, op. cit. p. 146.

31. G. Fehr, *Benedikt Ried*, 1961, p. 95.

32. Statues of this kind were exported, as can be proved by the *Pietà* in the Dominican church at Landshut.

33. Apart from that a type of Pietà on the Calvary arose in Bohemia which can be genetically connected to the Italian painted Pietàs of the Trecento. The only surviving example today is the Pietà in the church at Dlouhá Ves dating from the thirteen seventies or the period around 1380. This type soon penetrated into English miniature painting where it appeared in the early fourteenth century (British Museum, London, Yates Thompson 13, fol. 123 v) and later to France where we can find it, for example, on the *Très Belles Heures de N.D.* (Bibl. Nat. Paris, nouv. acqu. lat. 3033, p. 216) from the time around 1385 (M. Meiss, *French Painting in the Time of Jean de Berry*, 1967, pict. 644, 28). Later it influenced the Sluter *Pietà* at the Liebighaus in Frankfurt and Netherlandish painting in the fifteenth century adopted it. Compare for example the *Turin Hours* or the *Granada Altarpiece* by Rogier van der Weyden.

34. Cp. A. Kutal, *Bemerkungen zur Altstädter Madonna in Prag* SPFFBU, F. 10, 1966, p. 5 ff.; also *Material on the History of Gothic Sculpture*, SPFFBU, F. 11, 1967, pp. 76 ff. This relationship is also confirmed by the *Nursing Madonna of Mariazell* in the Deutsches Museum in Nuremberg, closely connected with the Old Town *Madonna*. Her Child is related to the Child of the *Madonna* of the Böhmer house in Trier, today in the local City Museum, which is marked as coming from Lotharingia and dated from *c.* 1360. It also belonged to the French 'pelerine' type.

35. Last seen in the catalogue of the exhibition *Schöne Madonnen 1350–1450*. Salzburg 1965, pp. 67 ff.

36. See A. Kutal, *Czech Gothic Sculpture*, Prague, 1962, p. 134.

37. This proposal of sequence leads to the dating of the *Plzeň Madonna*. If it truly comes from the same workshop as the *Altenmarkt Madonna* it must be later, that is made around 1393. If the records of indulgences from 1384 – last published by J. Čadík ('On dating the Plzeň Madonna', *The History of the West Bohemian Region*, *V*, p. 228) – really refer to our statue, its dating should be moved to that date and the chronological sequence of the whole group would have to be changed. Yet the formulation of the record made in the second half of the seventeenth century does not necessarily indicate that it refers to the *Plzeň Madonna*.

38. Th. Müller, *Kunst-Chronik 16*, 1963, p. 287. From the formulation of the indulgence it can be assumed that the statue must have stood there for some time. Indulgences had been issued before for the chapel consecrated to the Virgin, to St Mary Magdalene, St George and St Adalbert, for the first time in 1397. At that time the *Madonna* mentioned in the indulgences of 1400 might have stood in its place already. This would suit the style sequence of the *Krumlov Madonna*. Cp. Schmidt, Picha, op. cit. no. 427, 428, 465, 478, 479, where the indulgences from 1400 are given in relation to the *Krumlov Madonna*, p. 202.

39. L. Kalinowski, *Geneza piety średniowiecznej*, Polish Academy of Art, Work of the History Commission X, Cracow 1952, p. 243.

40. According to the inventory of the former Kaiser-Friedrich Museum it is known that it was purchased from a trader, Marx, who acquired it from an unnamed suburb in Vienna. The design of the draperies recalls the *Plzeň Madonna* and especially the *Epitaph of John of Jeřeň* from 1395. The face of the Virgin has unusually realistic features.

41. Ch. Sterling, 'Une Madone tchèque au Musée du Louvre', *La Revue des Arts, Musées de France X*, 1960, pp. 75 ff.

42. The *Madonna* probably formed part of the altarpiece. It stood on the console with Moses between the figures of royal appearance above the wooden panel with the Tree of Jesse. This is the reconstruction of the altarpiece by J. Kruszelnicka 'Dawny ołtarz pięknej Madonny Toruńskiej', *Teka Komisji Historii Sztuki IV*, Torun 1968, p. 9 ff. This form of altarpiece was unusual in Central Europe but has analogies in the West. Compare the altarpiece at Rouvres-la-Plaine, Côte d'Or, illustration ditto.

43. The gesture of the Christ Child's right hand and the veil on the Virgin's head recall the *Strahov Madonna*.

44. In the cathedral inventory: Ex primo supra tumbam S. Viti inter imagines beatae virginis et salvatoris pendet primum cortina rubea... Tomek, *Elements of Old Prague Topography III–V*, p. 248. This symbolical relation between the Virgin and Christ on the one side and Adam and Eve on the other is not unique in Gothic sculpture. Cp. the plinth below the statues of the Virgin on the south portal of the west façade of the cathedral at Amiens or the north portal of the west façade of Notre Dame in Paris.

45. K.H. Clasen, *Die mittelalterliche Bildhauerkunst im Deutschordennsland Preussen*, 1939. Also *Die Schönen Madonnen*, 1957: A. Feulner, 'Der Meister der Schönen Madonnen', *Zeitschrift des deutschen Vereines für Kunstwissenschaft X*, 1943.

46. S. Siebenhüner, *Deutsche Künstler am Mailänder Dom*, 1944.

47. W. Paatz, 'Prolegomena zu einer Geschichte des deutschen spätgotischen Skulptur im 15. Jahrhundert', *Abhandlungen der Heidelberger Akademie der Wissenschaft, Phil-hist. Klasse, 1956,* 2 Abh., 21.

48. Painter Nicholas was paid a score and a half of groschen in 1413 for work on an image (in labore imaginis) for the chamber of the New Town Hall. This record probably refers to *The Man of Sorrows* in the Museum of the City of Prague.

49. E. Wiese, *Schlesische Plastik vom Beginn des XIV. Jahrhunderts bis zur Mitte des XV. Jahrhunderts,* Leipzig 1923, p. 39 ff.; H. Braune, E. Wiese, 'Schlesische Malerei und Plastik des Mittelalters', *Kritischer Katalog der Ausstellung in Breslau,* Leipzig, 1929, pp. 24 ff.

50. Records exist for this statue which might aid dating. In 1399 the rooms in the Old Town Hall went up in flames and in 1407 there is mention of a new council chamber. It is quite likely that the statue of *The Man of Sorrows* stood there already at that time. (It has remained there to this day.) Later a new plinth was made for it. Tomek, op. cit., I, 1866, pp. 9 ff.

51. J. Cibulka, 'The Triptych depicting the Crucifixion and the Apostles Peter and Andrew', *Umění XIII,* 1965, p. 1. ff.

52. O. Pächt, 'A Bohemian Martyrology', *Burlington Magazine,* 73, 1938, pp. 192 ff.

53. The *Roudnice Madonna* was copied soon after it was made, as shown by the *Madonna* in the church of the Holy Trinity at České Budějovice, today in the Hluboká Gallery.

54. It is possible that the Parler tradition reached Brno only after the Hussite wars via Vienna.

55. The pre-Hussite origin of the statue is supported by e.g. K.M. Swoboda, *Peter Parler,* 1940, p. 39 and V.V. Štech, 'Sculptural Problems in Old Bohemian Sculpture', *Umění VII,* 1959, p. 93. The origin after the Hussite wars is upheld by A. Stix in 'Die monumentale Plastik der Prager Dombauhütte um die Wende des XIV. und XV. Jahrhunderts', *Kunstgeschichtliches Jahrbuch der K.K. Zentralkommission,* 1908, p. 98. The statue stands at the top of a pillar on the stairway in the form of a Romanesque cushion capital, which is a typical example of the Romanesque renaissance, typical for the period around and after the middle of the fifteenth century, but unknown in fourteenth-century architecture. The last part of the stairway where the statue stands was added later.

56. J. Krčálová, 'Contribution to the knowledge of the work of Hanuš of Olomouc', *Umění IV,* 1956, pp. 17 ff. The surviving copies of the Olomouc *Mount of Olives* show that it was considered a quite exceptional work

57. The influence of Augsburg sculpture probably reached Brno via Vienna.

58. *South-Bohemian Late Gothic 1450–1530,* exhibition catalogue, Hluboká 1965, pp 116 ff.

59. J. Pešina, 'Paralipomena to the History of Late Gothic and Renaissance Painting in Bohemia', *Umění XV,* 1967, pp. 329 ff.

60. Perhaps as replacement for an old one, dating from the time of Charles IV.

LIST OF PLATES

77 The Woman Clothed with the Sun. *c.* 1360. Mural painting. Lady Chapel, Karlštejn castle

78 Master Theodoric. The Annunciation (detail). Before 1365. Mural painting. Chapel of the Holy Cross, Karlštejn castle

79 John Swallows the Book (detail from The Apocalypse). *c.* 1360. Mural painting. Lady Chapel, Karlštejn castle

80 Relics Scenes (detail). Before 1357. Mural painting. Lady Chapel, Karlštejn castle

81 Master Theodoric. Benedictine Abbot. Before 1365. Wood panel. 115×85.5 cm. Chapel of the Holy Cross, Karlštejn castle

82 Master Theodoric. Church Father. Before 1365. Wood panel. 114.3×103.4 cm. Chapel of the Holy Cross, Karlštejn castle

83 Chus. Detail from The Luxembourg Family-tree in the Codex Heidelbergensis. Original 1356–1357, this copy is from the second half of the sixteenth century. National Gallery, Prague

84 Meromungus. Detail from The Luxembourg Family-tree in the Codex Heidelbergensis. Original 1356–1357, this copy is from the second half of the sixteenth century. National Gallery, Prague

85 Philosopher and Astronomer. 1370–1380. Pen and brush drawing on parchment. 13.8×13.5 cm. University Library, Erlangen

86 The Crucifixion from the Emmaus monastery. *c.* 1360. Canvas on pine panel. 132×98 cm. National Gallery, Prague

87 Master Theodoric. The Crucifixion. Before 1365. Wood panel. 221×175 cm. Chapel of the Holy Cross, Karlštejn castle

88 Master Theodoric. The Adoration of the Magi. Before 1365. Mural painting. Chapel of the Holy Cross, Karlštejn castle

89 Votive painting of John Očko of Vlašim. *c.* 1371. Limewood panel. 181×96 cm. National Gallery, Prague

90 The Gathering of Manna. *c.* 1360. Mural painting. Cloisters of the Emmaus monastery of the Slavonic Benedictines, Prague

91 The Flight into Egypt (detail). *c.* 1360. Mural painting. Cloisters of the Emmaus monastery of the Slavonic Benedictines, Prague

92 The Annunciation. *c.* 1360. Mural painting. Cloisters of the Emmaus monastery of the Slavonic Benedictines, Prague

93 The Rožmberk Antependium (detail). *c.* 1370 and *c.* 1400. Embroidery on silk. Present size 60×120 cm. National Museum, Prague

94 Reliquary Cross. Third quarter of the fourteenth century, foot of more recent origin. Gold, precious stones and cameos. 62.5×41.5 cm. Treasury of St Vitus's Cathedral, Prague

95 Old Town Hall, Prague. Oriel window. Before 1381

96 Royal palace at Hradčany, Prague. Hall of Columns. *c.* 1400

97 Holy Trinity church, Kutná Hora. Early fifteenth century

98 Church of Our Lady before Týn, Prague. West façade. End of the fourteenth century, towers finished in the second half of the fifteenth and early sixteenth century

99 Italian court, Kutná Hora. Oriel window of royal chapel. End of the fourteenth century

100 St Vitus's church, Soběslav. Nave. Last quarter of the fourteenth century

101 Church of Augustinian monastery, Třeboň. Monastery founded in 1367, church finished after 1380

102 Parish church, Dvůr Králové. Nave and aisles. *c.* 1400

103 Church of St Giles, Milevsko. Presbytery. End of the fourteenth century

104 Cemetery chapel. Sedlec. *c.* 1400

105 St Vitus's church, Český Krumlov. Before 1407–1439

106 Church of Our Lady before Týn, Prague. North portal, tympanum. 1380–1390

107 Church of Our Lady before Týn, Prague. North portal, detail of tympanum. 1380 to 1390

108 The Madonna from the Old Town Hall, Prague. Before 1381. Limestone with remains of old polychrome. h. 154 cm. City Museum, Prague

109 Virgin and Child. 1380–1390. Wood; later additions: the Virgin's hair, veil and the Child's hair. h. 135 cm. Parish church, Žebrák

110 St George. 1373. Bronze, probably originally gilded. h. 196 cm without spear, w. of plinth 177 cm. Prague castle

111 Pietà. Early fifteenth century. Plaster (?) with old polychrome. h. 56 cm. Český Krumlov Museum

112 Pietà. 1380–1390. Limestone with old polychrome. h. about 75 cm. Formerly in the church of St Mary Magdalene, Wroclaw, destroyed during the Second World War

113 Pietà. *c.* 1385. Limestone with original polychrome. h. 140 cm. w. of plinth 145 cm. Parish church (formerly Augustinian) of St Thomas, Brno

114 St Nicholas of Vyšší Brod. 1380–1390. Limewood with original polychrome. h. 144 cm. National Gallery, Prague

115 The Resurrection from the Třeboň Altarpiece. *c.* 1380. Canvas on fir panel. 132×92 cm. National Gallery, Prague

116 Three Saints from the Třeboň Altarpiece. (Reverse side of The Mount of Olives). *c.* 1380. Canvas on fir panel. National Gallery, Prague

117 The Mount of Olives from the Třeboň Altarpiece. *c.* 1380. Canvas on fir panel. 132×92 cm. National Gallery, Prague

118 The Adoration of the Child. *c.* 1380. Canvas on wood panel. 125.5×93 cm. Hluboká Castle

119 The Plzeň Madonna. *c.* 1395. Limestone. h. 125 cm. Church of St Bartholomew, Plzeň

120 The Krumlov Madonna. Before 1400. Limestone with parts of the original polychrome. h. 112 cm. Kunsthistorisches Museum, Vienna

121 The Roudnice Madonna. *c.* 1390. Canvas on limewood panel. 90×68 cm. National Gallery, Prague

122 Pietà. Early fifteenth century. Limestone with parts of the original polychrome. h. 121 cm. Church of St Ignatius, Jihlava

123 The Madonna of Torun. *c.* 1400. Limestone with traces of the original polychrome. h. 115 cm. Formerly in the church of St John, Torun, lost in the Second World War

124 The Madonna of Wroclaw. *c.* 1400. Limestone with original polychrome. h. 19 cm. National Museum, Warsaw

125 The Madonna of Šternberk. *c.* 1400. Limestone with old polychrome. h. 84 cm. Šternberk Castle

126 St Peter of Slivice (detail). *c.* 1395. Limestone with small fragments of old polychrome. h. 91.5 cm. National Gallery, Prague

127 Female saint from Dolní Vltavice. *c.* 1390 or earlier. Limewood with original polychrome. h. 32 cm. Hluboká Gallery

128 Pietà. *c.* 1400. Limestone, no polychrome. h. 100 cm. The Hermitage, Leningrad

129 Crucifix. Early fifteenth century. Limewood with original polychrome. h. 80 cm. St Vitus's Cathedral, Prague

130 St Catherine. *c.* 1400. Limestone with parts of the original polychrome. h. 116 cm. Church of St James, Jihlava

131 Pietà from Všeměřice. *c.* 1410. Limewood with partly original polychrome. h. 118 cm. Hluboká Gallery

132 Seated Madonna. *c.* 1420 or 1420–1430. Oak, new polychrome; Neo-Gothic throne. h. 162 cm. Church of Our Lady before Týn, Prague

133 The Man of Sorrows. Probably before 1413. Limewood with original polychrome. h. 136 cm. City Museum, Prague

134 Canonic folio from the Hasenburk Missal. 1409. Parchment manuscript. 24×17 cm. Nationalbibliothek, Vienna

135 Initial from The Astronomical Writings of Wenceslas IV, 1392–1393. Parchment manuscript. 29.5×21 cm. Nationalbibliothek, Vienna

136 Title page of The Golden Bull of Charles IV. 1400. Parchment manuscript. 42×30 cm. Nationalbibliothek, Vienna

137 Canonic folio from Missal No. 8. *c.* 1413. Parchment manuscript. 41.5×29.5 cm. City Archives, Brno

138 Epitaph of John of Jeřeň (right-hand side of a severed panel). Dated by the death of John of Jeřeň to 1395. Limewood. 64.5×49.5 cm. National Gallery, Prague

139 The Madonna of Jindřichův Hradec. *c.* 1400. Canvas on limewood panel. 25×19 cm. National Gallery, Prague

140 The St Vitus's Madonna. Before 1400. Canvas on limewood panel. 51×39.5 cm. Limewood frame with original polychrome also before 1400. National Gallery, Prague

141 Heads from the Ambrass Pattern Book. Early fifteenth century. Drawing in silver pencil on paper. Maple plates. 9.5×9 cm. Kunsthistorisches Museum, Vienna

142 Heads from the Ambrass Pattern Book. Early fifteenth century. Drawing in silver pencil on paper. Maple plates. 9.5×9 cm. Kunsthistorisches Museum, Vienna

143 Chasuble with the Crucifixion (detail). 1370–1380. Silk and gold embroidery. 112.5 cm. Moravian Gallery, Brno

144 The Master of the Rajhrad Altarpiece. The Way to Golgotha (detail). Before 1420. Canvas on fir panel. 99×147 cm. Moravian Gallery, Brno

145 Circle of the Master of the Rajhrad Altarpiece. The Martyrdom of St Catherine (panel from Náměšť). Canvas on wood panel. 87.5×95 cm. Moravian Gallery, Brno

146 The Nativity from the Boskovice Bible. *c.* 1410. Parchment manuscript. 42×30 cm. University Library, Olomouc

147 Powder Tower, Prague. Wenceslas and Matthias Rejsek. After 1475

148 Parish church at Dolní Dvořiště. Nave and aisles. 1488–1507

149 Deanery church, Chvalšiny. Vaulting in the nave. Early sixteenth century

150 Monastery church at Bechyně. End of the fifteenth century to early sixteenth century

151 Church of St Barbara, Kutná Hora. Vaulting in the presbytery. Designed by Matthias Rejsek. 1489–1499

152 Church of St Barbara, Kutná Hora. Choir. Peter Parler (?), Hanuš, Matthias Rejsek and Benedikt Ried. 1388–1548

153 Church of St James, Brno. End of the fourteenth – sixteenth centuries

154 Royal castle, Křivoklát. Interior of chapel. 1493–1522

155 Deanery church at Louny. Benedikt Ried. 1520–1538

156 Vladislav Hall, Prague Castle. Benedikt Ried. 1493–1502

157 Vladislav Hall, Prague Castle. North façade. Benedikt Ried. 1493–1502

158 Large chamber in the Town Hall at Tábor. 1521–1527

159 'Stone House', Kutná Hora. *c.* 1480

160 Pernštejn castle. Second half of the thirteenth century – first half of the sixteenth century

161 St Vitus's Cathedral, Prague. The royal oratory. Hans Spiess. 1490–93

162 Deanery church at Most. Interior. First half of the sixteenth century

163 St John the Evangelist from the Calvary. *c.* 1460. Wood with more recent polychrome. Larger than life-size. Church of St Bartholomew, Plzeň
164 The Archangel of Nedvědice. *c.* 1490. Limewood, no polychrome. h. 80 cm. Hluboká Gallery
165 Madonna. 1440–1450. Limewood with more recent polychrome. h. 148 cm. National Gallery, Prague
166 The Man of Sorrows. Signed HE 1511. Wood with original polychrome. 186 cm. Kutná Hora, chapel of the Italian Court
167 Seated Madonna. Before 1500. Wood with original polychrome. h. 120 cm. Church of Our Lady, Kájov
168 Anthony Pilgram. Saint of the Dominican Order. Before 1511. Wood. h. 134 cm. Moravian Gallery, Brno
169 The Lamentation of Žebrák. Limewood with remains of old polychrome. 126×127 cm. National Gallery, Prague
170 The Epitaph of Zlíchov (central part of an altarpiece). After 1520. Wood, no polychrome. 99×98 cm. National Gallery, Prague
171 The Primavesi Madonna. Before 1500. Wood with more recent polychrome. h. 133 cm. Moravian Gallery, Brno
172 Death of the Virgin. Central panel of the St George's Altarpiece. c. 1470. Limewood. 192×114 cm. National Gallery, Prague

173 The Annunciation. After 1460. Pine panel. 43.5×35.5 cm. National Gallery, Prague
174 The Blessed Agnes Tending a Sick Man. Part of the wing of the Altarpiece of the Grand Master Puchner. 1482. Pine panel. 124×96 cm. National Gallery, Prague
175 The Monogramist IVM. Doubting Thomas. *c.* 1470–1480. Limewood panel, signed IVM. 105×67 cm. National Gallery, Prague
176 The Birth of Christ. Part of a wing of an altarpiece. After 1490. Wood panel. Wing 202×52 cm. Castle chapel, Křivoklát
177 The Master of Litoměřice. The Bearing of the Cross. After 1500. Fir panel. 172×130 cm. Art Gallery, Litoměřice
178 Hanuš Elfeldar. The Last Supper. 1515. Wood panel. 123×284 cm. Křivoklát castle
179 Master of Litoměřice. The Crucifixion. After 1500. Fir panel. 178×122 cm. Art Gallery, Litoměřice
180 The Mass of St Gregory (detail). Original frame dated 1480. Wood panel. 117×93.5 cm. Moravian Gallery, Brno
181 Mural paintings. *c.* 1490. Smíšek chapel in the church of St Barbara, Kutná Hora
182 St George (detail). Mural painting. 1510–1520. Castle chapel, Švihov
Frontispiece:
The Original Sin. 1390–1400. Limestone with old polychrome. h. 50 cm. Console in the choir of St Vitus's Cathedral, Prague

List of Ground plans:

1 Plan of the Convent of the Poor Clares of the Blessed Agnes. Founded before 1234, finished *c.* 1280
2 Plan of the Cistercian abbey at Předklášteří near Tišnov. Founded 1233, finished *c.* 1250
3 Plan of the royal castle at Zvíkov. Third quarter of the thirteenth century
4 Plan of the Gothic town of České Budějovice. Founded 1265
5 Plan of the Gothic town of Český Krumlov
6 Plan of Prague with the reconstruction of the New Town at the time of Charles IV
7 Plan of Karlštejn castle (1348–1365) as restored in 1866
8 Plan of the Minorite church at Jindřichův Hradec. Aisle from the second half of the thirteenth century, presbytery from the second half of the fourteenth century, nave vaulting from the end of the fifteenth century, lateral chapel of St Nicholas alongside the presbytery before 1369

9 Plan of the Augustinian church at Třeboň. 1367 to after 1380
10 St Vitus's Cathedral, Prague. Matthias of Arras and Peter Parler. 1344–1420
11 Plan of the church of St Bartholomew in Kolín. Peter Parler. Nave and aisles after 1270, presbytery 1360–1378
12 Church of St Barbara, Kutná Hora. Ground-floor. 1388–1548
13 Plan of the chapel in the Italian Court at Kutná Hora. *c.* 1400
14 Plan of the destroyed Corpus Christi chapel in Prague. After 1382
15 Plan of the church of St Giles at Milevsko. Romanesque foundation, rebuilt in *c.* 1390
16 Plan of the church of St Vitus, Český Krumlov. Before 1407–1439
17 Facsimile page of the Book of the Prague Brotherhood of Painters with the record of the Prague Bachelors (Panici)
18 Church of St Barbara, Kutná Hora. Vaulting plan of nave and presbytery
19 Plan of the church of St Nicholas, Louny. 1520–1538

BIBLIOGRAPHY

I GENERAL

B. Balbín, *Epitome Historica rerum Bohemicarum*, Prague, 1677

B. Balbín, *Miscellanea historica regni Bohemiae*, Prague, 1679–1687

G. J. Dlabač, *Allgemeines historisches Künstler-Lexikon für Böhmen, Prague, 1815*

B. Grueber, *Die Kunst des Mittelalters in Böhmen I–IV*, Vienna, 1871–79

J. Neuwirth, *Die Wochenrechnungen und der Betrieb des Prager Dombaues 1372–78*, Prague, 1890

J. Neuwirth, *Studien zur Geschichte der Gotik in Böhmen I–IV*, Prague, 1892–99

J. Neuwirth, *Geschichte der bildenden Kunst in Böhmen vom Tode Wenzels III bis zu den Hussitenkriegen*, Prague, 1893

K. Chytil, *O Junkerech pražských* (The Prague Junkers–in Czech), Prague, 1903

A. Prokop, *Die Markgrafschaft Mähren in kunsthistorischer Beziehung, I, II*, Vienna, 1904

F. J. Lehner, *Dějiny umění národa českého II* (History of Art of the Czech Nation–in Czech), Prague, 1905

Umělecké poklady Čech I, II, (Art Treasures of Bohemia–in Czech), edited by Z. Wirth, Prague, 1913–15

V. Kramář, *La peinture et la sculpture du XIV^e siècle en Bohême*, L'art vivant IV, 1928

H. Braune–W. Wiese, *Schlesische Malerei und Plastik des Mittelalters, kritischer Katalog der Ausstellung in Breslau 1926*, Leipzig, 1929

Dějepis výtvarného umění v Čechách I, (History of Art in Bohemia–in Czech), edited by Z. Wirth, Prague, 1931

Československá vlastivěda VIII, (Czechoslovak Encyclopedia–in Czech), edited by Z. Wirth, Umění, Prague, 1935

W. Pinder, *Die Kunst der ersten Bürgerzeit*, Leipzig, 1938

E. Wiegand, *Beiträge zur süddeutschen Kunst um 1400*, Jahrbuch der preussischen Kunstsammlungen 59, Berlin, 1938

K. M. Swoboda, E. Bachmann, *Studien zu Peter Parler*, Vienna, 1939

K. M. Swoboda, *Peter Parler, der Baukünstler und Bildhauer*, Vienna, 1940

A. Matějček, D. Líbal, A. Kutal, *České umění gotické I* (Czech Gothic Art–in Czech) Prague, 1949

V. Denkstein–F. Matouš, *Jihočeská gotika* (Gothic Art in South Bohemia–in Czech), Prague, 1953

E. Poche–J. Krofta, *Na Slovanech* (The Monastery Na Slovanech–in Czech), Prague, 1956

L'art ancien en Tchécoslovaquie, exhibition catalogue, Paris, 1957

P. Frankl, *The Gothic*, New York, 1960

G. Bräutigam, *Gmünd–Prag–Nürnberg, Die nürnbergische Frauenkirche und der Prager Parlerstil von 1360*, Jahrbuch der Berliner Museen, Berlin, 1961

A. Kutal, *The Brunswick Sketchbook and the Czech Art of the Eighties of the 14th Century*, SPFFBU, X, Brno, 1961

Brian Knox, *Prague and Bohemia*, London, 1964

J. Pešina, J. Homolka, *K problematice evropského umění kolem roku 1400* (On the Problems of European Art around 1400–in Czech), Umění XI, Prague, 1963

V. Dvořáková, D. Menclová, *Hrad Karlštejn* (Karlštejn Castle–in Czech), Prague, 1964

J. Homolka, L. Kesner, *České umění gotické* (Czech Gothic Art–in Czech), National Gallery Catalogue, Prague, 1964

M. Aubert, *High Gothic Art*, London, 1965

Jihočeská pozdní gotika, 1450–1530 (Late Gothic in South-Bohemia–in Czech), exhibition catalogue, Hluboká Gallery, 1965

M. Dvořák, *Idealism and Naturalism in Gothic Art*, London, 1968

Les Primitifs de Bohême, L'art ancien en Tchécoslovaquie, exhibition catalogue, Brussels, 1966

S. Sitwell, *Gothic Europe*, New York, 1969

K. M. Swoboda (ed.), *Gotik in Böhmen*, München, 1969

G. Schmidt, *Peter Parler und Heinrich IV. Parler als Bildhauer*, Wiener Jahrbuch für Kunstgeschichte XXIII, 1970

České umění gotické 1350–1420, Prague 1970

J. Pešina, *Zur Frage der Chronologie des 'schönen Stils' in der Tafelmalerei Böhmens*, SPFFBU, XIX–XX, 1970–1971, I, pp. 14–15

II ARCHITECTURE

J. Hall, *Essay on the Origin, History, and Principles of Gothic Architecture*, London, 1813

K. Chytil, *Peter Parléř a mistři gmündští* (Peter Parler and the Gmünd Masters–in Czech) Prague, 1886

A. Neuwirth, *Peter Parler von Gmünd*, Prague, 1891

O. Pollak, *Studien zur Geschichte der Architektur Prags, 1520–1600*, Jahrbuch der Sammlungen des allerhöchsten Kaiserhauses XXIX, Vienna, 1910–11

V. Birnbaum, *Kdy přišel Petr Parléř do Prahy?* (When did Peter Parler come to Prague?–in Czech), Umění II, Prague, 1929

V. Birnbaum, *Chrám sv. Víta* (St Vitus's Cathedral–in Czech), Kniha o Praze I, Prague, 1930

K. H. Clasen, *Die gotische Baukunst*, Potsdam–Wildpark, 1930

O. Kletzl, *Zur Identität der Dombaumeister Wenzel Parler d. A. von Prag und Wenzel von Wien*, Wiener Jahrbuch für Kunstgeschichte IX, Vienna, 1934

E. Poche, *Benedikt Rejt z Pístova*, Umění VIII, Prague, 1935

O. Kletzl, *Die Junker von Prag in Strassburg*, Frankfurt a. M., 1936

J. Květ, *Síňový prostor v chrámové architektuře doby románské a gotické* (The hall-type church in the architecture of the Romanesque and Gothic Periods–in Czech) PA n. ř. VI–VIII, Prague, 1936–38

O. Kletzl, *Peter Parler, der Dombaumeister von Prag*, Leipzig, 1940

E. Bachmann, *Eine spätstaufische Baugruppe im mittelböhmischen Raum*, Brno, 1940

K. M. Swoboda, *Peter Parler*, Vienna, 1941

E. Bachmann, *Sudetenländische Kunsträume im 13. Jahrhundert*, Brno–Leipzig, 1941

E. Poche, *Pražské portály* (Prague Portals–in Czech), Prague, 1947

B. Kraus, *Mistr české gotiky Matěj Rejsek z Prostějova* (Matthias Rejsek of Prostějov, a Master of Czech Gothic–in Czech), Prague, 1946

D. and V. Mencl, *Pražský hrad v románském a gotickém středověku* (Prague Castle in the Romanesque and Gothic Middle Ages–in Czech), exhibition catalogue, Prague, 1946

D. Líbal, *Gotická architektura v Čechách a na Moravě* (Gothic Architecture in Bohemia and Moravia–in Czech), Prague, 1948

V. Mencl, *Czech Architecture of the Luxembourg Period*, Prague, 1955

D. Menclová, *Karlštejn a jeho ideový obsah* (Karlštejn Castle and its Meaning–in Czech), Umění V, Prague 1957

K. H. Clasen, *Deutsche Gewölbe der Spätgotik*, Berlin, 1961

V. Kotrba, *Komposiční schéma kleneb Petra Parléře v chrámu sv. Víta v Praze* (The Design of Peter Parler's Vaulting in the St Vitus's Cathedral in Prague–in Czech), Umění VII, Prague, 1959

V. Richter, *Raně středověká Olomouc* (Olomouc in the Early Middle Ages–in Czech), Brno, 1959

M. Aubert, S. Goubet, *Gothic Cathedrals of France and Their Treasures*, London, 1959

H. Busch, B. Lohse (ed.), *Gothic Europe*, London, 1959

V. Kotrba, *Kaple svatováclavská v pražské katedrále* (The St Wenceslas's Chapel in Prague Cathedral–in Czech), Umění VIII, Prague, 1960

M. and O. Rada, *Sklípková klenba a prostor* (Diamond Vaulting and Space–in Czech), Umění VIII, Prague, 1960

V. Mencl, *Vývoj středověkého portálu v českých zemích* (The Development of the Medieval Portal in the Czech Lands–in Czech), ZPP XX, Prague, 1960

Z. Wirth (ed.), *Architektura v českém národním dědictví* (Architecture in the Czech National Heritage–in Czech), Prague, 1961

E. Šamánková, *Architektura české renesance* (Czech Renaissance Architecture–in Czech), Prague, 1961

G. Fehr, *Benedikt Ried*, Munich, 1961

P. Frankl, *Gothic Architecture*, Hardmondsworth, 1962

H. Jantzen, *Die Gotik des Abendlandes*, Cologne, 1963

B. Langley, *Gothic Architecture, Improved Rules and Proportions*, Farnborough, 1964

G. Lesser, *Gothic Cathedrals and Sacred Geometry*, London, 1965

E. Panofsky, *Gothic Architecture and Scholasticism*, New York, 1967

A. Martindale, *Gothic Art*, London, 1967

W. Götz, *Zentralbau und Zentralbautendenz in der gotischen Architektur*, Berlin, 1968

V. Kotrba, *Wendel Roskopf, mistr ve Zhořelci a ve Slezsku* (Wendel Roskopf, Master at Görlitz and in Silesia–in Czech), Umění XVI, Prague, 1968

III SCULPTURE

K. B. Mádl, *XXI poprsí v triforiu dómu sv. Víta v Praze* (Twenty-one Busts in the Triforium of St Vitus's Cathedral in Prague—in Czech), Prague, 1894

A. Stix, *Die monumental Plastik der Prager Dombauhütte um die Wende des XIV. und XV. Jahrhunderts*, Kunstgeschichtliches Jahrbuch der k. k. Zentral-Kommission, Vienna, 1908

R. Ernst, *Die Krumauer Madonna der k. u. k. Staatsgalerie*, Jahrbuch des Kunsthistorischen Institutes der k. k. Zentral-Kommission für Denkmalpflege XI, Vienna, 1917

B. Lazár, *Die Kunst der Brüder Koloszvari*, Studien zur Kunstgeschichte, Vienna, 1917

E. Wiese, *Schlesische Plastik vom Beginn des XIV. bis zur Mitte des XV. Jahrhunderts*, Leipzig, 1923

W. Pinder, *Zum Problem des 'Schönen Madonnen' um 1400*, Jahrbuch der preussischen Kunstsammlungen 44, Berlin, 1923

W. Passage, *Das deutsche Versperbild im Mittelalter*, Augsburg, 1924

R. Hamann, K. Wilhelm-Kästner, *Die Elisabethkirche zu Marburg und ihre Künstlerische Nachfolge II*, Marburg, 1929

W. Pinder, *Die deutsche Plastik vom ausgehenden Mittelalter bis zum Ende der Renaissance I*, 1924, II, 1929, Potsdam

E. Kris, *Über eine gotische Georgestatue und ihre nächsten Verwandten*, Jahrbuch der Kunsthistorischen Sammlungen in Wien, N. F. IV, Vienna, 1930

J. Pečírka, *Jihlavské piety* (The Jihlava Pietàs—in Czech), Umění IV, Prague, 1931

A. Liška, *Česká dřevěná plastika v době vrcholné gotiky* (Bohemian Wood Sculpture in the High Gothic Period—in Czech), PAM XXXVIII, Prague, 1932

J. Pečírka, *O skulpturách severního portálu chrámu P. Marie před Týnem* (On the Sculptures of the North Portal of the Church of Our Lady before Týn—in Czech), Umění V, Prague, 1932

J. Pečírka, *K dějinám sochařství v lucemburských Čechách* (On the History of Sculpture in Luxembourg Bohemia—in Czech), ČČH XXXIX, Prague, 1933

O. Kletzl, *Zur Parler-Plastik*, Wallraf-Richartz-Jahrbuch, N. F. II, III, Vienna, 1933–34

J. Pečírka, *Socha sv. Jiří na hradě Pražském* (The Statue of St George at Prague Castle—in Czech), Umění VII, Prague, 1934

G. Osten, *Der Schmerzensmann*, Berlin, 1935

J. Opitz, *Sochařství v Čechách za doby Lucemburků* (Sculpture in Bohemia under the Luxembourgs—in Czech), Prague, 1935; German edition: *Die Plastik in Böhmen zur Zeit der Luxemburger*, Prague, 1936

V. Kramář, *Strakonická gotická madona* (The Gothic Madonna of Strakonice—in Czech), Volné směry XXXI, Prague, 1935

J. Opitz, *Mistr reliéfu Oplakávání Krista ze Žebráku* (The Master of the Lamentation of Christ from Žebrák—in Czech), Dílo XXVII, Prague, 1935–36

A. Springer, *Die bayerisch-österreichische Steingussplastik der Wende vom 14. zum 15. Jahrhundert*, Würzburg, 1936

A. Kutal, *Pieta v kostele sv. Tomáše v Brně* (The Pietà in the Church of St Thomas in Brno—in Czech), Brno, 1937

K. H. Clasen, *Die mittelalterliche Bildhauerkunst im Deutschordensland Preussen*, Berlin, 1939

H. Bachmann, *Gotische Plastik in den Sudetenländern vor Peter Parler*, Brno-Vienna-Munich, 1943

A. Feulner, *Der Meister der Schönen Madonnen*, Zeitschrift des deutschen Vereines für Kunstwissenschaft X, Berlin, 1943

K. Šourek, *Gotická plastika XIV. století v dómě sv. Víta v Praze, I* (Gothic Sculpture of the 14th Century in St Vitus's Cathedral in Prague—in Czech), Documenta Bohemiae artis phototypica, Prague, 1944

J. Cibulka, *Poprsí sv. Petra a Pavla v arcibiskupském paláci na Hradčanech* (The Busts of SS Peter and Paul in the Archbishop's Palace in Hradčany—in Czech), Cestami umění, Prague, 1949

K. Oettinger, *Anton Pilgram und die Bildhauer von St. Stephan*, Vienna, 1951

A. Feulner, Th. Müller, *Geschichte der deutschen Plastik*, Munich, 1953

E. Cevc, *Parlejanske maske v Ptuje in okolici*, Ptujski zbornik, 1953

L. Gerevich, *Prager Einflüsse auf die Bildhauerkunst der Ofner Burg*, Acta historiae artium, Budapest, 1954

A. Matějček, *Gotická plastika v chrámu sv. Víta v Praze* (Gothic Sculpture in St Vitus's Cathedral in Prague), Umění II, Prague, 1954

A. Kutal, *Nové práce z okruhu Mistra žebráckého Oplakávání* (New Works from the Circle of the Master of the Žebrák Lamentation—in Czech), Časopis Národního musea CXXIV, Prague, 1955

W. Paatz, *Prolegomena zu einer Geschichte der deutschen spätgotischen Skulptur im 15 Jahrhundert*, Abhandlungen der Heidelberger Akademie der Wissenschaften, Phil. – histor. Klasse, Heidelberg, 1956

J. Krčálová, *Příspěvek k poznání díla Hanuše z Olomouce* (Contribution to a Knowledge of the Work of Hanuš of Olomouc—in Czech), Umění IV, Prague, 1956

A. Kutal, *O mistru Krumlovské madony* (The Master of the Krumlov Madonna—in Czech), Umění V, Prague, 1957

K. H. Clasen, *Die Schönen Madonnen, ihr Meister und seine Nachfolger*, Königstein i. Taunus, 1957

A. Liška, *Gotická paralela* (Gothic Parallel—in Czech), Umění VI, Prague, 1958

A. Kutal, *Madona ze Šternberka a její mistr* (The Madonna of Šternberk and its Master—in Czech), Umění VI, Prague, 1958

J. Homolka, *Příspěvek k poznání plastiky na konci 14. století* (Contribution to the Knowledge of Sculpture at the end of the 14th Century—in Czech), Umění VI, Prague, 1959

G. Schmidt, *Der 'Ritter' von St. Florian und der Manierismus in der gotischen Plastik*, Festschrift Karl M. Swoboda, Vienna, Wiesbaden, 1959

A. Horvat, *Odraz praškoga parlerovog kruga na portale crkve sv. Marka u Zagrebu*, Peristil III, Zagreb, 1960

P. Skubiszewski, *Nagrobek Henryka II we Wrocławiu i problem śląskiej rzeźby nagrobkowej w drugie połowie XIV wieku*, Rozprawwy Komisji historii sztuki II, Wrocław 1960—in Polish

M. S. Frinta, *A Portrait Bust by the Master of the Beautiful Madonnas*, The Art Quarterly XXIII, 1960

D. Grossmann, *Die schöne Madonna von Krumau und Österreich*, Österreichische Zeitschrift für Kunst und Denkmalpflege XIV, Vienna, 1960

A. Kosegarten, *Plastik am Wiener Stephansdom unter Rudolf dem Stifter*, dis. Freiburg i. B., 1960

J. Kropáček, *Příspěvek ke studiu českého sochařství poslední čtvrtiny 15. století* (Contribution to the Study of Bohemian Sculpture of the Last Quarter of the 15th Century—in Czech), Časopis Národního musea, Prague, 1961

A. Liška, *České sochařství v době slohové přeměny kolem roku 1450* (Bohemian Sculpture at the Time of Stylistic Change around 1450—in Czech), Umění IX, Prague, 1961

A. Kutal, *České gotické sochařství 1350–1450* (Bohemian Gothic Sculpture 1350–1450—in in Czech), Prague, 1962

J. Homolka, *K problematice české plastiky na konci 14. století* (On the Problems of Bohemian Sculpture at the End of the 14th Century—in Czech), Umění XI, Prague, 1963

J. Homolka, *Některé otázky českého sochařství 1350–1450* (Some Problems of Bohemian Sculpture 1350–1450—in Czech), Umění XI, Prague, 1963

A. Kutal, *K problému horizontálních piet* (On the Problem of Horizontal Pietàs—in Czech), Umění XI, Prague, 1963

A. Liška, *Obnova české sochařské tvorby v 2. polovině 15. století* (The Revival of Bohemian Sculpture in the Second Half of the 15th Century—in Czech), Umění X, Prague, 1962

Th. Müller, *Recenze Kutalova Českého gotického sochařství* (Review of Bohemian Gothic Sculpture by Kutal), Kunstchronik 16, vol. 10, Munich, 1963

E. Cevc, *Srednjeveška plastika na Slovenskem*, Ljubljana, 1963

Schöne Madonnen 1350–1450, exhibition catalogue, Salzburg, 1965

D. Grossmann, *Schöne Madonnen 1350–1450, ein Nachbericht zur Ausstellung in den Salzburger Domoratorien 1965*, Mitteilungen der Gesellschaft für Salzburger Landeskunde, 106, Salzburg, 1966

A. Kutal, *K Problému krásných madon* (On the Problem of the Beautiful Madonnas—in Czech) Umění XIV, Prague, 1966

Th. Müller, *Sculpture in the Netherlands, Germany, France and Spain*, Harmondsworth, 1966

A. M. von Freeden, *Gothic Sculpture*, London, 1878

IV PAINTING

M. Pangerl, *Das Buch der Malerzeche in Prag*, Vienna, 1878

A. Patera, F. Tadra, *Das Buch der Prager Malerzeche*, Prague, 1878

A. Schlosser, *Die Bilderhandschriften Königs Wenzel I*, Jahrbuch der kunsthistorischen Sammlungen des allerhöchsten Kaiserhauses XIV, Vienna, 1893

J. Neuwirth, *Mittelalterliche Wandgemälde und Tafelbilder der Burg Karlstein*, Prague, 1896

J. Neuwirth, *Die Wandgemälde im Kreuzgange des Emmausklosters in Prag*, Prague, 1898

J. Neuwirth, *Der Bilderzyklus des Luxemburger Stammbaumes aus Karlstein*, Prague, 1897

M. Dvořák, *K dějinám malířství českého doby Karlovy* (On the History of Bohemian Painting at the Time of Charles IV—in Czech), ČČH V, Prague, 1899

K. Chytil, *Malířstvo pražské XV. a XVI. věku* (Prague Painters in the 15th and 16th Centuries—in Czech) Prague, 1966

R. Ernst, *Beiträge zur Kenntnis der Tafelmalerei Böhmens im 14. und am Anfang des 15. Jahrhunderts*, Leipzig, 1912

F. Burger, *Die deutsche Malerei vom ausgehenden Mittelalter bis zum Ende der Renaissance*, Berlin, 1913

A. Matějček, *Das Mosaikbild des Jüngsten Gerichtes am Prager Dom*, Jahrbuch des Kunsthistorischen Institutes der k. k. Zentral-Kommission IX, Vienna, 1915

K. Chytil, *Památky českého umění iluminátorského* (Monuments of the Bohemian Art of Illumination—in Czech), Prague, 1915

K. Chytil, *Antikrist v dějinách a umění středověku a husitské obrazné antitéze* (The Anti-Christ in the History and Art of the Middle Ages and the Hussite Pictorial Antithesis—in Czech), Prague, 1918

E. Dostál, *Čechy a Avignon* (Bohemia and Avignon—in Czech), Matice moravská, Brno 1922

A. Matějček, *Pasionál abatyše Kunhuty* (The Passional of the Abbess Chunegunda—in Czech), Prague, 1922

W. Worringer, *Die Anfänge der Tafelmalerei*, Leipzig, 1924

A. Matějček, *Velislavova bible a její místo ve vývoji knižní ilustrace gotické* (The Velislav Bible and its Place in the Development of Gothic Book Illustration—in Czech), Prague, 1926

E. Dostál, *Iluminované rukopisy svatojakubské knihovny v Brně* (Illuminated Manuscripts in the St James's Library in Brno—in Czech), Časopis Matice moravské, I, Prague, 1926

E. Dostál, *Příspěvek k dějinám českého umění iluminátorského* (Contribution to the History of the Czech Art of Illumination—in Czech), Brno, 1928

A. Friedl, *Malíři královny Alžběty* (The Painters of Queen Elizabeth—in Czech), Prague, 1930

J. Květ, *Iluminované rukopisy královny Elišky Rejčky* (The Illuminated Manuscripts of Queen Elizabeth Rejčka—in Czech), Prague, 1931

O. Kletzl, Studien zur böhmischen Buchmalerei, Marburger Jahrbuch für Kunstwissenschaft VII, Marburg, 1933

E. Panofsky, *Gothic and Late Medieval Illuminated Manuscripts*, New York, 1935

J. Dupont, C. Gnudi, *Gothic Painting*, London, 1951

A. Stange, *Deutsche Malerei der Gotik*, I, Berlin, 1934, II, 1936, III, 1938, IV, 1958

H. A. Stockhausen, *Böhmische Malerei der 2. Hälfte des 14. Jahrhunderts*, Marburger Jahrbuch für Kunstwissenschaft VIII–IX, Marburg, 1937

V. Kramář, *Madona se sv. Kateřinou a Markétou* (The Madonna with SS Catherine and Margaret—in Czech), Prague, 1937

A. Matějček, J. Myslivec, *České madony gotické byzantských typů* (Bohemian Gothic Madonnas of the Byzantine Types—in Czech), PA n. ř. IV–V, Prague, 1937

K. Oettinger, *Altböhmische Malerei*, Zeitschrift für Kunstgeschichte VI, 1937

J. Plachá-Gollerová, *České nástěnné malířství první poloviny 14. století* (Bohemian Mural Painting of the First Half of the 14th Century—in Czech), PAM XL, Prague, 1937

H. Jerchel, *Das Hasenburgische Missale von 1409, die Wenzelwerkstatt und die Mettener Malereien von 1414*, Zeitschrift des deutschen Vereines für Kunstwissenschaft IV, Berlin, 1937

K. Holter, *Die Korczek-Bibel der Nationalbibliothek in Wien*, Die Graphischen Künste, N. F. III, Vienna, 1938

O. Pächt, *A Bohemian Martyrology*, Burlington Magazine, London, 1938

J. Krofta, *O datování nástěnných maleb v křížové chodbě emauzského kláštera* (On Dating the Mural Paintings in the Cloisters of the Emmaus Monastery—in Czech), PA XLIII, Prague, 1939–46

J. Krofta, *Mistr breviře Jana ze Středy* (The Master of the Breviary of John of Středa—in Czech), Prague, 1940

A. Matějček, J. Šámal, *Legendy o českých patronech v obrázkové knize ze XIV. století* (Legends of the Patron-saints of Bohemia in Illustrated Books of the 14th Century—in Czech), Prague, 1940

E. Kloss, *Die schlesische Buchmalerei des Mittelalters*, Berlin, 1942

P. Kropáček, *Malířství doby husitské* (Painting of the Hussite Period—in Czech), Prague, 1946

J. Pešina, J. Mannsbart, *Studie k problematice prostoru v české malbě druhé poloviny 14. století* (Study on the Problems of Space in Bohemian Painting of the Second Half of the 14th Century—in Czech), Památky Historie XVIII, Prague, 1940

E. Trenker, *Das Evangeliar des Johannes von Troppau*, Vienna, 1948

J. Pavelka, *Karlštejnské malby* (Karlštejn Paintings—in Czech), Cestami umění, Prague, 1949

A. Matějček, *Česká malba gotická: Deskové malířství, 1350–1450* (Czech Gothic Painting: Panel Painting 1350–1450—in Czech), Prague, 1950

J. Pešina, *Česká malba pozdní gotiky a renesance: Deskové malířství 1450–1550* (Bohemian Late Gothic Painting: Panel Painting 1450–1550 —in Czech), Prague, 1950

A. Friedl, *Mistr karlštejnské apokalypsy* (The Master of the Karlštejn Apocalypse—in Czech), Prague, 1950

Z. Drobná, *Les trésors de la broderie religieuse en Tchécoslovaquie*, Prague, 1950

A. Matějček, J. Pešina, *Česká malba gotická: Deskové malířství 1350–1450* (Czech Gothic Painting: Panel Painting 1350–1450—in French, German, English), Prague, 1955

J. Pešina, *Podoba a podobizny Karla IV* (The Appearance and Portraits of Charles IV—in Czech), Acta Universitatis Carolinae, Philos. 7, Prague, 1955

V. Kratinová, *Gotické nástěnné malby v Bořitově* (Gothic Mural Paintings at Bořitov—in Czech), Umění III, Prague, 1955

A. Friedl, *Mikuláš Wurmser, mistr královských portrétů na Karlštejně* (Nicholas Wurmser, the Master of the Royal Portraits at Karlštejn Castle—in Czech), Prague, 1956

A. Friedl, *Magister Theodoricus*, Prague, 1956

Z. Drobná, *Die Gotische Zeichnung in Böhmen*, Prague, 1956

J. Pešina, *Mistr Litoměřický* (The Master of Litoměřice—in Czech), Prague, 1958

E. Panofsky, *Early Netherlandish Painting, its Origins and Character* I, Cambridge, 1958

J. Pešina (ed.), A. Bartušek, V. Dvořáková, A. Friedl, J. Krčálová; A. Merhautová, V. Mixová, K. Stejskal, *Gotická nástěnná malba v českých zemích I 1300–1350* (Gothic Mural Painting in the Czech Lands 1300–1350 —in Czech), Prague, 1958

J. Krofta, *K problematice maleb karlštejnských* (On the Problems of the Karlštejn Paintings—in Czech), Umění VI, Prague, 1958

J. Krása, *Renesanční nástěnná výzdoba kaple svatováclavské v chrámu sv. Víta v Praze* (Renaissance Mural Decorations in the St Wenceslas's Chapel in St Vitus's Cathedral in Prague—in Czech), Umění VI, Prague, 1958

J. Pešina, *Studie k malířství poděbradské doby* (A study of Painting at the Time of George of Poděbrady—in Czech), Umění VII, Prague, 1959

J. Květ, *Czechoslovakia, Romanesque and Gothic Illuminated Manuscripts* (UNESCO World Series), New York, 1959

J. Květ and H. Swarzenski, *Romanesque and Gothic Illuminated Manuscripts*, New York, 1959

J. Stejskal, *Nástěnné malby v Morašicích a některé otázky českého umění z konce 14. století* (Mural Paintings in Morašice and some Problems of Bohemian Art at the end of the 14th Century—in Czech), Umění VIII, Prague, 1960

J. Krása, J. Němec, *Svatovítská mosaika* (The St Vitus's Mosaic—in Czech), Umění VIII, Prague, 1960

V. Dvořáková, *Karlštejnské schodištní cykly, k otázce jejich vzniku a slohového zařazení* (The Karlštejn Stairway Paintings; on the Question of their Origin and Style—in Czech), Umění IX, Prague, 1961

J. Homolka, *Madona ze Svojšína* (The Madonna of Svojšín—in Czech), Umění X, Prague, 1962

J. Cibulka, *České stejnodeskové polyptychy z let 1350–1450* (Czech Polyptych Panels from the Years 1350–1450 —in Czech), Umění XI, Prague, 1963

J. Krása, *Nástěnné malby žirovnické Zelené světnice* (Mural Paintings in the Žirovnice Green Room—in Czech), Umění XII, Prague, 1964

J. Krása, *Astrologické rukopisy Václava IV* (The Astrological Manuscripts of Wenceslas IV —in Czech), Umění XII, Prague, 1964

V. Dvořáková, *Mezinárodní význam karlštejnského dvorského ateliéru malířského* (The International Significance of the Karlštejn Court Studio—in Czech), Umění XII, Prague, 1964

V. Dvořáková, J. Krása, A. Merhautová, K. Stejskal: *Gothic Mural Painting in Bohemia and Moravia 1300–1378*, London, 1964

Z. Drobná, *K problematice bible boskovské* (On the Problems of the Boskovice Bible—in Czech), Umění XIII, Prague, 1965

J. Pešina, *Obraz krajiny v české knižní malbě kolem r. 1400* (Landscape Pictures in Czech Book Painting around 1400—in Czech), Umění XIII, Prague, 1965

E. Carli, José Gudol, Geneviève Souchal, *Gothic Painting*, London, 1965

M. Meiss, *French Painting in the Time of Jean de Berry*, London, 1967

G. Schmidt, *Johann von Troppau und die vorromanische Buchmalerei*, Festschrift für Karl Hermann Usener, Marburg, 1967

K. Stejskal, *O malířích nástěnných maleb kláštera na Slovanech* (On the Painters of the Murals in the Monastery Na Slovanech—in Czech), Umění XV, Prague, 1967

J. Pešina, *Paralipomena k dějinám českého malířství pozdní gotiky a renesance* (Parapolimena on the History of Bohemian Painting of the Late Gothic and Renaissance Period—in Czech), Umění XV, Prague, 1967

J. Vacková, *O ideové koncepci renesančních nástěnných maleb ve svatováclavské kapli* (On the Concept of the Renaissance Mural Paintings in the St Wenceslas's Chapel—in Czech) Umění XVI, Prague, 1968

A. Friedl, *Nástěnné malby kapitulní síně slovanského kláštera na Sázavě* (The Mural Paintings in the Chapter-house of the Sázava Monastery—in Czech), SPFFBU XVI, Brno, 1968

M. Bohatec, *Illuminated Manuscripts*, London, 1970

Abbreviations:

SPFFBU–Sborník prací filosofické fakulty brněnské university (Selected Papers issued by the Philosophical Faculty of Brno University)

PAM–Památky archeologické a místopisné (A magazine devoted to the study of archeology and topography)

ČČH–Český časopis historický (Czech Historical Journal)

PA–Památky archeologické (A journal devoted to archeology)

INDEX OF NAMES

All numbers refer to text pages; those in italic indicate illustrations

PHOTOGRAPHS WERE RECEIVED FROM THE FOLLOWING INSTITUTIONS AND PHOTOGRAPHERS: